Claire Richards

SOVIET

WITHDRAWN FROM STOCK

2196

SOVIET SISTERHOOD
British Feminists on Women in the USSR

Edited by Barbara Holland
The Women in Eastern Europe Group

FOURTH ESTATE LONDON

© Barbara Holland 1985

First published 1985
Fourth Estate Limited
100 Westbourne Grove
London W2 5RU

Produced by
Charmian Allwright

British Library Cataloguing in Publication Data
Soviet sisterhood:–
British feminists on
 women in the USSR
 1. Women – Soviet Union –
 Social conditions
 I. Holland, Barbara
 305.4'2'0947 HQ1663

ISBN 0–947795–40–5
ISBN 0–947795–41–3 Pbk.

Typeset in 10/11pt Bembo by
Falcon Graphic Art, Wallington, Surrey.
Printed and bound by
Billings and Sons, Worcester.

CONTENTS

LIST OF CONTRIBUTORS

Mary Buckley is currently a lecturer in politics at the University of Edinburgh. She recently travelled to the Soviet Union and interviewed prominent sociologists interested in women and the family.

Lynne Attwood is a postgraduate student at the University of Birmingham studying sex-role socialisation. She recently contributed, along with Maggie McAndrew, to a book surveying women at work in the Soviet Union, and in other countries. She has travelled widely, including Eastern Europe and the Soviet Union.

Maggie McAndrew completed an MA at Essex University on women in the CPSU (Communist Party of the Soviet Union), and has been doing research at the University of Birmingham into Soviet women's magazines. She recently spent a year at the Faculty of Journalism, Moscow University.

Jo Peers completed a masters degree at the University of Essex on Soviet Central Asia and has been studying Soviet demography at the University of Birmingham.

Barbara Holland completed a M Soc Sc degree at the University of Birmingham on reproduction in the Soviet Union. She spent a year in Moscow in 1970–1 and has returned a number of times, most recently for a five-month research visit when she was accompanied by her then two-year-old son.

Teresa McKevitt completed a master's degree at the University of Birmingham on a comparison of British and Soviet maternity care. She has worked as an abortion counsellor.

Susan Allott has recently completed a PhD thesis at the University of Bradford on women in the Soviet countryside. She spent six months as a student in Moscow in 1973–4 and a further six months in 1981–2 as a research student at the Belorussian State University in Minsk.

Genia Browning has been well acquainted with the Soviet Union since working there in the 1960s. She is completing a PhD thesis on women in Soviet politics.

Alix Holt has written a number of articles on life in the Soviet Union. She is especially interested in the 1920s and recently edited the selected writings of Alexandra Kollontai.

INTRODUCTION

THE NINE of us who have contributed to this book are all British women without a single Russian ancestor between us. When we met together to plan our chapters, we started to ask ourselves – what is it about the Soviet Union that has such a hold on us? Why do we give it so much of our time, keep scheming to go back there, decide to give it all up and then find ourselves gazing again from train or plane at those endless forests of pine and birch?

We decided that part of the attraction was traditional Russia – the musical language, the literature, the richness of the old ikons and folk designs contrasted with the beautiful winter snow. The colour red is everywhere. The very centre of the country, Red Square, is named not for politics but is the old Russian word for beautiful.

Of course, politics is never far away. The Soviet Union is at the centre of myths for both left and right, as either the most progressive society to date, or the most oppressive. The more compulsive part of our attraction is the desire to cross into the 'enemy' camp and see for ourselves.

Looking back at the revolution of 1917, we still feel the tremors of those ten days, and the following ten years. Ordinary people won power, and with it a feeling of dignity and hope. Women took part as demonstrators, activists and leading party members, and women's concerns were recognised in new laws and initiatives. Our group of nine was sufficiently radicalised by the events of the late 1960s to recognise a moment of far greater democracy and equality than we have known ourselves. We are anxious to trace what became of all that excitement and idealism. In addition, our current ideas about feminism and socialism have to take account of the massive changes in the lives of Soviet women, whose experience is too often left out of discussions, even international exchanges.

Our travels to the Soviet Union have brought an awareness that it is greater than just Russia, and that the Russian language opens the door to a number of unique Eastern cultures. Between us we have made a number of visits, some lasting over a year, and have found that the longer we stay, the more we develop a love–hate relationship with the place.

On the positive side there are friendships with people there, and their warmth and hospitality. Russians have a reputation for pouring out their souls over empty bottles of vodka in the middle

of the night: though that does happen, they can be just as sincere and frank – and usually more lucid – over glasses of lemon tea. Friendships bring a feeling of breaking down unnecessary barriers.

As women we also find it a relief to be away from the pressures of the capitalist market, from conspicuous consumption, from advertising with its glamorous models and from street-corner pornography. Instead there are images of women successful as a result of their achievements, as factory workers, scientists, even astronauts. Some of the women we meet surprise us with their self-assurance, the way they take it for granted that their lives are varied and purposeful.

Russian people in general have a sense – hard to define – of their common destiny, and within it there is a certain solidarity. As the material needs basic to survival are secure, there is a willingness to share minor possessions, money, or good fortune such as a kilo of oranges in January. People may be envied for their acquisitions, but as yet their worth is not measured by them.

To balance against this there is the grind of the daily search for decent food, and the endless queues. (Three hours for a banana!) The stress of the competition for scarcities wears down the nerves, and leads to aggravation and rudeness. As foreigners we can save our vitality by using the special foreign currency shops. Ordinary Soviet people have to cope by swopping privileges – my access to beneath the counter of a good food shop against your friend involved in the import of East European shoes. Much time and energy goes into the development of these networks, whose running is greased by the payment of extra roubles. As in the West, it is women who bear the main responsibility for the family's 'shopping'.

Rudeness is also a feature of dealings with the bureaucracy, whose aim in life seems to be running obstacle courses for the achievement of the simplest goal. Those endless forests must be under threat from the proliferation of questionnaires, forms, authorisations, passes and refusals.

Alongside such routine difficulties, particularly the restriction on travel outside the city of residence, foreigners can face an atmosphere of wary suspicion. The KGB relies on its reputation for being omnipresent, so although this reputation is far removed from reality any new contacts between foreigners and Soviet citizens are marked by caution on both sides. Once trust has been established, friendships are often saddened by their unequal basis. We can only visit them, bringing news and ideas from the West, rarely able to bring our Soviet friends to the West to see our lives for themselves.

After a few months of living in the Soviet Union, even in Moscow, home and the rest of the world seem very remote.

We feel that this personal contact we have had with the Soviet Union has been important to our understanding of it. Academic study can take you a long way, even relying on published sources. Planners need information, so statistics and surveys are reasonably reliable, and mass publications need readers, so articles and readers' letters touch on issues of genuine concern. However, it is generally agreed that everything published passes through the censor, and that the only outlet for alternative views is the illegal *samizdat* (self-published) material. This is the category into which the *Almanac: Woman and Russia* belongs. Produced by a group of women in Leningrad in 1979, the *Almanac* is a bitter criticism of Soviet men and Soviet institutions.

Published material is also limited by being incomplete. Many topics such as abortion and divorce are covered not by national surveys but only by small local studies. Other subjects such as lesbianism, prostitution, rape and battering or women psychiatric patients, are hardly ever mentioned. As well as using the *Almanac*, we have drawn at times on our own experiences, observations and interviews, in order to fill in the gaps and reach closer to the reality of women's lives.

The Soviet Union is a country which claims to have made women equal, yet it takes little more than a glance to see it is still very much a male-dominated society. In choosing to write about aspects of the position of Soviet women we have chosen different areas, but all ones where tension is being felt as the result of women's inequality.

Our aim is to look at these areas in depth, to go beyond the easy sloganising of left and right about the Soviet Union and try to see the situation in all its complexity. In the struggle to combine work and homelife, Soviet women have hard and busy lives. They end up in predicaments or are forced to make choices sometimes quite different from those we meet in our Western lives. To give a feel to this, we have included in this introduction the following three letters by Soviet women. They were written to the Soviet press, and were quoted in a recent Soviet book by a popular woman journalist, Larisa Kuznetsova (*Zhenschchina na rabote i doma* (Moscow, 1980), pp. 96–106).

Tamara's Letter

My father left my mother when I was nine, and my brother five. It wasn't long before I realised that I was the eldest and mother had

only me to rely on for help with the housework which, by the age of twelve, I had taken on myself almost entirely. That's probably why I hate the sight of the kitchen.

I went to technical school. Then I did a college correspondence course. In time I began to earn good money. My brother, after completing his military service, is now at college, where he gets an additional grant. Our hard times are over, my mother is breathing freely again, and I too should be feeling satisfied with things, having something of a breathing space.

But instead I'm in a state right now, in more of a state than I've ever been before. After all people don't work just for their daily bread. Even when I was worn out by coping day to day, when I was trying to eat on just a few kopeks, economising, I was still concerned about my future. Not for the sake of money. I was offered a job where the pay was 30 roubles more but the prospects of promotion less. I refused on the spot. And my refusal was strategically correct – within a year I'd been promoted to chief technician.

I'm good at my work and I enjoy it. The ministry has rewarded me with a certificate of merit.

A few years ago our enterprise was merged with two subsidiary ones. Ours was, as it were, the leading carriage of the train. The enlarged enterprise needed a chief technician. They could have appointed me, but the management refrained. Probably they were right: my experience was still limited, and correspondence courses have their faults . . .

There was a string of applicants. The administration could think of nothing better to do than ask my advice. I felt like a match-maker, who would willingly have become the bride.

In the end they found someone. In fact I had recommended the man. He was a good technician and a nice, considerate person. But nobody's perfect. So it was in this case. He came to us from a different field. He found it hard to settle into the new job. He was always coming to me for consultations. For the first six months I more or less nursed him, until he was able to stand on his own two feet. Now he's grateful to me, pleased with himself, and the administration think he's wonderful. Then out of the blue a rumour went flying round that we might be losing him to the ministry. There's news! Surely I won't have to start all over again – take part in looking over the prospective bridegrooms, ease the newcomer into the job, shape him to our requirements, nurse him . . .

I plucked up courage, went along to the secretary of the party

committee and as soon as I was in the door came out with it: 'If Pavlov (the chief technician) leaves, the new chief technician should be me.' The secretary looked at me and said with a laugh 'Well, why have you come to me with this? Go to the administration, I won't object. But aren't you jumping in ahead of the lads? In the first place, nothing's definite yet about Pavlov leaving, so this conversation of ours can have only a theoretical character. In the second place, you should spare a thought for yourself. How many years did you bail out your mother, drag your brother along, your bones must be shaking from all the effort! Have you really got the strength left for new burdens? We've got to change all the equipment soon. There'll be all kinds of technological trouble! And now we have these bold, brave women, longing to be the boss! They want to take charge of men!'

I was incensed. Apparently, because I'm a woman I arouse pity and sympathy. I have to be cherished, I shouldn't be overburdened. Apparently, to be in charge of a male workforce is unfeminine. It's as if I've applied to be the attendant in a men's bath house. All this shot from my mouth. You could even say I was rude. I didn't mince my words. The conversation turned out to be decidedly theoretical, but extremely useful. It made me realise – we have to destroy this idea that a woman can only get so far at work. And destroy it not theoretically – our theory on this question is quite in order – but concretely, every time.

The man on the receiving end also came to some conclusion, I think. At the last party meeting he spoke about the need to pay special attention in the plan for the social development of our enterprise to the question of extending women's qualifications and responsibilities. Everyone, of course, was 'for'. It went through on the nod, being nothing new. But I know where that 'special attention' came from. I've got my way!

All the same, I can't get out of my head the dig the chairman made when he said I should think of myself. It was a hidden reproach on my private life – I'm not married. I don't have to inform everyone that my private life suits me. I'm not longing to get married: I'm afraid of repeating my mother's bitter experience. But all that's beside the point.

This week Pavlov announced that after some thought he had refused the transfer to the ministry. You've helped me along so much, he said, I'd be ashamed to give up now. I was so pleased to hear this that I threw my arms around him. We both shed a few tears: together we make such a good team!

This isn't the end of the story. Yesterday I was offered a transfer

to the ministry, to the very same job that Pavlov turned down. Fate, it seems, is laughing at me. And so, I'm in such a turmoil . . .

Svetlana's Letter

A little about myself: education – higher, children – two, middle-aged, an ordinary job – district paediatrician, length of service – fifteen years.

At first I threw myself into my work. Without being asked or instructed I used to call twice a day on all the young children who were seriously ill. It was as if they were my own family, I was so afraid to miss them out. I brought the number of emergencies in the district down to a minimum. It may sound funny, but with the help of officials from the regional GAI traffic police I secured the introduction of one-way traffic on two roads running alongside schools. This was after one of my patients, a little boy, was barely saved after a 'Volga' knocked him down. The little lad had only just recovered from severe angina with complications . . . How I fought at that time! My colleagues even started murmuring, saying I must have organisational talent, since I've swung such a matter.

I used to get terribly tired, and at home was no use at all. For the first ten years of my married life my widowed mother lived with us, for which I thank her. She organised the children for us, and she managed the household. Four years ago mother, who was regarded by all of us as a granny, and always called that, suddenly got married. A widower from our courtyard proposed to her. They made quite a good couple. I was happy for mother, but at first it was very hard on me. Still, the children grew up and began to help and I've got an understanding husband who helped with the housework. With my hand on my heart I cannot complain that the problems of day-to-day living have really oppressed me, the way it is usually talked about these days.

There was nothing to hinder my progress at work. I could even have become a professor. But I'm placid by nature, like a lamb, I've never really wanted to be a professor. However, the year before last, when I was offered a post as head of one of the departments in our local children's hospital, I gladly accepted. The hospital is simply miles away from home (and there's no metro in our town) but still my heart was singing: a whole department, the work I love, I'm getting somewhere!

To my new eyes the department was in a fundamental state of neglect. Even the needles for the syringes were blunt. For the first few months I was the new broom that sweeps clean. But I was nothing like hard enough in dealing with the staff. I couldn't

demand. My voice had no metal in it. I could only ask.

Fate had arranged a strange set-up: the new chief doctor in charge
of the hospital was the former head of the department where I had
arrived with the intention of sweeping clean. How they could make
him chief when he'd handled his previous job in such a slapdash
way I couldn't at first understand. I understand now – it wasn't a
lamb that peered out of his eyes, and there was metal in his voice.
Friction arose between us.

The chief doctor should deal with the affairs of the hospital as a
whole. But he carried on acting as head of the department where I
was now the boss. The matter became an absurdity. Once I let
myself joke: 'Who's mother in this department – me or you?' With
his forefinger raised didactically he replied in a harsh voice:
'Remember, everywhere . . . I'm father.'

Clearly I was head of department by authorisation, but not by
authority. Although I was in charge, I had not become the leader.

No, I'm not complaining. I simply want to share the thought,
how deeply the habit of commanding has entered into men's blood.
I would probably need a complete transfusion before I could turn
myself into a demanding leader of the workforce. My husband says
to me: 'Look here, you can't get along, but you can still work
together.' But I can't work with someone when we don't get
on . . .

I began to cry a lot, to sleep badly. I started going to work
reluctantly. My colleagues were aware of it . . .

I found some strength in myself – I left the hospital and went
back to the polyclinic. Once again I am a local doctor. I run up and
down stairs, I hold surgeries. The hospital has done a lot for me. I
would like to think that I am not just a local doctor, but an excellent
one. I've grown in my profession, not upwards but in depth. I'm
content. No longer worried. I've become convinced: any changes
of job will have to fit in with my personal abilities. I also have a
small general comment: it would seem that because for centuries
the weak sex has been 'propped up' by the strong, both the need
and the ability to govern have been crushed in women. This is the
only way I can explain why, even in the health service where,
wherever you cast your gaze, 'lady doctors' abound, the top jobs
are often occupied by men. The small number of boys who enter
medical schools can reckon from the start: I'll finish the institute –
become a chief doctor . . .

Valya's Letter
I think that the most equal women are those without children – or

without any family. Those without children have more time, and strength, and a head free of worries. They have different options. Why shouldn't they get on in the world, become something? But we mothers of small children – what hope have we?

Take me. I studied, tried hard, and got good marks. After finishing technical college I worked first as a laboratory assistant, then a senior laboratory assistant, but now I feel I must study more, even by correspondence, for with us there is always that pressure: study!

The post of head of the laboratory landed right in my lap. I remember, at the farewell dinner for our head's retirement, she said to me: 'Before long the keys to everything will rest with you, Valya. Don't fail. The laboratory is growing more important, you'll see for yourself, how busy we are, when you get involved in managing things.'

I had just got married, and didn't like to say during the conversation that I was expecting a baby. It seemed to me that I'd get by, nothing would especially change in my life. So I kept quiet.

A month and a half after this conversation I was in fact made the head. And then something totally unexpected happened – the smells in the laboratory started to upset me. They tormented me, almost to tears. Our laboratory, as luck would have it, had a poor ventilation system. They began to mend it. Our chief engineer then had a word with me. 'You', he said, 'should go on leave, and leave us to the ventilation.' Still, it had to be mended and it was. But even that didn't help – before long I was taken to hospital: the chemicals had, after all, affected me. I lay there thinking: I'd only just started to get a real grip on things, and now this . . .

I've a good husband, he didn't miss a single visiting hour at the hospital, he even changed his shift, and whenever he came he comforted me: 'You'll just stay at home with the baby for a while, and go for studying at the same time – catch two hares at once.' But it wasn't quite like that. The two hares turned out a bit different – I had twins, a boy and a girl. We called them Misha and Ira. We were pleased, the children were healthy. All the same, we had a hard time – twice as many nappies to wash, twice the feeds, and even two to carry about.

My mother in law is young and still goes to work, while four years ago my own mother gave me a brother. The way things turn out! So I couldn't get any help from the grandmothers, and what kind of grannies are they? The word doesn't seem right for them . . . Never mind, the children are content.

Then there began the trouble of finding a nursery for my little

twosome. This is where I found out just what the situation in our town is like regarding childcare establishments. Our population is mainly young, and there are lots of children, but the number of nurseries and kindergartens is, it seems, the same as in towns without our birthrate. Who makes plans like that? Our production is racing ahead, there are never enough workers. So if young mothers are needed for production, and if they too need production, there must be some thought given to childcare provision?

It was the director himself who helped me get a nursery, for which I thank him. But how many mothers cope as best they can: give up work, look for nannies, or send the children to the countryside . . .

We also had to suffer hard times. Early in the morning I had to take the children on one journey, and after work, bring them back. The buses are cold. Eight months passed by, in the course of which my two 'hares' were continually falling ill. It seemed that no sooner had I got them better and gone back to work than three to four days later it was back to doctors, compresses, mixtures. They were diagnosed as having a chronic inflammation of the lungs, and the doctor recommended keeping them at home until they were three.

I resigned myself, to wait for better times. What studies! I'd forgotten to think about that. You can't do all your buttons up in one button hole.

The children soon recovered, their cheeks filled out, I bought everything fresh for them at the market. But as time went on it became harder and harder for four to live off one wage. I'm ashamed to say how bad things got – we didn't have a television, and our furniture was the worst in all our block. I got tired at home, and after all, it's boring without work. I simply slept and thought, how to work again.

In order to go to work, I need a kindergarten. And who am I, that they'll give me a kindergarten, when I'm sitting at home? So a new merry-go-round started. It's a long story, but in the end I returned to my laboratory. But I had to start at the beginning – as an ordinary laboratory assistant. The first few days it was humiliating, but now I see it was right: production has moved ahead, and I have to catch up.

I realise that no one bears as much responsibility for her children's health as the mother. And I don't regret that for the sake of their health I stayed at home for a while. If I have to, I'll do it again. We don't want to bring up people who will spend their whole lives taking sick leave, and needing treatment in sanatoria. But my previous qualifications are now wasted, which is a pity.

Now I have to make a really big effort. It would be nice to be taken care of for a bit. I need to attend some kind of courses, but during, not after, work – after work I run home like a madwoman. But nobody's planning to take care of me, and we don't have any rules that give privileges to those who've fallen behind. You've fallen behind? Then run faster! However, while there's usually help getting up the mountain, you have to come down by yourself. [A footnote in the Russian text points out that since this letter was written, a new regulation permits women with children under eight years old to have paid time off work for study, at the discretion of the management.]

Tamara, Svetlana and Valya, the writers of these letters, have a clear sense of their own worth at work. They know that their contribution is valuable and that, in the right circumstances, they could develop their abilities and offer more. The obstacle in their way, though they are unable to name it as such, is male prejudice. Tamara and Svetlana encounter it face to face, while in Valya's case it is indirectly present, in the assumption that it is mothers who must make sacrifices for their children.

It is the same fight that women face in the West, but the battleground is different. Soviet women have won formal equality, and have both the right and the opportunity to go out to work. Some 90 per cent of Soviet women are in paid employment, and many of them are doing the same kind of jobs as Tamara, Svetlana and Valya. The issue at the heart of their three letters is the difficulties women face in gaining and keeping promotion, particularly when they are placed in positions of authority over men. Tamara, after a fight in which she used the party's stated policy of encouraging women against its reluctant official, won recognition. Svetlana gave in, her confidence in her own abilities undermined by an unsympathetic male colleague. Valya was pleading for more understanding of the extra demands placed on mothers of young children. In countries like Britain it is only a tiny minority of women who are able to challenge men for positions of influence, the great majority, if they work at all, are being forced to take routine and part-time jobs.

The letters also touch on a problem that women in the West certainly do share, that of combining employment with domestic work. Valya is pulled under by a combination of twins, distant nurseries and winter colds. Family commitments are not an immediate problem for Tamara and Svetlana, but they both take

some trouble to explain why, and both have been under pressure in the past. Although the Soviet Union does recognise domestic work, including childrearing, as an important social contribution, the level of state support is not that high. Encouragement to men to 'help' their wives at home is at best half-hearted. It would seem that in this sphere the only advantages Soviet women have when compared to women in the West are somewhat negative ones – they can easily get a divorce or end an unwanted pregnancy.

Soviet propaganda makes light of these difficulties. It sweepingly declares that the material conditions exist for women to have both a rewarding job and a happy home life. When these expectations are not met, women can be left with a guilty sense of personal failure, as in Svetlana's case, or with the extreme bitterness which underlies many of the writings in the *Almanac*. Often Soviet women say that they are not interested in women's liberation as their experience proves that it is an idea that has failed.

Propaganda is of course cruder than much of official ideology, which does allow for the existence of social problems. The first three chapters of this book look at different aspects of ideology as it affects women, and as it is presented for their consumption.

Chapter 1, 'Soviet Interpretation of the Woman Question', traces the development of Soviet thinking on women from its roots in Marxist theory, through the changes of the 1920s and 1930s and up to present-day debates. It looks at why the concept of patriarchy has failed to develop, and at how ideas have been shaped by the policy needs of a male-dominated government. In particular, it examines the government's wish to encourage stable families and traditional gender roles.

The second chapter, 'The New Soviet Man and Woman – Soviet Views on Psychological Sex Differences', takes the question of gender roles and examines Soviet views in depth. It shows how psychology, with its emphasis on the 'all-round development' of the human personality, is at odds with educational theory and its emphasis on bringing up traditionally 'feminine' girls and 'masculine' boys. It suggests that this thinking reflects a crisis of masculinity, which is causing social problems such as delinquency and alcoholism, and that women are being urged to remain weak and dependent in order to ensure the social control of men.

Chapter 3, 'Soviet Women's Magazines', looks in detail at the popular journals *Rabotnitsa* ('The Working Woman') and *Krest'-yanka* ('The Peasant Woman') to show how the government uses the press to transmit its policies to women. Because these magazines aim at a mass readership, they have to be in tune with the lives

and preoccupations of ordinary women. They reveal the importance of work to Soviet women's identity, as well as the pressures on women not to neglect the traditional domestic skills needed by a 'good' wife and mother.

The following three chapters are concerned with the reality of life for Soviet women as regards the 'double burden'; their experience of pregnancy and childbirth; and conditions in the countryside.

Chapter 4, 'Workers by Hand and Womb – Soviet Women and the Demographic Crisis', describes the continuing inequalities women face at work in terms of lower status, skills and pay, and in the home in terms of more housework and less leisure time. It argues that the immense contribution women have made to Soviet power has not been properly rewarded, and that the government is now paying the price in the form of the country's low birthrate, especially in European Russia. Women cannot come together to put their point of view, and the government, in looking for solutions that simply ease the double burden, is avoiding the basic problem of inequality.

Chapter 5, 'Maternity Care in the Soviet Union', takes up the question of the lack of female solidarity, and shows how the important networks of support women build around childbirth have gradually been undermined by Soviet medical practice, despite the predominance of women doctors. The exception is abortion, the illegal practice of which guarantees women control, albeit imperfect, over their own fertility. Current policies on the medical treatment of pregnancy and childbirth are examined in detail, and interviews giving the personal experiences of two women included.

In Chapter 6, 'Soviet Rural Women: Employment and Family Life', the conditions of life for rural women are described. Again, work is a major concern: women are being kept out of the skilled and better-paid jobs. They are also suffering from the double shift, and from men's irresponsible behaviour and chronic drinking. Although the government wishes to stem the migration of young women to the towns, it seems unable to tackle the underlying problem of the sexual division of labour in the countryside.

To sum up, the burdensome inequality of women's lives is causing a series of problems for the Soviet government, but dogmatic restrictions on its thinking about women mean that solutions, if they can be found, are unlikely to further the cause of women. This is well illustrated by the exception that proves the rule, the case of Soviet Central Asia.

Many of the people living in this area are of Turkish and Persian

origins and have a culture based on Islamic traditions. The majority of women belonging to these nationalities still lead a more traditional lifestyle, having an average of five or six children, and staying at home full time to care for them. The patriarchal family still has a strong hold, and within it women carry on the old traditions and religious beliefs. In an attempt to combat this, the government's policy towards women is sharply different in this area. Instead of more children, the government encourages women to have fewer, and instead of seeking to strengthen the family, the government organises a range of clubs, libraries and advice bureaux for women and girls which are designed to weaken the influence of Asian traditions and family ties.

Though the government has different policies towards women and the family in different areas, it is with the same end in view. It is attempting to steer both the European and Asian societies towards the ideal, the revered Soviet family, consisting of husband and wife who both go out to work, and three future builders of Communism. Thus the nuclear family is seen to have a vital, stabilising role as the basic cell of society. Despite the obvious strains the Soviet family is under, and despite Marx's own injunction to 'doubt everything', the central role of the family in the ordering of people's domestic and emotional lives is never questioned.

It is probable that assumptions like this will only be challenged by an organised feminist voice. The final two chapters of this book look at the possibility of such a voice emerging and being heard, either within the existing political structures, or outside them.

Chapter 7, 'Soviet Politics – Where are the Women?', is concerned with official political bodies. It shows that many women do play an active part in government and party organisations, but nevertheless lack real power. It looks in detail at the network of women–only organisations, the *zhensovety* (women's councils), and shows how stereotyped notions of women's issues restrict their potential as a possible focus for feminist consciousness. As a result they are little more than a cover-up for the absence of female power.

Chapter 8, 'The First Soviet Feminists', looks at the emergence of feminist ideas within the 'second culture' of the Soviet dissident movement, and their subsequent repression. In outlining these ideas it accounts for their peculiarly Soviet slant, such as their dislike of theory, and for the split that has occurred between secular and Christian groups of feminists. The fate of individual women is recorded, and the varied impact of the groups on dissidents within the Soviet Union, and on feminists and socialists in the West.

With the writers of the *Almanac* either exiled or stifled, it seems that the prospects for feminism developing in the Soviet Union are at the moment dim. Publications by Western feminists do reach intellectual circles, but the ideas in them are generally dismissed as 'bourgeois' and divisive, particularly the emphasis on male/female relationships and the need for political autonomy. However, we would argue that it is this absence of a feminist perspective that lies at the root of Soviet women's problems. Other factors matter too – an inefficient economy heavily weighted towards defence; a party that puts the continuation of its power and privilege above everything else – but without an awareness of male power and its workings, there can be no real solutions for women.

The usual explanation given by Soviet ideology for the government's failure to achieve all that has been promised for women is that of inadequate resources. At the time of the revolution the country was at a very low level of development, and the years after the revolution brought war, famine, the upheaval of collectivisation and another war. In the drive to industrialise and defend the country, it was convenient for the government to postpone the promised socialisation of domestic labour, especially as women would continue to do it for free. Soviet women are still waiting for the right material conditions.

The fact that priorities were and remain set in this way is the result of shortcomings in the theory behind the party's programme, and a lack of female influence at the level of policy-making. Marxist theory assumed that women's entry into paid employment was sufficient to bring about liberation; that after granting women formal equality with men, and the freedom to marry and divorce, male/female relationships would gradually equalise themselves. The other structures that underpin male power, such as violence, were not at that time discussed.

In reality women found that, without the resources to live independently of men, liberal laws only led to their greater exploitation. Men would go from woman to woman leaving children behind, or else put pressure on their partners to have abortions. Adjustments to policy were made in 1926, and a conservative family policy introduced in 1936, not without the support of quite a few women.

It is all too easy to say there should have been a women's movement to raise consciousness on these issues. Obviously ideas do not appear out of thin air, and in the Soviet Union of the 1920s there were few women with the education and interest to develop feminist policies, let alone press for their implementation. The two

prominent women who could have done this, Alexandra Kollontai and Inessa Armand, were silenced, the one by political defeat, the other by untimely death. There were other women in the party, particularly in the women's department, who were moving closer to feminist ideas such as positive discrimination through their practical experience, rather than through theory; however, their experiments came to an abrupt end in 1930 when the women's department was shut down, as Stalin's hold on the country grew.

Despite material progress and changes in women's lives which have opened up the possibility of their far greater political involvement, the women's department of the party has not been revived. Because of the difficulties of organising together, there is very little scope for women to bring about change. Other groups of intellectual women expressing feminist ideas may well emerge, to have a greater impact in the West than in their own country. The government may well introduce measures that make minor improvements in women's lives without dealing with the major problems. The ideology does not permit experimentation, or a really deep appraisal of the structures of oppression.

The majority of Soviet women, disappointed when their expectations of work are not fulfilled, will probably continue the trend towards a greater involvement in personal, home life. Many will find themselves disappointed here too. Though they are able to leave unsatisfactory men, and to avoid having children, there is little they can do positively to create new relationships or patterns of childcare. Their failures appear to be personal, not political matters. As a result they may try even harder to match up to the ideal of the truly feminine woman, and worry about their domestic skills and their appearance.

Feminists in the West may feel nostalgic for the determined pioneers of the past who, their red kerchiefs firmly knotted round their heads, climbed into the driving seat of a tractor or picked up a shovel on a building site. We may be hurt by the ridicule now attached to these images by Soviet women, themselves anxious to buy our fashionable jeans and dresses, and leave their dirty overalls behind.

The point, however, is to try to put aside our own prejudices and to understand the unique position of Soviet women. That is why we have written this book. We hope that our research, our experiences of the Soviet system, and our pleasure at knowing Soviet women, will help to develop that understanding.

BARBARA HOLLAND, 1985

1 SOVIET INTERPRETATIONS OF THE WOMAN QUESTION
Mary Buckley

UNTIL THE mid-1960s very little had been written in the West about the position of women in socialist systems. Then came a spurt of books and articles, mainly on women in Russia. Research was inspired in part by the women's movement throughout the West, the boom in women's studies in the United States of America and by International Women's Year in 1975. It was also helped by the revival of the 'woman question' inside the USSR after more than 30 years of slumber and by the rejuvenation of Soviet sociology, which not only provided useful data on women at home and at work, but also drew attention to the female 'double burden' or 'double shift'.[1] In just over a decade, the results of some thorough research were published in the USA and later in Great Britain. The flow has not stopped.

Certain topics, however, have been more systematically covered than others. We now have sophisticated analyses of the position of women in the paid workforce and in households and rather less insight into women in politics. We know more about Russian women than Azerbaidzhani or Kazakh women. We have a clearer picture of the lives of urban Russians than rural ones. Furthermore, what information we have gathered is empirical rather than theoretical. Research has focused on female roles, rather than on the theoretical treatment inside the USSR of these roles.

Our aim here is to start to close the gap in theory and to examine how the woman question has been interpreted in the USSR since 1917. In particular, we shall show how current discussions about women in society differ in content from the writings of the Stalin years. Inequalities between the sexes are now acknowledged to exist, whereas in the 1930s, 1940s and 1950s they were not. This refreshing and long overdue acknowledgement is one aspect of a recent shift in the status of the woman question.

This shift in status, however, has its limits. Although Soviet Marxism now recognises some inequalities between women and men, it does not go very far in questioning why they exist. Feminists in the West might be disappointed that the concept of patriarchy is not used in Soviet explanations of sexual inequalities, except in discussions of the subordination of Muslim women. Feminists might also be dismayed that at the level of practice,

Soviet writings increasingly encourage reproduction and part-time labour for women and emphasise how 'psycho-physiological characteristics' equip women, not men, for nurturing roles. Here Soviet ideology echoes the policy priorities of the Soviet leadership. It contains a highly practical dimension since its theoretical propositions are often prompted by the proclamations of party congresses and shaped in part by the directives of five-year plans. In short, Soviet theorists frame the woman question to fit directives from above, rather than in response to demands from below or from independent critical thinking. We shall argue here that despite the greater candour of current Soviet theoretical writings on women, Soviet ideology nevertheless reflects the needs and priorities of the Soviet state as defined by the male political leadership.

Because Soviet Marxism is influenced by political context we attempt to weave into our discussion references to political setting and to governmental policies when they have a particular bearing on developments in ideology. Although the emphasis of this chapter is on theoretical interpretations of the woman question, we do not want to keep ideology and practice apart in separate, rather false, compartments. Current Soviet policies on women as formulated in the Eleventh Five-year Plan, for instance, have given theorists cues about what themes to stress in their writings, and so these policies are briefly outlined below after theorectical interpretations of different periods have been traced. Our aim is to put Soviet Marxism into a broader context and to suggest practical reasons as well as theoretical ones for the positions taken.

The Shift in Status of the Woman Question
From about 1930 to the mid-1960s the official Soviet line on the woman question was that it had been 'solved'. Throughout these years it was really an invisible non-question, despite all the gushing rhetoric to the effect that women had been completely emancipated. Open and critical discourse was frozen. Debate about the position of women in society which had flourished in the ebullient 1920s, was silenced by the discipline of Stalin's industralisation. Then, 50 years after the revolution, the woman question resurfaced again. Once 'solved', it was freshly declared 'unsolved' and blossomed into an area of debate marked by a large degree of freedom of expression.

Debates usually arise in the USSR for practical reasons. Such was the case with the woman question. Debate about female roles did not flower because of a preoccupation with women's liberation. The Soviet leadership was not suddenly gripped by an interest in

this. Rather, debate was triggered by the very practical question of how women as a necessary 51 per cent of the Soviet labour force could combine production with reproduction without neglecting either role.

According to one estimate there was a shortage by 1970 of 1.7 million industrial workers in the USSR.[2] This shortage is worsening. So at a time of anxiety about labour shortages, concern about economic productivity, discussion about how best to rationalise the labour force and consternation about the relatively low birthrate among Russians, Belorussians, Ukrainians and Baltic peoples in comparison with that of Soviet Moslems, how women could produce and reproduce was seen as a pressing question.

Attempts to answer it led to more detailed investigations into the lives of Soviet women than have ever been pursued inside the USSR. These investigations took place in the intellectually more relaxed atmosphere of the 1960s after the political thaw of the Krushchev years and at a time when the Brezhnev leadership was keen for policy-makers to base their policies upon reliable data and to take into account the findings of social science research. With political approval 'from above', a spate of empirical research into the position of women at home and at work was conducted by Soviet sociologists, economists and demographers. A popular conclusion throughout the 1960s and 1970s was that women found it difficult to have large families, even small ones, due to their heavy workload which continued after the hours of paid employment with the largely unshared domestic 'second shift' of queuing for food, cooking, washing and cleaning.

Soviet empirical research indicated that women's lot was far less rosy than official proclamations and suggested that the double burden made emancipation difficult. A huge discrepancy existed between Soviet ideology and Soviet reality. According to official ideology, women were fully emancipated. Reality suggested otherwise. The theoretical treatment of the 'woman question' had to change if it was to match the facts. Gradually it did.

One positive effect of reopening the woman question was that debate not only drew attention to the achievements of Soviet women outside the home, but also pointed to some of the hurdles still to be confronted. A heightened sensitivity to the woman question arose along with the realistic conclusion that inequalities between the sexes had not been overcome and therefore needed to be tackled. While popular magazines and newspapers still frequently proclaim the complete emancipation of Soviet women, the official line of more academic publications now characterises

the final solution of the woman question as something of the future, not the past.

Before going into the woman question in greater detail, a few background questions need to be put first. What is ideology? What is the relationship between ideology and the Soviet state? What is the role of Marxism in the USSR? And to what extent does contemporary Soviet theory on women draw on the writings of Marx, Engels and Lenin? Exhaustive academic answers to these questions will not be given, but a few central points on them will set the scene for our discussion of changing Soviet interpretations.

What is Ideology?

We have already argued that theoretical analysis in the USSR is influenced by historical and political context. This applies to abstract Soviet theory or philosophy (Marxism–Leninism), or what Franz Schurman has called 'pure ideology', but much more so to ideology at large or 'practical ideology'.[3] Soviet Marxism can be viewed as having these two components – one philosophical, one practical. The philosophical component refers to Marxism–Leninism as a philosophical system of ideas, based on the writings of Marx, Engels and Lenin, but modified slightly by the addition of fresh concepts, such as 'developed socialism'. The practical component refers to the ideas which are used to promote, package and justify policies, such as 'psycho-physiological' differences between the sexes. These two components of ideology are not necessarily consistent with each other, and practical ideology may put forward ideas which cannot be found in classical Marxism. Soviet academic writings frequently incorporate elements of both, so mixing quotations from Marx, Engels and Lenin with proclamations from party congresses and with ideas used to justify new policies as part of socialist construction.

Ideology and the Soviet State

As socialist regimes officially committed to Marxist–Leninist ideology, governments of the Soviet Union have always expressed Marxist interpretations of socioeconomic and political change, and claim that they are pursuing Marxist goals through suitable strategies. According to the 1977 Soviet Constitution, the Communist Party of the Soviet Union is the 'guiding force of Soviet society' which 'armed with Marxism–Leninism determines the general perspective of the development of society'.[4] The party is portrayed as steering Soviet society on a Marxist course and is doing this by wielding socialist ideology. The Soviet conception of

ideology draws on Lenin's writings which argue that bourgeois ideology deceives and socialist ideology clarifies. Bourgeois ideology mystifies while socialist ideology is progressive and inspires noble deeds. Under socialism, ideology is not false consciousness but enlightened consciousness.

Students of Soviet politics in the West do not always take Soviet pronouncements at face value. Changes in ideological line, justifications of policy in terms of ideology after the policy has been drawn up, along with the lack of independent critical discourse in the USSR and the presence of rigid control from above, have given rise to scepticism about the status of Soviet Marxism as a critical philosophy and cynicism about the truly Marxist credentials of practical ideology.

What is the Role of Marxism in the USSR?

Speculation amongst Western scholars about the role of Marxism in the Soviet political system was frequent in the late 1950s and 1960s. Comments about the use, neglect and abuse of classical Marxism abounded. Many writers claimed that Marxist ideology had been eroded, displaced, revised, relativised, rationalised, fictionalised or falsified. The message they conveyed was that ideology was no longer what it used to be.[5] It had lost its revolutionary zeal because belief in it had waned. Nevertheless, reference to Marxism could not be dropped, it was contended, because the revolution had been made in its name. It is likewise argued today that wholehearted commitment to Marxist ideology is lacking in a system which saw its revolution nearly 70 years ago. The situation is no longer one of ardour, spontaneity, upheaval, overthrow and change. It is one of consolidation of past changes. The Soviet political leadership is more conservative and cautious than before. In keeping with this picture, ideology is portrayed as dead, weak, hollow or as a rationalisation of the *status quo*.[6] Marxism is not the inspiration behind Soviet policies, runs the argument, but the system of ideas in terms of which they are justified.

In contrast to this interpretation, Soviet leaderships stress that Marxism does guide policy-making. Philosophers in the USSR contend that alterations in doctrine illustrate how 'genuine Marxism is always living creative Marxism'.[7] They emphasise that Marxism is an evolving orthodoxy which is enriched by changing historical conditions.

If we confront arguments about the waning of ideology in socialist systems with Soviet reality, we encounter an apparent paradox. To some Westerners ideology in the USSR is dead, yet

reference to Marxism in that country is everywhere. Even if Marxist ideas play a diminishing role in policy-making, references to Marxism nevertheless permeate the lives of Soviet citizens, even those who criticise it in private. Marxism–Leninism is, after all, the official 'language game' of the Soviet system. From nursery through kindergarten and secondary school to university level, it pervades education. The more or less compulsory membership of the Pioneers and Komsomol reinforces it.[8] Political meetings in the workplace prevent citizens from ignoring Soviet Marxism. The system of KGB informers deters deviation from it in public. Television, radio, films, newspapers, magazines and books frequently cite or reflect it. Hoardings on the streets proclaim its glories. Public holidays celebrate it and museums and exhibitions applaud it. Only in recent years has Soviet-style Marxism–Leninism boomed less frequently from loudspeakers.

Subscribers to the 'end of ideology' school would contend that such widespread reference to Marxism in the USSR does not undermine their argument that ideology is not behind policy. Marxism may be quoted often, but that does not mean that it inspires policy. Justification of policy in Marxist terms by necessity requires reference to Marxist concepts. But reference is not the same as adherence.

Our own assumptions in approaching an analysis of ideology in the USSR are that we cannot declare *a priori* the blanket irrelevance of Marxism any more than we should succumb to proclamations about its eternal relevance and creativity in Soviet policy-making. The issue is not as clear-cut as *either* dead *or* living. So we begin by recognising that Soviet Marxism does have a place in the USSR, that it does have an impact on daily life, but not necessarily in ways revolutionaries once felt or hoped it would.

Marx, Engels, Lenin and Soviet Theory: Points of Agreement

There is a large amount of agreement between what Marx, Engels and Lenin wrote about women and Soviet interpretations of the position of women in society. This is perhaps not surprising given that the Soviet state has always been described by its leaders as Marxist. More importantly though, much of what Marx and Engels wrote was very abstract and so it would be hard for Soviet Marxists to disagree with many of their general statements.

At the same time, apart from theorists of the 1920s whom we shall discuss below, Soviet theorists have not really gone much beyond Marx and Engels. They have remained locked into a

derivative approach to the woman question. They still anticipate that equality of the sexes will somehow happen when other problems have been sorted out. The dynamics of female subordination have just not been explored. There have been no theoretical innovations from a feminist perspective. No competing definitions of the concept of equality have been put forward. No consideration has been given to the causes of violence against women. Exactly what female self-determination entails has not been hammered out. This is because there is no feminist consciousness behind official Soviet theory. Conceptual innovations are tied to the needs of the Soviet state as perceived by its leaders. These men see no reason for philosophers to attempt to integrate Marxism and feminism because feminism is still seen as 'bourgeois' and as working against a unified working class. It connotes separatism and diversion from the path of socialism.

Marx and Engels did not discuss female subordination thoroughly because the main thrust of their work dealt with the capitalist mode of production – its historical emergence, mechanics and repercussions. Their comments on women are largely relative to, and defined by, their broader scheme of historical materialism. The only exception can be found in Engels's *Origin of the Family, Private Property and the State*. In the preface Engels suggests that not only economic production, but also reproduction, is a determining factor in history. But Engels leaves much unsaid.

The central concern of most political philosophers has been to discuss the nature of actual and ideal political systems and to focus on their incipience, operation and decay. Anything which they have said about women tends to be slotted into, and fitted around, their central political statement. Marx constitutes no exception. But in contrast to most of the philosophers who preceded them, Marx and Engels not only advocated the liberation of women, but also considered it inevitable. It was not just historically possible, it was unavoidable. Soviet theorists have always concurred with this. Equality was seen as an integral component of Communist society. Sexual equality was not something which contradicted human nature for Marx and Engels as it did for Aristotle, Paul, Augustine, Nietzsche, Schopenhauer and others.[9] Rather, the nature of the relationship between women and men was seen as a gauge of the degree of humanity attained by society. In recent years Soviet theorists have increasingly echoed this sentiment.

Marx and Engels argued that the nature and behaviour of individuals is determined by external circumstances. Distinct from other animals by their creativity since they enjoy the ability to act

upon and change their environment, human beings have a rich, many-sided potential. Yet, what they actually become, which aspects of their broader potentialities are developed and which lie dormant and unrealised depends on the nature of society. Human nature can be cramped or enriched depending on the structure of society and one's place in it. Soviet theorists fully agree with this general argument.

The question of human nature and the property question are as inseparable for Soviet social scientists as they were for Marx and Engels. Under the capitalist system of private property human nature is stunted, but doubly stunted for women. Females suffer first as working women, as exploited labour alongside men, and secondly from their slave status in the family due to their economic and social dependence on men. Just as Marx argued that the many-sidedness of human nature could only be developed under Communism, an economic system in which self-activity coincides with material life, so do Soviet writers. Alienation is overcome because there is no private property and hence no surplus value.

Likewise, Soviet theorists accept that the bourgeois family is based on capital, on private gain, and that its main aim is to produce children of undisputed paternity as heirs to man's property. They agree with Engels's argument that in order to guarantee the fidelity of his wife and the paternity of his children, a husband places his wife in his absolute power. Such a domination precludes mutual love.

Mutual love, however, is possible in proletarian marriages under capitalism, according to Engels, since the foundation of classical monogamy – private property – is removed. Without property, heirs are not needed and hence the domination of men over women is superfluous because 'there is no stimulus whatever here to assert male domination'.[10] But patriarchy clearly does exist in working-class families and classical Marxism does not deal with it because it denies its existence. An absence of property is taken to mean an absence of domination. Here the specificity of female oppression is not appreciated and traditional male attitudes towards women are not taken into account. Similarly, patriarchy exists in Soviet families, but Soviet theory has chosen to ignore it. It is largely an academic non-topic except in discussions of Moslem women in Soviet Central Asia and the Caucasus. Here patriarchy is a 'vestige of the past', a carry-over from feudalism and Islam. Soviet social scientists maintain that it exists because capitalism was largely unknown to these regions, except for the oil industry in Baku in Azerbaidzhan. They argue that without capitalism there is cultural

backwardness. The uninterrupted handing down of feudal tradi-
tions acts as a brake on progress towards equality.[11] Consistent
with Marx and Engels, the positive aspects of capitalism are
stressed in Soviet theory as well as the negative ones of exploita-
tion, oppression and alienation. Capitalism is praised for des-
troying the patriarchal relationship between men and women by
drawing women into the labour force and thereby ending the
narrow, domestic one-sidedness of female life.

Marx and Engels said little about equality on a theoretical level.
At best, they implied that socialism would present the conditions
under which the maxim 'from each according to their abilities, to
each according to their work' could operate. Later under commun-
ism, 'from each according to their ability, to each according to their
needs' is rendered possible.[12] Soviet theorists inherited this very
abstract treatment of equality and never really clarified how these
maxims could be implemented, particularly with regard to equality
of the sexes. This is because their derivative approach claims that
equality will ensue once private property has been abolished and
equal opportunities for education will reduce previous disparities.
The emphasis is very much on what will 'happen' rather than on
what individuals should 'do'. Thus, equality remains something
which will automatically come about at some unspecified time,
without being directly pursued.

The active dimension of how to promote equality of the sexes is
lacking because what Juliet Mitchell calls the 'complex unity' of the
female position is not explored. A fuller analysis would result from
an examination of the structures of reproduction, sexuality and
socialisation as well as the structure of production. As Mitchell puts
it:

> The concrete combination of these produce the 'complex unity'
> of her position; but each separate structure may have reached a
> different 'moment' at any given historical time. Each then must
> be examined separately in order to see what the present unity is,
> and how it might be changed.[13]

In order to change the position of women we must first analyse it
thoroughly, going beyond conceptions of equality tied to property
ownership. We shall see below how attempts were made to do this
in the 1920s in the USSR. After that they ceased.

Despite their derivative approach to the woman question and the
abstract plane of their discussion, Marx, Engels and Lenin do offer
some policy proposals. A prerequisite for the emancipation of

women is their participation in production on a large scale, with an insignificant amount of time spent on domestic work. Engels argues that private domestic labour could be ended by transforming it into a public industry while Lenin emphasises that kindergartens and nurseries would allow mothers to participate in the labour force and public dining rooms would alleviate 'household bondage'.[14] These arguments were further developed by Inessa Armand and Alexandra Kollontai in the 1920s. Soviet theoreticians largely agree with these proposals, especially the importance of participation in the labour force and the necessity for kindergartens, but they do not today go so far as to advocate the replacement of family domestic labour. That option cannot be found either in practical ideology which instead portrays domestic work as largely woman's private responsibility. Here lies a contradiction between pure and practical ideology.

Despite this contradiction, agreement on many of the above very general points about women under capitalism and socialism has been voiced in Soviet writings since 1917. However, after the exciting 1920s – a time of upheaval, experiment and discussion – this agreement became frozen or fossilised. Concurrence was voiced, but theory (or more appropriately non-theory) went no further than reiterating the 'great texts'. The woman question lost all life in a political context which silenced critical analysis. The message was 'women have been emancipated: end of discussion'. For over 30 years the woman question slept. It became silent and invisible, seen only through slogans. Not until the 1960s did the woman question become visible as a topic of debate. Let us then take each period in turn, paying particular attention to the present day.

The 'Woman Question', 1917–29: Legal Emancipation and Debate

The years 1917–29 began with spontaneous outbursts of workers and soldiers against a highly autocratic political system which was fighting, and losing, an unwelcome war. A successful revolution took place because the Tsar no longer had the unanimous support of the army, police and bureaucracy to prop him up against opposition.[15]

The first demonstrations, in which women played a prominent role, took place without Bolshevik prompting and took the Bolshevik leadership by surprise. Once the Bolsheviks eventually managed to take control of an overripe revolutionary situation, they faced immense tasks. They had to contend with Civil War,

armed foreign intervention from Britain, the USA, France and Japan, discontent among the workers and peasants and in 1921 a mutiny of Soviet sailors at the naval base of Kronstadt. The economy needed to be organised, Bolshevik power had to be consolidated and the administration of the new regime got underway. In a political context such as this, it was hardly surprising that solving the woman question was not among the Bolsheviks' very top priorities. They were more preoccupied with basic political survival.

And yet the woman question did not go ignored in theory or in practice. The Bolsheviks were committed on a theoretical level to the liberation of women and the new government expressed this sentiment, which was reflected in policy. The principles of equality of the sexes and equal pay for equal work were enshrined in early Bolshevik legislation. Married women also won a freedom of movement previously denied them: they no longer had to live with their husbands if they chose not to; nor were they obliged to follow when their husbands moved elsewhere. Divorce was made simple and marriage became a civil, not a religious, affair. Children born to single women were given the same rights as children of married mothers and maternity pay was granted to working women. Abortion was legalised on the grounds that it was a necessary evil. These were laws that most liberal democratic regimes flinched from passing. Early Soviet legislation was truly revolutionary for its time.

In the 1920s, theoretical debates about women centred on various topics including the family, domestic labour, maternity, sexual relations and women's organisations.

It was argued that the liberation of women could not come about through women's participation in the workforce alone. Important changes in family life were necessary too. Fundamental to the transformation of the family, contended Inessa Armand in 1918, was the reorganisation of domestic labour and childcare.[16] The female double burden, endemic under capitalism, could be eliminated by ending the private domestic shift. Communal kitchens, canteens, and laundries would replace it. Kollontai also advocated the restructuring of domestic labour and stressed how unproductive housework was:

> Women's work is becoming less useful to the community as a whole. It is becoming unproductive. The individual household is dying. It is giving way in our society to collective housekeeping. Instead of the working woman cleaning her flat, the

communist society can arrange for men and women whose job it is to go round in the morning cleaning rooms.[17]

In short, housework under socialism is unnecessary. Socialist construction could end woman's status as what Lenin called a 'domestic slave' by socialising the 'barbarously unproductive, petty, nerve-racking, stultifying and crushing drudgery' of housework.[18] Socialism could terminate the 'routine of daily life and habits' which August Bebel had condemned in the late nineteenth century for crippling the development of woman's faculties.[19]

Armand felt that socialist construction made the socialisation of domestic labour possible and, by going one step further than Engels's earlier argument, held that at the same time socialism's success was linked to it because the new socialist person would not emerge from traditional families. The implication of this analysis of domestic labour for practice is that transformations in family life have to be actively pursued. They will not 'happen' on their own just because property ownership has changed hands.

Trotsky too had a keen grasp of the need for active pursuit of new family relations. He realised that:

A radical reform of the family and, more generally, of the whole order of domestic life requires a great conscious effort on the part of the whole mass of the working class, and presumes the existence in the class itself of a powerful molecular force of inner desire for cultural change.[20]

This, Trotsky knew, would not come easily in practice. He pointed out that achieving equality of man and woman within the family would be 'arduous' and cautioned that 'all our domestic habits must be revolutionized before that can happen'.[21] On the theoretical level, he stressed that sexual equality depended upon the successful reorganisation of domestic life.

Just as housework oppressed women, so did maternity, and so communal methods of childrearing were seen as integral to the transformation of family life too. Where maternity had enslaved women in the past, argued Kollontai, socialism could guarantee the care of children by society and generate more human relations between mother and child. Kollontai's dream was that:

When the child is strong enough, the mother returns to her normal life and takes up again the work that she does for the

benefit of the large family-society. She does not have to worry about her child. Society is there to help her. Children will grow up in the kindergarten, the children's colony, the creche and the school under the care of experienced nurses. When the mother wants to be with her children, she only has to say the word; and when she has no time, she knows they are in good hands. Maternity is no longer a cross. Only its joyful aspects remain; only the great happiness of being a mother.[22]

Without communal childcare facilities, Kollontai asserted, working women would not be liberated. Instead, their days at the factory would be spent fretting over the child at home. Socialism could end this anxiety.

These theoretical analyses of the family went beyond earlier Marxist writings by offering a preliminary analysis of domestic labour. Marxist theory was extended through the argument that socialists could not be created without the socialisation of domestic life. Liberated women could not emerge without it. Socialist relations of production alone would not guarantee socialist citizens. Such economic relations were necessary, but not sufficient. Both the economy and households had to be changed. Action was necessary.

Marxist theory was also extended in the 1920s by Kollontai's writings on sexual relations. Marx and Engels were not interested in sexuality as a topic for theoretical discussion and did not incorporate it into their analyses of the position of women in society. Engels did write about reproduction, but said little about sexuality. Neither did Lenin advocate theoretical work on sexuality. Klara Zetkin alleges that Lenin once said to her 'I mistrust those who are always absorbed in the sex problem, the way an Indian saint is absorbed in the contemplation of his navel.'[23] According to Zetkin, Lenin argued that a preoccupation with questions of sexuality detracted from political activity and stupefied the proletariat.

If Lenin felt, as Zetkin maintains, that discussions about sexuality distracted from politics and amounted to bourgeois self-indulgence, then Kollontai saw that the realm of the 'private' or personal could itself be political. She felt that changing the nature of the relations between women and men was integral to creating a socialist society and could not be put off. She disagreed with the view that sexual matters would be finally settled once the economic and social structures had been reorganised. She considered sexual relations could not be resolved without a 'radical re-education of

our psyche' and wanted to tackle this right away.[24] She saw no reason why the 'riddle of love', 'sexual crisis' and 'fleeting passion' should not be discussed. And so she discussed them. Although she did not come up with a full-blown theory of sexuality, she pushed the parameters of discussion a little wider than they had been before and posed questions not previously put by Marxists. She saw sexuality as one important aspect of the woman question. But many at the time disagreed with her conclusions and the party did not adopt her analysis. Instead, the party came to stand for discipline in sexual relations and frowned upon discussions of sexual expression.

While developments in theory took place in the 1920s regarding domestic labour, maternity and sexual relations, extensions in theory did not occur concerning women's organisations. Like the German social democrats before them, the Bolsheviks deliberated upon how to organise women from inside the party.[25] Although the Bolsheviks agreed that equality of the sexes would exist under communism, they were very reluctant for women's institutions separate from the party to be set up to push for this equality. Such institutions were condemned as incubators of 'bourgeois feminism'. This dangerous tendency was said to pull women away from the party, to divide the working class and to distract from class struggle. As Lenin put it: 'We derive our organizational ideas from our ideological conceptions. We want no separate organizations of communist women! She who is a Communist belongs as a member to the Party just as he who is a Communist.'[26] Kollontai agreed with this too. But Kollontai had a much greater appreciation of the specificity of female oppression and so she argued strongly for women's organisations to be set up within the party. She contended that women were oppresssed in ways that men were not and therefore women's organisations were necessary.

Those who disagreed with Kollontai maintained that the interests of working women were the same as those of working men and so women's organisations were superfluous. On a practical level, these critics of women's organisations were unhappy for them to exist even within the party apparatus because they viewed women's liberation as a low priority, a peripheral issue. Although at the level of theory there was a general consensus in favour of women's liberation, in practice the unanimity was not so perfect. Many is the tale of the loyal communist male who could not stomach the involvement of his own wife in political activity. And alongside those who championed female self-determination and an active role for women's organisations were those who felt

threatened and disturbed by women's liberation and women's groups. To many party members, women as well as men, women's liberation meant sexual promiscuity and a weakening of the family which they did not want.

When the Zhenotdel (zhenskii otdel) or Women's Department was set up in 1919 to conduct agitation and propaganda among working women, it was attached to the party and staffed by party women. Nevertheless, there is much evidence to suggest that it was not taken seriously in practice by the party, the trade unions or the Soviets. According to one commentator of 1920, party members considered work in the Zhenotdel as 'beneath their dignity'.[27] They nicknamed it 'Tsentro-Baba' which literally meant 'Central Old Woman' with 'Baba' being used in a pejorative way. Party members frequently called for the abolition of the Zhenotdel and in Perm province a party official actually disbanded it due to local opposition.[28]

Reaction to the work of the Zhenotdel among the population was particularly acute in Moslem communities. Party and non-party men did not want Moslem women to talk to party activists or to throw off the veil. Men murdered their female relatives rather than bear the humiliation of a family member having cast off the veil. Thousands of Moslem women died in this way. Female party activists often suffered the same fate.[29] Moslems considered women's liberation a threat to their way of life. But concern was not limited to them. Rural areas were full of rumours about what Bolshevik power would bring to women, which continued into the 1930s. In the Ukraine, a story went around that the young women would be shared by the men, while old women would be boiled down for soap.[30] Yet, despite this hostility to the Zhenotdel in practice, it nevertheless achieved a great deal, particularly in the early 1920s when Armand and Kollontai were its directors. They gave it an energy and commitment which it subsequently lost.[31]

Notwithstanding this opposition to women's liberation in the 1920s both inside and outside the party, we have argued that extensions to Marxist theory were made, in particular regarding domestic labour, maternity and sexuality. These extensions were not to be pushed further in subsequent decades, but halted, and even reversed.

The Woman Question, 1930–65: Years of Invisibility

In 1930 the slogan for International Women's Day in the USSR called for '100% Collectivization!'[32] Women's issues came off the agenda and became swallowed up as Stalin's five-year plans and the

collectivisation of agriculture were set in motion. The Zhenotdel was dissolved in that same year. The official line was that while it had been vital in the 1920s for making contact with the most politically backward and passive sector of the working class, it had now achieved its goal. Large numbers of liberated women supposedly existed. It was announced that the functions of the Zhenotdel would be taken over by general party institutions, where they rightly belonged. However, once taken over, they became buried – and once buried, the woman question fizzled out as a topic for genuine debate.

Soviet academic literature on the woman question from the 1930s to 1960s was sparse, because the woman question was seen as a closed question. It had been answered, so the argument went, because women had been emancipated. This was already an 'achievement' of Soviet socialism, so there was no need to work towards it. The following herioc-style proclamation of Vera Bil-'shai was typical of the period: 'The solution to the woman question occupies one of the top places among the great achievements of Soviet socialist construction.'[33] Female liberation had taken place because socialism had been secured. With the triumph of socialism came the solution to the class struggle. An end to class struggle brought about the liberation of the working class. Along with this came the liberation of women because the 'woman question' was subsumed under the 'human question'. In the words of Vera Bil'shai again:

> Marxism–Leninism teaches us to consider the woman question as an inseparable part of the general problem [*rabochii vopros*]. The practical experience of countries of the socialist camp graphically confirms that the complete liberation of woman as an individual and as a worker can be achieved as a result of the triumph of socialism over capitalism.[34]

Reluctance to devote special attention to the position of women meant that equality of the sexes was viewed very derivatively. The official line was that the 'woman question' automatically disappeared as other issues were resolved. Its solution depended on correct answers to other problems. There was no independent solution.

Writers in the West tend to agree that championing equality of the sexes in the Soviet Union has always been subordinate to other goals, such as political survival, rapid industrialisation and collectivisation. In the 1930s, many of the earlier gains for women were

watered down by a renewed stress on the nuclear family, by financial barriers to obtaining divorce and a ban on abortion. These measures, along with the introduction of internal passports, labour books and labour discipline, were part of the regulation of society that came with Stalin's industrialisation. Stable nuclear families were seen as very necessary at a time of industrial upheaval. The liberation of women in practical ideology meant no more than participation in economic production.

Despite the existence of priorities higher up the Stalinist policy list than ensuring equality of the sexes, an argument can nevertheless be made that the woman question need not have been ignored altogether. Although more pressing priorities have always existed, does this mean that analysis of women's oppression had to be shelved? It was certainly shortsighted to assume that the woman question would become 'solved' automatically as the construction of socialism progressed.

The Woman Question, 1965–83: Invisibility Breaks

In recent years Soviet social scientists have acknowledged that reality is more complex than the Soviet literature of the Stalin years allowed. The woman question is no longer viewed quite as derivatively as it was then. The heroic-style statements typical of former years have been modified and replaced by more sober appraisals. Earlier gushing praises of Soviet socialism for having liberated women have been replaced by circumspect comments that inequality has yet to be combatted. Zoya Yankova, a prominent sociologist, cautions that 'It would be a mistake to imagine that all problems concerning the woman question in our country have already been solved.'[35] Striving to solve the woman question is back on the agenda. A.S. Lysakova goes so far as to claim that 'The question of the liquidation of remnants of inequality between the sexes is one of the most important problems facing Soviet social science.'[36] Consistent with Chernychevsky, Fourier and Marx, it is now in vogue to assert that the future of Soviet society depends on the correct handling of the woman question.[37] From an official 'achievement' of socialist construction, solving the woman question has become a distant goal. Equality is no longer won, as was claimed in the past, but instead it is being worked towards.

The reopening of the woman question was necessitated by the policy priorities of combatting labour shortages and increasing productivity, made possible by the general relaxation in intellectual work and spurred on by the revival of Soviet sociology. Once resurrected as a topic for discussion, the woman question was

slotted into contemporary Soviet theory about society. Soviet theory itself had been changing and was more sensitive than before to the complexities and exigencies of industrial society. Although current Soviet theory lacks the ingenuity and vision that many of its critics expect social and political theory to have, it does reflect a refinement over efforts of the 1930s, 1940s and 1950s. Even though the quality of Soviet social science theory is derided in the West for being devoid of the very creativity that Soviet academicians profess it to enjoy, certain conceptual developments in recent years have opened up the possibility of richer and more realistic treatments of aspects of the woman question. Despite analytic inadequacies, recent innovations in Soviet theory have permitted theoretical justification for more probing inquiries into the hardships of the position of Soviet women. In particular, the introduction of the concept of developed socialism has meant that empirical investigations which would have been censured 20 years ago can now proceed.

Beginning in about 1967, Leonid Brezhnev gradually introduced the concept of 'developed socialism' or 'mature socialism' into his speeches.[38] Soviet theorists now argue that socialist society passes through different stages of development. In the early years of Soviet power, the USSR was in transition to socialism. Then, socialism, according to B. Mochalov: '. . . was in the main built in the 1930s. This stage was characterised by substantially greater socialisation of production, a further increase in output, and an increased complexity of the national economic structure.'[39] Once a socialist society had been built, developed socialism set in and still exists today. This present stage amounts to a long protracted period of socialist construction, which is characterised by the harnessing of the scientific–technological revolution. Since developed socialism is a protracted and complicated stage of development, it follows that building the prerequisites of communism is also a lengthy process. Brezhnev's concept nicely gets around the embarrassment of not having met Nikita Krushchev's 1961 proclamation that communism would be achieved by the 1980s. At the same time it allows for all the problems which exist in the USSR to be in the process of being answered. Solutions are on the way, even if they have not yet arrived. The concoction of stages of development after they have taken place is one way of accounting for why something that theoretically should have come about, has not.

As talk of stages of complicated development came to permeate Soviet vocabulary, discussions of the woman question correspondingly incorporated notions of stages, and of the many-sided

nature of its own solution.[40] The notion of developed socialism allowed theorists to acknowledge that equality of the sexes had not finally been achieved. The argument holds that since the state of Soviet socialism is inadequately developed, it is impossible for the woman question to be solved. Like socialism, the woman question must go through stages of development. The attainment of equality is a protracted process and the position of women at any given time is tied to the level of socialist construction. While socialism guarantees the eventual liberation of women, it cannot produce it instantly.

How different stages of socialist and communist construction tie directly to the woman question has not yet been rigorously elaborated. Little has been said other than that in the early period of socialist transformation women move away from concentrating solely on housework in the private sphere to participate in socially organised production as well. Socialism, however, inevitably retains remnants of the old division of labour. From this flows inequality of the sexes. This means lower average pay for women than for men; a traditional division of labour in housework; and less free time for women. The liquidation of these and other inequalities is depicted as a slow process, one which under developed socialism is directly connected with tackling the problem of the rational use of labour resources.[41]

Soviet social scientists stress that a distinction should be drawn between those remnants of inequality which are avoidable at a given stage of development and those deficiencies which in fact have a place in reality.[42] Unfortunately, criteria for 'avoidable' and 'unavoidable' inadequacies are not spelled out. Instead, social scientists revert to discussions of non-antagonistic contradictions. Along with the growing popularity of developed socialism as a term in theoretical discourse has come a revival of the distinction between antagonistic and non-antagonistic contradictions. The former are serious rifts in society and lead to a fundamental change in the nature of the economic system, whereas the latter are minor tensions reconcilable within the prevailing economic system. It is claimed that under socialism non-antagonistic contradictions exist – that is, problems which can be solved without radically altering society. Their presence is consistent with the notion that socialist construction is a protracted, complex process. The revised edition of *Fundamentals of Marxist–Leninist Philosophy* carries the message that:

The development of socialism, like that of any society, cannot

occur without some contradictions, without numerous difficulties, some of them extremely serious, that have to be overcome
. . . it is a specific feature of socialism, however, that the resolving of its contradictions contributes to its ascending development. But this is not a spontaneous process.[43]

In relation to the woman question, this means that overcoming non-antagonistic contradictions is integral to the process of attaining equality. The task for social scientists is first to define the contradictions affecting women and then to deal with them through policy suggestions to ensure 'ascending development' towards the solution of the woman question. The most frequently cited contradictions under socialism concerning women include the non-antagonistic contradiction between a woman's family and professional roles, more specifically between reproduction and production; between the professional qualification level of women and men; and between the high level of scientific and technical knowledge and the lack of mechanised equipment in everyday life. The existence of these non-antagonistic contradictions, it is argued, acts as a brake on the attainment of sexual equality.

When Soviet theorists talk about equality of the sexes they generally have equality of opportunity in mind. Nadezhda Tatarinova, a Soviet economist, put it this way in a recent conversation in Moscow: 'Equality of the sexes means that men and women have equal opportunities in education, choice of profession, pay and conditions of work.' Equality has two aspects according to Soviet theory – formal and factual. Formal equality refers to equality of the sexes before the law. It amounts to equality on paper and basic political rights for women and as such is an immediate gain of socialism – a 'most decisive revolution' in legislation.[44] Factual equality is equality in reality. It is broader than legal equality because it refers to the actual existence of equal opportunities in everyday economic and political life. Whereas formal equality can be quickly established after a revolution, the attainment of factual equality, like the construction of socialism, is a 'protracted, complicated and many-sided process'.[45] In this connection, Lenin's statement that 'equality in law is still not equality in life' is often quoted.[46]

Equality in life is only realised under communism. However, equality under communism is not absolute equality. This is impossible, say Soviet social scientists, since it implies that persons are identical. The mistake made by feminists in the United States of America, according to Yankova, is that they take equality of the

sexes to mean that men and women must become more alike.[47] A more realistic socialist notion of equality, she argues, takes immutable differences between the sexes as a given point of departure. Tatarinova similarly posits that, 'equality does not mean that women should be like men. This is a vulgar conceptualisation. Woman differs from man in character and physiology.'[48] Theorists agree that the existence of irremovable biological differences means that communist society will, and should, take attributes of the female organism into account.

Soviet social scientists maintain that since motherhood and the upbringing of children are 'inalienable and irreplaceable' functions, women belong to a separate group of workers from men. In social labour, women comprise a specific category. This is because women's position in society is not defined just by social labour, but by the social function of motherhood and female 'psycho-physiological characteristics'.[49] Women are depicted as sensitive, delicate, thoughtful, gentle and emotional and physically in need of greater protection than men. Due to biological and psychological differences between the sexes, complete social equality does not require a rigid sharing of roles in society or in the home. Communism will not eliminate the division of labour between the sexes. It is asserted that women will give more time than men to the care and upbringing of children, especially to young infants.[50]

The argument runs that communism will offer a perfection of social relations and create a new communist person whose character reflects the harmonious combination of 'spiritual richness, moral cleanliness and physical perfection'.[51] An exceptionally important role in the upbringing and moulding of the 'new person' is played by the family.

Like everything else, the transformation of the family is described as a complicated process. It continually changes as society changes. Its character is defined not only by the relations between husband and wife and between parents and children, but also by society, the economy, history, politics and nationality. At every stage of development, the family reflects the material and cultural level of society.[52]

Under socialism and communism, the family serves as a cell for satisfying the material and spiritual needs of its members, whereas under capitalism, the main function of the family is the accumulation of private property. Moreover, the needs of family members are also the needs of the Soviet state. This is because, according to Soviet ideology, the state pursues the interests of its people. There is no contradiction between them. Thus the socialist family per-

forms a socially necessary function: in it, individual and social interests coincide. Furthermore, family relations strengthen under communism. Stable marriages ensue, promoting respect, dignity, moral cleanliness and responsibility between partners.[53] Family stability is vital since on it depends:

> . . . the successful and effective fulfilment of the family's most important social functions: the birth and upbringing of children, the organization of housework and self-help, the renewal of strength and energy of working couples, the enjoyment of spiritual happiness, family rest and leisure and regular relations between the sexes.[54]

Note that first on the list is reproduction, followed by childcare and housework.

In the last two decades, Soviet writings on the family have not been couched in terms of the need to socialise housework and restructure the family, but rather in terms of the need to boost the birthrate through strengthening and stabilising the nuclear family. According to Soviet ideology this is a top priority. In Yankova's words: 'One of the most important tasks facing Soviet institutions and the public is the strengthening of the family and an increase in its role in the perfection and development of the socialist way of life.'[55] Secure families have for a long time been viewed as one means of increasing the birthrate. In recent years, however, the connection between them has been made more explicit. Family stability is guaranteed by what Yankova dubs the 'process of nuclearisation' (protsess nuklearizatsii).[56] Consolidation of the nuclear family is drawn as an inevitable part of the process of communist construction. This possibility was never discussed by Engels and Marx, both of whom left the nature of the future family an open question. At most, Engels speculated that under communism 'the equality of women thereby achieved will tend infinitely more to make men really monogamous than to make women polyandrous'.[57] But an open question it is not in the USSR. Ideology firmly states that the communist family is a nuclear family. Addressing Alexandra Kollontai's statement that 'the family is ceasing to be a necessity', Yankova expressed the following sentiment in an interview in Moscow in 1979: 'Kollontai stood with most Marxists on all points except the future of the family. History has proved her wrong on this. New forms of the family do not last.' Certainly new forms of the family are deemed incompatible with the Soviet ideal of the socialist family.

This ideal is connected at the practical level with population politics in the USSR. Many policy-makers feel that women should be encouraged to have more children in order to diminish future labour shortages and to check the falling birthrate. Russians, Ukrainians, Lithuanians, Latvians and Estonians, in particular, are encouraged to have more children due to consternation about the gap between high birthrates among Soviet Moslems and low birthrates among Slavic and Baltic peoples. It is in the interest of the Soviet state to have more children, and therefore it is the duty of Soviet women to bear them.

In short, pro-natalist policies have affected Soviet ideology on women and the family. They have injected it with biological determinism and also fostered references in the press to femininity, to the personality traits of the fair sex and to the rewards of motherhood. Ideology reflects policy priorities in the USSR just as it does in the West.

Soviet theorists go further than stating the obvious point that women and men have different reproductive functions, which is not biologism, but simple truth. They make a leap of inference from this to suggest that as physiologically, and hence psychologically, different creatures from men, women have a duty to the Soviet state not only to produce children (three is the desired number), but also to take proportionally far more responsibility for their upbringing than men. As mild, kind, understanding and nurturing beings, women find childrearing a natural pursuit. This aspect of Soviet practical ideology plays up woman's potential as mother and educator and plays down other directions her many-sided nature might take. With respect to childcare the 'new' socialist parents are not very new at all.

So although the existence of inequalities between the sexes in the USSR is officially admitted, reproduction is also emphasised as woman's key role. In the 1930s and 1940s reproduction was encouraged too, but the prevalence of inequality was then ignored. What is ignored today is the fact that policies aimed specifically at reducing the female double burden in order to stimulate population growth may serve to perpetuate inequalities. To these policies we now turn as they constitute the practical underpinning of Soviet ideology on women.

Current Soviet Policies on Women

The years 1981–5 mark the Eleventh Five-year Plan. In 1981 it was announced in the Soviet press that the Twenty-sixth Congress of the CPSU had 'held a highly serious discussion of ways to make

demographic policy truly effective'. Such discussion had led to
'important measures designed to increase the prestige of mother-
hood and create an atmosphere of increased concern for families
raising children'.[58] Overall, these measures are an attempt to reduce
the female work shift outside the home to allow women more time
to perform their duties inside the home; as such they constitute a
reinforcement of traditional gender roles. Although the small
amount of time awarded to overworked mothers will indeed be
welcome, the policies which offer this operate from the assumption
that all that is needed are modifications in the lives of women. No
systematic attack is being launched against the lack of male
participation in the home. That is taken as a given. It is a
non-problem. No fundamental restructuring of family life is
clamoured for as it was in the 1920s. What then are the details of
current policies?

Before 1981 women were allowed 56 days off work before and
after childbirth with full pay.[59] Beginning in 1981, working
women with one year's work experience and women engaged in
full-time study were eligible for partially paid leave to care for
children until they reached one year. This amounts to 50 roubles
per month in the Far East, Siberia and Northern regions and 35
roubles per month in the remaining areas of the country. Working
women were also given the right to take additional leave without
pay to look after newborn children up to the age of 18 months, to
be extended to 2 years at a later date. After such time a woman
could return to her job without suffering an interrupted work
record. While important legislation for families who do not want to
send their young to creches, these measures nevertheless legislate
childcare as a purely female domain.

Along similar lines, working women are allowed to take extra
time off work to care for their children. Working women with 2 or
more children under 12 years of age are granted 3 days additional
paid leave provided their total yearly leave does not exceed 28 days.
They also have the right to take up to 2 weeks additional unpaid
leave with the consent of the management for the same purpose.
Again, these measures reinforce the notion that childcare is
woman's work and private domestic work.

In keeping with the idea that work in the home is a female
preserve, it has been recommended that enterprises begin to
employ women on schedules based on a short work day or work
week, thereby alleviating the female double burden by giving
women more hours for the home shift. The debate about the
advantages and disadvantages of part-time labour for women

seems to have been officially resolved on the side of its advantages. This may serve to reinforce the concentration of women in low-paying jobs at the bottom of job hierarchies. Part-timers are not on the promotion track, but destined to stay off it.

Some social scientists view such policies in a favourable light. Two years before the party officially adopted this recommendation about part-time labour Svetlana Turchaninova of the Central Trade Union College in Moscow expressed the following in an interview:

> I would like to reduce the working hours of all women with children up to four years old without any reduction in pay. This would fulfil what Lenin wanted. Equality does not mean equality of work demands. Equality means to achieve according to abilities. Women have two main roles – one in the economy and one as mother. Therefore, to be equal woman should have less time at work, and in the long run her work hours would be the same as a man's.

This sentiment has its critics, however. A female lawyer interpreted part-time labour differently:

> A shortening of the working day would make it impossible for women to hold leadership positions. These jobs would be given to men. Part-time labour would mean a regression in the development of the individual.

The merits and demerits of part-time labour for women will probably remain a controversial aspect of recent Soviet policies. Its aim is not only to draw mothers with young children into the labour force, as was the case in the 1960s, but increasingly to entice women out in order to reproduce.

Along with measures designed to give working mothers more time at home have come limited financial incentives for women to embark upon motherhood. Upon the birth of a first child a woman receives 50 roubles, and 100 roubles for second and third children. Families whose average income per family member does not exceed 60 roubles per month are exempt from payments for their children at kindergarten. In an attempt to encourage citizens to marry and reproduce, priority on housing lists is given to newly-weds and couples with children. Soviet leaders are also casting a favourable eye on a policy adopted in the German Democratic Republic. There newlyweds under 26 who are embarking upon their first marriage receive an 8-year interest-free loan of 5,000

marks. The birth of a child cancels 1,000 marks of the loan. The birth of a second cancels 1,500 marks. If a couple runs into economic hard times they can always pay back their loan in children. No plans appear to be afoot to implement a policy along these lines just yet in the USSR, but Soviet leaders are enthusiastic in their praises of the German legislation.

Conclusion

From a call in the 1920s for an end to the domestic shift and for the socialisation of housework and childcare we have ended up with arguments in the 1970s and 1980s in favour of the extension of the private domestic shift and a reduction of participation, if only temporary, in the paid workforce. Analyses of domestic labour have been displaced by the practicalities of population politics. Although debates about women flourished in the 1920s and exist again today, some of the questions posed in these two periods are different. Hence the discourse is different and the answers are different.

In our discussion of contemporary interpretations of the woman question we have illustrated two main strands in Soviet ideology. One is the long overdue recognition of the theory, or pure ideology, that sexual inequalities exist and that attaining equality is a slow process. The other, at the level of practical ideology, is that women are biologically and psychologically different from men which gives them as natural nurturers a special relationship with children and particular domestic responsibilities resulting from it.

On the positive side, Soviet ideology now recognises the complexity of the process of bringing about equality of the sexes which opens up the possibility of further conceptualisation about this complexity. The notions of developed socialism and non-antagonistic contradictions offer theoretical space for broadening the analysis of the woman question and probing deeper. The theoretical straight-jacket of the Stalin years has been loosened. But on the negative side, from a feminist perspective, policies and priorities of current socialist construction influence which arguments theorists feel comfortable about putting forward and which arguments can pass the censor's scrutiny. At the moment, policy-makers want more Soviet children to be reared in stable nuclear families and they view this as largely woman's responsibility. These priorities block certain arguments from being made and restrain the scope of theoretical discourse.

As far as practice goes, when a government increasingly encourages its female citizens to have three children and take on part-time

jobs, female self-determination is unlikely to be encouraged. The entrenchment of traditional gender roles is likely to occur. In the Soviet Union a practical ideology has been developed which constructs femininity as nurturing and tied to motherhood and childrearing. Women are thereby selectively represented as caring and gentle, falsely implying that men lack this potential. The stereotypes or popular images of femininity and masculinity that result suggest that a traditional division of labour with regard to childrearing and homemaking is natural, universal and unchanging. 'Femininity' is thus politically constructed. Unfortunately, the ideological lines on motherhood, femininity and psychophysiological differences between the sexes are unlikely to change in the USSR so long as policy-makers perceive population politics as more important than female self-determination. So long as the majority of the top Soviet leaders are male, it seems that the woman question will remain subordinate to economic, demographic and patriarchal imperatives.

Notes and References

1 Sociology ceased to exist as an academic discipline in the Stalin years and was dismissed as 'bourgeois'. See Ann Weinberg, *The Development of Sociology in the Soviet Union* (London: Routledge & Kegan Paul, 1977).

2 Murray Feshbach and Stephen Rapawy, 'Soviet Population and Manpower Trends and Policies', *Soviet Economy in New Perspective*, US Congress, Joint Economic Committee, Compendium of Papers, 94th Congress, 2nd sess. (Washington DC: Government Printing Office, 1976), p. 113.

3 Franz Schurman, *Ideology and Organization in Communist China* (Berkeley: University of California Press, 1970), p. 23.

4 *Constitution (Fundamental Law) of the Union of Soviet Socialist Republics* (Moscow, 1980), Article 6.

5 Those who subscribe to this view include: Daniel Bell, 'Ideology and Soviet Politics', *Slavic Review*, vol. 24, no. 3 (1965), pp. 591–603; David Dinsmore Comey, 'Marxist–Leninist Ideology and Soviet Policy', *Studies in Soviet Thought*, vol. 2, no. 4 (1962), pp. 301–20; Alfred G. Meyer, 'The Functions of Ideology in the Soviet Political System', *Soviet Studies*, vol. 17, no. 3 (1966), pp. 273–85.

6 A more recent argument holds that ideology is being revitalised. See

Alfred B. Evans, Jr, 'Developed Socialism in Soviet Ideology', *Soviet Studies*, vol. 29, no. 3 (1977), pp. 409–28.

7 Otto V. Kuusinen, *Fundamentals of Marxism–Leninism* (Moscow, 1963), p. 18.

8 The Komsomol, or Young Communist League, is the youth group of the Communist Party of the Soviet Union. Under-14s join the Pioneers.

9 See Rosemary Agonito, *History of Ideas: A Source Book* (New York: Capricorn Books, 1977).

10 Friedrich Engels, 'The Origin of the Family, Private Property and the State' in Marx and Engels, *Selected Works* (London: Lawrence & Wishart, 1968), p. 508.

11 A.D. Azhibaeva, *Vozrastanie Roli Zhenshchiny v Obshchestvennom Proizvodstve – Zakonomernost' Epokhi Sotsializma*, Candidate degree dissertation abstract (Alma Ata, 1966); P.M. Chirkov, *Reshenie Zhenskogo Voprosa v SSSR (1917–1937)* (Moscow, 1978); N. Ashirov, *Musul'manskaya Propoved'* (Moscow, 1978); N. Bairamsakhatov, *Novyi Byt i Islam* (Moscow, 1979).

12 Karl Marx, 'Critique of the Gotha Programme' in Marx and Engels, *Selected Works* (London: Lawrence & Wishart, 1968), pp. 324–5.

13 Juliet Mitchell, *Women's Estate* (Harmondsworth: Penguin, 1971), p.101.

14 V.I. Lenin, *On the Emancipation of Women* (Moscow, 1977); and also his contributions in *The Woman Question: Selections from the Writings of Karl Marx, Friedrich Engels, V. I. Lenin and Joseph Stalin* (New York: International Publishers, 1951).

15 Alexander Rabinowitch, *The Bolsheviks Come to Power* (London: New Left Books, 1979).

16 A fuller discussion can be found in Alix Holt, 'Marxism and Women's Oppression: Bolshevik Theory and Practice in the 1920s' in Toya Yedlin (ed), *Women in Eastern Europe and the Soviet Union* (New York: Praeger, 1980), pp. 87–114.

17 Alexandra Kollontai, *Selected Writings of Alexandra Kollontai*, trans. Alix Holt (New York: W. W. Norton and Company, 1977), p. 255.

18 *The Woman Question* p. 56.

19 August Bebel, *Woman Under Socialism* (New York: Schocken Books, 1971), p. 120.

20 Leon Trotsky, *Woman and the Family* (New York: Pathfinder Press, 1970), p. 21.

21 Ibid.

22 Kollontai, *Selected Writings*, p. 134.

23 Lenin, *On the Emancipation of Women*, pp. 101–7.

24 Kollontai, *Selected Writings*, p. 245.

25 For discussions of women and German Social Democracy turn to Werner Thonnessen, *The Emancipation of Women: The Rise and Decline of the Women's Movement in German Social Democracy 1863–1933* (London: Pluto Press, 1973) and to Alfred G. Meyer, 'Marxism and

the Women's Movement' in Dorothy Atkinson, Alexander Dallin and Gail Warshofsky Lapidus (eds), *Women in Russia* (Sussex: Harvester Press, 1978), pp. 107−12.

26 Lenin, *On the Emancipation of Women*, p. 110.

27 Carol Eubanks Hayden, 'The Zhenotdel and the Bolshevik Party', *Russian History*, vol. 3, part 2 (1976), pp. 160−6.

28 Ibid.

29 Gregory J. Massell, *The Surrogate Proletariat: Moslem Women and Revolutionary Strategies in Soviet Central Asia: 1919−1929* Princeton University Press, 1974); R. Aminova, *The October Revolution and Women's Liberation in Uzbekistan* (Moscow, 1977).

30 Richard Stites, *The Women's Liberation Movement in Russia* (Princeton University Press, 1978), p. 339.

31 See Hayden, 'The Zhenotdel and the Bolshevik Party', Stites, *The Women's Liberation Movement in Russia*, pp. 329−45 and Gail Warshofsky Lapidus, *Women in Soviet Society: Equality, Development and Social Change* (Berkeley: University of California Press, 1978), pp.63−73.

32 Stites, *Women's Liberation Movement in Russia*, p. 344.

33 Vera Bil'shai, *Reshenie Zhenskogo Voprosa v SSSR* (Moscow, 1956), p.3.

34 Ibid., p. 238.

35 Zoya Yankova, *Sovetskaya Zhenshchina* (Moscow, 1978), p. 9.

36 A.S. Lysakova, *Likvidatsiya Ostatkov Neravenstva Zhenshchiny v Bytu v Protsesse Kommunisticheskogo Stroitel'stva v SSSR,* Candidate degree dissertation abstract (Moscow, 1966), p. 4.

37 Galina K. Dmitrieva, *Mezhdunarodnaya Zashchita Prav Zhenshchiny* (Kiev, 1975), p. 3; Marta P. Gavrilkina, *Obshchee i Osobennoe v Reshenii Zhenskogo Voprosa v SSSR,* Candidate degree dissertation abstract (Moscow, 1974).

38 Alfred B. Evans Jr, 'Developed Socialism in Soviet Ideology', and Donald R. Kelley, 'Developments in Ideology' in Donald R. Kelley (ed), *Soviet Politics in the Brezhnev Era* (New York: Praeger, 1980), pp. 182−99.

39 B. Mochalov, *Requirements of Developed Socialist Society* (Moscow, 1980), p. 40.

40 Elena B. Gruzdeva, 'Uchastie Zhenshchin v Obshchestvennom Proizvodstve Kak Forma Realizatsii Ikh Ravnopraviya v Sotsialisticheskom Obshchestve', in E. Klopov (ed), *Vo Imya Cheloveka Truda* (Moscow, 1979), pp. 182−94; Elena B. Gruzdeva, *Vozrastanie Roli Zhenshchin-Rabotnits v Obshchestvennom Proizvodstve i Sovershenstvovanie Ikh Bytu v Usloviyakh Sotsializma,* Candidate degree dissertation abstract (Moscow, 1979); Yankova, *Sovetskaya Zhenshchina*, pp. 39−45.

41 Z. I. Eremina, *Problemy Ispol'zovaniya Zhenskogo Truda v Narodnom Khozyaistve SSSR v Sovremennykh Usloviyakh,* Candidate degree dissertation abstract (Saratov, 1972), p. 7. N.M. Shishkan, *Sotsial'no-Ekonomicheskie Problemy Povysheniya Effektivnosti Obshchestvennogo*

Truda Zhenshchin, Candidate degree dissertation abstract (Kishinev, 1969), p. 8.

42 Lysakova, *Likvidatsiya Ostatkov Neravenstva Zhenshchiny v Bytu*, p. 4.
43 F. V. Konstantinov, *Fundamentals of Marxist—Leninist Philosophy* (Moscow, 1974), p. 589.
44 Gruzdeva, 'Uchastie Zhenshchin v Obshchestvennom Proizvodstve', p. 184.
45 N. Kh. Nagieve, *Kommunizm i Sotsial'noe Ravenstvo Polov*, Candidate degree dissertation abstract (Baku, 1971), p. 7.
46 S.V. Brova, *Sotsial'nye Problemy Zhenskogo Truda v Promyshlennosti*, Candidate degree dissertation abstract (Sverdlovsk, 1968).
47 Zoya A. Yankova, 'Razvitie Lichnosti Zhenshchiny v Sovetskom Obshchestve', *Sotsiologicheskie Issledovaniya*, no. 4 (1975), p. 42.
48 Expressed in an interview in Moscow in 1980.
49 Boris P. Zagrebel'nyi, *Formirovanie Otnoshenii Sotsial'nogo Ravenstva Zhenshchin i Myzhchin-Kolkhoznikov v Usloviyakh Razvitogo Sotsializma*, Candidate degree dissertation abstract (Kiev, 1977) p. 1. A. E. Kotliar and S. Ia. Turchaninova, *Zanyatost' Zhenshchin v Proizvodstve* (Moscow, 1975), p. 6.
50 Yankova, *Sovetskaya Zhenshchina*, p. 123. Nagiev, *Kommunizm i Sotsial'noe Ravenstvo Polov*, p. 21. G. Kh. Alibekova *Sotsial'nye Prichiny Sokhraneniya Ostatkov Fakticheskogo Neravenstva Zhenshchin v Bytu Pri Sotsializme i Pyti Ikh Preodoleniya*, Candidate degree dissertation abstract (Makhachkala, 1972), p. 23.
51 N.N. Gasanov, *Razvitie Semeino-Brachnykh Otnoshenii u Narodov Dagestana v Period Stroitel'stva Kommunizma*, Candidate degree dissertation abstract (Moscow, 1970), p.3.
52 V.I. Kiselev, *Osnovnye Tendentsii Sotsial'nykh Preobrazovanii Brachnykh Otnoshenii Pri Sotsializme*, Candidate degree dissertation abstract (Saratov, 1972), p. 3. Gasanov, *Razvitie Semeino-Brachnykh Otnoshenii*, p. 3.
53 Gasanov, *Razvitie Semeino – Brachnykh Otnoshenii*, p. 10. A. P. Akhmedov, *Dal'neishee Razvitie i Ukreplenie Semeinykh Otnoshenii v Period Stroitel'stva Kommunizma*, Candidate degree dissertation abstract (Baku, 1965); Kiselev, *Osnovnye Tendentsii*, p. 19.
54 V. Sysenko, 'Kak Otnosyatsya Zheny k Svoim Muzh'yam', in D.I. Valentei (ed), *Zhenshchiny Na Rabote i Doma* (Moscow, 1978), p. 63.
55 Yankova, 'Kul'turno–Psikhologicheskie Problemy', p. 36.
56 Ibid.
57 See Friedrich Engels, 'The Relations of Sexes', in Marx, Engels, Lenin and Stalin, *The Woman Question*, p. 75.
58 *Izvestiya*, April 14 1982, p. 3.
59 A.N. Aduev, *Trud i Zakon*, (Moscow, 1979), pp. 183—92.

2 THE NEW SOVIET MAN AND WOMAN – SOVIET VIEWS ON PSYCHOLOGICAL SEX DIFFERENCES
Lynne Attwood

SINCE THE early years of this century, social science in the West has taken note of male and female personality differences and attempted to explain them. The first writers in this field insisted on the biological basis of these differences, and saw them as inevitable. Freud, for example, attributed a range of unpleasant characteristics to women (they were more vain, hostile and masochistic than men, had a less developed sense of justice, were less creative, and suffered a perpetual sense of shame and inferiority), which, though not present at birth, were an inevitable response to the young girl's discovery of her physical inferiority – i.e. her lack of a penis.

The idea that sex differences in personality are rooted in biology has by no means disappeared. A number of psychologists still insist that the different reproductive roles of men and women necessarily produce corresponding differences in their personalities. However, the realisation that male and female personalities can vary considerably in different cultures has led to an increasing interest in the role of the social environment in their formation. The anthropologist Margaret Mead reached the conclusion that 'human nature is unbelievably malleable, responding accurately and contrastingly to contrasting cultural conditions . . . Standardised personality differences are of this order, cultural creations to which each generation, male or female, is trained.'[1] Psychologists and sociologists have similarly come to distinguish between a person's biological sex and his or her gender – i.e. the culturally-acquired manifestations of masculinity and femininity – and to use the terms 'social learning' and 'socialisation' to describe a process whereby the beliefs, attitudes, and behaviour of a given culture, including those concerning sex differences, are transmitted from one generation to the next. 'By direct prescription, by example, and by implicit expectation, a variety of people in a variety of relationships influence the growing individual. Gradually the child *internalises* what s/he has been taught.'[2]

The work of Mead and other Western anthropologists has linked differences in male and female personality, and the stereotypes which correspond to them, to the different demands made on men and women in different cultures – in other words, to the sexual

division of labour. Hence we would expect considerable divergence between the concepts of masculinity and femininity in Western capitalist countries and in the Soviet Union, since the capitalist countries have a marked sexual division of labour and 'a differentiation of maternal, inside-the-home functions from paternal, outside-the-home functions',[3] while the Soviet Union talks with pride of the level of equality enjoyed by its women and the vital role they play in the economy. This, however, is not the case.

The Soviet Union's interest in male and female personality differences is much more recent than that of the West. Its former indifference to the subject has been linked to its rejection of Freudianism, and in particular the 'inherent hypertrophy of the sex-life of man' perceived in the latter;[4] or to an over-sensitivity to the issue of women's equality, a 'belief that the exposition and study of the psychological differences between the male and female sexes is opposed to the principles of women's equality'.[5] The indifference has been replaced, however, by something approaching an obsession. In the past few years, the journals and newspapers of the popular press have been full of attempts to enumerate sex differences in personality, to determine the extent to which they are biologically or socially conditioned, and to predict how far they will erode as women continue to engage in hitherto 'masculine' occupations.

The answers which emerge are not those one would expect from a society pledged both to Marxism and to women's equality, and in which women perform such an active and vital economic function. Soviet views on male and female personality differences cling to a traditional notion of femininity which stands in sharp contrast to the reality of women's lives. Like the more reactionary Western pronouncements on the subject, they also emphasise the biological and hence inevitable nature of these differences.

Although Western psychology has contributed considerably to our understanding of psychological sex differences, Soviet psychology generally remains aloof from the discussion, in which pedagogy — the science of education — appears as protagonist, and the pronouncements of the latter are often in blatant opposition to the Marxist approach to human personality which is the cornerstone of Soviet psychology. While a totally homogeneous view of personality development is not to be expected, the dominance of an official ideology in the Soviet Union has led to a stricter control and direction of academic disciplines than exists in the West, which should lead to some degree of coherence in their views. Psychology and pedagogy have, furthermore, been particularly closely con-

nected in the Soviet Union ever since the revolution; one of the major tasks of the new government was the creation of a 'New Soviet Person', the remoulding of human personality into a socialist form, and psychology was to provide a theoretical framework for this process which pedagogy would then put into practice. Hence pedagogy's apparent ignorance of the basic tenets of psychology's approach to personality when it sets about explaining psychological sex differences is quite bewildering.

In this chapter we will explore the ideas on male and female personality which are emerging in the Soviet Union, and the contradictions which exist between them and psychology's understanding of personality development. We will also attempt to account for the recent topicality of the subject; i.e. to locate it within the broader social, economic and political framework of Soviet society.

At the risk of over-superficiality, it is important to give a brief outline of Soviet psychology's approach to personality development. Soviet psychology, unlike its Western counterpart, is located within a Marxist framework. Personality development is seen as a dialectical process; the personality passes through a series of stages which parallel the economic stages through which society passes en route to communism. The dialectical approach concentrates on movement and change. It maintains that one form of movement can turn into another, and quantitative change can thus be followed by qualitative change, i.e. a transition to a new level, such as the transition from sensation to thought. Such change occurs as the result of interaction with the environment and the contradictions which emerge through this interaction.

Applied to the intellectual development of children, this means that within each stage the mental capacity of children grows very slowly; their skills and knowledge increase, but this constitutes quantitative rather than qualitative change and their relationship to the world remains much the same. These stages are broken, however, by periods of much sharper, more violent change in which new mental characteristics emerge. Children now move beyond the relations with the surrounding world which characterised the previous stage in their development; their new mental characteristics necessitate new relations, new activities and ways of interacting with the people and objects around them. The contradictions which arise within each stage provide the motive force enabling the transition from that stage to the next.

Each stage is characterised by a 'leading activity', i.e. one which will maximise development and should thus be exploited by the

adults associated with the child. In the first stage (from birth till the age of one), the leading activity is emotional association with adults; in the second (from one till approximately three), it is activity with objects; in the third (from three till between five and seven), play; and in the fourth (till the age of eleven), systematic instruction.

A major element of 'play' is the imitation of the human activity children see around them. Since they are too young actually to perform many of these activities, they play parts, pretending to be adults; and as close a reproduction of adult roles as possible is striven for.

What matters to the child in this new kind of play is to act as exactly as possible the way his father or his brother, a chauffeur or an officer, acts . . . [6]

The accepted role determines the child's behaviour. 'The daughter' must obey 'the mother'; 'the mother' must be loving; 'the policeman' strict but courteous . . . [7]

The idea is not so dissimilar from that of social learning theory in the West, although the emphasis of the former seems less on society imposing its beliefs and attitudes on the child and more on the child actively seeking to acquire them.[8] Both, however, point to the influence of the social environment in shaping a child's attitudes and behaviour.

The problem of environmental influence as opposed to biological factors in personality development has, however, always posed a problem for Soviet psychologists. The 'New Soviet Person' was to be 'a socially open person, easily collectivised, and who can quickly and deeply transform his behaviour';[9] an all-round person, in whom all the strengths and faculties of personality would be developed. If this was to be achieved, the personality would have to be extremely plastic and malleable. Hence throughout the 1920s, psychology concentrated on environmental influences and granted biological factors a merely nominal role. However, by the 1930s this position had become an embarrassment. The Bolsheviks were now largely responsible for the environment, but undesirable personality traits, and differences between the educational achievements of different ethnic groups, still existed. M. Efimov's critique of F. P. Petrov's explanation for the underachievement of Chuvash children contains the following tirade:

Petrov explains the underachievement of a great number of Chuvash children as the result of current socioeconomic conditions, i.e. of those conditions which were created under Soviet rule, by workers under the leadership of the Communist Party. It is precisely these conditions, according to F. P. Petrov, which account for the low average performance of the children who were studied. F. P. Petrov, not understanding and not wishing to understand the real conditions for the development of workers' children in the Soviet Union, speaks from the point of view of counter-revolution.[10]

The individual had to be granted a more active role in relationship to the environment, and thus some responsibility for his or her behaviour. A four-factor theory evolved, which saw the personality as a product of the environment, biological inheritance, training and self-training.

This has not fully resolved the problem, however. Indeed, there appears to be a resurgence of interest in it at present. Dialectical materialism has again been invoked to free psychology from this impasse. The work of Fedoseev provides a suitable example. Fedoseev claims a dialectical interdependence between social and biological factors in the individual, with the former taking the dominant role and capable of actually transforming the latter when they prove incompatible with social progress. In Fedoseev's own words: 'In the course of social activity, the person actually *transforms*, but does not abolish, the natural or biological within him or herself. Hence the interdependence, the continuity, between the biological and the social does not disappear but historically develops.'[11] Biological factors are unable to resist this transformation. 'There is no evidence whatsoever', he states, 'that the biological traits of a person can act as irresistible barriers to social progress.'[12]

This unity of the biological and the social is evident in the development of abilities. People do not possess innate abilities, though they may have certain potentialities which will assist in the development of abilities. The abilities themselves, however, can only be formed through interaction with the social environment – i.e. during the course of activity. Their formation represents a qualitative change in the person's psychological development.

The distinction between potentialities and abilities is stressed frequently in Soviet psychology. One more example will make its importance clear. To quote Posnanski:

The theory of dialectical materialism . . . excludes the existence of abilities before the appearance of activity which first makes the ability effective. Abilities are formed and develop only in the process of the activity which requires them.[13]

The more basic tenets of Soviet psychology's approach to human personality should now be clear. Unfortunately there has been no attempt to apply these to a study of male and female differences in personality. However, we can make some suggestions as to how this might be done.

We have seen that Soviet psychology does not deny the existence of innate traits, but sees them merely as potentialities; and that cultural influences are not only given preeminence over biological factors but are actually able to transform them. We might expect, then, that if natural male and female personality tendencies existed they would be considered inferior to cultural influences, which would, in fact, transform them. Hence if women did have a tendency to be passive, dependent, excitable, overemotional and vain (characteristics with which they are often associated in the West), this could be overcome through their interaction with a socialist environment, which had no use for such traits and encouraged the development of others. This process would be facilitated through training and self-training. Posnanski asserts that 'even naturally caused differences of birth, e.g. racial, can and must be abolished by a new historical development'.[14] This surely bodes well for the abolition of negative psychological sex differences too. Without doubt, many of the characteristics associated with women in Western culture are considered negative in Soviet society. Kovalev, for example, analysing personality traits thought to determine undesirable behaviour in school children, listed amongst them shyness and impulsiveness; he attempted, through a process of reeducation, to eliminate these.[15] Vygotskii, one of the greatest figures in the pantheon of Soviet psychology, considered overemotionality to be negative, and attached great importance to teaching children how to control their emotions through the use of play.[16]

Soviet psychology also pledged itself to the all-round development of personality. Hence it should not prove guilty, as its Western counterpart often has, of denying women any function but the maternal, and of attributing to her a range of psychological characteristics geared exclusively towards this function. Even if she had innate potentialities in this direction, Soviet psychology would surely set itself the task of developing all other aspects of her personality — as well as developing a range of nurturant qualities in

men, in the interests of their all-round personalities. Since play is seen as an important factor in preparing children for adult roles, the development of all-round personalities would involve the encouragement of children of both sexes to engage in a vast variety of non-sex-typed activities during such play. Furthermore, since abilities are not innate but are formed only in the process of the activity which requires them, we cannot know what natural male and female potentialities are until men and women engage equally in all activities.

Let us turn now to the Soviet writings on sex differences in personality to see how well they reflect these suggestions. Although psychologists have generally ignored the subject of sex differences, there is one notable exception; I. S. Kon, a social-psychologist, has recently entered the field. We will start with his work.

On first glance, Kon's ideas look somewhat similar to those of Western exponents of socialisation or social learning theory. He talks, for example, of sex-role stereotypes, and implies a distinction between a person's biological sex and his or her gender.

> In order to become male or female, the individual must recognise his [sic] sex membership and learn the corresponding sex-roles. *Sex identification* of the personality presupposes the recognition by an individual of his sex membership, learning the corresponding habits and behaviour, and even the psycho-sexual aims and orientations (an interest in the opposite sex etc.).[17]

However, elsewhere he insists on the biological basis of these stereotypes. The division of labour along sex lines in a given society was initially based on natural sex differences, though it then served to engender a whole series of psychological differences between men and women which were, in their turn, reflected in corresponding stereotypes in the public consciousness. These stereotypes now exert a strong influence on the self-image and behaviour of each generation. Although such stereotypes are exaggerations and not themselves direct descriptions of reality, they are rooted in natural differences; hence although they will modify with changes in the sexual division of labour, they will not disappear.[18] This seems a severe limitation on the power of the social environment to transform the biological; all it can do is change the *stereotypes*, not the underlying biological foundations.

What are these differences? For the most part they rest on the difference in reproductive roles. 'The dependence of the social on

the biological is particularly clear regarding the reproduction of the race and the upbringing of children.'[19] There is no suggestion that the characteristics appropriate for child upbringing should be developed in men, or that participation in this role might reveal hitherto hidden potentialities. Women's natural potentialities for this role are evidently not sufficient, however, since Kon advocates 'corresponding variations in the upbringing of boys and girls within the boundaries of their mutual instruction'.[20] What happened to the all-round development of personality?

Kon also claims undoubted sex differences in other abilities. Men, for example, have a greater aptitude for mechanical habits and knowledge, while women are better at precise and delicate hand-movements, at perception, and at fluency of speech.[21] We saw earlier, however, that abilities are only formed during the activities which require them. Hence if there is a proven differentiation of abilities, this must mean that boys and girls participate equally in all activities. This, however, is not the case. For the 'Trud' (work) class in school, for example, boys and girls are taught separately; while boys learn metalwork, how to operate machines, etc., girls learn how to sew and type. Such differentiation is quite likely to develop mechanical abilities in boys and dexterity in girls. Although in theory children can choose which class to attend, there is considerable psychological pressure to choose that which is considered appropriate for their sex. Toys are also strongly differentiated, along similar lines. One Soviet writer notes that those intended for boys include machines and technical designs, while those aimed at girls consist of miniature animals, people and furniture![22]

Kon also asserts that natural psychological differences render boys keener on active, tough games connected with competition and risk, while girls prefer quiet activities and submit more easily to the influence of people around them. Men of all ages are more assertive and persistent than women, and more emotionally stable; women's greater emotional fragility makes them more prone to neurosis, and results in a greater need for a stable social environment and human contact. Although, as we saw earlier, Soviet psychology has applied itself to the problem of helping schoolchildren control their emotions, no suggestion is made that women's overemotionality could similarly be controlled; neurosis would hardly seem, however, an appropriate characteristic in those responsible for rearing the next generation!

Kon also seems unconcerned about evidence for his assertions. He does offer one study, an analysis of drawings by children aged

six to seven, which were sharply differentiated in their subject-matter according to sex: 70 per cent of the boys but only 6 per cent of the girls drew industrial landscapes, while the majority of girls drew houses, trees, flowers, landscapes and human figures. Kon ignores the fact, however, that children of this age have already had ample exposure to the influence of sex-stereotypes to form ideas about sex-appropriate attitudes and behaviour, and that this could influence their choice of subject-matter — especially according to the tenets of Soviet psychology, which, we will recall, sees children as active agents in their learning process, anxiously seeking to acquire what they see as appropriate attitudes and behaviour. Curiously, the same study is referred to by another psychologist, Anan'ev, from whom we learn that children of three preschool age-groups were involved, and that this difference in subject-matter was only noted in the oldest group. If the difference stemmed from biological tendencies, as Kon believes, surely it would be evident in children of all ages? Its absence amongst the younger children indicates a cultural rather than biological explanation, suggesting that the younger children had not yet fully assimilated ideas about sex-appropriate attitudes. Anan'ev also notes that the older girls adorned the figures in their drawings with decoration, and took great care with clothes and hairstyles, while none of the boys did. He takes this as an indication that visual perception and the abililty to perform delicate hand-movements develop faster in girls than in boys.[23] However, even the casual observer in the Soviet Union cannot fail to notice the abundance of feminine frills and bows with which girls of the youngest ages are adorned; surely this would serve to inform children of both sexes that such attention to one's appearance is an exclusively female concern, and this, in turn, might be reflected in their drawings?

On the whole, Kon has a fairly liberal attitude (at least, in comparison with writers we shall be looking at shortly!) towards modifications in the stereotypes of masculinity and femininity — but only providing these do not go too far. He still thinks it necessary to 'train, and train again, girls to be girls and boys to be boys, so that we will then see in them the women and men we want to see'.[24] However, he adds, the cultural trend in modern Soviet society is a stress on the individual, and individual self-expression is not possible within the confines of strict stereotypes of masculinity and femininity. Hence training should not attempt to stifle individual traits, even if these do not fit exactly with our ideas of masculinity and femininity. One must wonder, however, how often the existence of natural, non-sex-typed individual traits

would be evident; surely they would be 'transformed' into more appropriate characteristics under the influence of society in general, and this training programme in particular.

Sociology's contribution to this debate adds little to Kon's suggestions. Like that of psychology, it has been slight; the difference between male and female roles in the domestic and productive spheres has been a greater concern than the development of differences in their personalities. Z. A. Yankova, however, does devote a chapter of her book *The Soviet Woman* to 'The Problem of Femininity'. She, like Kon, grants social and cultural influences some role in the creation of female personality, and argues that the different needs of a developed socialist society as compared to a capitalist society have led to a restructuring of female personality in the Soviet Union. However, many traditional sex differences remain as an inevitable result of the different male and female roles in reproduction. 'The function of motherhood has formed and will continue to form in women such character traits as tenderness, attentiveness, concern, softness, emotionality . . . '[25] Socialism has, on the other hand, provided new outlets for such qualities; they now benefit not only family life but also all professional and sociopolitical spheres in which women engage. The feminine woman can understand the moods and qualities of her colleagues in the collective, and has the desire to help and support them; in addition, her femininity has a positive effect on all around her. Hence, while femininity has changed, it has done so by becoming deeper and having greater social significance. In addition, women have acquired some new characteristics; they see themselves as, for example, more independent and self-confident. The image of the modern Soviet woman is thus 'characterised above all by a high level of citizenship, selflessness, steadfastness, responsibility, and confidence in the correctness of her actions, but it is also suffused with spiritual softness, emotion, an urge to help, to ease, to take care of others, to support'.[26] Yankova does not suggest that the demands of developed socialism should produce in men these 'feminine' qualities which are so useful in family and professional life. Hence the 'double burden' women experience in combining domestic and professional work has a parallel in their psychological development. They have entered into certain hitherto male professional spheres as well as retaining their domestic functions, which men do not share; similarly they have developed a range of 'masculine' personality characteristics in addition to their traditional 'feminine' ones, which men have not acquired. One might, perhaps, argue that women have thus benefited more than

men psychologically, and come closer to the ideal 'all-round personality'. However, the development of a genuine all-round personality will not be possible until characteristics cease to be sex-typed. At present women experience a 'double burden' psychologically in that they need to exhibit both 'feminine' and 'masculine' characteristics in order to be seen as real, socialist women!

Just as their involvement in male professional spheres is not allowed to go too far, however, neither is their personality development. If women become too masculine — adopting masculine habits incompatible with femininity, becoming coarse, losing interest in domestic skills — this leads to adverse effects on the psychological climate of the family, and to frustrations and collisions within the collective.

The ways in which psychology and sociology deal with sex differences in personality, and the contradictions between these and the Marxist approach to personality development inherent in Soviet psychology, are, I hope, clear now to the reader. The lack of interest shown by both disciplines in the subject is evident, however, from this complaint, made recently by two pedagogical theorists: 'In the available literature of the past thirty to forty years, we have not encountered any scientific work on this subject.'[27] Pedagogy has itself stepped in to fill the void.

Despite the force of the above assertion, there has, in fact, been a trickle of pedagogical essays on the subject of sex differences since the 1960s. This trickle has now become a torrent. The more recent works do seem to attempt a more scientific language than their forerunners; the content, however, remains largely untheoretical. The association of prominent pedagogical writers with the subject seems little more than an attempt to give weight to popular ideological assumptions, to imbue them with academic prestige. What we generally find is a mere description of psychological sex differences, with the (usually implicit) suggestion that these are biologically determined; but just in case social influences start interfering, a programme of training is recommended, designed to nurture these differences and thus produce healthy, dichotomised male and female personalities. Despite the strong connection between psychology and pedagogy in the past, the pedagogical approach to sex differences stands in even starker contrast to the psychological theory of personality than did the pronouncements of Kon. While social influences occupied a fairly tenuous foothold on his theory, they were still granted a positive function, that of modifying the outdated features of masculine and feminine

stereotypes; yet in the pedagogical view, they appear as a negative force, threatening social collapse by perverting the natural order of feminine women and masculine men unless we can succeed in controlling them. The development of all-round personalities now seems neither possible nor desirable.

Does this mean that the pedagogical writers deny the authority of Marx? On the contrary, certain writings of Marx would appear to form the basis of their ideas on masculinity and femininity. In response to a questionnaire given him by his daughter, Marx listed his favourite male quality as 'strength' and his favourite female quality as 'weakness'. His idea of happiness was 'to fight', and of misery 'to submit'. His most detested vice was 'servility'.

It is not difficult to see a connection between the concepts 'weakness', 'to submit' and 'servility'; nor to conclude that Marx either had a very negative view of women, or else was in a flippant mood that day. However, pedagogical theorists have seriously set about explaining and justifying his words, and constructing a model of masculinity and femininity on their basis.

Iosif Dik, for example, writes that:

> In these words, in my opinion, is concentrated the romance of human life. Behind the word 'strength' I divine the deep implications of masculinity and nobleness, the strength of masculine intelligence and the poetry of iron muscles. And behind the word 'weakness' I see not feebleness and an unpractical approach to life, but femininity, beauty and charm.[28]

One has to wonder why Marx was at such a loss for words that day, forcing his followers to play guessing games about his intended meaning. Levshin concedes that he may have dealt with the questionnaire in a 'half-joking manner', and that his answers are not easy to decipher. None the less, he makes a serious attempt to do so.

> What did Marx have in mind when he answered that he valued strength in a man and weakness in a woman? Of course not physical strength; such an opinion would be too primitive and platitudinous. But evidently it could not mean spiritual strength either, nor creative strength, nor strength of character, otherwise one could reach the conclusion that Marx denies the presence of such strength in women. This would contradict the real opinions of the great revolutionary on woman and on the reason for her subordinate position in bourgeois society.

Undoubtedly Marx had in mind something completely different; above all, the beauty of those vital relations between man and woman which flow from the difference in their sexes. For woman it is natural to lean on the help, the support, and the protection of man, in order to give life to a new creature, rear him and make him independent. And it is equally natural for the man to support, protect and defend the woman in order that she is able to fulfil the mission entrusted to her by nature.

These natural relations, enriched by all the achievements of human culture and morality, led to the formation of that quality in man which we call masculinity, and that quality in women which we call femininity. These qualities are profoundly different, because the beauty of humanity is organically fused with the beauty of the sex. Marx had in mind precisely this when he talked about strength in man and weakness in woman.[29]

The scientific nature of the pedagogical approach to sex differences might already seem in serious doubt to the reader. None the less, since pedagogical writers insist that 'the study of the psychological differences between men and women is an important scientific and practical question, no less important than the further study of their biological and physiological peculiarities',[30] let us study them with the serious scrutiny they deem them to merit.

Again, woman's maternal function is seen as the foundation of sex differences. Not only does it prompt her to lean on the 'strength' of man, but also produces in her a range of nurturant qualities which are evident from the youngest age. Khripkova and Kolesov note that 'girls are inclined towards caring activities – looking after people, nursing, showing concern, and so on. They are more inclined to criticise, admonish and teach their smaller brothers, than boys are with their younger sisters. This inclination may be seen as a manifestation appropriate to their age of the maternal instinct.'[31]

Female characteristics are not confined to the directly maternal, however. Here are some of the myriad features of femininity offered by Khripkova and Kolesov. Girls are more emotional and subjective than boys. They are more shy and modest. They are more sensitive, taking praise and censure more to heart. They are less brave than boys (hence raise their hands less often in class, for fear of giving the wrong answer). They are less inclined towards investigative and inventive behaviour (hence prefering to use a toy for its direct purpose, rather than adapting it to different uses). They are, none the less, more impulsive. They are better than boys

at understanding simple and commonplace ideas, but worse re-
garding more specialised concepts. They are more attracted to
things concerned with the immediate environment — the home,
people known to them — while boys do better in unknown
situations. When telling stories, they are more detailed than boys
and inclined to digress; boys, on the other hand, are more concise
and keep to the point. Girls are more concerned about their
appearance, which can turn into a pathological conviction of
inadequacy. They are neater, more accurate, conscientious, indust-
rious and responsible. They are more likely than boys to turn to
figures of authority for advice and help, and more likely to go
along with accepted forms of behaviour. It is easier to get girls to
follow instructions. Different school subjects attract girls and boys.
Girls tend towards arts subjects such as history and literature,
especially poetry, and dislike physics, biology and maths; while
boys are more interested in handcrafts and sport.

Other writers offer similar traits and tendencies. Timoshchenko
adds, on the subject of sports, that boys prefer those stressing
action, e.g. football, volleyball and hockey, while girls prefer those
requiring 'flexibility and beauty of movement'.[32] The male urge for
action is also reflected in reading preferences; while 'boys seek
action in books, girls are more interested in the psychology of the
heroes. They concentrate on the experiences and the inner world of
the hero, his emotional life.'[33] Hence boys read detective and
adventure stories, while girls prefer lyrical poetry.

Could some of these characteristics not be linked to social
factors? Not according to Khripkova and Kolesov, who insist that a
child's upbringing merely 'promotes . . . that which the child
already possessed from the moment of birth'.[34]

Although girls are given a rather rough deal as far as characteris-
tics are concerned (Timoshchenko, like Kon, tells us that the female
tendency towards overemotionality can lead to emotional scarring
and neurosis), it is never suggested that the social environment be
employed constructively to transform any of them. On the con-
trary, despite psychology's commitment to all-round personalities,
pedagogical theorists insist on the need for cultivating polarised
male and female personalities along traditional lines. According to
Khripkova and Kolesov, 'the recognition of the character of one's
own sexual group is the basis for the formation of the psychological
structure, which defines the behaviour acceptable in a given society
for members of the male or female sex; therefore the formation of
ideas about the necessary type of behaviour of a boy or girl, a
young man or woman, is an aim of upbringing'.[35] Gudkovich and

Kondratov are still blunter: 'it is necessary to programme the son into definite traits of behaviour of "a boy", the daughter of "a girl".'[36] Parents are advised, for example, of the importance of instilling in their daughters the concern for personal appearance which is meant to be natural (and, we will recall, sometimes becomes pathological), as well as a range of domestic skills and nurturant qualities.[37] In boys the most important quality, as we have seen, is strength; but Kostyashkin suggests that this is little more than a potentiality in boys and that without positive effort on the part of parents and teachers it may never become manifest.

> The strength of man, to which Marx gave such significance, does not arrive suddenly and is not an inevitable consequence of age and sexual development. It must be developed from earliest childhood. Strength is one of the basic traits of man; on its basis are developed more easily nobleness, restraint, generosity, and moral purity. A weak body, a cowardly and timid character, and frailty of spirit are the most negative results of bad upbringing of the boy.[38]

Evidently such traits are perfectly acceptable in girls, however. This is the programme Kostyashkin advises a 'sensible family' to adopt:

> the attitude towards the boy is stricter, demands on his physical strength and endurance and on a display of bravery are decisively higher, and defeats and failures are criticised more sharply. Even the food of the boy begins, from the age of fourteen or earlier, to be distinguished by fewer sweets and porridge, and a larger portion of meat. The boy's bed is harder, the mother's caresses are more restrained, the look of the father is more stern and punishment is stricter. And especially important is the continuous increase in the physical load, especially the workload.[39]

Other writers urge parents to 'scold a boy for tearfulness ("You burst into tears, just like a girl!") and a girl for being naughty ("You are playing pranks, like a boy!")'.[40] The benefits of sporting activities for boys are stressed, while the more active, strength-building sports are considered inappropriate for girls 'not only because of biological considerations, but also for aesthetic reasons'.[41] The development of strength in boys seems dependent

on an emphasis on the corresponding weakness of girls.

> From the boy's earliest years, from the moment when he begins
> to speak, it is necessary to instil in him a feeling of respect for
> girls. In as much as boys are physically stronger than girls, it is
> important to explain to them that man has been given his
> strength in order to protect the weak.[42]

There is surely something contradictory about attempting to instil
respect in boys for girls by stressing the inherent weakness of the
latter; this is never acknowledged, however. Other writers similar-
ly insist that:

> Even from the first class it is important to demand of boys that
> they defend girls, giving up their places to them, letting them go
> first, not allowing them to do heavy physical work. The
> understanding 'You are a boy' or 'You are a man', which
> strengthens these actions, will inculcate a chivalrous attitude
> towards girls. Let such an attitude enter into boys as a habit a
> long time before they begin to get interested in questions of
> sex.[43]

One could be excused for forgetting that women in the Soviet
Union do not lead pampered, indolent lives at home while their
menfolk struggle on their behalf with the harsh conditions of
economic life. In fact, the level of female participation in the Soviet
workforce is extremely high, constituting 51 per cent of the total
(while women form 53 per cent of the population). Surely many of
the features of femininity listed by pedagogical theorists constitute
a sex-stereotype based on female passivity and dependence, which
even Kon and Yankova, despite their stress on the biological basis
of femininity, considered to be eroding as women gained confi-
dence and a sense of responsibility through their activities beyond
the home? Khripkova and Kolesov, however, insist that whatever
occupations women undertake,

> the character of the activity or profession does not smooth out
> the specifically sexual differences and . . . with an attentive and
> unbiased scrutiny it is always possible to bring them to light.
> Therefore any changes in the nature of the activities of members
> of the male and female sex will never lead to a smoothing-out of
> the psychological differences between them.[44]

Even if we ignore the psychological theory about the power of the social environment to transform the biological, the important position granted to the inculcation of sex differences through training makes this confidence quite surprising.

We will recall that, according to pedagogy, women have a natural attraction for the home environment. Hence even if changes in female activities are seen as no real threat to femininity, they must still be seen as somewhat unnatural. Pedagogical theorists do not actually speak out against women's employment — women are, after all, an essential part of the workforce — but their natural attraction for domesticity has been used to justify their overrepresentation in service industries. '[T]he girl prepares herself for a future work activity just as the boy does; all paths of life are open to her', but 'especially those connected with women's nature — treatment of the ill, the upbringing and teaching of children, and so on'.[45] According to this notion, women's underrepresentation in politics, heavy industry and the higher echelons even of the spheres in which they do predominate (the majority of head teacherships are filled by men, for example, as well as the higher reaches of the medical profession) could also be explained in terms of their natural inclinations, rather than such factors as traditional ideas about male and female careers, training in schools (e.g. the 'Trud' class), and the blow which childrearing and the domestic burden in general deal to women's chances of promotion. Such an idea would surely be challenged by psychology, however, which posits that inclinations are not the same as abilities; until women engage on an equal footing with men in those occupations currently monopolised by the latter, we cannot know where their true inclinations and potentialities lie. As Marx noted, only music awakens the musical feeling in people.

As we have seen, Soviet pedagogy's insistence on the natural, vital and inevitable difference in male and female personalities often stands in stark contrast to the Marxist approach to personality inherent in Soviet psychology. Why, then, does it persist? Is it nothing more than a sentimental reluctance to abandon an age-old tradition? Does it represent, alternatively, the desire to promote an idealised image of femininity as a pampered, cosseted state, to act as antidote to a harsh reality in which they are forced to work much harder than men for little reward or gratitude?

These might be contributing factors. The full picture, however, is more complex. The recent focus on the subject provides a clue to several other possible factors. In addition to an increase in articles and pamphlets exhorting parents and teachers to devote more

attention to developing sex-appropriate characteristics in children, the subject is soon to enter the school curriculum in the form of a course on family life, which is already being tried out in a number of schools. A glance at some of the topics covered is quite revealing. They include the importance of the family in socialist society; the socialist personality and its relation to the family; the family's role in forming children's personalities, and its harmonious combination of the psychological characteristics of all its members and generations; the unity of personal and social interests under socialism; masculinity and femininity and personal relations between the sexes; love and marriage; and the family and the state. What is evident is that the family has moved full cycle; from the experimentation of the 1920s, which sought to socialise family functions and explore new modes of personal relationships, the family has now been reinstated as the basic cell of society. It is, in fact, virtually impossible to opt out and explore alternative ways of living; shortage of accommodation forces young people to remain within the family at an age when their Western counterparts (at least, in the more affluent countries) often choose to live alone or with friends. Getting married and starting a family of their own is almost the only way they can obtain their own homes, and this method is not always guaranteed success.

Of course, strengthening the image of the family, delineating more clearly the roles and functions of its members, and showing how differences in their personalities equip them for these differentiated roles, have a number of purposes besides economy of accommodation. Demographic problems, for example, are now openly proclaimed to be a major concern in the Soviet Union. The decrease in the birthrate is frequently discussed in the press, accompanied by sociological analyses of why people are having fewer children and how this can be rectified. The joys of multichild families are avidly discussed, as well as ways of improving their material conditions. Stressing the woman's natural instinct for motherhood, showing how it forms the basis of her entire personality and affects all areas and activities of her life, might be one method of strengthening her desire to have children. Without them, she is told, she cannot think of herself as a real woman. The fact that in Soviet Central Asia, where the birthrate remains high, the media emphasise the importance of women's economic and political roles as opposed to the maternal, supports this contention.

In addition, although women are an integral part of the labour force, their free labour in bringing up children, as well as performing other domestic functions like the laundry, and feeding and

nurturing other members of the family, is essential unless the state
is to divert considerable resources into socialising such functions —
something once envisaged, but abandoned on largely economic
grounds. Hence the stress on women's natural propensity not just
for childcare but for all domestic and home-centred occupations
might be intended to sustain these vital female roles. The family
also relieves the state of the burden of providing accommodation
and care for the aged; it is a legal stipulation that children provide
for their parents in old age.

Curiously, the current attention bestowed by the Soviet state
upon the family is offered as evidence of the state's benevolence.
Many articles on the subject begin by applauding the fact that 'the
family is now under the protection of the state', a reference to
Clause 53 of the 1977 Constitution. The family is presented as a
warm, supportive, nurturant institution, an antidote to any inade-
quacies society may still have. However, 'the family' generally
means 'the woman' — it is she who must support and nurture its
other members — hence, again, the stress on developing such
qualities in women.

An emphasis on the obligations of the family (i.e. the woman)
also provides a scapegoat for increasing social problems such as
hooliganism, alcoholism, etc., thus diverting attention from other
defects in society which might be factors in the creation of such
problems. It is easier to blame the mother for not bringing up her
children properly than to examine the very fabric of Soviet life for
clues to the genesis of antisocial behaviour.

Women are to blame for such behaviour not just in their role as
mothers, but also as teachers and even school pupils. Boys, we are
told, have a psychological need to be in positions of power; they
also need, as they reach adolescence, to show off their masculinity
in front of girls.[46] Teachers, due both to their poor understanding
of these aspects of male psychology and to their desire for an easy
life, place girls in the top posts of the school and Komsomol
organisations. It is girls, after all, who seem more suitable because
of their readiness to follow instructions, their greater conscien-
tiousness, etc. Boys, however, finding their need for power
blocked, resenting female dominance (not only that of their
mothers and teachers but also of 'preaching girls in the
Komsomol'!),[47] and unable to display their masculine strength and
heroism through legitimate means, turn to illegitimate, delinquent
means. Positive discrimination in favour of boys is recommended
to help alleviate this problem. 'Rarely will a girl', Kostyashkin
assures us, 'be offended if a boy is nominated president of the

council of the detachment, or field-team leader. Girls are fully satisfied with a secondary role, and in fact will quietly get on with practically any job.'[48]

Male antisocial behaviour is generally seen as one aspect of the wider problem of the feminisation of men. This can also manifest itself in such traits as apathy, indolence and disrespect for others. Such feminisation is partly a consequence of the shortage of male models for boys to emulate; fathers play an insignificant role in their son's upbringing, and the majority of teachers are female. Curiously, certain features of femininity play negative roles: women's natural timidity and softness can result in them mollycoddling their sons, or being insufficiently tough with intransigent male pupils.[49] The main culprits, however, are women's equality with men and their *loss* of femininity. Now that women work outside the home, men have lost 'the title of family breadwinner — an honourable and responsible title [which] has always helped the man to realise his significance and his essentialness to the people closest to him. Without this role the very earth slips from beneath his feet.'[50] Simultaneously many of men's former domestic functions have passed to state agencies; they no longer need to gather and chop firewood, to mend the roof, or defend their wives' honour. What results is a sense of failure and apathy. Women have not, at least, been urged to rectify this situation by returning to full-time domesticity and allowing men their former breadwinning roles (though shorter working hours for women have been suggested); they are, however, told to cultivate their feminine qualities in order to rekindle the masculinity of their partners. Ada Baskina describes the positive benefits this will have:

> Marriage with a really feminine girl instils in a man two things. On the one hand, he becomes more masculine from the need to protect and defend her, and on the other hand, sharp traits in his character soften; gradually he becomes more tender and kind.[51]

Women are virtually being urged to play at being weak and helpless in order to give men someone to protect. If this need is so strong in men, perhaps it is they, and not women, who are more suited to childcare?

Polarised sex characteristics might, then, be seen to serve a number of purposes in Soviet society. What is perceived as a crisis in the Soviet family at present (encompassing the increase in divorce, the decrease in the birthrate, the higher incidence of juvenile delinquency and alcoholism) has played a particularly

prominent role in focusing attention on traditional family values
and the concepts of 'real' men and women (strong and powerful on
the one hand, nurturant and caring on the other). As we have
noted, pedagogy promoted such ideas before the 'crisis in the
family' became apparent; hence it is unlikely to have been briefed to
provide theoretical support for the resurrection of these values.
However, the current climate has certainly produced a receptive
and influential audience, which has enabled the proliferation of
these views.

What do women stand to gain from this reassertion of traditional
notions of masculinity and femininity? The answer must be very
little, if anything. Some sociologists have tried to redefine 'mascu-
linity' so that it is not incompatible with 'helping' women with
domestic tasks; however, the majority of men, judging from
readers' letters to magazines, reject this. The pedagogical stress on
the peculiar fitness of women for domestic tasks can only reinforce
this rejection. The emphasis on women's weakness and men's
strength is also hardly likely to imbue the work for which women
have a natural propensity with much status. Nor will a resurgence
of male chivalry add greatly to the quality of women's lives, since it
too rests on an emphasis on women's weakness; true respect for
women will surely not develop on such a foundation. In return for
having men open doors for them and give up their seats on the
metro, women must suffer a severe curtailment of their sphere of
opportunity and action; their domestic skills must be improved if
they are to be 'real' women, and other occupations available to
them will be reduced to those reflecting these domestic functions,
on the grounds of their biological disability for all others. While so
much is written about boys' loss of self-respect due to female
dominance in their childhood and teenage years, the effects of male
domination in virtually all adult spheres on the female psyche is
virtually ignored. No doubt this is because, as Kolbanovskii insists,
women have no need of power and will happily do almost anything
they are told to. A sociologist, Afanas'eva, does acknowledge that
women have a tendency to undervalue themselves:

> Ideas about masculine superiority run very deep . . . [E]ven
> emancipated women sometimes betray a tendency to recognise
> masculine properties of intelligence and character as standard, as
> the point of reference for both sexes. Tell, for example, one of
> my successful colleagues that she writes like a woman, and she
> will be offended. It is another matter if one says, 'You have a
> masculine cast of mind' — what great praise![52]

Her implication is that this tendency is rooted in traditional conceptions of male superiority which are no longer propagated but still retain a hold on the public consciousness. The material we have looked at in this chapter indicates that such conceptions are still propagated, however.

At present the subject of femininity and masculinity is still under debate. Not all women, judging from readers' letters, are content to accept the definition of themselves set out by pedagogical writers. Indeed, the extremity of some of the views we have looked at might well be, at least in part, a backlash against the erosion of traditional masculinity and femininity which has actually occurred in Soviet society. The expressed concern about the feminisation of men is one indication of this. It remains to be seen whether the more formal instruction now under experimentation in some schools as to the nature of men and women and their different roles within the family and society will halt this erosion and make 'real men' and 'real women' of the new generation. For the cause of women's equality, this will be a huge step backwards.

Notes and References

1 Quoted by Roy G. D'Anrade, 'Sex Differences and Cultural Institutions', in E. Maccoby (ed), *The Development of Sex Differences* (London: Tavistock, 1967), p. 85.

2 Helen Weinreich, quoted in M. Barrett and M. McIntosh, *The Anti-Social Family* (London: Verso Editions, 1982), p. 106.

3 L. Kohlberg, 'A Cognitive−developmental Analysis of Children's Sex-role Concepts and Attitudes' in Maccoby, *Development of Sex Differences*, p. 99.

4 V.N. Kolbanovskii, 'The Sex Upbringing of the Rising Generation', in *Soviet Education* vol. 6, no. 11, (Sept. 1964), p. 4.

5 A.G. Khripkova and D. V. Kolesov, *Devochka − podrostok − devushka* (Moscow, 1981), p. 74.

6 A.N. Leotiev, 'Intellectual Development of the Child' in Ralph B. Winn (ed), *Soviet Psychology* (New York: Philosophical Library, 1961), p. 61.

7 Ibid., p. 63.

8 This is not to say that no Western writers have acknowledged such a possibility. See, for example, the cognitive−developmental theory of sex differences advanced by Lawrence Kohlberg, which stresses the child's active efforts to acquire sex-role characteristics. See also Barrett

and McIntosh, *The Anti-Social Family*, p. 107, which points to the weaknesses of the idea of socialisation transmitting static, unchanging roles and beliefs.

9 A.B. Zalkind, 'Psikhonevrologicheskie nauki i sotsialisticheskoe stroitel'stvo' in *Pedologiya*, no. 3 (1930), p. 318.

10 M. Efimov, 'F.P. Petrov, Opit issledovaniya intellektual'novo razvitiya Chuvashskikh detei po metodi Bine–Simon, 1928', in *Pedologiya*, nos. 7–8, (1931), p. 128.

11 T.N. Fedoseev, 'Problema sotsial'nogo i biologicheskogo v filosofii i sotsiologii', in *Biologicheskoe i sotsial'noe v razvitii cheloveka*, Akademiya Nauk SSSR, Institut Psikhologii (Moscow, 1977), p. 20.

12 Ibid., p. 8.

13 N.F. Posnanski, 'Heredity and the Materialist Theory' in Winn, *Soviet Psychology*, p. 50.

14 Ibid., p. 52.

15 L.I. Bozhovich and L.S. Slavina, 'Fifty Years of Soviet Psychology of Upbringing', in Josef Brozek and Dan I. Slobin (eds), *Psychology in the U.S.S.R.: An Historical Prospective* (New York: IASP, 1972), pp.167–8.

16 Ibid., p. 167.

17 I.S. Kon, *Psikhologiya starsheklassnika* (Moscow, 1980), p. 113.

18 From an interview with I.S. Kon in Larisa Kuznetsova, *Zhenshchina na rabote i doma* (Moscow, 1980), p. 179.

19 Ibid., p. 190.

20 Ibid., p. 191.

21 I.S. Kon, 'Muzhestvennie zhenshchini? Zhenstvennie muzhchini?' in *Literaturnaya Gazeta* (1 Jan. 1970), p. 120.

22 D.B. Kolesov, *Besedy o polovom vospitanii* (Moscow, 1980), p.42.

23 B.G. Anan'ev, *Chelovek kak predmet poznaniya* (Leningrad, 1968), p.175.

24 Kuznetsova, *Zhenshchina na rabote i doma*, p. 191.

25 Z.A. Yankova, *Sovetskaya Zhenshchina* (Moscow, 1978), p. 123.

26 Ibid., p. 125.

27 Khripkova and Kolesov, *Devochka — podrostok — devushka*, p.72. (This book is also partly serialised in the journal *Semya i Shkola* (Aug. — Dec. 1979). The quote is taken from the August edition, p.28.)

28 Iosif Dik, *Rastet v dome muzhchina* (Moscow, 1966), p. 43.

29 L.A. Levshin, *Mal'chik, Muzhchina, Otets* (Moscow, 1968), pp.13–14.

30 Khripkova and Kolesov, *Devochka — podrostok — devushka*, p.75.

31 Ibid., p. 76.

32 L. Timoshchenko, 'O vospitanie devochki', *Vospitanie Shkolnikov*, no. 6 (1980), p. 37.

33 Ibid., p. 37.

34 Khripkova and Kolesov, *Devochka — podrostok — devushka*, p. 76.
35 Ibid., p. 84.
36 L.N. Gudkovich and A.M. Kondratov, *O tebe i obo mne* (Stavropol, 1977), p. 17.
37 Timoshchenko, 'O vospitanie devochki', p. 40.
38 E.G. Kostyashkin, 'Pedagogicheskie aspecty polovogo vospitaniya', *Sovetskaya Pedagogika*, no. 7 (1964), p. 48.
39 Ibid., p. 47.
40 Gudkovich and Kondratov, *O tebe i obo mne*, p. 18.
41 V.N. Kolbanovaskii, 'Sex Upbringing'. See also Khripkova and Kolesov, *Mal'chik — podrostok — yunosha* (Mowcow, 1982); and B. Karakovskii, 'Uroki dlya mal'chishek', *Sem'ya i Shkola* (Sept. 1979), pp. 18—20.
42 Kolbanovskii, 'Sex Upbringing', pp. 6—7.
43 The same advice, virtually word for word, appears in V. Aleshina, 'Chtoby vyros nastoyashchii myzhchina', *Sem'ya i Shkola*, no. 4 (1964), pp. 4—5 and A.G. Khripkova, *Voprosy polovogo vospitaniya* (Rostov na Donu, 1969), p. 53.
44 Khripkova and Kolesov, *Devochka — podrostok — devushka*, p. 81.
45 I. Gyne, 'Zhenstvennost', in P. Peter, V. Shebek and I. Gyne, *Devushka prevrashchaetsya v zhenshchinu* (Moscow, 1960), p.12.
46 Kostyashkin, 'Pedagogicheskie aspecty polovogo vospitaniya', p. 51; Levshin, *Mal'chik, Muzhchina, Otets*, p. 68.
47 Kon, 'Muzhestvennie zhenshchini? Zhenstvennie muzhchini?'
48 Kostyashkin, 'Pedagogicheskie aspecty polovogo vospitaniya', p. 51.
49 A. Koryakina, *Ottsi i deti* (Cheliabinsk, 1978), pp. 25—6, and Dik, *Rastet v dome muzhchina*, p. 41.
50 T. Afanas'eva, 'Muzhchina doma', *Nedelya*, no. 22 (1977), p. 6.
51 Quoted by Khripkova and Kolesov, *Devochka — podrostok —devushka*, p. 120.
52 Afanas'eva, 'Muzhchina doma', p. 6.

3 WOMEN'S MAGAZINES IN THE SOVIET UNION
Maggie McAndrew

WHEN I was in Moscow, working on my research, I was quite often questioned about my subject. I noticed two different sets of responses when I told people that I was interested in Soviet women's magazines. One set of responses was characterised by a certain puzzlement as to what possible interest the affluent West could have in the relatively impoverished world of Soviet women's publications. I was constantly hearing 'but you have the best fashions . . . you have lots of beautiful magazines . . . what do you need from ours?' The other set of responses came from journalists and colleagues at the prestigious Faculty of Journalism, where research into many aspects of media production and consumption is conducted. Journalists in Soviet society are regarded as overt ideological workers and for them the significance of women's magazines as an aspect of the relationship between women and the state was quite clear.

It is the task of journalists in Soviet society to 'create a model of the world in people's consciousness'.[1] Their duty is to 'bring influence to bear upon people's consciousness, to endow that consciousness with desirable properties and qualities and to move it towards the ideal corresponding with the political, cultural and ideological standards and values of Soviet society'.[2] So my interest in women's magazines was quite credible to the media professionals who saw the magazines as ideological artefacts, but somewhat bizarre to the consumers of the ideology, the women readers whom I met who saw those magazines as pallid imitations of Western ones.

There has been a great deal of Soviet research in recent years on the relationship between the press and its readers, but no research into women's publications or women as readers per se. Soviet scholars have, however, examined American women's magazines and classified them as important links in the US propaganda system, playing a leading role in the construction of the relationship between women and the ruling class. The function of such propaganda is termed 'sociological' — 'the spreading of a definite ideology, not directly through propaganda ideas, doctrines and slogans, but through the reproduction and strengthening of a

defined style and way of life.'³ This is a recognition of the fact that propaganda messages do not have to be explicit and hortatory, although this is the dominant tendency in Soviet propaganda.

For the vast majority of media consumers in the US and Western Europe, ideology is, apparently, non-existent. The press, on the whole, traditionally presents itself as a non-ideological, non-partisan describer of events. Certainly publications such as women's magazines are not commonly regarded as political. A piece of reality is selected by the media organisation, worked over and presented in such a way that the presentation is offered as the only possible logical and comprehensible presentation of the event. The selection and working over processes are invisible to the reader. The reader is likewise not informed that the matter and style of what is offered as objective fact does contain analysis and has been made intelligible in terms of dominant definitions of reality; that is, it has already been interpreted for the reader. Ideological messages are both invisible, in that they do not declare themselves, and ubiquitous in that they form the language through which reality is offered for consumption.

> The common assumption that one section of a newspaper — that dealing in public affairs — is political, whereas the rest is apolitical seems to us to be profoundly misleading. It is precisely where the content offers itself as apolitical . . . that ideological significance is most successfully concealed and therefore most demands analysis. If the media are seen as providing a major fund of images and a key repository of available meanings, the importance of examining human interest and other entertainment content becomes clear because it is not simply a neutral window on a multifaceted and diverse world, but embodies a particular way of seeing the world.⁴

Material that is apparently lacking in political content, in its selection and mode of presentation, is replete with political content which reinforces and complements the more overtly political content of the press. Thus, in examining media material, we are looking not only at the apparent message, but at the same time at the other messages provided by the selection of language and the various signposts in the form of social and cultural referents.

In looking at Soviet women's magazines, we are interested in finding out the model of the world which they seek to plant in women's consciousnesses. This involves us in thinking about the Soviet press system as a whole and its relationship with the state

and its readers. Discussing British mass-circulation women's magazines, Janice Winship emphasises: 'It is not the magazines themselves that determine what women are. Their "peculiarity" — note there are no men's magazines of a comparable kind — is constituted from the marginality of women's position outside the magazine.'[5] We must be wary of attributing causal relationships between press and behaviour. However, we can use these women's magazines to approach the attitude of the state towards women, to identify demands and expectations, both explicit and implicit, on Soviet women. This is not to suggest any autonomy of the media, but to attempt to locate the operation of women's magazines within the ideological system of the USSR so that they, the magazines, may be recognised as a moment in the multiple determination of behaviour and attitudes of Soviet women.

The most important defining characteristic of the Soviet press is its intimate relationship with the Communist Party of the Soviet Union (CPSU). Party control of the press is seen as fundamental to the leading role of the CPSU in Soviet society. 'The Soviet press is the true standard bearer of Marxism—Leninism and the strongest ideological weapon of the Party in the struggle for the construction of Soviet society.'[6] That the press maintains its function as an ideological weapon of the CPSU is guaranteed by the operation of party leadership at two levels: first, through party monopoly of the dominant ideology of the USSR, Marxism—Leninism, within the framework of which all officially published material must be formulated; and secondly, through a more immediate control of the organisation and personnel of the press, which includes nomination of editors and department heads.[7] The State Committee of the Press of the Council of Ministers, subject, like all state institutions, to party direction, supervises press matters. Resolutions from the Central Committee of the CPSU or decrees from the Supreme Soviet deal with press policy, for example reactions to international events, or new economic campaigns. The Union of Journalists provides a further layer of supervision by ensuring that journalists maintain a professional code, largely congruent with party expectations.[8] There are party committees attached to all newspapers and journals, to whom the editor is responsible. These committees participate in regular editorial meetings, suggesting and approving both long- and short-term plans.[9] A recent Central Committee (CC) resolution encourages the party committees to 'realise measures for the further improvement of the system of political leadership of the means of mass information and propaganda'.[10]

The theoretical principles of the Soviet press outlined in the journalists' handbook further illustrate the relationship between the CPSU and the press. These principles include *partiinost*,[11] 'party-mindedness; partisanship; seeing things and acting as one committed to realising the future as envisaged by the Party';[12] and *ideenost*, ideological content.[13] Closely connected with *partiinost*, this means that the press employs Marxist—Leninist theory in carrying out the tasks allocated to it by the party — hence the numerous references to the writings and speeches of Marx, Engels, Lenin and current leaders throughout the Soviet press. A third principle, *pravdivost*,[14] defines the methodology of Soviet journalists: they not only describe facts but interpret them correctly in terms of Marxism—Leninism and CPSU policy. Soviet journalists are not only observers but also ideological workers, 'active social participants playing a direct part in the affairs of the working people'.[15] A conference of journalists in 1977 pointed to the role of journalists in propagandising the socialist way of life:

> the underlying spirit of [their] activity is to bring influence to bear upon people's consciousness, to endow that consciousness with desirable properties and qualities and to move it towards the ideal corresponding with the political, cultural and ideological standards and values of socialist society.[16]

Most Soviet citizens have no access to a press which is not controlled by the CPSU, even to the level of notice-board newspapers in offices and factories; thus the CPSU holds the monopoly on the publication and dissemination of ideas. Restrictions on the production and circulation of non-official printed matter make the existence of any publication independent of the party very difficult. Such a publication is automatically illegal and its authors and distributors subject to prosecution, as was the case with the Leningrad women's *Almanac*.

Media policy in the USSR is based on the assumption that people are influenced by what they read: 'a magazine is one of the principal media of mass information and propaganda and it exerts an influence on public opinion, moulding it in accordance with the interests of certain social classes, political parties and organisations'.[17] The daily and periodical press aim to mould a certain type of citizen, the New Soviet Man (*sic!*), who is the 'chief hero of the press'.[18] Most newspapers and magazines carry articles on individuals who are described as at the same time exemplary and ordinary: ordinary in that they are shown as an average type of

person whom the reader might encounter daily in their own working life; exemplary in that they display the desired attributes of the New Soviet Man, usually as efficient workers overfulfilling their production targets. 'The hero of the newspaper pages is a worker, a team leader, a foreman, engineer, apprentice, doctor, teacher, collective farm chairperson, commander of Soviet industry, a Party or Soviet worker, put forward as models for imitation.'[19]

Presentation of role models is one aspect of the educative nature of the Soviet press. The glorification of successful individuals is seen as educating through inspiration and is coupled with exhortation to greater efforts. The press is one of the many agencies in Soviet society engaged in *vospitaniye*, the constant process of moral training and education of Soviet citizens of all ages in the needs and values of their society. 'Our papers carry the huge burden of explaining the tasks facing the workers of the country, forming the attitudes of the Soviet people and training them in the spirit of the Moral Code of the Builder of Communism.'[20] The press is a constant propagator and reinforcer of the desired values, ideals and behaviour which constitute the norms of prescribed Soviet life.

Lenin's demand that the press be not only a collective propagandist and collective agitator, but also a collective organiser is still a basic tenet of the Soviet press, and much quoted by journalists and press theorists, although in contemporary Soviet society, such terms will not carry the same significance as in pre-revolutionary Russia or in the early days of Soviet construction. It is propagandist functions which are now uppermost, as the press acts as a transmitter of the policies of the CPSU.

Resolutions of the CC concerning the press have stressed its importance to the fulfilment of the national economic plans. A 1978 CC Plenum recommends that the press engage in:

> the profound elucidation of questions of the increasing effectiveness and improved quality of work in each sector, acceleration of scientific—technical progress, growth of labour productivity, strengthening of the economy, exposition and utilisation of the reserves of industrial and agricultural production, decreasing of the length of time and costs of new construction and increasing the output of goods for national needs.[21]

Further instructions to the press in the same document ask for its cooperation in socialist emulation (a mechanism whereby factories compete for the highest output figures). Other campaigns encour-

age communist attitudes to work, and publicise leading workers and innovators, that is, workers or work collectives who increase their production levels and efficiency by developing more effective methods of production. A resolution on party work in light industry points out the importance of press propaganda in increasing the efficiency and quality of work.[22] Another, 'On the elucidation of the question of socialist emulation in the press of the Lithuanian Republic',[23] gives guidelines for the work of the press in encouraging increased labour productivity. Editors are asked to publish more productivity figures from factories in order to encourage socialist competition between factories, and to publicise the experience of factories in cutting costs and improving efficiency.[24]

An interesting feature of the Soviet press is the incorporation of readers into the production of articles, by means of the *rabselkor* (worker/peasant correspondent) institution. This is responsible for the large proportion of articles in all sectors of the Soviet press written by non-staff, non-professional journalists. Their articles are signed and also carry the address and occupation of the author. Typical contributors to women's magazines in recent years include workers and administrators from all areas of agricultural work (including agronomists and other agricultural specialists), doctors, teachers, engineers, construction workers, industrial workers, and party and state officials from various levels. Their articles are usually about specific aspects of the author's work, and frequently include experiments in increasing production and improving the quality of work at the workplace. These authors are usually party or trade union officials or winners of various labour orders. Soviet press theorists point proudly to the *rabselkor* movement as a qualitatively new stage in the development of the press, a phenomenon peculiar to Soviet democracy, expressing the increasing participation of the people in all areas of public life.[25]

The *rabselkor* movement has its origins in the pre-revolutionary press, to which Lenin encouraged workers to contribute in order that it might be an authentic tribune of the people, an embodiment of the two other principles of the Soviet press — *narodnost*,[26] referring to its popular nature and appeal, and *massovost*,[27] its mass participation.

The *Great Soviet Encyclopedia* defines the *rabselkor* movement as 'the participation of the broad mass of the workers by way of articles in the press, radio and television in the management of public affairs, one of the active manifestations of the work and political activity of the Soviet people'.[28] The *rabselkor* movement is

estimated to have about six million activists. It has its own monthly journal, *The Worker–Peasant Correspondent*, with a circulation of 135,000. The movement is highly organised under party supervision, with training schemes, such as *rabselkor* schools, seminars, conferences and universities, organised by the Union of Journalists. The duties of *rabselkors* were defined at the Twentieth Congress of the CPSU: '*Rabselkors* must put forward courageously the radical questions of the organisation of production and agriculture, the struggle for the increasing productivity of labour, lowering the costs and increasing the quality of production.'[29] Intervention in order to improve economic indicators is, then, a significant area of responsibility for the non-professional contributor to the press, as well as for the professional journalist.

Those articles in the press with authors other than professional journalists, however, cannot be said to be spontaneous contributions: they are the results of a highly organised, supervised institution, taking guidance from national CC directives as to the current priorities in propaganda and from local journalist supervisors. Often such active participation in the press is part of an individual's party or trade union work.

One American commentator compares the letters pages in the Soviet press to a US company newspaper. The selection process at the editorial level is such that those contributions printed are those with which management, his metaphor for the CPSU, agrees, or upon which it is willing to act, or to allow a certain amount of public disagreement prior to introducing a new policy.[30] In the Soviet case the political culture, the organisation of the press and the *rabselkor* press participation movement cause the selection process to be brought into play before the editorial board stage. That is, both professional and non-professional writers are aware of the parameters of permissibility.

Nevertheless, the articles by non-professional journalists help to make the press more lively, to populate it with a wider range of characters. Instead of abstract, theoretical articles on the need to improve the quality and quantity of production, or the advances of socialism, the reader is presented with the real and concrete experience of working people. For instance, an article in *Rabotnitsa* ('The Working Woman') (no. 3, 1982) is written by a teacher from Kazakhstan, one of the Central Asian Republics of the Soviet Union. The author talks of the impact of socialism on her family's life, and by implication, as well as explicitly, on that of all the people of Kazakhstan, particularly the women. Her mother was illiterate, and when widowed with five children had become the

property of her husband's brother, forty years older than herself. Then came the October Revolution and the mother was able to realise her dearest wish, to see her children educated and able to plan their careers. This type of article is frequently found, in women's magazines and the press generally. Comparisons are made between pre- and post-revolutionary life, particularly in the case of the minority nationalities, expressing the advances made during the Soviet period. This serves the purpose of first announcing the success of the Soviet nationalities policy, in the social and economic development of relatively undeveloped and traditional countries, and further of offering the opportunity of comparing these areas with similar non-Soviet regions, which they surpass on most indicators of health, life expectation, education, industrialisation and so on. The improvement in standard of living and quality of life over the past three generations is another regularly recurring motif. Readers' attention is drawn to the differences between their lives, their mothers' and their grandmothers'.

In Western Europe and the US traditional women's magazines are defined as:

> those magazines whose content and advertising is aimed primarily at a female audience and at female areas of concern and competence customarily defined within our culture [and] . . . specialise in such consensually agreed areas of female interest as fashion, dressmaking or beauty; others . . . embrace the three Cs of traditional role performance, Cooking, Cleaning and Caring.[31]

Studies of women's magazines in Britain and the US confirm the 'face of "femaleness"' as the face of the traditional woman, the smiling pleaser our culture defines'.[32] Mass circulation women's magazines are generally regarded as inimical to the emancipation of women from and within the domestic sphere in so far as the majority of the messages in the genre contribute to compound the traditional catalogue of activities attributed to women. Cynthia White somewhat tautologically defines women's magazines as magazines, periodicals or journals which are produced primarily for women and addressed to a female audience.[33] We identify a magazine as a woman's magazine because its articles and pictures present women doing the things that our society tells us that women do. In the same way that we instantly recognise the constituency to which *Motor Cycle News* is directed, we recognise the potential consumers of women's magazines as being women —

all women. We recognise women's magazines by their covers and titles — *Woman, She* — before exploring their contents. Soviet women's magazines similarly declare themselves: *Rabotnitsa* ('The Working Woman') *Krest'yanka* ('The Peasant Woman'), *Sovietskaya Zhenshchina* ('Soviet Woman').

Because of the differing nature of the market in the USSR, covers do not act in the same way as in Britain, to differentiate one magazine from a vast number of competitors. (In fact, there are very few women's magazines, more or less one to a republic, in the USSR, and because of the shortages of paper, there are not enough printed to meet the demand.) Cover pictures, like content, will be selected by the editorial board on a functional basis — their representation and propagandising of desirable characteristics of Soviet women.

The covers of both *Rabotnitsa* and *Krest'yanka* usually show pictures of women, often in a work setting, or with children. Occasionally a picture of Lenin or a political poster will be used. Covers for *Krest'yanka* for 1982 included women agricultural workers, women with children, a woman violinist in local costume and an abstract poster with the slogan 'Proletarians of the world, unite!' Covers of *Rabotnitsa* for the same year featured full-face, large photographs of women in four editions, three of whom appear to be over forty; two others show women working (one a group of construction workers, the other a young woman assisting a male surveyor); the remaining covers include a landscape painting, examples of Russian folk art, children playing and a poster of a woman construction worker with the slogan 'We are prepared for feats of labour'. The covers of these magazines are certainly addressed to women, offering a definition of the scope of women's interests and activities. Where women are portrayed, they are physically recognisable as the type of woman whom the reader might see in the street or at her place of work.

Janice Winship describes the cover of *Woman* magazine in terms of the 'glossiness and perfection' of the model, which is unattainable for the reader and compared to whom she feels a failure. Furthermore, although *Woman* appeals to women readers, the covers represent 'woman with that seductive expression directed not to women, but to men'.[34] Pictures of women in Soviet magazines, with the recent exception of fashion shots, suggest activity: women in working clothes, getting on with their jobs, in a discussion group, or at a conference, wearing their medals or in some similar, everyday environment, photographed unselfconsciously, rarely looking straight into the camera. These women

are more preoccupied with what they are doing than with the presence of a camera and a photographer. We are left with the impression that they would be doing exactly that, whether a camera were there or not. These are emphatically *not* women who have been designed solely to attract male attention. The fashion photographs in Soviet women's magazines are different, and have become more influenced by Western fashion photography in recent years. The poses and attitudes of the models are recognisable to the habitués of British fashion magazines — hands on hips, bodies in unnatural stances to display the line of a garment, faces glossy with cosmetics and eyes challengingly looking straight into the camera. These women are in contrast to the ordinary working women elsewhere in the magazine. The contrast between the reader and the model is more acute in the Soviet case than in Britain, for example. In the West, women can feasibly buy the cosmetics, clothes and accessories that comprise the model, but in the Soviet Union such consumer goods are not high on the list of economic priorities and are not easily available. The two types of photograph portray women in two aspects: as the worker—producer and as the plaything—consumer. The latter is a relatively new role for Soviet women. While there is still a relative dearth of cosmetics and perfume and fashionable clothes, there have been moves in the direction of making some provision for these goods. From conversations with women and observation of the rush when a consignment of foreign cosmetics arrives in a shop, it seems that there is a great demand from women for these consumer goods.

In Britain and the US, magazines are not sex-specific, that is, aimed at one sex, *unless* they are for women (with the exception of pornographic publications). Magazines with titles like *Men's World* and *Men's Own* not only do not exist as brother publications to *Woman* and *Woman's Own*, but sound vaguely ridiculous. There are no equivalent publications for men, directed solely at men, identifying men as a group with common interests and activities. Marjorie Ferguson indicates the uniqueness of women's magazines: they are at the same time both specialist and generalist — specialist in that they are directed at one group, and generalist in that they aim to cover a wide range of the concerns of that group.[35]

Similarly in the USSR, we will not find magazines called *Rabotnik* ('The Working Man'), *Krest'yanin* ('The Peasant Man'), nor indeed *Sovietskii Muzhchina* ('Soviet Man'), although there are female variants of these titles. Again, the only sex-specific publications are aimed at women. Clearly, in terms of magazine publication, there is the world, and there is the women's world. Given the

expressed ideological nature of the Soviet press, the existence of a separate women's press in the USSR leads us to ask: what do Soviet women need to know that Soviet men don't need to know? Why, of the 5,967 journals published regularly in the USSR are 39 for women?

We will look now at the early history of *Rabotnitsa*, the first Soviet women's publication, and currently the periodical with the largest print-run, in order to compare the original demands and expectations of the journal with its current functions.

Rabotnitsa, the first women's journal of the Russian Social Democratic Labour Party (Bolshevik), developed out of the women's page in *Pravda*, the party's main newspaper, and means of publicity and organisation. By the end of the nineteenth century women were 13 per cent of industrial workers in Russia and formed a substantial proportion of the workforce in certain industries — textiles, garments, food. They were beginning to form a significant part of the Bolshevik constituency, the industrial working class.[36] However, there were rivals for the political affiliation of working women, in the form of various feminist groups agitating around questions of female suffrage, and legal, educational and professional rights.

The slogan of the First All-Russian Women's Congress of 1908, 'The women's movement must be neither bourgeois nor proletarian, but one movement for all women',[37] was a clear denial of the relevance of class to women's oppression. The Bolsheviks criticised demands for equal rights for women; equal rights were a bourgeois myth, impossible of realisation so long as people continued to stand in unequal relations to property. Inessa Armand, a leading Bolshevik publicist, claimed that bourgeois feminists had two aims in attracting working women to their ranks: first, they needed their numerical support; secondly, they wanted to weaken the growing workers' movement by setting female worker against male worker. The Bolsheviks criticised the feminist concept of all women united into a 'sisterhood of misfortune' as totally lacking in political or economic reality in class society.[38] They pointed to the unity of class interests between men and women proletarians. Only through a united struggle could the exploitation of the entire proletariat, and, within its ranks, the specific oppression of women, be ended.

The Bolshevik paper *Pravda* had a section devoted to women workers which published letters from women on their specific and vulnerable position within the workforce: 'In order to get a job, you've got to please the foreman, go walking around the town with him . . . then he invites you to his garret . . .'[39]

From 1910 onwards, there was discussion in the party of the need for a separate organ for women workers. In January of 1913, *Pravda* set up a department, 'Women's Day and the Working Woman', to prepare for the celebration of International Women's Day for the first time in Russia, and to bring out a special issue for that day. The response of working women was such that it was felt to be an appropriate time for a publication aimed at women. The Bolshevik Central Committee established an editorial board composed of leading women party activists, some in Russia, some in exile, and it was decided to publish the first issue for Women's Day, 1914. At the final pre-publication meeting in Petersburg all the participants were arrested as police rounded up many of the city's leading women political activists in an attempt to preempt Women's Day demonstrations. It was left to Anna Elizarova (Lenin's sister) to assemble and publish the journal. A message got through to the women's prison that International Women's Day had been marked by a meeting followed by a demonstration at which the first edition of the journal had been distributed. 'The news of the success of Women's Day quickly went round the prison. From joy, each cell burst into revolutionary songs.'[40]

Although the women Bolshevik activists were enthusiastic about the appearance of *Rabotnitsa*, and had the support of Lenin, many male comrades wondered why the party was wasting money on a women's journal.[41]

Rabotnitsa, in common with all legally circulated publications, had to receive initial authorisation from the Tsarist censors and present each edition for censorship. The journal lasted for seven issues, two of which were confiscated by the police. In common with many workers' and left-wing publications, it was closed down at the beginning of the First World War as potential hostile propaganda, and did not reappear until the overthrow of the Tsar.

Censor's criticisms of an article in *Rabotnitsa* no. 3 discussing factory conditions for women workers included the complaint, from the censor, that such articles 'not only created a feeling of dissatisfaction amongst a number of women workers, but also directly set them against factory owners, stimulating hostile relations . . .' That number was confiscated. In no. 6, also confiscated, an article on the high mortality rates of the children of Petersburg women workers was condemned for 'attracting women workers by discussing such painful subjects as children's deaths', and suggesting that if women wished their children to live, they must struggle against capitalism.[42] In the first issue, the editors had also

indicated that 'for reasons beyond our control', that is, censorship, certain articles had not appeared.

The journal was planned to show women workers 'that their interests were those of all working class, not only of Russia, but of all countries'.[43] It was described by its editors variously as a younger brother and as a younger sister of *Pravda*, playing the same role as *Pravda* for the women proletarians' movement. '*Pravda* also printed correspondence from women workers but space was limited, and many of them remained unpublished. Besides this, women workers were the most backward layer of the population and needed their own organ.'[44]

The party press was guided by Lenin's formulation that a newspaper be 'not only a collective propagandist and collective agitator, but also a collective organiser'.[45] That is, the press was to function not only to inform and raise consciousness through the printed word, it was also to serve as a focus for activity, as a means of drawing people into revolutionary politics. Distributing the journal was a way of making an initial contact with women; local distribution channels were important arenas of political activity. *Rabotnitsa* no. 2, 1914, published a letter from women readers at an aviation factory, offering to set up their own distribution channel. They wrote: '*Rabotnitsa* will work for united women workers and therefore, for the whole working class.'

Meetings were called and demonstrations organised to raise women's consciousness and involve them in political activity as members of the working class. An article in no. 3, 1914, pointed out that women workers had as much interest in the reduction of the working day, freedom of unions and improvement of working conditions as men. No. 4 called upon women to fight for the eight-hour day. No. 6, 1917, discussed a protest meeting organised by the editors of *Rabotnitsa*, calling upon the 10,000 women workers present to 'unite around their journal'. No. 5, 1917, reported a factory gate meeting at which two of the journal's editors called upon women workers to unite in the class struggle. Alexandra Radlonova was one such woman worker. She was a tram conductor, uneducated. She described herself as 'very ordinary'. She met some of the editors of *Rabotnitsa* as she was delivering a collection taken up by the workers at the tram garage for the journal. They asked if she would write an article. She felt that this was beyond her and sat 'for ages with a blank page and a blank mind . . . But as soon as I started, there it was. I began to write about how we worked in the garage. I wrote about the things that agitated us . . . '[46]

After the October Revolution, *Rabotnitsa* had the task of outlining to women their part in the struggle for a new socialist Russia, by informing them of the decrees of the Soviets, particularly those on women and the family, and by organising and publicising meetings of women workers and activists. The journal was closed down again in 1918 as a result of disruptions in paper supplies, due to the general confusion of the Civil War. It was replaced by women's pages in the other party organs, which were supervised by a Commission for Agitation and Propaganda amongst Women. Again, the aim was to stress common cause between men and women as proletarians and show women as 'one of the sectors of the huge army of labour'.[47]

In 1923 *Rabotnitsa* was reestablished as a 32-page monthly journal with a print-run of 15,000 copies. It combined political and economic articles with short stories, poems and articles on health care and popular science.

No. 1, 1923, discussed the social basis of many illnesses, pointing out that workers were far more likely to suffer from some diseases than capitalists because of the conditions in which they worked and the poverty of their lives. Another article discussed tuberculosis and described bacteria; an article on evolution explained the origins of man. The editorial of this first issue stated that the journal had been revived at that time because the New Economic Policy, a partial return to a market economy, was serving to strengthen old social values and women must be on their guard:

> To help women workers, books, papers, schools and study circles must be introduced. Women workers can find such help in the first instance in their journal, Rabotnitsa. In it she can find enlightenment on all current political questions. In it she can find out how to stop kindergartens from being cut; why it is necessary for her to participate in the cooperatives. Here she can find why it is necessary to be a member of a Trade Union, and why it is necessary to increase her knowledge of her work. Rabotnitsa will also help her to understand the various new decrees.

Other articles in this issue included some historical documentation of Civil War events; memories of a pre-revolutionary childhood; a report from the Tenth Congress of the Soviets; a report from the Fourth Congress of the Communist International; a tribute to Rosa Luxemburg; an article explaining the 1918 Family Law, arguing that it really was best for women, even the most advanced, to give

a legal form to their marital relationship, although in fact, by law they were not obliged to do so. This was an acknowledgement of women's vulnerability under a new law to men's sexual opportunism. A section called 'Stinging Nettles' invited readers to send in their experience of high-handedness or excessive bureaucratic zeal on the part of those in authority, which were then presented in the form of comic verses.

Rabotnitsa, under the direction of the Women's Department of the Central Committee, was part of a large-scale campaign to increase literacy and health awareness as well as social and political skills amongst women, in order to establish them rapidly as active and conscious constituents of the new order.

Challenges were presented to traditional perceptions of women's roles. An article in no. 2, 1923, asks whether working women ought not to organise their daily domestic routines along a socialised pattern. It discusses the worries that women might feel in surrendering more and more of their traditional strongholds to outside agencies, such as nurseries, laundries and canteens. It points out that the attitude that such domestic activities were women's province was rooted in the understanding that men worked outside the home as breadwinners, providing money to purchase products which the labour of his wife would then transform into essentials for the family. The article then went on to query the usefulness of this approach for the state, the family as a whole or women, in terms of duplication of effort and resources, and to assert the importance to women's real equality with men of the creation of networks of organisations to assume domestic responsibility.

An article by Nadezhda Krupskaya in no. 8, 1923, explained the importance of the Young Pioneer youth organisation to the equal socialisation of the boys and girls of the next generation and urged mothers to enrol their children.

Another article by Krupskaya (no. 9, 1923) stressed the importance of education for the children of socialist society, and described how, under socialism, schools differed from those of bourgeois regimes. As a leading party activist and as Lenin's wife, Krupskaya was a relatively prestigious figure to contribute to the journal: 'in her articles [she] drew the attention of working women to the business of socialised dining, organisation of creches, kindergartens, school assistants and socialised laundries. Questions of production, plan fulfilment and difficulties at work were also vital problems of women workers.'[48]

Rabotnitsa was one prong of a campaign to create a new type of woman — active and aware, socially, professionally and politically,

a conscious participant and supporter of the new society. Proclamations and decrees had been issued on the new legal rights and status of women; it was up to the press to inform women and to propagandise these new roles.

The key to the direction of the development of *Rabotnitsa* is found in the relationship between the Zhenotdel, the women's department of the Central Committee of the party, and the party as a whole.

The Zhenotdel was formed as a section within the Central Committee Secretariat in 1919, with the brief of drawing women towards the new regime and explaining what socialism would mean for women. It played an important part in the literacy campaign amongst women and in mobilising women for medical and welfare work during the Civil War. The restructuring of daily life, through the public services, regarded as necessary to relieve women of the burdens of privatised domestic labour (public catering, laundries, creches), was also seen as the responsibilty of the women's department. Thus there was already a certain ghettoisation of 'women's issues'; this was further emphasised by the fact that of the seven most prominent women at national level, five (Armand, Kollontai, Nikolaeva, Samoilova and Smidovich) were leading figures in the Zhenotdel.[49] Of the other two leading Bolshevik women, Krupskaya was involved in the Commissariat for Education and Stasova was a party administrative worker. Certain issues became confirmed as women's issues, not only because of the traditional views on women's areas of specialism, but because they were issues around which party women were visibly working, apparently taking the responsibility from other sectors of the party. Traditional male prejudices as to the unimportance of women's issues received structural support in the party's anti-feminism, shared by both male and female comrades. The profound suspicion of any division in the working class laid all women's activities open to suspicion as divisive separatism by some members. On the whole, the Zhenotdel was not taken very seriously, either by individual male party members or by the party organisation. It was not accorded representation on important committees, nor given the status and support necessary to implement policies. The party needed a channel to reach women, but it was anxious that this channel remain unidirectional and within its control; autonomous activity or consciousness-raising were not on the agenda.

Rabotnitsa, hence, was regarded as a means of educating women in the route to their emancipation prepared for them by the

Bolshevik Party. Just as there could be no autonomous women's organisation, there could be no autonomous women's press. Zhenotdel editorship of the journal ended in 1930 when the Zhenotdel was disbanded after years of criticism for its feminist tendencies.

Now, when equality of the sexes is proclaimed as a current reality in the USSR, it is difficult to understand upon what theoretical basis the continued existence of a separate sphere of journalistic production for women is justified. Within the terms of traditional Marxist theory, the primary cleavage in society, is class, not sex: individuals are defined through their class allegiance, through their labour, rather than through their sex. What I am suggesting here is that the existence of separate women's magazines in the USSR is indicative of the qualitatively different life experiences of men and women in the USSR, and of the partial, one-sided nature of the emancipation of Soviet women. Emancipation, for Soviet women, has meant the grafting of new public and professional roles on to the traditional family and domestic roles. Women are now exhorted and expected to achieve in both areas, as successful mothers and homemakers and as socially and politically active professional women. Women's emancipation has not called for reappraisals of male roles in any significant way.

Work in both the domestic and public sectors is sexually segregated. It is almost exclusively women who do childcare and domestic work.[50] In paid employment, women generally occupy lower-status, lower-paid, less skilled positions.[51] Discussions of sex roles in the USSR stress 'equality', not 'identity', as the formula for the relative status of men and women.[52] That is, the status of men is not to be used as a yardstick for the status of women, because they are quite different, and have different needs − akin to the familiar 'equal but different' doctrine of South Africa. This approach effectively serves to compound and legitimise the functional inequality between the sexes, particularly in the domestic area, by its implicit suggestion that certain activities, those connected with housework, certainly, are intrinsically women's activities. Behind this is a fundamental biological determinism. A representative of the Soviet Women's Committee explained it thus: men and women are different; women are mothers; this must be a chief defining characteristic. She felt that the Soviet Union had passed the stage wherein equality of the sexes had meant sameness, that women no longer needed to prove themselves as being as much like men as possible, as for example during the Great Patriotic War (the Second World War), when women had hardened

themselves into male roles and attitudes to keep the country going during the deprivations of wartime. Now, because of the background of their legislative equality, women could afford to allow these differences to emerge, to become more feminine. It was difficult to penetrate the definition of femininity here, but it was a familiar stereotype, involving words like 'emotional', 'tender', 'caring', as natural attributes of women, and including a woman's equally natural need to be interested in her appearance, in cosmetics and perfume, to make herself attractive to men.[53]

Women journalists from *Sovietskaya Zhenshchina* were even more concerned with the fundamentality of maternity to women, regarding motherhood as woman's most important activity. When I questioned sex-segregated classes in Soviet schools — cookery and domestic skills for girls, metal and wood work for boys — the response was that this was fine; that girls would need those skills if they were to be good wives and mothers, and if they wished to enter professions requiring wood or metal work skills, they could train at college later. Implicit in the preparation of girls for motherhood was their preparation for housewifehood. One member of the staff, a journalist in her late thirties, said that when she was a girl, her parents had wanted her to have everything that they themselves had lacked: music lessons, dancing lessons, encouragement in her study and so on, and she had never been asked to do any housework; 'but when I married, I couldn't even make porridge, and had to learn out of a book, so I am teaching my daughter how to be a housewife, a cook'.[54]

An article in *Rabotnitsa* talks about women's natural qualities which make them suitable for some types of work: their attention to detail, skill at fine work, etc.[55] 'Women are women' is an endlessly repeated phrase in any discussions about sex roles. The suggestion is that woman's biology creates her characteristics and aptitudes, her destiny, in an immutable fashion, that woman's maternal function is the major determinant of her lifestyle.

According to various leisure-time activity surveys, and time-budget studies, reading is a regular free-time activity for most Soviet citizens. Some 66 per cent of Soviet respondents to a multinational time-budget study read regularly, but, not surprisingly in the light of the pressures on their time from the double working day in the home and professional place of work, women read less than men. Nevertheless, women spend on average 3.8 per cent of their free time reading, compared with men's 16.3 per cent.[56] A Moldavian survey ranks reading of papers, books and journals as the most popular leisure-time activity of the women

interviewed.[57] Another survey indicates that periodicals are the chief reading matter of most women.[58] It is easy to see the attraction for a busy woman in a magazine: she can pick it up and put it down, there is no need for the continuity of reading and concentration required of a book. Women are less likely than men to read a newspaper, and when they do, they are less likely than men to read articles on politics, the economy, agriculture, industry or party affairs, preferring instead human interest stories, articles on everyday life or fiction. Thus, women as a group are less likely to receive propaganda messages through a newspaper. As they are also considerably less likely than men to attend political lectures and meetings, they are similarly inaccessible to oral propaganda. There is a fear that women are a 'non-public' in terms of ideological work.[59] Political and economic articles in women's magazines are a possible counter to this, and indeed editors have acknowledged that many women will get most of their political information in a digested form, through a monthly magazine.[60]

Of the 5,967 periodicals published in the USSR, with a total print-run of over 2,572 million, two of the largest are *Rabotnitsa* and *Krest'yanka*, with a combined print-run of 266.4 million copies.[61] Their extremely large − and increasing − print-run testifies to their popularity. Both magazines have grown at a faster rate than the female population. This increase in copies printed has been a general pattern in the publishing world in the post-Stalin period. It is noticeable that *Rabotnitsa*, directed towards the urban working woman, has increased its circulation at a faster rate and to a higher level than *Krest'yanka*, aimed at women working in agriculture, hence rural dwellers. This is congruent with the decline of the overall rural population, and the decline of the female workforce in the countryside.

Editors of Soviet women's magazines claim that many more copies are demanded than are printed, and the observed absence of these journals on newsstands bears out their popularity. The shortage of paper in the Soviet Union puts limits on all printed matter.

Rabotnitsa and *Krest'yanka* are described in the *Great Soviet Encyclopedia* as 'mass socio-political and fiction magazines', which use 'informational, journalistic and literary genres − reviews and surveys on various themes, articles, essays, reports, poems, short stories, novellas and novels' to introduce material that is of 'an entertaining and educational nature . . . or of a practical nature (fashions, advice to housewives . . .)'.[62]

Rabotnitsa is further described in the journalist's handbook: 'The

aim of the journal is the cultural and political education of working women and housewives, mobilising them to fulfil tasks established by the CPSU.'[63]

Both magazines carry after their title the legend 'monthly socio-political and literary-artistic journal'. They are published by *Pravda*, the CPSU's own printing house, and thus are under the direct auspices of the journals section of the Propaganda Department of the CC of the CPSU.

The two magazines are very similar in appearance. Both are slightly larger than A4 size, invariably 32 pages long, with four pages of colour inside and a colour cover front and back, the remainder monochrome, with a pull-out section of knitting or dressmaking patterns or do-it-yourself advice. There is a broad similarity in layout and content: political, industrial and agricultural stories at the front, then short stories, poems, items of social or cultural interest, with the final six pages or so devoted to family and domestic matters, consumer advice, fashions and the occasional piece of music or a chess problem. The magazines are plentifully illustrated, with photographs, reproductions of paintings and drawings accompanying every article.

Rabotnitsa has a full-time staff of 35, 15 of whom deal with the 500–700 letters received every day. This reflects the importance given to readers' letters throughout the Soviet press; they are an example of the public and democratic nature of the press. Each publication has a letters department which keeps files on all letters, deals with issues raised and initiates appropriate action. This action usually involves passing the complaint or query on to the relevant ministry or organisation, and following up the response. The letters department also serves to offer a picture of public opinion on certain issues, as well as being an acknowledged grievance procedure.

Grievance letters are called signals, and are frequently concerned with violations of labour legislation, as in the case of the reader who complained that she had been asked to work a weekend, but had not been paid. Action was taken by the magazine, with the result that the head of the workshop was reprimanded, and the worker received her money.[64] On other occasions, letters are concerned with shortages in the shops, or problems with repair and service industries. The magazine in many cases publishes the letter, followed by the nature of its intervention, and the result. This is not always successful in resolving the problem, though. A reader complained of the problems of her newly-built flat — leaking roof, inadequate plumbing; the attention of the local housing official was

drawn to the problem, which he acknowledged and issued a report on repairs. However, over a year later, the reader wrote once more to the magazine to say that the work still had not been done.[65]

Other departments at *Rabotnitsa* cover working life, international affairs, family/everyday life, science, political life, art and public and social activity. As the magazine has no local correspondents, it relies heavily on material from *rabselkors*, and letters, solicited and unsolicited, from readers. From time to time, an invitation is issued to readers to send in their thoughts on certain subjects. For 1982, articles were invited under the general title, 'Our Mutual Home', to celebrate the sixtieth anniversary of the founding of the Soviet Union. The overall theme in those articles was the friendship between the many national groups in the USSR, and their mutual help to progress under socialism.

The editor of *Rabotnitsa* sees it as a tribune for her readers, representing their interests at national level, and acting as a forum where problems can be aired. She felt that women used the magazine to help solve problems at work, either through the letters department, or by inviting journalists to come to the workplace and see for themselves. This examination, or 'raid', is a frequently mentioned technique of the Soviet press, and again, is one of the areas of activity which is regarded as part of the public participation structure. One such raid was initiated in February 1981 by a letter from 19 women workers from a wood-processing factory complaining about their working conditions, in dirty, cold workshops with inadequate ventilation. *Rabotnitsa* contacted the health and safety section of the trade union department responsible for the wood-processing industry with the women's complaints, and received a letter from the head of the section, six weeks later, outlining the measures that had been agreed with the management to correct the problems. Early in 1982, a second letter arrived at *Rabotnitsa* from the women saying that nothing had been done. The magazine turned to the Central Committee of the trade union, demanding action. Upon investigation, the workshop was found to be so unhealthy that it was closed down, and a meeting with management was set up to criticise their undemocratic lack of consideration for the workforce.[66]

Many similar breaches of labour legislation or health and safety regulations are reported: women expected to work on their days off; young women expected to work illegally long hours; lack of protective clothing; inadequate canteen facilities; pregnant women expected to work overtime.[67] Practically every issue contains complaints about these types of shortcoming at work.

The other major area of complaint with which the magazine deals is the lack of consumer services. Letters cover lack of goods and services, rudeness of shop assistants and unsuitable opening times. One article discusses the impossibility of finding a pair of sports shoes, a product which the Ministry of Trade acknowledges has long been in a state of 'serious shortage';[68] another reader complains of the impossibility of finding baby things.[69] Shopping is such a complex and time-consuming activity in the Soviet Union that many workplaces will have a shopping facility on the premises and ordering systems for food and other items.

The magazine sees itself acting almost as a pressure group to care for the interests of its women readers, both at the level of intervention at individual enterprises and at the policy-making level. The editor felt that *Rabotnitsa* had played a significant role in the recent introduction of part-time work for women with small children, by passing to the decision-makers the needs expressed by women in their communications with the magazine, and, by printing articles on the subject, creating a favourable climate of opinion.

Like all Soviet publications, both *Rabotnitsa* and *Krest'yanka* are replete with references to the state and party organisations, their decrees, meetings, history and role in Soviet development. These are supplemented by photographs, drawings and reminiscences of Lenin, references to his life and writings as well as a preoccupation with the Great Patriotic War (the Second World War), which gives these magazines a very different atmosphere from the frivolity that characterises many British women's magazines, and reflects the use of the Soviet publications as overt means of education and propaganda, whereas the propaganda in the British magazines is less visible.

Biographical articles on women who were involved in the Revolution, or the events of the early years of Soviet construction, or were activists in the Great Patriotic War, appear frequently. These present an historic perspective on Soviet life, and serve to legitimise the government by publicising, and trying to incorporate the reader into, a shared history and political culture. In one of these articles a woman who was an anti-aircraft gunner during the seige of Stalingrad recounts her experiences.[70] Another similar type of article celebrates the ninetieth anniversary of the birth of Claudia Nikolaeva, one of the early editors of *Rabotnitsa*, who was also a party and trade union worker and an activist during the Great Patriotic War.[71] A similar function is served by articles such as 'I am a citizen of the USSR', in which an electricity worker elected to

the Supreme Soviet writes about her pride in her country and her citizenship, and how she, 'an ordinary worker', was elected to be a Supreme Soviet deputy.[72]

The role of the women's press in encouraging improvement in the various indicators of the economy is demonstrated in articles by both staff journalists and *rabselkors*. Every issue of both *Rabotnitsa* and *Krest'yanka* carry articles on women's role in the different sectors of the economy. One such article discusses the work of two women, 'leaders of socialist emulation' and state prize-winners for their labour achievements. One, a worker in a china factory, was instrumental in increasing her output by 120 per cent. The other, 'short, feminine with a lacy collar on her overall', is a power station worker whose workshop motto is 'Efficient rhythm and highest quality for minimum labour and material expenditure.'[73] Another typical interview with a construction worker, Valentina Belyaeva, discusses the hardships she has to endure in her work laying the gas pipeline that will bring gas to Western Europe. She finds her work demanding and fulfilling. She talks of the important role women workers play in maintaining the psychological climate of the isolated construction camps by organising celebrations for holidays, birthdays and other occasions. Valentina describes a male colleague who told her that she worked too hard (she is the site manager, so in a responsible position managing many male workers); he went on to tell her that it was not women's work. Her reply was 'For me, my work is my life.' Her work was a source of joy for her.[74]

Another major topic, reflecting the bifurcation of women's lives, is family life. *Krest'yanka* has regular features, 'For you, parents', on child upbringing, discussing topics such as bad behaviour and the role of the family in encouraging a reading habit.[75] Regular articles also cover household budgeting, planning and correlating income and expenditure. At a more intimate level, features on love and marriage cover topics such as 'How can you be sure it's love?' and the rural family.[76] One piece on the rural family stresses that young rural working women are very different from their counterparts of the past. They are likely to be as educated as their husbands, if not more so, and demand respect in marriage. They are warned, however, that they should spare the self-esteem of their husbands and not make their demands too strongly, otherwise the husbands would develop an inferiority complex.

Rabotnitsa, directed at the urban reader whose family life is in general less stable than that of rural women, deals more often and in greater detail with marital and family life. These areas are

covered principally in two sets of articles under the rubrics 'Advice in love' and 'Family pages'. These are usually written by doctors, psychologists, psychotherapists or educationalists, and are often presented in the form of a response to a reader's letter. A woman wrote in describing a disagreement between two of her colleagues, in which one claimed it was better not to cause rows by bringing family problems into the open, whereas the other felt it was best to discuss them, and clear the air. The reply, by the psychotherapist, concentrates on the need for dialogue and communication in marriage. She writes that physical incompatibility is often preceded by a breakdown of trust and communication. A 'True or False?' questionnaire for husbands and wives to do together is included — it features such statements as 'I like to discuss books I've read or films I've seen' and 'The most important human qualities are kindness and tact.'[77] A discussion in another issue of the need for young married couples to be independent of their parents focuses on the tensions that arise when they are living with the parents in a small flat, and also dependent financially, for, 'Whatever about emancipation, man is the defender and the woman the guardian of the domestic hearth.' The shortage of housing stock and the low wages that create such tensions are not dwelt upon.[78] The concern of the government about the rising infant mortality levels is indicated in an article by a doctor on the deformities and relative backwardness of children whose parents are heavy drinkers.[79]

A 'Family Consultant' places her work in the context of the decisions of the Twenty-fifth and Twenty-sixth Congresses of the CPSU, to strengthen the family. Family consultancies, counselling centres, are new in Russia, although they have been operating in Lithuania since 1969. They are a response to the increase in divorce, and what are seen as its attendant problems, ranging from low birthrate to juvenile delinquency to loneliness, and act as marriage guidance centres. The counsellor interviewed felt that propaganda for a strong, healthy family was needed along the lines of the propaganda for good productive workers.[80]

Soviet women's magazines do not discuss sexuality, either in terms of the problem pages of magazines such as *Woman's Own*, or the 'How to be good in bed' advice of *Cosmopolitan*, or in more serious educational pieces. A coy article in *Rabotnitsa* refers to the work of a sexologist who provides consultations on 'problems of family life', solely in terms of improving husband—wife relations and thus strenghening the family; sex is not seen as a source of gratification in itself.[81] Whilst the absence of the more exploitative or oppressive aspects of an emphasis on sexuality is to be ap-

plauded, it is apparent that the avoidance of discussion of sexual matters to the extent that it occurs in the Soviet Union has produced many social and personal problems. In recent years there has been a barrage of criticism from sociologists, psychologists, educationalists and medical personnel on the inadequacy of the provision of sex education, and the near total absence of publications on the subject. It is suggested that ignorance of sexual matters is one of the reasons behind the rising divorce figures.[82]

Much of the content of *Krest'yanka* shows the government's anxiety about the rural/agricultural situation: low levels of productivity; undermechanisation; unskilled workforce; rural migration. The solution is seen as the replacement of labour by capital: the mechanisation of agriculture and the training of a highly skilled workforce to apply the technology. Thus the frequency of articles on increased production by means of new technology in the hands of specialists. One story combines the government's fear of the excess migration of young people from the countryside, with the importance of specialist training. Valya, a young woman, leaves her village for the town in search of excitement. She quickly realises, though, that she is a country girl at heart, and returns to join the Komsomol (Communist Youth League), and embark upon a specialist agricultural training course.[83] Many of the articles on rural life centre on the work histories of individuals and work collectives, many of whom are champion producers and heroes of socialist labour offering their example to the reader. There are also articles on a wide range of topics, some of which would also be found in British women's magazines: cookery, fashion, art, theatre, cinema, music, household hints, do-it-yourself, childcare as well as the items more peculiar to the Soviet context: articles on state, party and trade union and Komsomol affairs, international politics, the dangers of nuclear war, and Soviet history. The general content of *Rabotnitsa* is fairly similar, given its different constituency, urban women workers; its articles feature women in different occupations and lifestyles.

Perhaps the best way of gaining a picture of what Soviet women's magazines are like is to flick through the pages of a couple of issues.

Picking up a copy of *Krest'yanka* for October 1978, for example, we see that the cover reproduces a painting of Lenin surrounded by a group of young men and women, an early Komsomol meeting, as the slogan underneath announces the sixtieth anniversary of the organisation. The inside cover proclaims another celebration for October: agricultural workers' day, with a large photograph of

smiling agricultural workers holding a sample of their grain harvest. A paragraph beneath reminds readers of the call of the agricultural plenum of the CC, CPSU, for increased production, and goes on to say that the workers pictured had harvested eight times their planned target. Opposite this is an article submitted by workers of a tractor production plant, pointing out the importance of agricultural machinery to a successful harvest, and quoting L. I. Brezhnev: 'Our harvest is the result of the united work of peasants, workers and the intelligentsia.' (In 1974 there were more tractors and other machines on Soviet farms than could be operated by the trained workers available.[84])

The next article, about the high level of job satisfaction to be found in agricultural work, is illustrated by photographs of smiling young workers. It emphasises the freedom of choice of occupation in the USSR, guaranteed by the Constitution. Over the page, a *rabselkor* article presents a picture of life on a Siberian collective farm, referring to the use of new techniques to raise production, and the need to set ever higher production targets. A more lighthearted *rabselkor* piece describes harvest celebrations at a farm. Another *rabselkor* gives a biography of an animal specialist, a woman with 'severe eyes, but a kind heart', whose high work standards led to her comrades electing her to the local Soviet (local government). She is now fulfilling both her professional and political responsibilities with success.

The Komsomol anniversary is celebrated in a number of articles in this issue. These include a selection of reproductions of paintings of young people at work or study, accompanied by a eulogy to the Komsomol contribution to the development of Soviet power. A reproduction of a painting of rural youth introduces an article by a woman who joined the Komsomol in 1929. Her cell was one of the first rural Komsomol groups, and she remembers that it was their duty to encourage their families to join the collective farms. One of her group's first campaigns was to distract rural youth from the church. This was achieved by the simple expedient of setting up a cinema show opposite the church on Sundays. An article on a young woman Komsomol member, an activist in the underground movement in the occupied areas of the USSR during the Great Patriotic War, discusses her heroism and her ultimate death, like many of her associates, in prison.

The issue contains several short stories and a serial, with a general theme of active rural women workers, interested in developing their abilities. The centre of the magazine has a pull-out section; this month it offers a pattern for a child's coat and

instructions to convert cellars into storage space. The Festival of Youth and Students in Cuba is the focus of the international news. It is illustrated by photographs of Castro and carnival parades and activities. The letters page is devoted to the theme of courage — with several readers describing the courageous, usually wartime, deeds of friends and relatives. Advice is given to a reader querying her pension entitlement, and support given to a group of women writing from a village, demanding that officials clean up their local beauty spot.

An article under the 'For you, parents' section warns parents of the difficulties their children may have in adjusting to their early days at school, with the new disciplines of timetable and lessons.

A three-page article on the Moldavian Women's Council details the achievements of communism in Moldavia, one of the constituent republics of the USSR. A report from the Congress of the Women's Council quotes speeches on the changing nature of agricultural work and the necessity to improve and expand professional training, and also to raise the standards of everyday life in the countryside. The First Secretary of the Moldavian Communist Party (a man) reported that production was higher and lateness and absenteeism lower in those enterprises where women formed the majority of the workforce. As the major cause for lateness and absenteeism amongst male Soviet workers is alcohol related, and women in the USSR are far less likely to be heavy drinkers than men, we can see why their work attendance is better.

Some information is offered about the scope of the activities of the Women's Council, which 'under the guidance of the Party conducts mass educational and cultural work, concerns itself with the protection of children and mothers, strengthens the family, helps increase the work activities and the qualifications of women, continually improves conditions of work, daily life and medical and cultural services'. This catalogue of activities reflects the ghettoisation of women's officially defined spheres of interest. Just as women's occupational categories reflect the extension of mothering, nurturing and domestic servicing to the professional world, in so far as they are the majority of health employees (89 per cent), schoolteachers (72 per cent), and childcare workers (99.5 per cent), so their political and social activities show the same tendency. Women in political office suffer from this association with 'housekeeping' functions, as the ideological, cultural and educational areas where they gain their political experience and early posts are not normally congruent with higher office.

The article on the Women's Council goes on to say that about

half the members of the council are party members who 'give direction in work and social life'. As in all organisations in the USSR, the CPSU plays the 'leading and guiding role'. The parameters of activity for the women's councils are set by the party and represent the official attitudes to women's activities.

The following article discusses the cultural activities and facilities available to collective farm workers, and shows photographs of dancers in traditional costumes. That not all rural young people are interested in folk dancing is made clear in the reasons given for their emigration from the farms, chief amongst which is the lack of social life and entertainment in the villages.[85]

The final three pages are an amalgam of short paragraphs, including scientific information — the use of deep freezing in medicine; some light-hearted verse and cartoons; recipes — this month's for pork dishes and preserving vegetables; household hints — wiping out food cupboards with a cloth soaked in vinegar gets rid of food odours (replacing them with vinegar odours, perhaps?). There is a short humorous piece about a man who comes back from a business trip to find that his wife, previously a book-keeper, is taking a course in tractor maintenance. In a reversal of the usual situation, he is asked whether he is 'Smirnova's husband'.

The inside back pages show a collection of winter coats, which, while not so very different from the type of clothing seen in the streets of Britain, nor indeed, Moscow, is not typical of the clothing available to rural consumers, where goods of all description are in very short supply.

The dominant impression of *Krest'yanka* is as an organ of economic propaganda in the countryside. Its clear and often repeated message concerns productivity. Soviet agriculture is permanently in a somewhat parlous state; shortages of even the most basic foodstuffs occur frequently. So women are exhorted to increase productivity by learning the skills to use new methods of farming. The women workers who feature in the magazine articles are the specialists the government would like them to be, rather than the unskilled, untrained manual workers that most rural women are. Agriculture has the lowest number of female trained and skilled personnel of any of the branches of the Soviet economy, and women are a 'disproportionately large share of the less skilled workers in agriculture and a disproportionately small number of the professional and high level administrative workers'.[86] When young women do receive specialised training, they are loathe to return to the countryside to use it.[87] In other words, the women agricultural workers featured in *Krest'yanka* are not typical of the

female agricultural workforce, at whom the magazine is directed, but are models for the readers to emulate in order to improve the implementation of economic policy in the countryside.

Turning to *Rabotnitsa*, the issue for March, no. 3, 1982, is celebrating International Women's Day, 8 March. The cover shows a smiling Central Asian woman in evening dress; she is an actress from Turkmenia, interviewed inside. The inside cover has a reproduction of a mosaic of women of many nationalities and calls upon the millions of working women of the different countries to unite their strengths in the struggle against nuclear war and for disarmament and peace. Opposite this is an extract from Brezhnev's memoirs, concerning his mother. He writes of the importance of respect for one's mother, and uses it as a general indicator of human worth: 'It's not for nothing that we call our country our motherland; he who is able to abandon and forget his mother will also be a bad son to his country.' The editorial continues the theme of motherhood, proudly proclaiming the successful combination of motherhood with work for Soviet women. Soviet women are not only professionally skilled and politically active, 'they also bear the title "mama" '. This is followed by a series of poems on relationships with mothers.

A resolution passed at a meeting of the Committee of Soviet Women on their role in the struggle for world peace calls on the women of the world, 'mothers, guardians of the domestic hearth, workers in town and countryside', to forbid the further development and siting of nuclear weapons and divert the money to the elimination of hunger and disease. This is aptly followed by a feature on the use made by artists of women in war memorials, illustrated by photographs of statues of women and children. Although women were active combatants in the Civil War and the Great Patriotic War, the tradition of weeping women waiting for husbands and sons is a strong motif in Soviet anti-war propaganda. As can be seen from the wording of the appeals to women to fight for disarmament, they are seen as the guardians of peace, with the implication that they have a more deep-seated, vested interest and inclination to peace because they are women.

An interview with a Turkmenian actress is illustrated by a still from one of her films, a costumed epic from the republic's ancient history. She talks about the development and national identity of the Turkmenian film industry, in one of the series of articles under the general title 'Our Mutual Home'; the actress talks of the developments that Soviet power has effected in Turkmenia. 'The Turkmenians dreamed of water and they were grateful to their

Russian brothers for transforming the desert.' This statement reflects the fraternal relationship between Russia and the minority nationalities — with Russia as the elder and wiser brother. An interview with the Secretary of the Praesidium of the Belorussian Supreme Soviet, Elizavyeta Chagina, concentrates on the measures taken in Belorussia in accordance with the declaration of the Twenty-sixth Congress of the CPSU to improve state help to families with children and to improve the conditions of work, daily life and leisure for women. The secretary acknowledges that, although there are many laws designed to protect women, these are not always followed. In common with the other republics, Belorussia has had, since 1976, a permanent Commission on the Problems of Women's Work and Everyday Life and the Protection of Motherhood and Childhood, attached to the Supreme Soviet. This commission has paid special attention to the needs of the republic's .two million working women. The first inquiry the commission initiated was on the implementation by local industrial managers of the laws concerning women workers. There had been a number of 'signals' — letters of complaint — from workers at various factories in the town of Mogilyev. Women complained of breaches of health and safety laws and breaches of the laws designed to protect pregnant women and mothers of young children. Members of the commission plus specialists on health and safety and social security went to Mogilyev, where they found not only were the complaints justified, but there were many other problems in the area of medical and service facilities. Meetings were set up between the local Soviet, the commission members and industrial managers, which drew up plans and a timescale for their implementation. The result was improved working conditions, installation of ventilation, canteens and women's rest rooms, as well as the improvement of the town's medical facilities. Secretary Chagina went on to give an example of another town in which the commission intervened, and where now shops and consumer facilities have been much improved. Some idea of the problems of shopping in the Soviet Union may be gleaned from the description of one shop singled out for praise because one could buy 'eggs, noodles, oils, jam, drinks, and various types of bread', as well as meat. This article is illustrated by photographs of women working, studying, wearing national costume and in a maternity hospital.

An army colonel writes about his childhood, as a war orphan, brought up in a children's home. He has fond memories of one of the staff, a woman who gave them the warmth and tenderness, the 'vitamin of joy', the substitute for the maternal love they had lost.

The articles following are concerned with marital life: the first says that because couples are married, they do not have to be together every minute, and do everything together. If a couple did not share an interest, this need not be a source of argument or anxiety; they must respect the interests and activities of the partner. The second, under the 'Advice on love' rubric, talks about wedding anniversaries and their role in strengthening a marriage, especially for young couples. It advises that drunkenness be avoided during such celebrations.

A piece on the work of the trade union in a large factory begins with a woman telling of her son's frequent illnesses which caused her to be absent from work. The factory trade union committee arranged for the woman and her son to go for a month to a rest home, where they could both have a holiday and where the child could receive medical care and supervision. She watched him grow healthier over the month; since their return he had not been ill. The trade union committee added that they had done the same thing for another 79 mothers who had been absent more than three or four times because of a child's ill health. The trade union describes its work in the factory, ensuring health and safety and maintaining welfare amongst the workforce. It has also been involved in the development of new technology and the consequent increases in productivity, and in the formulation of the collective agreement with the workforce to fulfil the factory five-year plan in three and a half years. Women workers have been encouraged to develop their skills and retrain by a system of 'mother's days' set up by the trade union, allowing working mothers to study and receive full pay. Another area of trade union involvement is housing. In the past year the trade union has housed 500 families. This is felt to be an important factor in reducing labour turnover, a significant problem in Soviet industry. The style of this article is typical of the cosy intimate tone of many reports, in the way it introduces a number of women workers who talk, apparently informally, about their experiences.

The short story, translated from Latvian, is about the love of a young father for his young son. The pull-out section has a pattern for a blouse and some embroidery instruction. It is followed by an article on a textile worker who regularly doubles her production norm, and 'doesn't waste a moment'. A description of a typical day for her begins at 5.30 a.m., as she inquires at the local tram station, in her capacity as deputy to the local Soviet, why certain trams did not run to schedule.

A lawyer writes a mini-biography of a colleague, a judge, who is

the mother of five children. The article describes the woman's work history and emphasises the help that she, as the mother of a large family, receives from the state — a large flat, children's allowances and free school meals. The international news comes from a Congress of Nicaraguan women in Managua.

Again under the title 'Our Mutual Home', the effects of the October Revolution on one of the minority nationality groups is discussed. The author, a college administrator and member of the Kalmuk Women's Council, writes of the role of their Soviet proletarian brothers in establishing Kalmuk independence. She continues to talk of the improvements in the lives of women: according to the traditional ideas of feminine beauty amongst the Kalmuk people, women were supposed to have small breasts, therefore from eight years of age onwards their chests were tightly bound, restricting breathing, giving rise to much illness and pain and creating difficulties in feeding babies. Now Kalmuk women are active in all branches of industry, and together with men, build towns and operate complex machinery. This theme recurs in another article, in which a Kazakhstani teacher compares her own life to that of her mother, who was enslaved by the traditional attitudes to women before the Revolution. She underlines the progress made in women's lives since the Revolution. A collection of short paragraphs, 'Information', includes an interview with the manager of a newly opened Moscow maternity-wear shop and a description of the goods and services on offer. A congress of midwives discusses a new approach to childbirth in one hospital, where mothers are given responsibility for their babies from the moment of birth. This is felt to be successful, with advantages in terms of both infant health and maternal peace of mind. Another paragraph introduces a new formula baby milk, and others mention the arrival of new goods on the market: steam irons; a new type of pushchair; and ultraviolet sun lamps.

An article on ethnography describes the work of ethnographers and its social value, and talks of the pioneering work of women ethnographers in the early years of Soviet power.

The art feature, a regular two-page piece, gives a biography of a nineteenth-century Russian artist, alongside a portrait of a woman by him. This is followed by an interview with the Russian World Champion woman speed skater. In an article entitled 'I'm looking for baby clothes', the author comments on the large number of letters from women who have difficulty in finding clothes and other things for babies. She asks the chairwoman of the responsible department, who replies that there are certainly sufficient pro-

duced, but that the problems lie in distribution, whereby some shops receive a large quantity of goods and others none. The author discovers that this is true: shops in areas with low birthrates were receiving large quantities of goods; those in areas with high birthrates, conversely, were receiving very small amounts.

A legal specialist from the trade union department on social security answers readers' queries on their entitlement to pensions, maternity and child allowances in the light of recent legislation to improve these.

Crime and corruption at the workplace is a common theme in the Soviet press. The case against a group of women rail ticket-sellers is discussed. They were accused and found guilty of issuing false tickets and pocketing the money. The writer describes the ease with which people can slide deeper into crime after one act of dishonesty, reasoning 'Our state is wealthy. If I take a little bit, it won't do any harm. Others do it, so why shouldn't I?' Theft starts with a small sum which, if left unnoticed, grows. However, in the case of the railway workers, weren't others guilty as well? Didn't other rail workers notice that there were passengers on the train who were not accounted for on the passenger list? Didn't anyone notice the incorrect tickets? The only way to eliminate crime is to create a moral climate where it is not tolerated.

The final pages of the magazine are devoted to domestic issues: a short piece on housework notes the reluctance of men to do anything around the house; some are too lazy, others procrastinate, and still others regard it as being incompatible with male dignity, and solely a woman's 'privilege'. The writer suggests that they be encouraged to do repairs and do–it–yourself work about the home, as these are more in tune with male interests than washing or cooking. This is followed by some DIY advice: how to build a bunk bed and elementary plumbing. The recipe page suggests some one-saucepan dishes and the fashion section shows models in summer dresses.

Like *Krest'yanka*, much of *Rabotnitsa* is concerned with economic messages. Women are offered role models who are super produc-ers; they read multiple repetitions of the need to increase productiv-ity and save resources. The magazine certainly fulfils its function as an organ of economic propaganda. The dominant theme in this issue, and most others, is that of the working woman, assisted in combining her domestic and maternal roles with her professional work by the state, whether in the form of party and Soviet decrees and interventions, or trade union support at the workplace, or by the journal itself. The women who appear on the pages of

Rabotnitsa are exceptional woman workers, skilled and trained, mainly occupying senior positions in their professional hierarchy as well as positions of social and political responsibility in the community. The stories concentrate on the successful career women who achieve, rather than on the problems faced by the majority of women who have low-status, low-skilled, low-paid unmechanised jobs, not challenging careers.

The barriers to women developing such careers, such as over-burdening with housework, inadequate and unsuitable childcare, difficulties in acquiring training, stereotyped occupational choice, are rarely touched upon as large, general issues. The acknowledgement of the tensions between work and family life exists at a remove, in that it is accepted that the trade union will make efforts towards the provision of childcare places, shopping facilities and the opportunity to study during paid work time to its women workers. There is no challenge, however, to the values and beliefs which assume that women must cope with the difficulties of combining sole responsibility for domestic duties with their professional work. However, the converse of this is that women are presented with positive images of themselves: the New Soviet Woman is nothing if not active and successful and the image portrayed to women of themselves allows them to esteem their potential as beings for themselves, rather than beings for husbands or lovers, even if they may find the image as hard to live up to as many British women do the Cosmo Supergirl.

Clearly the state accrues many benefits from the Soviet concept of emancipation of women, which has meant the addition of social, political and economic roles to the domestic one.

It has already been noted that there are no male equivalents of Soviet women's magazines. The state does not feel the need to intervene to form male attitudes and behaviour, as it does female. This is not to say that men's behaviour is not socially determined but to point to the different levels of ideological interference and direction. Women receive far more overt instruction in how to be women, in the USSR and in other countries, than do men. Might this bear relation to the fact that the emancipation of women has been male-defined in the Soviet Union, its parameters set by male theoreticians and its implementation organised by a predominantly male state and party apparatus?

Certainly it is accepted that emancipation has not brought the anticipated liberation of women from 'antiquated methods of housekeeping', as the individual family unit was once called;[88] nor has it included any attempt to alter male attitudes and behaviour.

The priorities in the emancipation of Soviet women were not those of liberation, but those of economic necessity in times of acute labour shortage, from the 1930s to the 1960s.[89] Economic needs plus an over-economistic Soviet Marxism confine the discourse of the 'woman question' to the labour market.

There has been neither financial nor ideological commitment to a fundamental altering of sex roles. Their right — and indeed their obligation and social duty — to work is important to Soviet women. Most say that they would continue to work even if their husband's pay were sufficient for all their needs.[90] However, emancipation into the workforce has meant that women's overall workload is 15 to 20 per cent higher than men's,[91] and that women are frequently tired and often ill; [92]they have far less free time than men, for relaxation, study or social or political activity.

There is little suggestion of official interest in effecting any major transformation in the pattern of women's lives, or of men's. Discussions of domestic overburdening of women suggest the industrialisation of housework by the improvement of services rather than through any reassessment of the individual family unit of consumption, based on the unpaid labour of the wife/mother.[93]

To reiterate: women's magazines do not themselves create and promote a certain female type: they refer to the position of women outside the pages of the magazine. In the Soviet case, women's magazines are part of a complex ideological structure confronting Soviet women with the image of themselves as the Super-achiever, the New Soviet Woman, which is at some distance from the reality of most women's lives.

Notes and References

1 E.P. Prokhorov, *Sotsiologiya Zhurnalistiki* (Moscow, 1981), p. 22.
2 B.A. Grushin and L.A. Onikov, 'The Media in a Soviet Industrial City' in *Soviet Sociology*, vol. XX, no. 4 (1982), p. 79.
3 O.A. Feofanov, *Formi i metodi burzhoisnoi propagandi obraza zhizn* (Moscow, 1975), p. 11; see also: O.G. Kirianova, *Vestnik Moskovskogo Universityeta — Zhurnalistika*, no. 1 (1978), p. 80.
4 J. Curran, A. Douglas and G. Whannel, 'The Political Economy of the Human Interest Story', in *Newspapers and Democracy*, ed A. Smith (Massachusetts: MIT: 1980), p. 305.
5 J. Winship, 'A Woman's World: "Woman", an Ideology of Feminin-

ity', in *Women Take Issue*, Women's Studies Group, Centre for Contemporary Cultural Studies (London: Hutchinson, 1978), p. 135.
6 N.G. Bogdanov and B.A. Vyazemski, *Spravochnik Zhurnalistika* (Leningrad, 1971), p. 25.
7 Ibid., p. 40.
8 G. Hollander, *Soviet Newspapers and Magazines* (Massachusetts: MIT, 1967), p. 19.
9 V.P. Smirnov, *Sovietskaya Demokratiya i pechat* (Mowcow, 1978), p.73.
10 *Spravochnik Partinogo Rabota* (Moscow, 1978), p. 236.
11 *Spravochnik Zhurnalistika*, p. 22.
12 R.E.F. Smith, *Russian–English Dictionary of Social Science Terms* (London: Butterworths, 1962).
13 *Spravochnik Zhurnalistika*, p. 25.
14 Ibid., p. 29.
15 Smirnov, *Sovietskaya Demokratiya* p. 15.
16 Grushin and Onikov, 'Media in a Soviet Industrial City', p. 80.
17 *Great Soviet Encyclopedia*, translation, vol. 9 (New York: Macmillan, 1970), p. 340.
18 Smirnov, *Sovietskaya Demokratiya*, p. 122.
19 Ibid., p. 123.
20 *Spravochnik Zhurnalistika*, p. 21.
21 *Spravochnik Partinogo Rabota*, p. 225.
22 Ibid., p. 277.
23 *Spravochnik Partinogo Rabota* (Moscow, 1973), p. 225.
24 *Sorevnovaniye i Pechat* (Moscow, 1975), p. 7.
25 *Gazyeta, avtor i chitatel* (Moscow, 1975), p. 99.
26 *Spravochnik Zhurnalistika*, p. 32.
27 Ibid., p. 34.
28 *Bolshaya Sovietskaya Entsiklopedia*, vol. 21 (Moscow, 1975), p. 319.
29 *Spravochnik Zhurnalistika*, p. 62.
30 M.W. Hopkins, *Mass Media in the Soviet Union* (New York: Pegasus, 1970), pp. 302–7.
31 G. Tuchman, A.K. Daniels and J. Benet, *Hearth and Home: Images of Women in the Mass Media* (New York: Oxford University Press, 1978), pp. 97–8.
32 Ibid., p. 113.
33 C.L. White, *Women's Periodical Press in Britain, 1946–1976* (London: HMSO, 1977), p. 31.
34 Winship, 'A Woman's World', p. 133.
35 M. Ferguson, *Forever Feminine* (London: Heinemann, 1983).
36 *Zhenshchini i deti v SSSR* (Moscow, 1969), p. 9.
37 C. Porter, *Alexandra Kollontai, A Biography* (London: Virago, 1980), p. 141.
38 S.V. Karavashkova, *Publitsistika A.M. Kollontai, I.F. Armand, L.N. Stal, A.I. Ulyanov-Elizarovoi v Borbe za ukrepleniye mezhdunarodnogo rabochego dvizheniye* (Moscow, 1973), p. 67.

114 SOVIET SISTERHOOD

39 *Vsegda s Vami* (Moscow, 1964), p. 17.
40 Ibid., p. 69.
41 Ibid., p. 45.
42 *Rabotnitsa*, no. 5 (1959).
43 S.V. Karavashkova, *Publitsicheskaya deyatelnost A.M. Kollontai, I.F. Armand, K.N. Samoilova* (Moscow, 1979), p. 52.
44 *Vsegda s Vami*, p. 47.
45 V.I. Lenin, *Polnoye Sobraniye Sochinenye*, vol. 5, p. 11.
46 *Vsegda s Vami*, p. 47.
47 *Sovietskaya Zhurnalistika, Istoiya, Traditsii, Opit* (Moscow, 1979), pp.80–5.
48 *Vsegda s Vami*, p. 39.
49 B.E. Clements, 'Bolshevik Women: The First Generation', in *Women in Eastern Europe and the Soviet Union*, ed. T. Yedlin (New York: Praeger, 1980), p. 60.
50 A.G. Kharchev and S.I. Golod, *Professionalnaya Rabota zhenshchin in sem'ya* (Leningrad, 1971); see also: E. Klopov and L. Klopov, *Man After Work* (Moscow, 1975).
51 L. Attwood and M. McAndrew, 'Women at Work in the USSR', in *Women at Work*, ed M.J. Davidson and C.L. Cooper (London: John Wiley and Sons, 1984), pp. 287–93.
52 Z.A. Yankova, 'Razvitiye Lichnostiye Zhenshchini v Sovietskom Obshestve in *Sotsiologicheskie Issledovaniya*, no. 4 (1975), pp. 42–51.
53 Personal Interview, November 1979.
54 Personal Interview, November 1979.
55 *Rabotnitsa*, no. 3 (1983).
56 G. Hollander, *Soviet Political Indoctrination* (New York: Praeger, 1972), p. 52.
57 N.M. Shishkan, *Trud Zhenshchin v Usloviyak Razvitogo Sotsialisma* (Kishenyev, 1976), p. 162.
58 Kharchev and Golod, *Professionalnaya Rabota*, p. 107.
59 E.P. Mickiewicz, *Media and the Russian Public* (New York: Praeger, 1981), p. 60.
60 Personal Interview with Zoya Timofyevna, editor of *Rabotnitsa*, May 1982, provides most of the background to the section on organisation of the magazine.
61 *Great Soviet Encyclopedia*, vol. 9, p. 344.
62 Ibid., p. 344.
63 *Spravochnik Zhurnalistika*, p. 590.
64 *Rabotnitsa*, no. 5 (1983).
65 *Rabotnitsa*, no. 8 (1983).
66 *Rabotnitsa*, no. 3 (1983).
67 *Rabotnitsa*, nos. 7, 9, 11 (1979); no. 3 (1982).
68 *Rabotnitsa*, no. 11 (1982).
69 *Rabotnitsa*, no. 3 (1982).
70 *Rabotnitsa*, no. 1 (1983).
71 *Rabotnitsa*, no. 6 (1983).

72 *Rabotnitsa*, no. 1 (1979).
73 *Rabotnitsa*, no. 1 (1983).
74 *Rabotnitsa*, no. 6 (1983).
75 *Krest'yanka*, nos. 1, 4 (1982).
76 *Krest'yanka*, nos. 1, 6 (1982).
77 *Rabotnitsa*, no. 10 (1983).
78 *Rabotnitsa*, no. 7 (1983).
79 *Rabotnitsa*, no. 6 (1983).
80 *Rabotnitsa*, no. 6 (1982).
81 *Rabotnitsa*, no. 2 (1978).
82 *Current Digest of the Soviet Press*, vol. 28, no. 15 (1976), p. 1; vol. 30, no. 19 (1978), p. 14.
83 *Krest'yanka*, no. 7 (1978).
84 R.D. Laird, J. Hajda and B. Laird, *The Future of Agriculture in the Soviet Union and Eastern Europe* (Colorado: Westview, 1977), p. 22.
85 G.W. Lapidus, *Women in Soviet Society* (Berkeley: University of California Press, 1978), p. 181.
86 N. Dodge, 'Recruitment and the Quality of the Soviet Agricultural Labour Force', in *The Soviet Rural Community*, ed. J.R. Millar (Chicago: University of Illinois Press, 1971).
87 Lapidus, *Women in Soviet Society*, p. 177.
88 1919 Program of the All Russian Party (Bolsheviks) in *Soviet Communism, Programs and Rules*, ed. J.F. Triska (San Francisco, 1963), p. 136.
89 Lapidus, *Women in Soviet Society* p. 99; *Narodnoe Khosyaistvo SSSR v 1979 g* (Moscow, 1980), pp. 391, 394.
90 M.G. Pankratova and Z.A. Yankova, 'Sovietskaya Zhenshchina, Sotsialnoe Portret', in *Sotsiologicheskie Issledovaniya*, no. 1 (1978), pp.19–29.
91 *Current Digest of the Soviet Press*, vol. 29, no. 29, p. 8.
92 A.E. Kotliar and S.Ya Turchaninova, 'The Educational and Occupational Skill Level of Industrial Workers' in *Women, Work and Family in the Soviet Union*, ed. G. Lapidus (New York: M.E. Sharpe 1982), pp.110, 102.
93 Yankova, 'Razvitie Lichnostie', p. 45.

4 WORKERS BY HAND AND WOMB: SOVIET WOMEN AND THE DEMOGRAPHIC CRISIS
Jo Peers

THE NUMBERS and distribution of the population in the USSR are officially viewed as resources to be applied to the needs of the state, rather than the other way round. If population trends are not in keeping with those essentially abstract 'needs', then the trends are perceived as a 'problem'. The 'demographic problem' which currently besets the Soviet Union is probably the major reason for the rekindling of the 'woman question' there in recent years. It is a problem, now reaching crisis proportions, which has its roots in economic factors, but also has social, political and even military implications, many of which lie beyond the scope of this chapter. The leadership has been slow to recognise and act against the worsening demographic situation, and still slower to pinpoint its root cause. It was not until the Twenty-fifth Party Congress (1976) that Brezhnev called for the formulation of a demographic policy, and not until the Twenty-sixth Congress in 1981 that he declared that such a policy should be implemented. This policy is aimed, among other things, at effecting a rise in the birthrate in most parts of the country, up to an 'optimum' level of two to three children per family.

Given this aim, the measures adopted so far can only be described as 'too little, too late'. They give no hint that any major social or economic change is planned and thus seem unlikely to have a major effect. A change in reproductive behaviour could best be achieved, in the Soviet context, by a complete reappraisal of prevailing gender roles, coupled with a very substantial reallocation of resources to public amenity provision. Such a radical solution, though, is apparently beyond the permitted bounds of official Soviet thinking. Given their blinkered view of possible policy options, the leadership now finds itself in an impossible position, wherein future, sustained economic performance can be truly secured only at the risk of jeopardising the economy in the near term.

The Soviet demographic crisis and the difficulties confronting the leadership in alleviating it are an eloquent expression of the contradictory nature of women's position in the Soviet Union. The crisis highlights the paradox wherein women, en masse, wield

immense economic and social power in the Soviet Union but remain with little control over their own lives, with economic and social odds stacked against them, and with little co-ordinated articulation of those disadvantages. This chapter aims to explore the enormous economic and social contributions made by women to Soviet power, and to explain the nature of the demographic crisis which has resulted from insufficient tangible recognition of and reward for those contributions by the Soviet authorities. It goes on to examine some of the measures recently put into force as part of the new demographic policy and considers the likely reactions of and consequences for Soviet women, both as individuals and as a group.

The Economic Contribution of Women

Throughout the 1970s, through to our present decade, a full 51 per cent of the Soviet workforce have been women. This figure ranged, in 1982, from a low of 39 per cent in the rural, Moslem Central Asian republic of Tadzhikistan to a high of 55 per cent in the highly urbanised and economically advanced Baltic republic of Latvia.[1] This very large percentage can, to some extent, be explained by the fact that females outnumber males quite considerably in the USSR. In 1982, they made up 53.2 per cent of the population. Again, this figure varies for the different republics, with the less urban, Moslem communities having a lower percentage of women, but in every area they form an overall majority. The terrible upheavals of the First World War, the revolution, the Civil War, the advent of Stalinism and then the Second World War are responsible for this imbalance. Throughout the first half of our century, this unending catalogue of dislocation, struggle and oppression took its toll of misery and deprivation from the whole Soviet population, but many more males than females actually perished. The proportion of females has been falling slowly since the 1950s, as the younger age groups have been allowed, at last, to raise their families in peace. But in 1959, in the Russian republic, there were only 58 males per 100 females in the prime 35–59 age group.[2] Such was the scale of the loss of male lives in this period. Today, there is a huge generation of aged widows and spinsters who lost or were never able to meet their partners. Women were needed, then, to take part in the Soviet economy because of this shortage of males and, as elsewhere, to run the backbone of the war effort when their men were at the front.

Also, and equally, we must look to the unparalleled industrialisation drives of the late 1920s and 1930s when the five-year plans

were launched and Stalin decided to build his 'socialism in one country'. These drives to develop the economy, with increasingly unrealistic targets for industrial expansion, meant that women were needed to enter the workforce in their hordes and to participate in this great effort. Russian women, as do their sisters the world over, had always worked on the land and in domestic service. But with the advent of this 'second revolution', women's employment outside the home took on a new magnitude. By 1929, 27 per cent of the workforce were women – a figure which rose to 30 per cent in 1930, 38 per cent in 1940 and to 55.3 per cent in 1945.

TABLE 1: Age and Sex-specific Participation Rates, 1959 and 1970

Age group	Female 1959	Female 1970	Male 1970
15–19	60.2	37.4	41.8
20–29	75.1	85.1	89.5
30–39	71.6	92.1	97.6
40–49	65.8	88.6	95.9
50–54	52.9	74.2	89.4
55–59	30.0	23.5[b]	79.5
60–69	18.2	7.8	29.5
TOTAL	60.2	65.0[a]	79.9

[a]	Official 1970 census figures give the total percentage of able-bodied women employed as 86 per cent. The total participation rate in the table is lower, as this gives figures for the age-range 15–70, rather than 16–54.
[b]	Retirement age is 60 for men, 55 for women in the USSR. This explains differences in the 55–59 age group, and much of the total variation in male/female participation rates.

Source: Alastair McAuley, *Women's Work and Wages in the USSR* (London: Allen and Unwin, 1981).

Finally, we should not entirely disregard the impact of the Soviet ideological commitment to maintaining high levels of female employment, as this was perceived as an 'automatic' route to the achievement of sexual equality. There was, for instance, another drive to get remaining women into the paid workforce under Khrushchev in the 1960s. The success of this and the extremely high participation of Soviet women in the workforce today are illustrated in Table 1. According to 1970 Soviet census figures, a

full 86 per cent of women of working age were in employment, and a further 7.5 per cent were studying. Table 1 also shows that, unlike women in the West, most Soviet women work throughout their lives and do not take a long break while their children are growing up. The average 'time out' taken by a Soviet women in 1970, from leaving education to retirement, was a mere 3.6 years.[3] The increasing importance of women's part-time work in Britain, in providing a major and constant source of family income, should not be underestimated. Even so, it should be stressed that the overwhelming majority of Soviet women workers are full time: working a 41-hour week.

By no means are these millions of women workers spread evenly throughout all sections of the economy. They are specifically barred from some areas of employment and have been unable to do underground manual work since 1957. Certain categories of particularly heavy and dangerous work are also closed to women, although many work in what might be considered 'dirty' or 'men's' jobs in the West. The majority of chemical and building material production workers are women, and over a quarter of construction workers are women (see Table 2). There are legal restrictions on maximum loads to be carried by women, and on night-time working, but it is doubtful whether these are strictly adhered to in practice.

TABLE 2: Changes in the Distribution of the Population of the USSR, and Percent Female, by Occupation, 1959 and 1970

Type of Employment	Whole pop. 1970 as % of 1959	Female pop. 1970 as % of 1959	% female 1959	% female 1970
Employed in mainly physical work	105	104	47	46
Mechanical engineering & metal workers	170	182	15	16
Chemical workers	176	176	58	58
Work in production of building materials, concrete, reinforced concrete, china, pottery articles	103	108	54	56
Woodworkers (joiners)	99.9	126	18	22
Paper and cardboard makers	131	132	64	65
Polygraphic workers	114	117	70	72
Textile workers	104	105	85	85
Sewing industry workers	142	147	90	93

Type of Employment	Whole pop. 1970 as % of 1959	Female pop. 1970 as % of 1959	% female 1959	% female 1970
Tanners (leather workers) & furriers	81	110	50	68
Shoe makers	95	132	39	54
Food industry workers	111	132	64	77
Agricultural occupations	67	64	58	56
Railway workers	83	91	31	34
Work in motor transport & city electric transport	184	138	6	4
Postal workers	146	168	73	84
Workers in trade & public catering	188	197	87	91
Communal-lighting service workers	100.3	118	67	79
Nurses, sick-nurse, nannies	179	181	97	98
Laboratory assistants	454	445	92	90
Inspectors, sorters, controllers	162	173	82	88
Store-keepers, weighers, examiners, dispensers	136	172	59	74
Construction workers (builders)	107	164	18	27
Employed in mainly brainwork (mental work)	163	184	52	59
Directors of state administrative organs & their structural subdivisions	86	128	26	32
Directors of enterprises & their structural subdivisions	143	182	13	16
Engineering & technical staff	209	230	40	44
Agronomists, zootechnicians, veterinary workers	131	137	34	36
Medical workers	161	160	89	89
Scientific workers, teachers, educators	175	179	67	89
Literature and press workers	137	159	46	53
Workers in cultural-instructive institutions	130	156	54	65
Art workers	144	151	31	33
Juridical personnel	138	159	33	38
Communication workers	126	134	78	83
Workers in trade, public catering, procurement, supply and sales	125	188	37	56
Planning and accounting workers	145	169	71	83
Workers in communal enterprises & everyday services	161	191	55	65
Typists & stenographers	189	188	99.4	99
Secretaries and clerks	157	164	91	95
Agents and forwarding agents	116	171	37	54

Source: N.M. Shishkan, *Trud Zhenshchin v Usloviakh Razvitogo Sotsializma* (Kishinev, 1976), pp. 109, 110.

Historically, women have tended to shift away from agricultural to industrial employment and from manual to white-collar work, but this reflects changes and developing employment opportunities in the Soviet economy generally. Women there, as in the West, are very heavily concentrated in services and in light industry and this, if anything, has become more pronounced over time. One set of statistics frequently quoted by the Soviet authorities is the percentage of female teachers and doctors in the USSR, which is very high by international standards. In 1981, 68 per cent of Soviet doctors were women, compared with just 7 per cent in the United States. However, this percentage has declined from a high of 77 per cent in 1950.[4] Women teachers in 1981–2 comprised 72 per cent of the total – a figure which has steadily increased through the years.[5] There has been some considerable disquiet expressed in the Soviet press about the 'feminisation' of this particular profession, as it is felt that growing Soviet boys should have greater access to male role-models at school, in order to instil in them good, manly attitudes.

Although statistically better than in the West, Soviet women remain badly underrepresented in top-level and managerial jobs, in relation to their participation in the workforce as a whole. In the teaching profession, for instance, women make up 77 per cent of primary school heads, but only 34 per cent of heads in secondary schools.[6] In 1981, only 14 per cent of those holding a 'Doctor of Science' degree (a super PhD) were women, and they are similarly underrepresented among senior academic staff. Table 2 shows that, of directors of enterprises and section heads in 1970, only 16 per cent were women: we may expect that the higher the level of responsibility involved, the less visible women will be. The number of women in trade and public catering involved in 'physical' work is given as 91 per cent, but those in the same section on the 'mental' work side (presumably, management and administration) is given as only 56 per cent.

These comparisons may seem surprising in light of the fact that women have, for over a decade, comprised 59 per cent of Soviet specialists with higher and special secondary education. The percentage of women students in higher education compares favourably with other countries, being 52.2 per cent for the USSR in 1981–2, compared with 42.4 per cent in Britain, 50 per cent in the USA and 22.4 per cent in Japan for the year 1978–9.[7] The overall difference in educational levels between men and women in the USSR is negligible, particularly among the younger age groups and in the developed regions. The problem is that this high level of

education and training among women is very often not reflected in their employment. Many Soviet women work in jobs for which they are overqualified. One Soviet study in the 1970s showed that 40 per cent of the sampled women with secondary specialised or higher education were employed in jobs which demanded little or no expertise, but this applied to only 6 per cent of the men in the survey. On the other hand, only 10 per cent of the women held highly skilled jobs, compared with 46 per cent of their male counterparts.[8]

While there is equal pay for equal work in the USSR, these differences in male and female employment mean that women overall take home less money than men, even when they might be more highly qualified. The peculiar development of the Soviet command economy, with its emphasis on heavy industrial expansion, has led to work in these basic economic sectors being rewarded more highly than in others. Some of these heavy and dangerous jobs are closed to women who are, in any case, concentrated in light industry and services. While jobs which require very high levels of skill and responsibility (where we have seen women to be largely absent) are paid well, general 'white-collar' occupations are often less well rewarded than heavy manual work. Teachers and doctors, although needing extensive training, are essentially non-productive workers, and thus not particularly well paid. Soviet women, for all their massive participation in the economy, for all the numbers involved and all the years they put in, earn only about 65 to 75 per cent as much as men. Their increasing concentration in service and light industries is only likely to exacerbate this.

The Social Contribution of Women

Unfortunately for Soviet women, their great movement into the paid labour force has not been matched by a corresponding decline in their responsibilities at home. The notion of the 'double shift' has received a great deal of publicity in both Soviet and Western studies in recent years.[9] Because of the relatively poor provision of consumer goods and services, and because men have failed to take over their fair share of housework and childcare, women are forced to spend almost the same amount of time on domestic as on paid work. Shortages of certain foods and provisions and long queues are an aspect of Soviet life which most Westerners are aware of. It is women who must stand in these queues and who must make efforts to plan and acquire daily meals, clothing and other family needs in the face of these difficulties.

Again, the emphasis placed on the development of heavy industry is largely responsible for these inadequacies, although there has been some realignment of priorities in recent years. The provision of consumer 'durables' such as fridges, washing machines and vacuum cleaners, for instance, has improved considerably. Even so, a Soviet study of 1975 estimates that only 66 per cent of Soviet families had washing machines and only half had fridges.[10] On the other hand, almost all Soviet homes have a television and a radio. There are launderettes and dry-cleaners, but they apparently offer a rather poor quality service and require a long wait before laundry is ready.

Childcare facilities are relatively comprehensive by international standards and the falling birthrates (see below) have made it easier to accommodate a large proportion of children in them. The Soviets readily admit, though, that there are not enough nurseries to meet the full need. Around 45 per cent of pre-school children (under-sevens) now have nursery school and kindergarten places. The majority of these institutions operate for five or six days a week and provide care for nine or twelve hours a day. There are a few which operate around the clock. In the countryside, though, many women can only find nursery places for their children in temporary schools which are set up at peak times in the seasonal agricultural cycle, when all hands are needed. Classes in these nurseries and kindergartens are large (25–35) and the standard of hygiene is often poor – sometimes resulting in frequent sickness and epidemics of contagious diseases among the children. Apparently, too, the staff in these institutions, who consist of poorly-paid middle-aged and elderly women, are often susceptible to corrupt practices, such as taking the children's food.[11] For these reasons, some mothers are reluctant to place their children in the nurseries. For these families, for those without kindergarten places or for those where the mother can't cope with everything on her own, the grandmother is frequently wheeled out to look after the children and stand in the queues.

What, we might ask, are the millions of Soviet husbands and fathers doing when they get home from work? The answer, sadly and predictably, is 'relatively little'. In addition to their working week of 41 hours, Soviet women spend an average of a full 40 hours per week on various domestic chores, although this time varies considerably with the level of service provision in the different parts of the country. Women may spend only 30 to 35 hours per week on housework in the towns and cities, but up to 55 hours in some rural areas where services are poor and families tend

to be larger. Men spend an average of only 15 to 20 hours on home-related work, and most of this involves doing small household repairs.[12] One extensive study of 2,500 working women in and around Moscow, where one might expect Soviet male attitudes to be among the most enlightened, found that husbands took *no* part in looking after children in 50.3 per cent of the sampled households. Similarly, 67.7 per cent did no cooking, 44.4 per cent no dishwashing, 65.8 per cent no everyday housekeeping, 83.9 percent no laundering and 65 per cent gave no assistance in shopping for small items.[13] As Table 3 shows, this imbalance leaves women with precious little leisure time, time to raise their self-awareness or participate in outside activities. The fact that single women spend a great deal more time on these leisurely pursuits shows the great additional burden which marriage and children place on Soviet women in terms of time and effort. For men, on the other hand, marriage makes little difference to their overall leisure time and, in some passive areas such as watching television and reading papers, actually seems to increase it. Men in young families tend to assume more equal responsibilities than their older and, perhaps, more traditional counterparts, but the level of education seems to make no difference. Whether he left school with few qualifications or stayed on and gained a degree, a Soviet man is likely, in married life, to remain a relative parasite within the home and to further his own education and enjoyment at the expense of his wife's. Only about one quarter of couples are reckoned to have adopted anything approaching equality in the home, and even this estimate applies only to families in large cities.[15]

The Demographic Crisis

Women's huge contribution to Soviet power, both in the work-force and in servicing the population at home, brings her unequal rewards in terms of money, time, status and political power. This is not, and has never been, properly recognised by the authorities. But the very fact that women *are* so indispensable, and have had to fashion their behaviour to accommodate their massive responsibility, has led to a situation which threatens the working of the Soviet system as it presently exists. The collective power of Soviet women has made its impact quietly and without organisation. It can no longer be ignored. The leadership has recognised the scope of this threat and many rightly see the root cause as being the unreasonable burdens placed upon the female sex. But the problem is officially conceived not as one of the inequality and shabby treatment of women in itself, but as an economic problem which has arisen

because of it. It is the economy and the need to achieve economic goals which has given rise to anxiety, not the plight of Soviet women.

TABLE 3: Time-budget Study on Housework and Leisure Activities, by Education, Sex and Marital Status (no. of hours and mins, per week)

| | Women | | | | Men | | | |
| | Married with children | | Single | | Married with children | | Single | |
	All workers	Highly educated workers	All workers	Highly educated workers	All workers	Highly educated workers	All workers	Highly educated workers
Housework	30.45	25.25	17.40	19.30	12.10	8.00	5.40	1.20
Self-education and raising one's cultural level, including:	8.20	10.20	21.35	25.45	20.10	26.40	25.30	33.20
reading newspapers	0.30	1.40	0.45	1.50	2.40	2.50	1.15	1.00
reading books and journals	1.10	0.55	4.35	4.20	1.50	2.50	3.35	5.30
watching television	4.10	2.35	2.15	2.05	9.40	6.55	4.35	1.45
public entertainment (movies, theatre)	0.35	1.00	3.20	3.30	0.35	1.00	2.55	6.25
amateur art	0.30	—	1.10	1.40	0.45	1.35	1.15	—
study	1.10	4.10	9.05	12.05	3.25	10.10	10.05	17.10
sport, excursions	0.15	—	0.30	0.25	1.20	1.20	1.55	1.30

Source: E.E.Gruzdeva, 'Osobennosti obraza zhizni "intelligentnykh rabochikh" ', *Rabochii klass i sovremennyi mir*, no. 2 (1975), 96.

There are real, but narrowly political reasons why the leadership should have such great regard to their own economic plans. In a centralised state, planned and administered by a single party which has not been voted in by the population, the ability of the leaders to secure sustained economic performance becomes one of the most important ways in which they can justify holding power. The impressive rates of economic development achieved since the onset of Soviet industrialisation have, in large measure, been made possible by the abundance of potential labour resources. Soviet

labour has, historically, been plentiful and extensively applied. But Soviet economic planners and administrators are today finding this vital commodity in increasingly short supply. This is particularly so in relation to the demand for labour in the resource-rich but remote and inhospitable regions of the far north, the far east and Siberia which have been earmarked for priority development in successive five-year plans.

The two labour pools traditionally drawn upon by the state, rural inhabitants and women, have now been virutally depleted. The out-migration of the young and skilled from many rural areas has been on such a scale as to cause labour supply problems in some parts of the countryside itself while, as we have seen, the great majority of women now work full time in the public sector, up to and beyond retirement age. In turn, these two developments (mass urbanisation and the widescale introduction of women into the state economy) have, along with other factors, had a great and depressing influence upon the other major source of labour supply: that is, upon natural population reproduction. Between 1951-8, the average annual population increase was 3.4 million people, or 1.8 per cent, but in the decade 1959-69 it was only 3.0 million (1.3 per cent) and for the years 1970-8 had fallen to 2.3 million, or just 0.9 per cent.

This fall in the natural population growth rates is, to some degree, due to a rise in the death rate. This has been caused largely by a simple 'ageing' of the population but also by rather substantial and alarming rises, in recent years, of the infant and adult (male) mortality rates. This has been put down to a range of factors, including alchoholism and environmental conditions.

The main reason for the falling growth rates, though, is the sharp decline in the Soviet birthrate which occurred in the 1960s after a postwar 'baby boom' in the previous decade. This decline was due, in part, to the fact that the smallish number of people born in the war-torn 1940s had entered their prime reproductive years (and, hence, there were fewer potential 'young mums'), but mainly because of a general transition to smaller family size. USSR total birth, death and natural growth rates are shown in Table 4. As can be seen, during the 1970s, the birthrate showed a slow and steady increase, but this was wholly the result of the relatively large number of people born in the 'baby boom' period of the 1950s reaching the ages of greatest fecundity. By the time of the 1979 census, this trend had already been reversed. This rise in the 1970s was not due to a desire or tendency to have more children per family.

TABLE 4: Birthrate, Deathrate and Natural Growth of the Population of the USSR (per 1,000 population)

Year	Births	Deaths	Natural growth
1913	45.5	29.1	16.4
1926	44.0	20.3	23.7
1940	31.2	18.0	13.2
1950	26.7	9.7	17.0
1960	24.9	7.1	17.8
1970	17.4	8.2	9.2
1971	17.8	8.2	9.6
1972	17.8	8.5	9.3
1973	17.6	8.7	8.9
1974	18.0	8.7	9.3
1975	18.1	9.3	8.8
1976	18.4	9.5	8.9
1979	18.2	10.1	8.1

Source: 1913–76: T.V. Ryabushkin, 'Dinamika i struktura, naseleniya SSSR', in Ryabushkin (ed), *Naselenie soyuznykh respublik* (Moscow, 1977), p.15. 1979: Ts. S. U. SSSR, *Narodnoe Khozyaistvo SSSR v 1979g* (Moscow, 1980), p.39.

In fact, Soviet sociological and statistical research indicates the emergence of a preference for rather smaller families in the 1970s. A recent survey of married women in the Russian republic revealed that the average number of children desired by women married in 1930-4 was 3.72. For those married in 1960-4, the figure was 2.39, while women married in 1970-2 desired an average of only 1.70 children.[16] Likewise, an examination of age-specific fertility rates, shown on Table 5, indicates that, in comparison with the previous decade, fewer Soviet women in the 1970s continued to bear children after the age of 30, when larger families can be built.

Around 80 per cent of today's Soviet population – the Russians, Ukrainians, Belorussians, Balts and Georgians – have now adopted this 'modern' reproductive behaviour, living mostly in nuclear families with only one or two children. This scale of childbirth is insufficient to secure even the simple replacement of the population, let alone the population expansion which the Soviet authorities think desirable. In the large 'European' cities in particular, over 90 per cent of families want only one or two children. According to data from the 1979 census, 25.2 per cent of women over 15 are childless, 22.9 per cent have only one and 25.3 per cent have two children. This, then, accounts for almost three-quarters of Soviet women over 15. Among married women, the respective percentages are 9.4 per cent, 27.8 per cent and 33.7 per cent, together comprising just under 71 per cent of all married women having two children or less.[17] The average family size in the USSR as a whole dropped from 3.7 persons in 1970 (3.5 in urban areas and 4.0 in rural areas) to just 3.5 persons in 1979 (3.3 in towns, 3.8 in the countryside).[18]

TABLE 5: No. of Births per 1,000 Women in Specific Age Groups, 1965–6 and 1974–5

Mother's age	1965–6	1974–5	1974–5 as % of 1965–6
20–24	159.6	176.8	111
25–29	136.0	133.5	98
30–34	97.0	77.9	80
35–39	50.6	42.7	84
40–44	19.1	14.4	75
45–49	4.4	1.8	44

Source: V. Perevedentsev, 'Estestvennyi v Sem'e', *Literaturnaya Gazeta* (16 March 1977), p.12.

Even this figure is somewhat inflated because, in some regions, women still tend to have very large families. The figure for the

main Russian republic is an average size of 3.3, and in the Baltic states of Latvia and Estonia, it is as low as 3.1.[19] The reproductive behaviour of the indigenous peoples of the less developed regions, particularly in the four Central Asian republics, has failed to reflect the changes undergone by the bulk of the population in the 1960s, and the birthrate there remains exceptionally high, as can be seen from Table 6. The huge increases in population are attributable almost entirely to the rural population where the indigenous people live. The cities in Central Asia are dominated by Russians and other 'European' settlers, but in the countryside people still retain a traditional, Moslem way of life. Women remain primarily concerned with home and family and are much less likely to work outside the home, except at peak periods like harvest time, and so on. The fact that the many European women in the Central Asian cities tend to adopt full-time employment like their Soviet sisters elsewhere disguises the full extent of the difference in lifestyles between Central Asian women and others. In the mid-1970s, for instance, the official figure for the percentage of women in the workforce in Turkmenistan was given as 40 per cent, now 41 per cent. But less than a third of that 40 per cent were actually Turkmenian women in July 1973.[20] According to a survey conducted in 1972, 58.8 per cent of Uzbek women wanted to have six children or more, compared with only 1 per cent of the Russian women surveyed. Only 5.4 per cent of Uzbeks wanted two children, compared with 52 per cent of the Russian women.[21] This desire for very large families is often translated into practice, and appears to be increasing over time. The average family size in rural Tadzhikistan rose from 6 in 1970 to 6.6 in 1979, while 15.8 per cent of families there consisted of ten or more people, compared with 8.2 per cent in 1970.[22] A total of 26.1 per cent of married women in Tadzhikistan had seven or more children in 1979.[22]

This high birthrate in Central Asia is coupled with a relatively low deathrate. Although infant mortality in Central Asia is considerably higher than elsewhere in the USSR, for 1979 there were just 7 deaths per 1,000 population in Uzbekistan, compared with 12.7 per 1,000 in Latvia and 10.1 for the USSR as a whole.[24] These figures compare with a deathrate of 11.9 per 1,000 in Britain and 8.7 per 1,000 in the USA for the same year. These very high birthrates and relatively low deathrates mean that the Central Asian population is rapidly growing 'younger', again in contrast to general trends in the USSR and to those in the 'European' parts in particular. In 1970, 47.1 per cent of the population of Uzbekistan was under 16, compared with 28.3 per cent in the Russian republic

and 23 per cent in Latvia.[25] In three out of the four Central Asian republics, the population has increased from between a quarter and a third during the nine-year gap between the Soviet censuses of 1970 and 1979. This 'population explosion' in the traditional Moslem regions, plus the fact that the peoples there are very reluctant to leave their culture and migrate to other regions of the USSR, adds a serious political (and even military) dimension to the demographic crisis, as the numerical weight and labour-force potential of the different nationalities and cultures changes.

TABLE 6: Birthrate, Deathrate and Natural Growth of the USSR Population, by Republic, 1940, 1965, 1970 and 1979 (per 1,000 Population)

Republic	1940			1965			1970			1979		
	Births	Deaths	Nat. growth	Births	Deaths	Nat. growth	Births	Deaths	Nat. growth	Births	Deaths	Nat. growth
USSR	31.2	18.0	13.2	18.4	7.3	11.1	17.4	8.2	9.2	18.2	10.1	8.1
RSFSR	33.0	20.6	12.4	15.7	7.6	8.1	14.6	8.7	5.9	15.8	10.8	5.0
Ukraine	27.3	14.3	13.0	15.3	7.6	7.7	15.2	8.8	6.4	14.7	11.1	3.6
Belorussia	26.8	13.1	13.7	17.9	6.8	11.1	16.2	7.6	8.6	15.8	9.5	6.3
Uzbekistan[a]	33.8	13.2	20.6	31.7	5.9	28.8	33.6	5.5	28.1	34.4	7.0	27.4
Kazakhstan	40.8	21.4	19.4	26.9	5.9	21.0	23.4	6.0	17.4	24.0	7.7	16.3
Georgia	27.4	8.8	18.6	21.2	7.0	14.2	19.2	7.3	11.9	17.9	8.3	9.6
Azerbaidzhan	29.4	14.7	14.7	36.6	6.4	30.2	29.2	6.7	22.5	25.2	7.1	18.1
Lithuania	23.0	13.0	10.0	18.1	7.9	10.2	17.6	8.9	8.7	15.2	10.2	5.0
Moldavia	26.6	16.9	9.7	20.4	6.2	14.2	19.4	7.4	12.0	20.2	10.5	9.7
Latvia	19.3	15.7	3.6	13.8	10.0	3.8	14.5	11.2	3.3	13.7	12.7	1.0
Kirgizia[a]	33.0	16.3	16.7	31.4	6.5	24.9	30.5	7.4	23.1	30.1	8.3	21.8
Tadzhikistan[a]	30.6	14.1	16.5	36.8	6.6	30.2	34.8	6.4	28.4	37.8	7.7	30.1
Armenia	41.2	13.8	27.4	28.6	5.7	22.9	22.1	5.1	17.0	22.9	5.6	17.3
Turkmenia[a]	36.9	19.5	17.4	37.2	7.0	30.2	35.2	6.6	28.6	34.9	7.6	27.3
Estonia	16.1	17.0	−0.9	14.6	10.5	4.1	15.8	11.1	4.7	14.9	12.3	2.6

[a] Central Asian Republics

Source: Ts. S.U. SSSR, *Narodnoe Khozyaistyo SSSR v 1979g* (Moscow 1980), pp.38–9.

The effects of the Soviet population's adjustment to these new norms of reproductive behaviour will manifest themselves most keenly in the present decade and beyond. During the course of the 1980s, the small number of people born in the 1960s will not only be entering their prime reproductive years, but also taking up their places in the workforce. There are not enough of them to go round. Meanwhile, the relatively large generation born in the 1920s is now reaching retirement age, taking valuable labour power out of the economy and adding to the 'demographic load' of dependency upon the dwindling proportion of working-age citizens. How are the Soviet leaders attempting to counteract the effects of these demographic pressures upon the economy, and how will those attempts affect the principles and realities of women's position in the USSR?

Although labour shortages can, to some extent, be offset by improved productivity and technological advances, the Soviets have not had great success in securing such qualitative change. In the period of the tenth five-year plan (1976–80), officially dubbed the 'plan of quality and productivity,' only half the scheduled labour productivity increase was achieved (17 per cent as opposed to 30–34 per cent).[26] Brezhnev's call for the formulation of a 'comprehensive' demographic policy at the Twenty-fifth Congress in 1976, and for its implementation at the Twenty-sixth Congress in 1981, indicates that the Soviet leadership regard a rise in the birthrate, along with certain other factors such as rationalising migration flows, as an important prerequisite for further economic development. As mentioned earlier, evidence suggests that this new Soviet population policy aims to achieve a so-called 'optimum' population reproduction rate, which has been set at two or, preferably, three children per family, throughout the USSR. What are the measures currently being formulated and implemented, and how are they likely to affect the position of women in the USSR?

The Demographic Policy
'Strengthening the Family'
One area isolated by Soviet demographers as a factor contributing to falling birthrates has been rising divorce rates. Around one marriage in three now ends in divorce in the USSR, and the proportion in major cities is substantially higher (see Table 7). Urban areas generally have higher divorce rates, throughout the USSR. The 1979 census showed that, of the population aged over 16, 70.1 per cent of men in towns were married, compared with 71.8 per cent of men in the countryside. The figures for women are

only 57.7 per cent and 58.5 per cent, respectively. Far more women than men were widowed: 19 per cent as opposed to only 2 per cent of men over 16. This is partly due to the ravaging effects of Soviet history, as discussed above, but also because women generally tend to live much longer. The average life expectancy is around 74 for women, but only 64 for men. Some 24.1 per cent of urban men over 16 had never married, compared with 17.6 per cent of urban women. A total of 7.9 per cent of urban women over 16 were divorced or separated in 1979, compared with 3.8 per cent of men.[27] These figures indicate that far fewer women than men are actually married, and that women seem less keen to re-marry on divorce. A full one third of divorces in 1976 were the result of marriages of less than one year's duration, while another third were obtained by couples who had been married from between one to five years. Among the causes of rising divorce rates can be cited the generally higher expectations of marriage which accompany the increase in educational levels and social development; the enduringly unequal burden of women in the home; alchoholism and the related behaviour of men; the general relaxation of social and sexual mores; and the correction, in the younger age groups, of the population imbalance which, throughout the troubled history of the USSR, has made potential husbands relatively scarce. People are also tending to get married earlier than in the past, which may be attributable to the decision, in 1967, to decrease the duration of national service. Men now return to civilian life at the age of 20 instead of 22, as before. A total of 33.2 per cent of women marrying for the first time were under 20 in 1978, compared with 25.6 per cent in 1966.[28]

TABLE 7: Divorce per 100 Marriages

	1950	1960	1963	1971	1974
USSR	3.4	10.7	14.3	27.0	28.5
Moscow	13.5	27.6	33.3	47.0	46.0
Leningrad	10.7	21.9	30.6	43.0	44.0

Source: 1950–71: Jeff Chinn, *Manipulating Soviet Population Resources* (Macmillan, 1977), p.114, 1974; G. Naan, 'On'ona, i vtoroi zakon terodinamiki', *Liturnaya Gazeta* (15 Sept 1976), p.12.

Initially, liberal divorce proceedings (instituted in the 1918 Family Code) were made much more complex legally and more expensive in 1936 and 1944 but, since 1968, divorce has once again been made easier. Today, a couple who mutually agree to divorce and have no minor children can simply obtain a divorce certificate from their local registry office (*ZAGS*) at a charge of 50 roubles. When one partner contests the divorce, or when children are involved, the dispute must go to a court which can try to reconcile the couple and postpone the proceedings for up to six months in order that a reconciliation may be attempted. Although a man may not divorce his wife without her consent while she is pregnant or has a child under one year old, a marriage may otherwise be dissolved if and when it has been established by the court that 'the spouses' further living together and the preservation of the family has become impossible.'[29] As a large majority of divorce suits are initiated by women, a tightening of divorce proceedings could substantially affect their position as marriage partners. No serious, widespread discussion of such a move has been initiated, though. There have been arguments raised to the effect that judges should use their powers of effecting reconciliation more widely, but a recent survey revealed that such measures were taken in only 8 per cent of cases.[30] As is characteristic of post-Krushchevian policies orientated towards influencing the life-decisions of Soviet citizens, positive inducements for getting and staying married, rather than sanctions against divorce, have been the order of the day. So-called 'family services', such as marriage guidance bureaux, consultancies for sexual problems and 'young marrieds' clubs, as well as dating bureaux and 'singles' meeting clubs have been set up in some major European cities. With a similar aim in mind, the Small Family Tax, set at 6 per cent of total income and levied, since 1941, on all men aged 20 to 50 and married women aged 20 to 45 who do not have children, has been waived, in a decree of March 1981, for couples in their first year of married life. With so many marriages breaking up at a very early stage, this latter measure has been introduced in the hope that greater financial security at the inception of a marriage will help to hold it together until children can be produced. Young couples with children have also been given priority for state housing in some cities.

There has been no major consideration given to the possibility of tightening the present abortion laws, which were liberalised in a decree of 1955, after abortion was prohibited by Stalin in 1936 on all but the most rigid medical grounds. There have been suggestions that women should, as far as possible, be dissuaded from

terminating a first pregnancy, but the most prolific and prestigious anti-abortionist, Boris Urlanis, died in 1981. Abortion is available, to all intents and purposes, on demand, for a small fee. According to an article in the Soviet 'feminist' dissident journal, *Almanac*, the conditions in abortion clinics are extremely inhumane – staff are often unsympathetic, there is an appalling lack of privacy and anaesthetics are either not used at all, or the dose is too small to have any effect. Abortion remains the primary form of birth control, however, and Soviet women are obviously prepared to go through this ordeal several times during their reproductive lives, in order to control family size. Despite inconclusive evidence that repeated abortion may be instrumental in increasing infant mortality rates (quite apart from its effects on women's health), there has been no determined and coordinated effort to increase the range and supply of alternative contraceptive measures.

Easing the 'Double Shift'
The press and politicians' speeches are full of proclamations about the need to improve the supply of consumer goods and services in order to ease women's 'double burden'. Brezhnev, in his speech to the Twenty-sixth Party Congress in February 1981 spoke, in the part of his speech concerning demographic policy, of the need for 'the extension and improvement of the network of pre-school institutions . . . and all everyday services'. Even so, he warned that 'we cannot do everything overnight'.[31] There have been some improvements in the supply of these services, goods and appliances. The improvement of consumer durable provision has already been mentioned. Efforts have been made, too, to set up food-selling stalls at the workplace and to improve the supply of pre-prepared and ready-to-cook food. They have begun to import 'TV dinners' from Finland. Despite this, the Soviet commitment to increase and improve the supply of consumer goods and services has been largely rhetorical, and the advances made have been mostly confined to the large cities.

While women wait for their double shift to be relieved by the development of these services, there seems little apparent effort to induce greater domestic responsibility among males or other members of the family. Although a number of specialists have advocated the desirability of such a development in scholarly journals, the popular press seems, to say the least, half-hearted in attempting to redefine sex-role stereotypes. Such attempts as are made, are couched in terms unlikely to develop genuinely egalitarian attitudes. As one recent press article stated, involving men in

domestic chores 'gives the woman time for rest and development, helps her to preserve her youth and attractiveness, helps prevent her turning from a princess into a Cinderella, from a dove into a hen'.[32]

Employment Legislation and Welfare Benefits

Measures have also been taken to ease the arduous life of Soviet women in their capacity as workers. In addition to the large body of 'protective' legislation built up since the 1930s, further restrictions have recently been made. From 1 January 1981, 460 occupations were closed to women on the grounds that they were harmful to their health. These include arduous jobs in construction, metals and chemicals and driving large vehicles. Although such work is undoubtedly often hazardous and injurious to health, these restrictions are likely to lead to a greater sexual division of labour within the Soviet economy. It is, of course, impossible for large numbers of women to withdraw from the workforce to raise larger families, as they play such an enormous and important part in keeping the economy going.

Since the 1960s, Proposals have been made for the introduction of part-time and flexi-time work for mothers with small children, but the suggestions have received increasing attention in recent years. Only about 0.5 to 1 per cent of the workforce are currently engaged in such schemes, although Brezhnev indicated, at the Twenty-sixth Congress, that such practices should be extended as part of a demographic policy aimed at helping women to combine work and childrearing responsibilities. Again, such a step would mean a substantial loss of wages for women, as well as acting as a brake on promotion prospects. There has been no discussion of extending the availability of part-time work to men in order that they may take a greater part in home and family life.

A major decree of March 1981 was issued 'on measures for strengthening state help to families with children'. One measure contained in this decree is the introduction of partially paid leave for working mothers in order to care for their child until it reaches the age of one, with the option of taking an extra six months unpaid leave, without loss of job or service record. Previously, a Soviet woman received 56 days paid maternity leave before and after giving birth, with the option of taking up to a year's *unpaid* leave. The amount of payment is set at 50 roubles per month in the far east, Siberia and the Northern regions of the USSR, and at 35 roubles elsewhere – i.e. at 50 per cent of the *minimum* wage in the respective parts of the country. The leave is not compulsory, but it

is likely that many women will opt for it, given the pressures they currently face. Again, there is no hint of an introduction of paternity leave, on these or any other grounds: an omission which reinforces the official Soviet premise that childrearing is women's exclusive responsibility.

TABLE 8: Graded State Child Allowances, Payments System, 1948 and 1981 (roubles)

Payment due to mother of	Lump-sum payment from 1948–81 (at birth)	Lump-sum payment from 1981 (at birth)	Monthly allowance (paid when child is aged from 1–5 years) from 1948
1st child	0	50	0
2nd child	0	100	0
3rd child	20	100	0
4th child	65	65	4
5th child	85	85	6
6th child	100	100	7
7th child	125	125	10
8th child	125	125	10
9th child	175	175	12.50
10th child	175	175	12.50
each subsequent child	250	250	15

Source: For 1948 payments: *Soviet Legislation on Women's Rights* (Moscow, 1978), p.134.

Another provision in the same decree introduced a lump sum payment of 50 roubles on the birth of a first child, and 100 roubles on the birth of the second and third, with the retention of existing levels of payment for the fourth and subsequent children. The provision of state payments is shown in Table 8. As can be seen, a mother now receives a greater sum at the birth of her second and third children, than at the birth of her fourth and fifth. This is clearly an attempt to encourage 'optimal' population reproduction

– i.e. to stimulate the birthrate in the direction of the all-important three-child family in those 'European' areas of the country where it is considered too low, without overtly discriminating against the populations of the Caucasus and Central Asia, where fertility is so high as to prove disquieting to the authorities. Given the scale of the payments, however, it seems unlikely that they will be sufficient to influence significantly the birthrate in either case.

Single Mothers

Although the rather meagre monthly allowances paid to mothers for the fourth and subsequent children have not been increased in this decree (see Table 8), it did contain very significant increases in the monthly allowances for single mothers. Since 1948, single mothers have been granted monthly allowances of 5, 7.5 and 10 roubles for the first, second and third child, respectively, until the child's twelfth birthday. Under the new provisions, a single mother receives 20 roubles per month, per child, until it is 16. These allowances are not for children of dissolved marriages (alimony and social security exist for these), but for illegitimate children. Around one in six or seven families is headed by a single parent, where the mother is divorced, widowed or unmarried. Attitudes to unmarried mothers and their offspring have had a chequered history. In 1944, in an attempt to 'strengthen the family' and increase the birthrate, unmarried mothers lost the right to establish paternity, even if it was voluntarily acknowledged by the father, and the space for the father's name on the child's birth certificate was left blank. This, it should be remembered, was coupled with a ban on all non-medical abortions, and the introduction of small allowances for unmarried mothers, or the option of placing the child in a state institution at no expense.[33] Since 1968, fathers of children born out of wedlock can voluntarily acknowledge paternity, or it may be established by a court if the mother can prove she was cohabiting with the father at the time of conception, that they jointly supported the child, or that paternity was irrefutably acknowedged by the father at an earlier date. Although abortion is now available again, the new and relatively generous monthly allowance may be interpreted as an attempt, if not to encourage, then to facilitate the bearing and raising of more children by single mothers. The late Boris Urlanis, the prominent and extreme pro-natalist mentioned earlier, argued vehemently that unmarried women should be discouraged from having abortions, and that every material assistance should be offered them, in an attempt to improve the demographic situation.[34]

Ideological Work

The Soviet popular press in the European parts of the country gives over a great deal of space to the examination and discussion of the problems arising from population trends. The two–three-child family is advocated very vigorously, and a spate of articles on the undesirability of having only one child has appeared in recent years. These are couched in terms which suggest that one-child families cause problems both for the development of the child's personality – it will grow up into an egoist – and for harmonious family relations – the parents become dependent on their love for the child, having more children helps keep a family together, and so on. On a research visit to Leningrad in 1981, I was left with the impression that there exists a very wide awareness of these topics among the general population, and that the urging of the authorities for larger families has made itself clear to most people. The father of a newly-born child joked: 'You see? I'm obeying the government!', and a professional woman, when asked if she had any children replied with a smile: 'Just the one, I'm afraid. I'm a bad citizen!'

There are also great attempts to elevate and bolster the family as the 'basic cell' of society; to enhance the appeal of traditional roles and behaviour. Official thinking stresses the need for women's all-round personality development, but has very rigid and traditional ideas about what that personality should be:

A woman only shows her worth, her essence, when she, alongside participating in production and socio-political activities, also fulfils her social role in the family, connected with the specific character of her sex. The character and structure of a woman's personality will be incomplete if she abstracts herself from her family functions, and especially from the function of maternity.[35]

Again:

The process of the harmonious development of a woman's personality presupposes not only her participation in creative labour, but also the cultivating of typically female traits of character such as pride, virtue, maternal care for near and dear ones, gentleness, etc.[36]

This attempt to reinforce traditional sex-role stereotypes has also been extended to men. Alarm has been expressed over the so-called

'feminisation' of men which, as mentioned above, is often blamed on the domination by women of the teaching profession.

Parents are advised to counteract such tendencies from an early age. As one author, a woman, writes:

> Attitudes towards a boy in the family should be stricter than towards a girl, the demand on his physical strength, towards displays of bravery and decisiveness – higher; the criticism of his defeats and failures – sharper. Even the food of a boy from the age of fourteen or even earlier should have a specific character – less sweet things and porridge, more meat. His bed should be harder, the caresses of the mother more restrained, the gaze of the father firmer, the punishment more severe . . .Girls need individual attention, tender and warm relations on the part of the parents. In bringing up a girl, parents should bear in mind that, in the future, this girl will be a woman, a mother. In bringing up a boy, the parents should not forget that in the future this boy will be a man, a husband, a father, the head of the family.[37]

In Soviet Central Asia, where divorce is rare and the birthrate is considered too high, this sort of propaganda is largely absent. Soviet specialists from all regions of the USSR recognise that large families are a deeply entrenched and long-standing element in Central Asian culture, which is deeply respected in the more tradition-bound rural areas. Perhaps because the achievement of 'optimal' levels of reproduction among the Central Asian populations is a rather politically sensitive topic, there is little attempt directly to influence reproductive behaviour there. Despite the fact that Central Asian scholarly journals are full of material on local population problems, the popular media are generally silent on demographic issues. This author's examination of the main Turkmenian newspaper, *Turkmenskaya Iskra*, from 1976 to mid-1979, found only one article on the subject (apart from a few statistical tables), in the entire period under review.[38] On the other hand, the Central Asian press gives great attention to encouraging women to take outside employment, to increase their qualifications and to turn their backs on the cultural and religious attitudes surrounding family life. This difference in ideological work in the two cultures indicates a certain cynicism by the authorities in all their apparent, paternal concern for women's psychological well-being. Again, it seems, the 'needs' of the Soviet state are paramount when it comes to moulding attitudes.

Conclusion

How might we expect Soviet women to react to these material and moral appeals to alter their reproductive behaviour? Evidence suggests, first of all, that for most women, work in the public sector has become an important and valued aspect of their lives, despite the fact that they are concentrated in low-status, poorly-paid employment. A recent investigation of 10,000 industrial women workers found that 80 per cent of the respondents said they would not give up work, even if their husbands earned a sum equivalent to their family's combined income.[39] They are unlikely, therefore, willingly to leave the paid workforce in large numbers, even if the economy could stand it at some future date. On the other hand, other attitude surveys (including Table 9) have suggested that women in the 'European' regions, whatever their education or income, tend to desire more children, given ideal conditions, than they actually expect to bear. It should be borne in mind, though, that in most cases even the women's ideal falls below the three-child level which the authorities consider optimal. Surveys among Soviet men also show that they, like their leaders, would ideally prefer larger families than their womenfolk.

Most Soviet women will probably welcome the new welfare benefits and the opportunity to take partially paid maternity leave. Soviet surveys report a generally positive response among women with regard to the desirability of increasing opportunities for part-time and flexi-time work. The latest employment restrictions and the persistent, rigorous sexual stereotyping are also not likely, on the whole, to engender great bitterness. After years of stringent sacrifice, heavy labour and material deprivation, borne stoically by many Soviet women in their contribution to building Soviet power, many of them apparently feel able, at last, to 'indulge' their 'femininity'. The last decade or so has seen a slow but steady rise in wages, an improvement in conditions and the expansion of public service and consumer good provision. But there is still a huge demand for the non-essential consumer trappings of life. While Western feminists may see little validity in such demand in their own culture, it seems eminently reasonable that Soviet women should view and look forward to the coming of a less ascetic life with enthusiasm.

Despite Soviet women's apparently diminishing satisfaction with marriage, and copious complaints in the media about the 'unfemi-nine' behaviour of women, many continue to place the demands of home and family before those of career and, indeed, of personal development.

TABLE 9: Women's Opinions on the Number of Children in the Family, by Education, Income per Family Member and Nationality

Education	Average ideal no. of children Nationality groups[a]		Average expected no. of children Nationality groups[a]	
	I–III	IV	I–III	IV
Primary & lower	2.86	6.98	2.58	7.28
Incomplete secondary	2.72	6.24	2.24	6.52
Secondary & secondary specialist	2.59	5.23	1.98	5.26
Higher & incomplete higher	2.56	4.36	1.86	4.11
Income Groups (per family member)				
I	3.11	6.87	3.10	7.27
II	2.83	5.43	2.45	5.37
III	2.64	4.65	2.08	4.45
IV	2.54	3.87	1.87	3.59
V	2.68	4.00	1.82	3.45
Average	2.68	6.05	2.16	6.24

[a] Group I: Russians; Group II: Ukrainians, Belorussians, Moldavians; Group III: Latvians, Estonians, Lithuanians; Group IV: Uzbeks, Kazakhs, Kirghiz, Tadzhiks, Turkmen and Azerbaidzhanis.

Source: V.A. Borisov, *Perspektivy Rozhdaemosti* (Moscow, 1976), p.161.

Perhaps the most distressing factor is a seeming lack of sympathy and cohesion among women themselves. Women are not at all prominent at the higher levels of the political and economic hierarchy, so have little say in major policy issues. But they make up a full third of the primary party organisation First Secretaries,

and those with a career in the party apparatus tend to be concentrated in the sphere of ideology and culture where one might expect any commitment to the cause of female solidarity and liberation to be put to good use. The vast majority of teachers, again with a strong potential socialising influence, are women, as are the unsympathetic personnel in the abortion clinics, in kindergartens and other service enterprises. One point which comes over strongly in the 'feminist' *Almanac* of 1979, the first dissident publication written 'for women about women'[40] is that many Soviet women feel pessimistic about their own lives and disdainful of other members of their sex.

In the absence of the growth of solidarity and cooperation among women to fight patriarchal attitudes at the grass-roots level, the effects of official measures aimed at satisfying the demographic 'needs' of the Soviet state are likely to have a negative influence on the position of women in the USSR. Even though positive inducements, rather than sanctions, are being developed in an attempt to influence reproductive behaviour, the bulk of these measures are aimed at facilitating women's fulfilment of their multiple roles, rather than changing present sexual divisions of labour and behaviour. Although women, as the producers of an essential commodity − labour − may, by their present behaviour, force the authorities to change their economic priorities somewhat, this may not be an entirely positive development as far as women are concerned.

It has sometimes been stated that, in the Soviet context, the broad extension of consumer goods production and of public services and utilities is a feminist issue. Such extension would certainly be beneficial to women in allowing them more time to relax, more hours to sleep. But, in the presence of more 'protective' legislation banning women from alternative fields of employment, and the extension of opportunities for part-time work to which the service industries are most amenable, it would be *women* who would take up employment in the new enterprises. This would lead to a greater sexual division of labour in the state economy and a greater concentration of women in light industry and services. Given prevailing Soviet economic values and priorities, this would amount to nothing less than a ghettoising of female employment, whereby they would continue to fulfil the role of 'servicers' of the population, albeit in the capacity of workers, rather than housewives. Such a development, especially if accompanied by the widespread introduction of part-time work, would lead to the greater economic dependence of women, poorer promotion pros-

pects, wider wage differentials between women and men and, of course, a lesser likelihood of more women achieving real, political power, concentrated, as they would be, in low-status, low-priority, non-productive sectors.

Notes and References

1 *Vestnik statistiki*, no. 1 (1983), p. 71.
2 Michael Paul Sacks, *Women's Work in Soviet Russia* (New York: Praeger, 1976), p. 28.
3 A.E. Kotlyar and S. Ya Turchaninova, *Zanyatost' zhenshchin v proizvodstve* (Moscow, 1975), pp. 106−7.
4 *Vestnik statistiki*, no. 1 (1983), p. 73.
5 Ibid.
6 Ibid.
7 Ibid., p. 74.
8 E.E. Gruzdeva, 'Osobennosti obraza zhizni intelligentnykh rabochikh', *Rabochii Klass i Sovremennyi Mir*, no. 2 (1975), p. 94.
9 For a more detailed discussion see, for instance, G.W. Lapidus, *Women in Soviet Society* (Berkeley: University of California Press, 1978); M. McAndrew and J. Peers, 'The New Soviet Woman?' *Change International Reports*, no. 3 (London, 1981).
10 *Soviet Woman* (Moscow, 1975), p. 125.
11 See, for instance, V. Golubeva, 'The Other Side of the Medal', *Almanac for Women About Women* (London: Sheba Feminist Publishers, 1980), p. 54.
12 Y. Ryurikov, 'Zolushli i koroli', *Trud* (23 Oct. 1976), p. 4.
13 Calculated from data in *Soviet Women*, p. 139.
14 Cited in G.W. Lapidus, *Women in Soviet Society*, pp. 272−3.
15 Y. Ryurikov, 'Zolushli i koroli'.
16 *Skol'ko detei budet v sovetskoi sem'e* (Moscow, 1977), p. 102.
17 'Vsesoyuznaya perepis' naseleniya', *Vestnik statistiki*, no. 1 (1982), pp. 64−5.
18 Volodarski, 'Our Soviet People', *Ekonomicheskaya Gazeta*, no. 7 (Feb 1980), Trans in *CDSP*, vol. 32, no. 7, p. 13.
19 'Vsesoyuznaya perepis' naseleniya', *Vestnik statistiki*, no. 12 (1980), pp. 59−60.
20 M.O. Orazgel'dyev, 'Turkmenskaya SSR', in T.V. Ryabushkin (ed), *Naselenie soyuznykh respublik* (Moscow, 1977), p. 290.
21 *Skol'ko detei budet v sovetskoi sem'e*, p. 27.
22 'Vsesoyuznaya perepis' naseleniya', *Vestnik statistiki*, no. 12 (1980), 64.

23 'Vsesoyuznaya perepis' naseleniya', *Vestnik statistiki*, no. 1 (1982), p.64.
24 Ts.S.U. SSSR, *Narodnoe Khozyaistvo SSSR v 1979g* (Moscow, 1980), p. 39.
25 Figure for Uzbekistan: R.A. Ubaidullaeva and R. Kh. Shadiov, in Ryabushkin, *Naselenie Soyuznykh respublik*, p. 106. Figure for RSFSR: L.D. Shorotupova, in Ryabushkin, ibid., p. 46. Figure for Latvia: Ya. Yu. Rudzat and E.K. Vitolin, in Ryabushkin, ibid., p. 126.
26 Ann Helgeson, *Soviet Demographic Policy for the 1980s*, CREES study paper (University of Birmingham, November 1982).
27 'Vsesoyuznaya perepis' naseleniya', *Vestnik statistiki*, no. 12 (1980), p.58.
28 A. Ya. Kvasha, *Demograficheskaya politika v SSSR*, (Moscow, 1981), p.54.
29 *Grazhdan'ski kodeks RSFSR . . . Kodeks o brake i sem'e RSFSR* (Moscow, Yurid, lit., 1979), pp. 237−8.
30 A. Dem'yanenko, 'Rol' suda v ukreplenii semeinykh otnoshenii', *Sotsialisticheskaya Zakonnost*, no. 4 (1981), p. 20.
31 L.I. Brezhnev, *Report of the Central Committee of the CPSU to the XXVIth Congress of the CPSU and the Immediate Tasks of the Party in Home and Foreign Policy* (Moscow 1, 1981), p. 73.
32 Y. Ryurikov, 'Zolushli i koroli'.
33 For a broader discussion of this and other, related legislation, see Peter H. Juviler, 'Women and Sex in Soviet Law', in D. Atkinson et al., *Women in Russia* (Sussex: Harvester Press, 1978), pp. 243−65.
34 See B. Urlanis, 'Zhelannyi rebenok', *Nedelya*, no. 49 (1980), p. 16.
35 D.I. Pomonarev, 'Rost sotsial'no-ekonomicheskoi aktivnosti zhenshchin i demograficheskaya politika', *Upravlenie, lichnost', Kollektiv, Obshchestvo*, no. 2 (1979), p. 114.
36 *Soviet Women*, p. 180.
37 V.A. Grigorova, 'Pedagogicheskie aspekty polovogo vospitaniya', *Sbornik studenticheskikh nauchnykh rabot*, Blagoveshchenskogo gos. ped. in-ta, issue 11 (1974), p. 91.
38 See J. Peers, 'Towards a Demographic Policy in the USSR: a Comparative Examination of Ideological Work concerning Women and the Family', unpublished MA dissertation, University of Essex, Oct. 1979, ch. 4.
39 E. Mikhailovskaya, 'O podlinnom ravnopravii', *Gudok* (8 March 1979), p. 2.
40 *Almanac for Women about Women* (London: Sheba Feminist Publications, 1980).

5 MATERNITY CARE IN THE SOVIET UNION
Barbara Holland and Teresa McKevitt

Introduction

Reality turned out to be inescapable. You might find the door open but there was no way you could run from your burden. Inescapable, it was inside you. You fell into complete dependence on those whom you at first despised — they did stupid crosswords — on those whom you then began to hate — they talked of something else while women cried in terror. They, only they, could offer you an escape. But the escape which you needed was not their escape. They jabbed and jabbed and jabbed you, until your body, your organism, ceased to obey you. It submitted to them, to their needle, thrusting over and over again into your skin. Convulsions forced a howl from your lips, but you could change nothing. Even if you were a genius, you would still be in constant risk of having your personality crushed.[1]

Childbirth as described by one of the Russian feminists writing in the underground *Almanac*, produced in Leningrad in 1979. She is full of anger that in the midst of pain and fear women are offered no comfort, that when the doctors are reproached for the lack of sympathy they only mutter 'We have enough work as it is . . . Forget the philosophy. Lie down and get on with it.' This experience becomes for her the epitome of female oppression in a patriarchal society — despite the fact that in the Soviet Union the majority of doctors are women.

The aim of this chapter is to describe Soviet care of pregnancy and childbirth. While acknowledging its achievements, we want to examine it from the viewpoint of women, to see to what extent they have benefited from Soviet policies and from a feminised medical profession.

When the Bolsheviks came to power in 1917 they had a radical commitment to improving the lives of women, which involved a clear recognition of the importance of maternity. As Alexandra Kollontai wrote, 'Soviet workers' Russia is the first Republic in the world, to recognise motherhood as a social, and not a private family responsibility.'[2]

There was grave concern about the high levels of maternal and

infant mortality. Some 30,000 women died every year in child-
birth; more than a quarter of the babies born died before they were
a year old, and nearly half before the age of five. It was a major
political goal of the new government to reduce this suffering. Even
in the midst of Civil War, campaigns were launched to eliminate
infectious diseases, to bring sanitation to working-class areas, and
to educate people about the importance of hygiene. Plans were
made for the mass provision of medical care to women during
pregnancy and childbirth.

The achievements of the Soviet government were remarkable.
By 1925 infant mortality in the cities was nearly half the 1914 level[3]
and a large network of women's clinics had been set up. These
results are a demonstration of how effective social planning and
determined collective effort can be. Nowadays the Soviet Union
has an infant mortality rate of around 30 per 1,000 births and a
maternal mortality rate of 2 to 3 per 10,000.[4] If it is compared with
countries like India, where 122 out of every 1,000 infants die, and
37 out of every 10,000 women giving birth, it may seem churlish to
complain about insensitive doctors, or reliance on drugs and
technology.[5] Life and safety must come first.

But the quality of maternity care does matter, for the following
reasons. First, the Soviet medical system is producing almost as
many problems as it solves. The state of female health is poor[6] and
women do not feel in control of their bodies; the infant mortality
rate may be low, but in contrast to other industrial countries it is on
the increase.[7] Secondly, women are isolated and deprived of each
other's help during childbirth, and the months of caring for a new
baby. This not only contributes to the problem of infant deaths,
but also undermines female networks of support. Thirdly, it is our
view that to win popular support, especially as a model for
developed Western societies, a planned economy must be able to
take account of the needs of the individual.

It is only in recent years that women in the West have begun to
discuss what they consider their needs to be during pregnancy and
childbirth. While the discussion continues, many now feel that
there must be recognition of the significance of birth as a social
event, and that there must be respect for the wishes of women who
want to stay in control of their labour, and give birth with the
minimum of medical assistance. At the moment the medical
profession ignores such wishes and implies that women are putting
their own interests before those of the baby, and are being selfish
and irresponsible. This view fails to recognise that women are
equally committed to a safe delivery, and that they have knowledge

about their bodies which is not accessible to the professionals, but which can help guide pregnancy and assist labour. Ideally, modern medicine should encourage women to use this knowledge, and at the same time, should give them detailed information about current medical practices (for example, technology, drugs, delivery positions) about which they can then make a genuine choice. It can also provide a back-up service for medical emergencies.

Although there is no similar movement to question medical control of pregnancy and birth in the Soviet Union, we feel that examining the system of maternity care from the point of view of its ability to respect women's dignity, can reveal much about attitudes to women in general. Furthermore, R. Batalova's cry of anger suggests that Soviet women themselves feel all is not well in the maternity hospitals.

For our description of the medical system we have drawn in the main on published Soviet sources — surveys and articles by doctors and sociologists; political statements by the Communist Party; advice offered to women by medical experts and letters to the press.

This material is supplemented by information given to one of us who recently visited a number of women's clinics in Moscow – not an objective survey but nevertheless first-hand facts. In addition we have included two interviews with Soviet women talking about their experiences of having a baby.

The Development of Soviet Maternity Care
Before the revolution only one in twenty women received any kind of qualified medical help during childbirth.[8] Maternity hospitals existed in the larger towns, but the few radical doctors and midwives willing to help the poor were spread very thinly across the vast countryside. Untrained peasant healers, known as *babki*, were for the majority of women the only help available. Although untrained, such women possessed a considerable store of traditional knowledge, and a familiarity with peasant life which enabled them to bring appropriate rituals to the event, whether to celebrate a live birth or comfort relatives in the event of death. Births sometimes took place in the family bath-house, where warmth and hot water were plentiful, and in the towns the communal women's bath-house was a centre where help and advice could be obtained on many kinds of female ailments.

The privileged minority of rich women relied on the predominantly male medical profession. This had been set up and encouraged by the state as part of its efforts to modernise and westernise

the country. Its practitioners therefore followed the latest developments in scientific medicine.

Within the medical profession there was a significant radical wing, concerned about the appalling state of health of the peasants and workers. Many of these doctors joined the *zemstvo* movement, an attempt to bring reforms such as modern medicine to the countryside, where they struggled against overwhelming odds. It is interesting that many radical women were attracted to medicine as a socially useful skill, and fought hard for their right to train and to be recognised as doctors. At first they had to do this outside the country at Zurich, until in the 1870s special medical schools were opened to women in St Petersburg. Ten years later these were closed by the government, but in 1897 the Women's Medical Institute was founded, and women were finally admitted to university courses.[9] Prominent women had a medical training, such as Sofia Perovskaya, the first woman to be hanged for her revolutionary activities, and Vera Figner, a qualified midwife, who became famous for the shooting of a Tsarist police official. By 1913 8 per cent of Russian doctors were women.[10] After the revolution, radical doctors took it for granted that the main aim of the new Soviet health service was to make their professional skills available to the population as a whole. Of course not all doctors were radical, and a number who were not committed to the aims of the revolution, but were persuaded to stay in the country, remained influential in medical circles.

At that time it was questioned by no one that the introduction of modern scientific methods — in medicine as in other walks of life — was anything but a good thing. The Bolsheviks' adherence to 'scientific communism' was the basis of their understanding of society; the perception that scientific ideas are not neutral, but are themselves the product of social activity, has grown from our more recent experiences such as concern about the world's ecology and about the destructive potential of nuclear power. The present-day women's movement has added a new understanding — that science has a built-in male bias, because nearly all its practitioners are men, and because the values attributed to it — objectivity, rationality, impersonality, inventiveness, competitiveness, etc. — are highly regarded in men and considered 'unfeminine' in women. The maleness of science extends to medicine as it does to other scientific disciplines. In the field of women's fertility and childbearing, it has meant that a form of medical practice has developed which is devoid of women's experience, and is often informed by prejudiced notions of it.

Soviet medicine — although scientific — is not an exact copy of Western medicine. The influence of socialist ideas shows in its much stronger emphasis on preventive medicine and an acknowledgement of the importance of social factors in causing illness. In practice this has led to an extension of the medical system, which in theory aims to involve the population in routine check-ups, monitors conditions at the workplace, and devotes considerable resources to health education. A further important difference is the absence of pressures from profit-making companies involved in the development and marketing of drugs and medical technology.

Despite the apparent potential within Soviet medicine for a more holistic approach to health and illness, this potential has not been realised, since respect for science and hospitalised medicine has predominated. In the care of pregnancy and childbirth, as in other areas, the medical system undermines personal autonomy and forces women to conform with a male-defined medical approach.

In the years just after 1917,[11] there was some recognition that pregnancy and childbirth were more than a medical matter, that their successful outcome was linked to women's social situation, and that state provision could both help individual mothers and contribute to the emergence of new family relations. It was in line with such views that the new Department for the Protection of Motherhood and Infancy, responsible for women's clinics, creches and in some places maternity services, was at first set up within the Commissariat of Social Welfare. However, not enough activists supported this approach and in 1920 the department was transferred to the Commissariat of Health and its focus narrowed. There were also attempts to set up a kind of 'collectivised childbirth' in the form of mother and baby homes, where women would spend several months around the birth of a new baby, but these proved unpopular as they took women away from the community. (Before long they were filled only by unsupported mothers who previously might have abandoned their babies.)

Such developments were part of the process whereby a serious discussion of how to integrate maternity and childcare with the mainstream of social life faded away. The assumption became commonplace that once material conditions improved women would want to bear many children, as their inevitable female destiny as well as their social duty. There was no mention of men's possible involvement in childcare, even in collective institutions such as nurseries. There was little thought given as to how such an imbalance in women's and men's lives was compatible with their equality.

Soon the emphasis was solely on society as a whole, in the form of the state, assisting mothers with their responsibilities. In the early years of the Soviet government a series of measures, very generous for their time, were passed with this aim in view. They made provision for pregnancy leave and maternity grants, and gave rights to pregnant women and nursing mothers at work. The 1920 law legalising abortion is often counted as part of this liberal package, but it was seen as a temporary measure only, to cope with such problems as backstreet abortions and abandoned babies. It is significant that the law permitted abortions to be carried out only in hospitals and only by doctors. It specifically outlawed the *babki* and *akusherki* (trained midwives) — even though for a great many women they were still the only possible source of help. There were never enough resources put into providing abortion facilities throughout this early period, leading to a relaxation in the law to allow private clinics and, of course, the continuance of illegal abortion.

The 1920 law was clearly a part of the government's campaign against women's traditional helpers, the *babki*. This was carried out with great energy and with hardly a voice raised in opposition. While the sphere of competence of the *akusherki* was debated, and in the mid-1920s they were grudgingly allowed to perform abortions, the *babki* won no support. The most common description given to them was 'dirty' — they were to be swept away along with the disease and ignorance of the old life. However, the reasons why this particular group of women were thought to be unreformable probably go deeper. It was felt that at the dangerous moment of giving birth and risking death, the *babki* were perpetuators of old religious values and as such a threat to the new society. In the villages the new Soviet-trained midwife, to whom women were encouraged to switch their allegiance, had an explicitly political role. The 'red thread' of Communist propaganda was to run through all her talks on women's health.[12]

In contrast to the position in the West, where traditional healers were ousted by a male medical profession, the majority of those campaigning against the *babki* and of those replacing them were themselves women. The Zhenotdel (the women's organisation within the party) encouraged local women activists to spread the word about the advantages of modern medicine, and before long women were taking up the majority of places in the expanding medical schools.[13] Female predominance in the medical profession reached its height in the years just after the Second World War (77 per cent in 1950), and is now declining (68 per cent in 1981)[14] — a

fact which can largely be explained by the present policy of favouring male applicants to medical schools. As shown in Table 1, men have consistently occupied the top positions in the Soviet medical service, and thereby influenced policies and attitudes: in the USSR it is not so much a takeover by men as by a male-defined medical practice.

TABLE 1: Percentage of Women in the Health Service, 1967–74

	%
Academy of Medical Sciences	10
Professors	20
Managers and administrators	50
Tertiary care physicians (e.g. specialists)	40
Secondary care physicians	70
Primary care physicians	90
Feldshers (auxiliary doctors)	85
Paraprofessionals (e.g. nurses)	99.5
Non-professional workers	70

Source: V. Navarro, *Social Security and Medicine in the USSR* (Toronto: Lexington Books, 1977), p.76.

Women have displayed some resistance to this significant change in their lives. In some rural areas the new midwife was greeted with outright hostility, in others her services were ignored and the new hospital beds lay empty. Poor organisation may be partly to blame — in one case there were pleas that transport should be made available as a priority to midwives and women in labour, but it is probable that many women preferred the comfort of the familiar.[15]

In the towns, where the practice of hospital births was already established, women accepted the new ways more readily, though doctors did complain that some were reluctant to give birth in hospital and wanted to bring their friends and relatives along too.[16] Unless they decided to return to the village to have their babies, urban women probably had little real choice, because of the poor housing conditions. In other aspects of women's health, particularly abortion, state resources were less than adequate and so ensured that there was still work for the traditional healers. Comments from doctors in the 1920s indicate that the bath-house was still a popular centre for women.

In this way the networks of women's mutual help survived, and after the passing of the 1936 law banning abortions, came into their own again. Women chose to defy the law on a massive scale by having illegal abortions, using both the *babki* and the newly-trained Soviet doctors, many of them women. Eventually the pressure of illegal abortion became so great that the government relegalised it in 1955, conceding for the first time that women had a right to determine the number of children they bore. Despite the economic problems resulting from a low birthrate, the government has not gone back on this law, knowing that if they did so, illegal abortion, which still continues, would again be organised by women on a massive scale.

One unfortunate consequence of this pattern of events is that contraception has fared very badly in the Soviet Union. In the 1920s there was little enthusiasm for it. The methods were not very reliable, and in any case, for the majority of peasant women, the concrete reality of a pregnancy was easier to understand and deal with. Among the intelligentsia, the lack of a libertarian tradition, combined with the fear that limiting the birthrate was anti-socialist, made the topic unpopular. Since that time women have not been able to organise as a group defending female interests, and so there have not been the pressure groups which campaigned effectively for contraception in countries like Britain.

Nowadays, although it is widely accepted that reliance on abortion is harmful and that contraception and even sex education should be promoted, there is something like a failure of nerve, a lack of determination to carry this policy through. Barrier methods, the IUD and in a few places the pill are available when asked for, and the IUD especially is being promoted in the women's clinics.

However, women continue to have a number of abortions during their fertile lives, four or five being nothing unusual,[17] and this has serious implications for their general health – and the outcome of their future confinements.

The continuance of illegal abortion is not the result of an oppressive law, although there are restrictions which do not permit abortion after 12 weeks of pregnancy or within six months of a previous abortion or birth. Rather, it is a reflection on the standard of Soviet medical care and the prevalence throughout the society of petty corruption. Women will buy an unofficial abortion – often by the same doctors who would have performed it officially – because the payment of extra money ensures them quicker treatment, secrecy or simply better care.[18] Anaesthetics cannot always

be relied on for the 'd and c' operation usual in hospitals, but by paying, women can ensure that anaesthetics are used, or even the alternative of a vacuum suction abortion in the privacy of their own homes. Unqualified helpers are used too, and occasionally a botched abortion gives rise to a lurid scare story in the press, attacking these practitioners.[19]

Although the *babka* has almost disappeared, private medical practice and 'fringe' medicine are permitted in the Soviet Union. Doctors practising privately are severely restricted, and do not have access to state facilities, but both they and 'folk' healers are consulted by people anxious for a second opinion or advice on herbal remedies. It is in this context that Igor Charkovsky has been able to develop his notorious underwater births, which are only just tolerated by a sceptical medical profession. They are a marked contrast to the ordinary kind of Soviet birth, less because the baby emerges under water, but more because the mother is a central figure, experiencing her labour with the assistance of husband and friends in a relaxed and happy atmosphere. Experimentation of this kind is very much the exception, and is unlikely to spread far. Even if there were a significant demand among women for this birth, it could not be practised clandestinely as, unlike abortion, the resulting baby has to be made public.

When it comes to continuing a pregnancy and to childbirth, Soviet women have no choice but to enter the domain of the medical profession. What happens to them is the subject of the rest of this chapter.

The Organisation of Antenatal Care

When a Soviet woman becomes pregnant, she is urged to seek medical confirmation of her pregnancy as soon as possible, ideally before the twelfth week. Explanations for the need to attend for antenatal care at an early stage are very similar to those given in Britain — certainty of diagnosis and dates, calculation of maternity leave, early monitoring for problems, and so on.[20]

Antenatal care in the USSR is the responsibility of the women's clinic, which is the most widespread unit of primary and outpatient health care for Soviet women. Exceptions to this rule tend to be outlying rural districts which rely upon a *feldsher* (auxiliary doctor) or *feldsher*/midwife clinic for their primary care. The majority (80 per cent) of women's clinics are based within *polyclinics*, which are multispeciality centres for primary and outpatient care. The remainder are based in maternity hospitals and health centres within factories. Soviet doctors prefer antenatal care to be based in the

large *polyclinics* because studies show that they have lower rates of illness and death for mother and baby.

The clinics are staffed by obstetrician—gynaecologists, as well as midwives and nurses, which means the majority of Soviet women are routinely placed under specialist care during pregnancy. The nearest Soviet equivalent to a general practitioner is the general physician or district doctor, but she is not involved with maternity care. For those rural women too far from a women's clinic there is a mobile specialist service which periodically visits the more remote rural health clinics. Since there are no formal arrangements for home birth in the USSR, theoretically every women will give birth in the most convenient or most appropriate maternity unit.

Once pregnancy has been confirmed, women are advised to return to the clinic seven to ten days later for their first antenatal check-up. It is recommended that during this visit, in addition to the routine tests, every woman should be referred to other specialists — a general physician, dentist, occulist, urologist, throat specialist, etc. — in order to ascertain her overall health. On the basis of all the information gathered, a woman is then allocated to one of two groups, either a group of healthy women with a straightforward pregnancy who receive routine care, or a group of women who, by virtue of their age, social background or medical problems, are considered to be at risk and in need of additional specialist care.

Women without problems are expected to attend the clinic once per month in the first half of pregnancy, twice per month after 20 weeks and once a week after 32 weeks. Home visits are organised for those women who are unable to attend the clinic for health reasons, and midwives are responsible for visiting women who miss their appointments. The midwife is also supposed to pay at least one home visit to assess material conditions and the family's health. Recent legislation in Britain which provides for time off with pay to keep antenatal appointments has no equivalent in the Soviet Union, and the loss of wages that results from attending the clinics may well be a disincentive for some women.

The antenatal clinics set themselves three main tasks — medical supervision, health education including preparation for birth, and advice on maternity rights. Before looking at each of these in more detail, it will be useful to describe the medical profession's attitude towards pregnant women.

Attitudes to Pregnancy

During her pregnancy, a woman is not only subject to physical

changes, she is also confronted by changes in her social and economic status, her lifestyle and relationships, and by her own and others' expectations regarding the social role of mother. Medical attitudes to pregnancy typically take little or no account of this aspect, concentrating instead on the physical side, and finding potential problems more interesting than normal, healthy developments. When there is some acknowledgement of the emotional aspect of pregnancy, it is usually limited to discussing a woman's feelings towards her baby and the changes in her body, and does not cover the more complex feelings she may experience in the transition to motherhood.

Moreover, medical science, particularly in the West, has developed a built-in tendency to regard anything outside male experience with suspicion. Reproduction is the prime example and doubts have been raised as to whether premenstrual tension, morning sickness and even labour pains 'really' exist or are just hysterical, neurotic or acquired reactions. The issue is further complicated because, once recognised, the physical and emotional changes which can be induced by women's biology tend to be perceived as abnormal, and evidence of women's vulnerability to physical and/or mental imbalance.

Soviet medicine, despite its feminisation, follows the same tendency to measure female health against the male norm. One medical textbook states 'The menstrual cycle, pregnancy, birth and lactation are accompanied by definite neuro-psychic displacements.'[21] For example, while textbooks often attribute a psychological basis to sickness during pregnancy, women seeking help are told that it is caused by organic changes and is the rule rather than the exception. As Soviet doctors are wary of prescribing drugs, one recent article has discussed treating 'morning sickness' with psychotherapy instead[22] — but perhaps an opportunity to discuss the cause of the symptoms and simple ways to alleviate them would suffice for most women.

The same unwillingness to deal straightforwardly with women is also apparent in the content of routine antenatal care. There is an overemphasis upon the physiological aspects of pregnancy and a preoccupation with the pathological, which means that women are subject to an increasing number of tests and procedures designed to detect abnormality. However, the natural anxieties and questions these give rise to, as well as the feelings a woman has about her pregnancy, cannot easily be accommodated within this approach. For some women this may mean that their anxieties are exacerbated by the medical attention they receive, whilst for others, who feel

able to ask questions and request explanations, it may mean that they are classed as 'troublesome', 'aggressive' or unduly anxious patients who then meet with hostile, patronising or unhelpful responses from clinic staff.

There are no Soviet studies which specifically look at the doctor–patient relationship in the context of an antenatal clinic, but articles which discuss patient satisfaction with their medical care in a general sense give some insight into the situation.[23] The most common complaints registered by patients and researchers sound familiar — for example, clinic location, travelling and waiting times, attitudes of staff, and the lack of privacy in some clinics. An average waiting time of an hour and a half is reported, and this has to be set against the five to ten minutes which is actually spent with the doctor. Moreover, the queues of people prompt a sense of urgency all round, giving little opportunity for raising more general problems and questions, even if the 'brusqueness and lack of concern' displayed by clinic staff has not already silenced the patient. It seems that Soviet women are likely to experience the 'production-line' atmosphere of antenatal clinics which has been so much criticised in Britain.

The medical view of pregnancy is also apparent in the pamphlets and articles written for expectant mothers. They are urged to see the doctor as soon as possible, and obediently to follow any orders. Doing so is made to seem a *precondition* for having a healthy baby:

> Rest assured, the necessity during pregnancy of observing a correct regime and diet, of fulfilling hygienic requirements, and paying constant attention to your health, is dictated by serious scientific considerations. It is not an empty formality, thought up by midwives and doctors, but the main precondition for the normal development and birth of a healthy baby.[24]

Often anecdotal case-histories are given in which women neglected medical advice, with serious or near-fatal results. Possible complications such as varicose veins, inflammations, toxicosis and eclampsia are dwelt on at length, and women are specifically warned against listening to friends' advice or treating themselves: 'Not a single tablet without the doctor's permission!'[25] Women have to balance this attitude with soothing reassurances that pregnancy is normal and health-giving. It must not seem too debilitating, as pregnant women are needed in the workforce. So despite its dangers, pregnancy is 'the culmination of physical and emotional development and enables its full flowering'.

Nature has carefully prepared women for one of the most beautiful pages of her life — pregnancy and birth . . . All these changes are completely natural and physiological, and do not harm the woman's health. On the contrary, they have a beneficial influence on her organism.[26]

On the positive side, the information given about physical changes is detailed and clear. But when it comes to emotions, the woman's attention is directed away from herself and towards a preoccupation with the baby:

For a woman pregnancy is a kind of special two-in-one existence; throughout this time she is somehow different, she depends on the foetus, and to an even greater extent the foetus depends on her.
 Nothing can be compared with the first sensation of the baby kicking . . . [27]

Mixed feelings about the pregnancy, or the possibility of postnatal depression, never get a mention. At no time does the woman have an active role to play — the predominant view is that everything will be taken care of by Nature, with more than a little help from the medical experts.

Medical Supervision
Medical control of pregnancy starts at the very beginning with the simple chemical test or physical examination used to confirm it. Doctors in both Britain and the USSR insist that a medical diagnosis is the only reliable way of confirming pregnancy, which undermines women's confidence in their own bodies. Recent Soviet articles have gone even further, suggesting that the only certain proof of pregnancy is ultrasonic scanning.[28] However, this is only a pointer for the future. The general problems in the Soviet economy of inefficiency, waste and basic shortages are found in the health sector too: stretched resources are still all too common. Although there is a commitment to provide every clinic with advanced equipment, as yet the majority of women do not come into contact with it.
 At their antenatal visits, women have the usual routine clinical tests, such as blood and urine tests to detect disorders and infections. These are undertaken by midwives, while physical examinations are carried out by doctors. Any women with complications are referred to the more specialised obstetric hospitals and clinics.

With regard to the less routine tests, amniocentesis (the taking of a sample of fluid from the womb in order to detect genetic abnormalities) is used in the USSR, though it is not clear how widely. A recent article recommended its routine use without mentioning the risk of inducing a miscarriage, but as before, shortages mean that its use is unlikely to be widespread.[29] Ultrasonic scanning also appears to be gaining in popularity, and is used in the later months of pregnancy to assess foetal development, as well as at the beginning to confirm pregnancy and detect problems. There have been objections to repeated routine scanning in Britain because, while it is a simple and painless procedure, with no risk of miscarriage, it is still an unknown quantity with regard to its long-term effects on the foetus. It also requires a highly skilled operator if it is to be of any value, and to the pregnant woman represents one more piece of technological apparatus.

A recent article suggested that one way of exercising better medical supervision during pregnancy, and thereby ensuring a better outcome, would be to send pregnant women to rest homes at the beginning of their maternity leave so that preparation for the birth could be combined with preventive health measures.[30] While the proposal may reflect a genuine concern to see that women get the rest and diet they need, it would further medicalise pregnancy and isolate women. It would seem that the lessons of the 1920s, about the need to respect women's existing network of relationships, have not been learnt.

Soviet doctors may well have good reason for wanting to supervise pregnant women more closely. In the context of the rising infant mortality rate, concern has been expressed about the effect of repeated abortions on women's fertility and gynaecological health.[31] In addition, recent Soviet studies have given a poor picture of the general health of pregnant women.

One such study, which looked over a number of years at the health of large numbers of pregnant women in Leningrad, established that both general illnesses and conditions specifically related to pregnancy were common. For example, mothers in almost one third of the births documented had suffered toxaemia in the second half of their pregnancy. Toxaemia of pregnancy is a relatively serious complaint, characterised by a rise in blood pressure and either protein in the urine or generalised oedema (effusion of fluid into the tissues) or both. It can culminate in convulsions in some cases and can also lead to premature births, and the death of the baby and even the mother. There are conflicting views about the causes of toxaemia, but it is generally associated with poor diet,

poverty and inadequate antenatal care. The same survey noted that the illness rate amongst pregnant women was reflected in the high level of sick leave in the weeks before maternity leave began. The women were also followed through into the postnatal period and it was found that 12.2 per cent of those who had illnesses during pregnancy had acute diseases, aggravation of chronic illnesses and complications during the first year after the birth. Although Leningrad as a city may not be typical of the Soviet Union, as its poor position on marshy ground and its long, damp winters are known to cause health problems, nevertheless this survey is a typical example of the concern expressed by Soviet experts dealing with maternal health.[32]

Health Education

Advice to women about their personal behaviour during pregnancy can also be found in pamphlets and articles, where it features more prominently and has a more authoritarian tone than in equivalent Western material. Women are told that they must keep to the correct diet, and a balanced regime of work, rest and exercise; they must give up smoking and drinking altogether, and refrain from sex during much of their pregnancy.[33] The importance attached to this advice probably reflects the difficult conditions many women experience: hygiene is especially important in cramped housing; good diet needs attention when food shortages are common; and women's double burden on full-time paid employment and unpaid domestic labour makes it difficult to maintain a healthy lifestyle. Yet there is a credibility gap between the advice given and the reality of women's lives, precisely because these problems receive no mention.

Husbands make an appearance in this literature. They should help by supporting, or at times supervising, their wives in carrying out the doctor's orders, and make allowances for their 'more vulnerable' emotional state, or their lowered efficiency in doing the housework. Husbands are told to take on some practical tasks too − such as building a playpen, mending the pram, or checking the room for safety. They may take on some of the housework *until* the woman regains her former strength, and should learn how to change a nappy, just in case they are ever left on their own with the baby![34] The emphasis throughout is on helping rather than taking equal responsibility, and is part of a wider move to encourage men to be more involved in home life. However, the propaganda is not backed up with concrete measures − there is no paternity leave for Soviet fathers.

In the antenatal clinics, health education and preparation for birth come together under the label of 'psychoprophylaxis'. The idea behind this is that if a woman is clear in her mind (psyche) about what is happening to her body during labour, then her anxiety and fear are overcome and the pain prevented (prophylaxis).

Since the revolution, Soviet doctors had sought for effective methods of pain relief in labour, and had experimented with hypnosis as well as different kinds of drugs. Psychoprophylaxis was developed by two doctors, Platonov and Velvovskii, as a development of the 'conditioned reflex' theory of the Russian scientist Pavlov. The ideas are similar to those of Grantly Dick-Read, who advocated natural childbirth in Britain in the 1940s, but appear to have been developed independently. There was some cross-influence when the French obstetrician Lamaze visited the Soviet Union in the 1950s and, much impressed with their new approach, introduced it in France. Because it fitted well with the preventive health approach, psychoprophylaxis as the main method of pain relief in childbirth quickly gained acceptance in the Soviet Union, and in 1951 the Ministry of Health advocated its use in all maternity hospitals.[35] It has been claimed as a great achievement for Soviet medicine: 'Mass painless birth in our country is one of the signs of the humanist principles and prophylactic direction of Soviet public health.'[36]

However, while the adoption of psychoprophylaxis was undoubtedly a breakthrough, it has not been developed to its full potential. Partly this is because of poor organisation. In theory pregnant women will attend a course of ten classes to learn about the physical process of labour, and the breathing techniques and massage they can do during it. However, the classes involve no actual practice of these techniques, and furthermore are held after the regular antenatal clinic, which means a long wait for those women who choose to stay. There is no idea that a woman will benefit from support during labour, so husbands or friends are not involved at this or any other stage. Women do not visit a delivery room beforehand, and are not even booked in to a particular hospital, so when they are admitted in labour both the surroundings and staff are likely to be unfamiliar.[37]

The main problem with psychoprophylaxis is that it remains a technique whereby women can be better prepared and coached to help the doctor direct their labour for them. Two extracts from a popular health magazine sum up the prevailing attitude:

A saying of one of the oldest midwives was 'Labour must be

managed and not allowed to drift along.' Just such a tactic of actively managing and directing labour is adopted in our maternity institutions.

A woman who has undergone psychoprophylactic preparation can take part in this process herself — and by her correct behaviour, her attentive and accurate obedience to the doctor's and midwives' orders, she can help the labour go more smoothly.

. . . a woman prepared in this way actively participates in the act of birth, not hindering, but on the contrary helping the doctor and midwife, by understanding and fulfilling all their demands.[38]

Maternity Rights

The rights given to pregnant women and nursing mothers in the early years of the revolution have gradually been extended.[39] They are often cited in the Soviet press, and held up as evidence of the government's concern to safeguard maternal and child health, although nowadays a number of countries in both East and West have advanced on them. All Soviet women are entitled to paid maternity leave for 56 days before and 56 days after the birth, although leave may be extended to 70 days after the birth if a woman has a difficult delivery or gives birth to twins. Maternity benefit is paid at a woman's former average wage rate and is paid irrespective of length of service or of the time she has belonged to a trade union. A one-off grant is also paid to expectant mothers, and single mothers are entitled to a small monthly state grant until the child reaches twelve years of age. Recent changes in the law have increased levels of benefit and made provisions for extended unpaid leave, largely as a response to the falling birthrate. However, these measures do nothing to strike at the root of the problems which have led women to have fewer children as a means of coping with their day-to-day lives. Any attempt to tackle women's double burden and the related problems of food shortages, cramped living conditions, shortages of consumer durables, dissatisfaction with nursery provisions, etc., would require a much more radical change in socioeconomic policy.

Soviet legislation to safeguard the health of pregnant women and nursing mothers at work is quite far-reaching. Labour laws restrict the employment of pregnant women and mothers with infants up to one year old in certain types of work, and limit the number of hours which they can work. The law states that they cannot work on night shifts, or be expected to work overtime or go on business

trips. In addition, women employed in strenuous labour must be transferred to lighter work during pregnancy and be paid at their former average wage (this also applies for the first year following the birth). Pregnant women cannot be refused work or be paid at a lower rate due to their pregnancy, and employers are legally obliged to allow nursing mothers to take regular breaks from work in order to feed their babies. The latter right reflects the continuing support for and popularity of breast-feeding.

Legislation introduced in 1978 has extended the list of occupations from which women are prohibited due to the potential threat such occupations pose to women's reproductive health. This policy, like those adopted by other industrialised countries, is double-edged. Because it applies only to women, and not to all workers, it can be used to justify discriminatory practices against women. Furthermore, the concern for women's health which protective legislation is supposed to represent does not stretch to tackling the many other social problems which undermine women's well-being.

It is the responsibility of clinic staff to advise pregnant women about their employment and welfare rights, and doctors working in clinics within factories are expected to ensure that these rights are enforced by the management. But some research suggests that, in practice, these responsibilities are overlooked.[40]

Two Experiences of Antenatal Care

The two interviews with Soviet women that follow show two different experiences of antenatal care.[41] Sveta is a working-class woman, who had eight years' schooling, and is first-generation urban (i.e. her parents moved from village to town); she attended an ordinary women's clinic in a workers' district, and her experience is typical of that social layer. Masha can be counted as part of the intelligentsia, though only just; she had a medical secondary education, and her background is urban. The important difference is that because of Masha's job in the health service she has 'connections' and attended a clinic where she was known; her experience is that of the more privileged. Both women were asked how often they had visited the clinic when pregnant, and how they had been treated.

Sveta: Not very often. You're supposed to go every month, but it doesn't help at all to go . . . I got fed up having to undress and be weighed so I didn't like going. The doctors weren't pleasant either, very coarse, they don't talk to you. Some women come out of the

room crying. The doctors aren't nice at all. The queues are very long. You sit for an hour or for two hours, it's not clear why . . . The consultation is about ten minutes, very quick. Like I said, it's like animals, like a machine. You go in, sign your name on the paper. She tells you to undress and weigh yourself then you lie down, they do you and that's it! [laughter] . . . During the examination the doctor doesn't talk to you at all. They talk amongst themselves about shopping, children, but not to you . . . They didn't explain anything, just did the tests . . . They didn't give us any literature or talks. Maybe they do in other places, but they didn't at my clinic.

Masha: Once a month. It was my first baby so it's best. There's nothing frightening, they measure your blood pressure and they treat you very well. I am connected with medicine so I didn't just go to the nearest clinic but to the clinic where I work, to my own people so to speak . . . They didn't really explain what they were doing . . . They gave me literature to read, but it didn't help all that much as I knew it anyway, about the physiological process and woman's hygiene.

Attendance at Antenatal Clinics

One way of evaluating the success of antenatal care is to see how keen women are to attend the clinics. While overall attendance rates are said to be high, there is also concern that some women are not going to the clinics as soon and as often as the doctors would like, and that these women are from the poorer sections of society who are likely to need help most. Estimates of the average number of visits a woman makes during her pregnancy vary from eight to fifteen, which compares with an average of twelve in Britain. Some articles suggest that there is little difference between rural and urban areas since women's mobile clinics make medical supervision accessible to rural women, although it seems that there are significant variations between the republics.[42]

Soviet doctors stress that to benefit from medical care, it is important for women to make their first visit to the clinic during the first three months of pregnancy. They are not satisfied that a 'significant number' − roughly a third − of women attend later than this, and also that after registering their pregnancy, women are missing subsequent visits. Soviet studies show that single mothers are the most likely group to avoid medical supervision during pregnancy. Both they and housewives are less likely to attend for antenatal care than students, manual workers and white-collar workers. The best attenders are white-collar workers,

especially women with a higher level of education. Surveys also show that even when single mothers, manual workers and house-wives make the same number of visits as white-collar workers, they are more likely to suffer the loss of their baby at birth or in its first week of life.[43]

The conclusion seems to be that the Soviet system of antenatal care is falling short of its declared aim to find, monitor and assist those women most at risk of having a difficult pregnancy. More-over, it operates in such a way that those women who do seek medical supervision can find the whole experience alienating and one which leaves them ill-prepared for the birth and the transition to mother-hood.

Giving Birth In The Soviet Union

The USSR has a policy of 100 per cent hospital confinement of births and this has almost been achieved; at present all urban births and 90 per cent of rural births are hospitalised. Underlying this policy is the idea that whilst many births proceed without com-plications, it is essential that qualified staff and the necessary equipment are on hand to deal with any complications which may arise. It also reflects practical considerations, since cramped living conditions and the fact that not all rural homes have running water could present problems for home births. There is no discussion about the advantages of home births, and no provision is made for them. Those that do occur seem to be unplanned and largely confined to rural areas; in these cases, the midwife is obliged to help the woman and her baby and to call a doctor if necessary.[44]

The size of maternity hospitals can vary considerably between the town and the countryside and between republics. They range from large specialist teaching hospitals to small maternity units on collective farms or two to three beds situated in the feldsher−midwife clinics in the more remote villages. If unexpected complications occur in the small hospitals or units, then the midwife can call for the nearest doctor, who should arrive by car or plane. Sometimes it is the woman who has to travel to a better equipped, larger hospital. Although this is not recommended it seems to be fairly common, apparently because medical workers in rural establishments believe that by transporting such women they are providing more immediate active help. Women whose labours are expected to be difficult should be booked into the main regional or city hospital. These arrangements can vary between the repub-lics. For example, nearly all rural women in the Baltic republics give birth in urban hospitals because the density of the population

and the good roads allow easy access to such facilities, while in the Central Asian republics the small, two- or three-bed rural hospitals are more widely used.[45]

The range of facilities makes it difficult to generalise about the management of childbirth in the Soviet Union. The following discussion is limited to the larger, more urban hospitals, partly because over two-thirds of the population live in towns and so women are more likely to give birth in urban hospitals, and also because urban hospitals are assumed to be more advanced and so are setting standards for the rest.

It seems that in normal pregnancies, women are not booked into a particular hospital in advance. When labour begins and the ambulance arrives, the crew will ring round to locate an empty bed. It is only by good fortune that a woman will give birth in the hospital attached to her antenatal clinic, or even in her part of the city. It seems also that women living outside the big cities, believing the care there to be better, take advantage of this by ensuring that their labour begins while they are in the town.[46]

Medical Procedures

What happens in the process of 'becoming a patient' in Soviet maternity hospitals appears very similar to what has, until recently, been standard practice in Britain. Different articles refer to pre-delivery shaving and enemas as part of the 'sanitary treatment' essential for women on their admission to hospital. Although it is recommended that women should be free to walk around in the first stage of labour, the dorsal position for delivery is usual.[47] Rules such as these, whose medical value has been thrown into question in the West, signify that the woman is not a person, but a patient, under doctor's orders. In the Soviet Union this process is reinforced by the total exclusion of the woman's family and friends from the maternity hospital. They are not allowed to attend the birth, or to visit the mother and new-born baby at any time during their stay, which lasts on average eight to ten days.[48] This ruling does not apply to other types of patient in Soviet hospitals and may reflect a real concern about cross-infection, which is the official justification. Nevertheless, it means that women are isolated from familiar sources of support at a significant and often vulnerable time.

Active management of labour of the type often found in Britain is less common in the Soviet Union. There are no national figures available showing the proportion of births which are induced or accelerated, though some Soviet doctors claim that 'methods of

labour stimulation are widely used'.[49] It is notable that recent articles in the medical journals have expressed concern about the effects of using drugs to stimulate labour on the health of both mother and baby. Electroanalgesia (explained below) and acupuncture have been recommended as viable alternatives. Studies have shown that both methods can be used either to stimulate uterine contractions or forestall premature labour, and they can also be used as methods of pain relief in labour. It is not clear, however, to what extent these alternative methods have replaced the use of drugs.[50] Though active management of labour is generally recommended only on medical grounds, recent suggestions that electroanalgesia should be used for women over 30 and that active management is best for overdue pregnancy, imply that this approach is gaining ground.[51] Nevertheless, Soviet doctors seem far more disposed to find and use effective non-pharmacological means of intervention than their British counterparts.

The same cautious attitude is apparent when it comes to the active management of birth, in particular the use of Caesarian section, and instrumental delivery (forceps or vacuum suction) and episiotomy (cutting of the perineum). Recent national rates for the incidence of these techniques in the USSR are not available, so we have drawn tentative conclusions from a variety of sources. Overall it would appear that Soviet doctors are reluctant to use any form of surgical intervention − to such a degree that some articles have criticised their inactivity in cases where a Caesarian section could have prevented death or handicap. One article states that 'medical workers strive for a delivery without surgical intervention', and the limited data available seems to support this claim.[52] Episiotomies are not standard practice in Soviet hospitals, and though one researcher says there has been a long-standing debate about the prevention of tears to the perineum, the policy at present seems to be one of 'wait and see'.[53] Of the two methods of instrumental delivery, vacuum suction is the most widely used, in common with most of Europe though not Britain. (There has been no randomised control trial to compare the two methods, but it is widely accepted that vacuum suction is less traumatic for the mother than forceps delivery and, unlike forceps, no case of maternal death due to this method has been reported.[54])

Recent issues of medical journals have referred to the use of various types of technological apparatus for the management of labour, for example electrofoetal monitoring. At present the use of such technology seems to be limited to research clinics, but there is support in medical circles for extending its use.[55] If foetal monitor-

ing becomes more widespread, it could well lead to higher rates of surgical intervention, since studies in Britain and the United States have associated higher rates of Caesarian section with increased foetal monitoring.[56]

Pain Relief in Labour

The Soviet Union claims that the vast majority of its births are provided with pain relief, and that this is an example of its great humanity. Since the early 1950s, the greatest stress has been on pain relief through psychoprophylaxis, though other methods are available and sometimes used. These include, in addition to the anaesthetic drugs familiar in the West, electroanalgesia and acupuncture.

The method of electroanalgesia involves placing electrodes on either side of the woman's head and allowing a mild electric current to pass through. It was first developed as an anaesthetic in general medicine, and was developed for use in childbirth by Soviet researchers in 1978. Their findings claim that it is highly effective both as a stimulant and as a form of pain relief and that it is harmless to both mother and baby. Apparently it induces a 'feeling of calm and warmth and occasional pain at the points where the electrodes are attached'. It is suggested that this method should be used, in conjunction with psychoprophylaxis, for those women who are in poor health or who have had bad experiences with previous births or past 'emotional disturbances'. Ideally they are acquainted with the method during antenatal visits.[57]

A group of Chinese specialists first discovered the potential of acupuncture within obstetrics in 1959 and its analgesic effect and the absence of harmful side-effects have attracted the attention of Soviet doctors. Studies in the Soviet Union have shown varying degrees of success for acupuncture as a method of pain relief during childbirth. Between 33 and 60 per cent of women have found it adequate, a rate which compares favourably with the drug pethidine, most commonly used in the West. Apparently the method is simple to apply and does not require expensive apparatus, and it has been claimed that it results in less surgical intervention and does not lead to post-anaesthetic depression. Its main disadvantages are that it limits the mobility of women in labour during the time it is being applied, and has insufficient analgesic effect for surgical operations or for very strong painful contractions.[58]

The usual pain-relieving drugs such as pethidine and gas and air are also available, though it seems that epidurals (spinal injections) are not very common.[59] It is difficult to make firm statements about the pattern of use of the different methods, especially as they

are often used in conjunction with one another. Psychoprophylaxis is also counted as a method, so the common claim that almost all births (95 or more per cent) in a particular hospital involved pain relief may simply mean that most of the women attended a few antenatal classes. Two maternity hospitals were asked about their methods of pain relief [60] and provided figures for the previous year, 1980. The first, which was established in 1958 and considered a model hospital, had 52 per cent using only psychoprophylaxis, 28 per cent a combination of methods, and 18 per cent medication. Electroanalgesia was one of the most common methods. In all, 98 per cent of the births involved pain relief. The second hospital, which was older and in a more rundown part of the city, found that only 58 per cent of its women had been prepared in the use of psychoprophylaxis, and of those well over half were also given medication. Electroanalgesia was not much used, drugs and gas and air being preferred. The percentage of births involving pain relief was 99 per cent. In contrast, the prestigious All-Union Research Institute of Obstetrics and Gynaecology uses electroanalgesia in 70 per cent of deliveries, and also makes wide use of acupuncture. It recommends that drugs should be used in small doses, and only as a last resort.

Although it is clear that methods of pain relief vary considerably, the responsibility for deciding which to use does not − it is invariably the doctor's decision. The signs are that as different methods of pain relief are becoming available, doctors are losing some of their enthusiasm for psychoprophylaxis. A recent article in a popular magazine discussed its limitations and called it 'not the key to all locks'.[61] It said that preparation had to be done correctly and thoroughly, and often women did not have sufficient time. What figures there are for women using psychoprophylaxis suggest that it is losing ground, though they may also reflect the wider availability of other methods, as resources slowly expand.

Women have no choice about the conduct of their labour. They may feel prepared to use their own resources but find themselves forcibly injected; they may long for pain relief and be denied it. This is why one of us, who happened to be present when the birth of a child was being celebrated, was assured by some Soviet citizens that 'in our country women give birth without any pain relief' − precisely the opposite of what the government claims.

Postnatal Care
Childbirth is presented to Soviet women as the peak experience of their lives, one which will transform them into serene and beatific

mothers. They are told that the hours after birth 'will stay in your memory as your happiest ever'; the baby's cry will bring 'a moment of invigorating happiness, comparable with nothing' and will 'reward you for all your efforts, bring you great joy'. In the face of every new mother 'there is something of Raphael's madonna' and 'a mother's smile lights up the world' . . . [62]

> Doctors say that the eyes of a mother who has just given birth change completely, they become deep, shining, peaceful. Go into the ward of a maternity home where the young mothers are and you will be warmed as if by sunshine; nothing can be compared to the light of a mother's eyes. [63]

These accounts make no mention of the possibility of postnatal depression, though medical books do discuss it as an accepted problem. They do not even prepare women for the mixed feelings or simply the sense of anticlimax that often follow childbirth. Similarly the organisation of the postnatal ward does little to ease the transition to motherhood. Women are not only denied visitors, they are also separated from their babies, whom they see only at feedtimes, strictly every three hours. [64] When the time comes to leave, the baby is ceremonially handed over, often to the father, at the hospital entrance by one of the medical staff. During the mother's stay husbands and friends try to get round the no-visitors rule by gathering under the windows, bringing flowers and gifts which the mothers conspire to retrieve. The official reason for their exclusion is concern about the spread of infection, and though other countries have overcome this problem, Soviet medical literature does suggest that peurperal fever remains a significant problem. [65]

The overall success of maternity care is difficult to evaluate. Medical criteria of success are largely confined to the perinatal and maternal mortality rates, and the decline in these rates suggests that much progress has been made over the last 60 years, although at least part of the decline is likely to be due to improvements in living standards, housing and sanitation, and simple hygiene measures. But some Soviet articles express concern that the rate of perinatal mortality, at around 15 to 17 deaths per 1,000 births, is still relatively high and that it has shown little tendency to fall in recent years. The numbers of premature births and stillbirths are perceived as the greatest problem, and both are said to be associated with repeated abortions and the poor state of women's health. [66] One doctor unequivocally states that 'rational contraception' could

reduce the rate of perinatal mortality by reducing the need for repeated abortions.[67]

A study of the causes of neonatal mortality (i.e. death in the first four weeks of life) in a region of the Ukraine between 1975 and 1977 found that the rate of asphyxia, birth trauma and congenital defects had all increased over this three-year period, and that the remaining causes of death had remained stable. By checking the medical records, the researcher was able to identify any defects in the management of those births where death occurred. He concluded that a quarter of the deaths were related to 'incorrect treatment for poor labour, unjustified and crude carrying out of surgical intervention, and incorrect assistance with breech birth'. Of the remainder, a quarter were related to the medical care of the baby at birth, and a third to the management of the pregnancy.[68]

Studies like these suggest that a further reduction in the rate of early infant death may not be dependent upon greater medicalisation of pregnancy and birth, but may be influenced by the wider availability of safe, effective contraception, by measures which promote women's health and by the willingness of the medical profession to reassess its effectiveness. Adopting medical criteria of success to evaluate maternity care illustrates that the medical profession is apparently failing to meet its own objectives, let alone those of the women giving birth. We consider how Soviet women themselves feel about their experience of childbirth in the next section.

Two Experiences of Childbirth

Sveta and Masha, the women interviewed about antenatal care, were also asked the following questions about childbirth. The interviews were not conducted simultaneously, but their answers are put together for convenience.

Q. Did you have any preparation for childbirth?
Sveta: No, there was no talk of anything like that.
Masha: No, but classes do exist. I knew the exercises anyway and did them at home. But the birth was difficult, I had thought it would all be much simpler.
Q. Were you given medication during the birth? If so, who made the decision, and was the reason for it explained?
Sveta: Yes, during labour they do a number of injections, they call it setting the scene for labour. But if the labour is normal they don't need to. Of course I protested, argued with them. I think it's better to suffer for ten hours, and do it all myself. The doctors

insisted on the injections. There isn't a chief doctor, they're called *akusherki* [midwives]. They rush around, they have a plan — they have to see that everything goes quickly. They also give *kastorka* [castor oil], they give it to nearly everyone and they force you to drink it. I protested, but the labour pains began and she brought me the *kastorka* — she did it very rudely, I felt she was ready to beat me to get me to drink the stuff. They don't explain anything, they just do what they think necessary.

Masha: No, you see if they give you some kind of drug you don't have the same strength to push the baby, the contractions are reduced. So even though I was in hospital *po blatu* [through connections] with good doctors, and even though I had a very hard time they couldn't do anything to help me, so they didn't give me any analgesia . . . Later on though the baby turned over and I had to lie on my side for a whole day, hoping it would right itself — they gave me morphine injections then. But no, they don't ask if you want them.

Q. Were you left alone during labour? And what was the attitude of the doctors and midwives?

Sveta: There were two beds in the room, but I was alone. The doctors went out and didn't come in very often. If the mother calls them they come and start kicking up a fuss — why do you keep crying like a mad thing, you're giving birth. Well that's true, but still they ought to watch, to calm you. The thing is that there aren't enough doctors, the staff is very small . . . Yes, the mother has to call out; of course, there are all sorts of ropes on the wall that you're supposed to pull to call the doctor, but nothing works. We haven't got that far yet. Childbirth is considered a normal happening, so the bells don't work.

Masha: I was with two other women in the ward when labour began. A midwife was with me all the time. I wasn't left alone.

Q. During the second stage, do they make a cut?

Sveta: No. Often the vagina tears, usually women are left to get on with it and get torn very badly, but I was okay. A lot depends on the midwife. If she is experienced she can help a lot and see that there are no tears.

Masha: A cut is preferable. Usually when it's your first baby they make a cut, it's better for the baby and for you because very often the vagina tears. This can be terribly painful whereas the cut heals well. So here they make cuts very often because it's much better that way.

Q. How did you get on after the birth, on the postnatal ward?

Sveta: Straight after the birth I felt a great relief. The rest of the

time I felt tired, weak. I wanted to rest, to sleep, but it's hard to sleep much because it's painful. I was allowed out of hospital on the fifth day but I think that's too soon. I found it was an effort to keep on my feet. In the hospital the babies are kept separate in the children's ward. I was shown her after the birth and then I didn't see her for 24 hours. They only bring the babies for feeds. If a woman doesn't know how she asks and they help until she herself gets the hang . . . No one is allowed in the ward to visit, no one at all. I looked out of the window and saw B. The father has to ask about the birth at the information desk, he can't see the baby. They don't even allow us mothers into the children's ward. They don't say why. They don't know why themselves, they can't give a reason — there is just this regulation . . . To be honest, I have to say they treat people badly, like a dog that gives birth and that's it. That's how they see childbirth. And afterwards, things are always happening that wear down the nerves — they all have their own rules, one comes and says like this, another comes and says like that. They're all so bossy and like giving orders. It's very unpleasant, as if we were small children . . . It doesn't matter that the staff are women — I don't think women ought to be doctors; they ought to be somewhere else and doctors should be men.

Masha: After the birth I felt a wonderful bliss, all the pain left me immediately. But later in the hospital my mood was terrible. The cuts didn't heal and because the birth was difficult I was there a long time and all the other women left. The nurses tried to cheer me up, they would come in and sympathise, talked with me as if I were a baby, but I wanted to go home very much. In the end I was hysterical so they gave in and sent me home even though I wasn't quite well. Usually they send you home on the seventh or eighth day but I went home on the fifteenth. In the hospital the babies have to be kept separately, and when they bring them in you put on masks. They bring them in six times a day for feeding, but not during the night. Of course they will help you with the feeds . . . Husbands aren't allowed to visit, no way. We could only talk with me leaning out of the window . . . Yes, it was difficult, but you forget the pain very quickly, it's hard to describe it all now.

Conclusion

The experiences of Sveta and Masha show that it is difficult to generalise about the details of Soviet maternity care. Within one city they met with different policies on injections and episiotomies, and with different attitudes on the part of the medical staff. However, what they did share was a willingness to see their labour

through using their own resources, a willingness which was ignored by the doctors. Both had to comply with whatever measures were deemed necessary; neither was involved in making decisions. A statement made in a medical journal by a Soviet doctor shows why they hold to this approach:

> The doctor cannot put the question of the desirability of this or that therapeutic measure before the woman in labour and establish this right to choose treatment measures. You see, if we establish this right for women in labour then, whether we like it or not, it automatically shifts responsibility for the outcome of the birth onto the childbearing woman. Therefore such a position is incorrect.[69]

This attitude fails to realise that women's active and genuine participation in labour, in partnership with doctors, is a factor that can favourably influence its outcome, and it fails to recognise that even if problems do occur, women may well be prepared to take the consequences of their decisions. It is sad to see responsibility being denied women by members of their own sex. Sveta, in resentment at the orders being handed out, even began to wish that all doctors were men. Feminisation of the medical profession without a feminist critique is no guarantee that women will have better experiences.

The crux of the problem is a medical model which is narrowly scientific, and does not take account of the emotional and social aspects of becoming a mother. The scientific approach has achieved a lot in what was a backward country, though even in its own terms its success has now either levelled out or declined. The perinatal and infant mortality rates are no longer cause for boasting. The system of maternity care has also had consequences, not measurable by statistics, for the social role of mothers.

By sentimentalising a woman's feelings towards her baby, and by excluding her relations and friends from close involvement with the birth, the Soviet approach emphasises her lone responsibility for the child she has borne. In this way traditional networks of female support have been undermined. Though in theory the state acknowledges that giving birth is a contribution to society and that mothers are owed respect and support, in practice women undergo lonely, unsupported and powerless labours.

Notes and References

1 R. Batalova, 'Human Birth' in *Woman and Russia* (London: Sheba Feminist Publishers, 1980), p. 45.

2 A.M. Kollontai, 'Okhrana materinstva i mladenchestva i rabotnitsa' in *Materialy pervogo vserossiiskogo soveshchaniya po okhrane materinstva i mladenshestva* (Moscow, 1921), p. 31.

3 A.N. Antonov, *Sanitarno-prosvetitel'naya rabota po okhrane materinstva i mladenchestva* (Leningrad, 1926), p. 27.

4 Regarding infant mortality see note 7. For maternal mortality see R. Gause and L.S. Persianinov, 'Maternity and Infant Care in the Soviet Union' in *Obstetrical and Gynaecological Survey*, vol. 26 (1971), p. 615.

5 R. Bang, 'Pregnancy and Childbirth in Developing Countries' in *ISIS*, no. 20, p. 28.

6 N.A. Kravchenko and I.P. Katkova, *Sotsial'no-ekonomicheskie aspekty planirovaniya sem'i* (Moscow, 1977), pp. 50—2.

7 The infant mortality rate has not been published since 1974, when it was 27.9 per 1,000 live births. C. Davis and M. Feshbach, 'Rising Infant Mortality in the USSR in the 1970s' in *International Population Reports*, Series P-95, no. 74, US Dept of Commerce, ch. 1, pp. 1—6.

8 *Zdorov'e*, no. 1 (1968), p. 7.

9 A. Dernovoy-Yarmolenko, 'Chetvert'reka zhenskogo meditsinskogo obrazovaniya' in *Vrachebnoe Delo — Nauchnyi Meditsinkii Zhurnal* (Kharkov, 1928), p. 3.

10 *Prakticheskii vrach*, no. 14 (1913), p. 216.

11 We are indebted to E. Waters for providing sources and discussing attitudes related to the 1920s.

12 B.S. Ginzburg, *Rodovspomozhenie i aborty v Zapadnoi Sibiri* (Tomsk, 1931), p. 13.

13 A. Dernovoy-Yarmolenko, 'Chetvert'reka zhenskogo meditsinskogo obrazovaniya' and M. Ryan, *The Organisation of Soviet Medical Care* (Oxford: Martin Robertson 1978), p. 42.

14 *Vestnik Statistiki*, no. 1 (1983), p. 73.

15 S.S. Yerman, *Organizatsiya rodovspomozheniya v kolkhozakh*(Moscow, 1934), p. 29.

16 K.K. Skrobanskii, 'Sleduet li zabyvat' pri organizatsii rodovspomozheniya — organizatsiyu rodovspomozheniya na domu' in *Zhurnal Akusherstva i Zhenskikh Bolezhnei*, book 3 (1926), p. 230.

17 Kravchenko and Katkova, *Aspekty planirovaniya sem'i*, p. 25.

18 I.M. Avdeeva, 'Izuchenie prichin i uslovii, sposobstvuyushchikh soversheniyu prestupnykh abortov, i mery po ikh ustraneniyu' in *Voprosy Preduprezhdeniya Prestupnosti*, no. 2 (1965), p. 75.

19 *Zdorov'e*, no. 5 (1973), p. 15.

20 For general descriptions of antenatal care see: G. Muchiev and O. Frolova, *Okhrana zdorov'ya ploda i novorozhdennogo v SSSR* (Moscow, 1979) and *Organizatsiya rodovspomozheniya i ginekologicheskoi pomoshchi v SSSR* (Moscow, 1980).

21 S.N. Davydov, *Deontologiya v akusherstve i ginekologiya* (Leningrad, 1979), p. 17.

22 Voronin, 'Opyt psikoterapii bol'nikh rvoti beremennykh' in *Akusherstvo i Ginekologiya*, no. 7 (1980), p. 38.
23 T. Krotova, in *Sovetskaya Kultura* (23 Jan. 1976), p. 6, and M. Ryan, 'Soviets Criticise Their Own Polyclinics' in *World Medicine* (Oct. 1979), p. 77.
24 *Zdorov'e*, no. 1 (1972), p. 18.
25 *Zdorov'e*, no. 5 (1977), p. 22.
26 *Zdorov'e*, no. 10 (1968), p. 14 and no. 4 (1969), p. 24.
27 *Zdorov'e*, no. 3 (1974), p. 18 and no. 10 (1968), p. 14.
28 *Organizatsiya rodovspomozheniya i ginekologicheskoi pomoshchi v SSSR* (Moscow, 1980), p. 50.
29 *Current Digest of the Soviet Press*, vol. 28, no. 18 (1976), p. 4.
30 L. Kurilenko et al., 'Organizatsiya mediko-sotsial'noe pomoshchi rabotnitsam promyshlennikh predpriyati v zhenskikh konsul'tatsiyakh' in *Sovetskoe Zdravookhranenie*, no. 1 (1980), pp. 30—3.
31 A.G. Pap et al., *Antenatal'naya okhrana ploda i profilaktika perinatal'noy patalogii* (Kiev, 1979), pp. 56—7.
32 N. Sokolova, 'Voprosy izucheniya iskhodov beremennosti i zhenshchin' in *Zdravookhranenie Rossissk Federatsii*, no. 3 :1980), pp.13–15.
33 *Zdorov'e*, no. 5 (1976), pp. 20—1.
34 *Zdorov'e*, nos. 3, 5, 7, 10 and 12 (1974).
35 A. Yu. Lur'e, *Izbrannye Trudy* (Kiev, 1960), p. 158.
36 *Organizatsiya rodovspomozheniya i ginekologicheskoi pomoshchi v SSSR* (Moscow, 1980), p. 55.
37 Personal communication from a doctor at a women's clinic, Moscow, 1981.
38 *Zdorov'e*, no. 6 (1969), p. 24 and no. 2 (1972), p. 16.
39 For a more detailed discussion see the chapter on 'Workers By Hand and Womb'.
40 L. Kurilenko et al., 'Organizatsiya mediko-sotsial'noe pomoshchi rabotnitsam promyshlennikh predpriyati v zhenskikh konsul'tatsiyakh'.
41 We are grateful to E. Waters for allowing us to use these interviews. They were conducted in Moscow in 1978.
42 A.G. Pap et al., *Antenatal'naya okhrana ploda i profilaktika perinatal'noy patalogii*, pp. 108—9. S.N. Vakoolik and S.P. Radchook, 'Opyt organizatsii raboti viyezdnikh zhenskikh konsul'tatsii v sel'skoy mestnosti' in *Sovetskoe Zdravookhranenie*, no. 1 (1978), pp. 24—6.
43 G. Muchiev and O. Frolova, *Okhrana zdorov'ya ploda i novorozhdennogo v SSSR* (Moscow, 1979), pp. 36—9.
44 *Osobennosti organizatsii akushersko-ginekologicheskoi pomoshchi v sel'skoi mestnosti* (Moscow, 1977), p. 7.
45 I.N. Zhelokhovtseva, *Organizatsiya akusherskoi pomoshchi v sel'skoi mestnosti SSSR* (Moscow, 1963), p. 5.
46 Personal communication from a doctor in a women's clinic, Moscow, 1981.
47 S.N. Davydov, *Deontologiya v akusherstve i ginekologiya*, p. 45.

48 I. Zhelokhovtseva, *Organizatsiya statsionarnoi akushersko-ginekologicheskoi pomoshchi* (Moscow, 1977), p. 6.

49 N.V. Arkhibaeva, *Organizatsiya raboty rodil'nogo doma* (Moscow, 1965), p. 20.

50 A.G. Pap et al., *Antenatal'naya okhrana ploda i profilaktika perinatal'noy patalogii*, pp. 148—50.

51 Ye.I. Kosach and G.A. Lukashchevich, 'Electroanalgeziya v akusherstve' in *Zdravookhranenie Belorossii*, no. 7 (1980), pp. 50—1.

52 Arkhibaeva, *Organizatsiya raboty rodil'nogo doma*, p. 20. H.C. Heins, 'Perinatal Mortality Red, White and Black' in *Journal of the South Carolina Medical Association*, vol. 67, no. 11 (1971).

53 E. Danilishina, *Razvitie profilakticheskogo napravleniya v akusherstve v SSSR* (Avtoreferat dissertatsii), (Moscow, 1977), p. 18.

54 I. Chalmers and M. Richards, 'Intervention and Causal Inference in Obstetric Practice' in *Benefits and Hazards of the New Obstetrics*, eds T. Chard and M. Richards, Clinics in Developmental Medicine, no. 64 (London: Spastics International Medical Publications/William Heinemann Medical Books, 1977), pp. 34—61.

55 Ye. A. Chernukha, review in *Akusherstvo i Ginekologiya*, no. 7 (1980), pp. 61—2. V.Ya. Golota et al., 'Techenie i vedenie beremennosti i rodov pri perenashivanii' in *Akusherstvo i Ginekologiya*, no. 7 (1980), p.20.

56 Reported in the newsletter of the Association for Improvements in the Maternity Services, Spring 1981, p. 11.

57 Kosach and Lukashchevich, 'Electroanalgeziya v akusherstve', and *Organizatsiya rodovspomozheniya i ginekologicheskoi pomoshchi v SSSR* (Moscow, 1980), p. 59.

58 S.M. Zol'nikov et al., 'Refleksoterapiya v akusherskoi klinike' in *Akusherstvo i Ginekologiya*, no. 5 (1981), pp. 8—9.

59 A.G. Pap et al., *Antenatal'naya okhrana ploda i profilaktika perinatal'noy patalogii*, pp. 50—1.

60 Personal communication from doctors at two women's clinics, Moscow, 1981.

61 *Zdorov'e*, no. 11 (1976), p. 4.

62 *Zdorov'e*, no. 9 (1975), p. 25; no. 2 (1972), p. 16; no. 6 (1969), p. 25; no. 10 (1968), p. 14; no. 3 (1967), p. 3.

63 *Zdorov'e*, no. 3 (1967), p. 3.

64 I.N. Zhelokhovtseva, *Organizatsiya statsionarnoi akushersko-ginekologicheskoi pomoshchi*, p. 6.

65 *Zdorov'e*, no. 5 (1980), p. 23.

66 L. Chernomaz, *Puti profilaktiki prezhdevremennykh rodov i perinatal'noi smertnosti u zhenshchin s razlichnoi stepen'yu riska nevyashivaniya beremennosti* (Avtoreferat dissertatsii), (Tashkent, 1979).

67 A.G. Pap et al., *Antenatal'naya okhrana ploda i profilaktika perinatal'noi patalogii*, pp. 56—7.

68 A.G. Pap et al., ibid., pp. 26—8.

69 S.N. Davydov, *Deontologiya v akusherstve i ginekologiya*, p. 47.

6 SOVIET RURAL WOMEN: EMPLOYMENT AND FAMILY LIFE
Susan Allott

SINCE 1917 the Soviet countryside has been seen by successive generations of Soviet policy-makers as a problem area. From the first days of the revolution the Bolsheviks were obliged to come to terms with the essential paradox of their position: having seized power with the support of the relatively tiny urban working class, they were obliged to consolidate their gains in a country where four people in every five lived on the land.[1] Armed with an ideology which made the proletariat the focus of social progress and faced with international hostility, the Soviet government was from the first committed to urban development and industrial growth. Alternate attempts at appeasement and coercion of the peasantry throughout the 1920s to ensure a supply of grain for the cities led ultimately to a massive use of force in 1930 when the campaign for rapid collectivisation of agriculture was begun. Since the 1930s, government attitudes towards the rural population have been fundamentally exploitative: its role has been to feed the cities and to provide a pool of surplus labour to facilitate industrial development. The women of the countryside have invariably been seen as the most backward and conservative sector of society with the lowest levels of education and training and the highest resistance to the aims and appeals of the Communist Party. Yet, as the problems of agriculture continue to provide a major headache for Soviet planners, it has become clear that rural women today are no longer a dormant and uncomplaining mass. Soviet observers of rural life are becoming increasingly aware that the fulfilment of women's demands is a crucial element in the success or failure of agriculture in many regions of the USSR.

Until as late as 1960 the majority of the Soviet population lived in the rural areas. Today the rural share of the population has fallen to 37 per cent; a considerably larger proportion than in other developed industrial countries.[2] Yet despite the relatively large numbers of people who live on the land, Soviet agriculture is in many areas faced with an acute shortage of skilled labour. Where industrial development has been most intense, in European areas of the USSR and in Siberia, the demands of the factories for labour and the attractions of city life have drawn millions of young people away from their native villages during the past two decades. Since

1970 the rural population of the Non Black Earth Zone, the northern half of the European USSR and a major area of mixed farming, has fallen by more than a fifth, most of the migrants to the cities being young people. As this trend is expected to continue, farming in this region is faced with the problem of an ageing and low-skilled workforce.[3] Although the government has invested heavily in agriculture since the mid-1950s, and levels of mechanisation have increased dramatically, productivity has remained low. Without a skilled and stable workforce, economists warn, capital investment will remain ineffective.

In recent years the state has increasingly come to look to women to help solve its economic problems. As the birthrate has fallen, the need for labour has prompted the state to urge both urban and rural women to have larger families. At the same time the immediate demands of the economy have led to appeals to rural women to operate agricultural machinery and staff livestock farms. Many of the demands of national government have met with local resistance, either from women themselves, or from men who are unwilling to admit women to traditionally male occupations. As young women increasingly reject the few occupations which are effectively open to them in the countryside in favour of more satisfying work and better conditions in the towns, economic planners and farm managers are being obliged to take notice of women's response in their efforts to solve agriculture's problems.

Female Employment in Rural Areas
Machine Operators
A chronic shortage of skilled workers in arable farming has, since 1969, prompted the Soviet government to introduce a series of measures to encourage women to train and work as agricultural machine operators. In the 1930s a number of patriotic appeals led to the training of thousands of peasant women to drive tractors, at that time a symbol of technological progress on the new collective farms. The few women who in this way became heroines of the early five-year plans were joined by an army of former trainees when war broke out in 1941. As skilled men left the farms for the front, women came to dominate tractor and combine driving in the USSR.[4] Yet immediately after the war the proportion of women in these jobs fell dramatically: men were returning from the war and workers were urgently needed in the traditional female sphere of dairying. Most important of all, women themselves were tired of work which, under the agricultural organisation of the day, obliged them to accept difficult living and working conditions and took

them away from their homes and children for prolonged periods. In the postwar years this work, which was once a symbol of emancipated womanhood, has become an almost exclusively male domain. By 1970 the number of women employed as machine operators had dwindled to such a low level that it was no longer recorded in the Soviet census. At the same time, the high turnover of men in these jobs and the migration of many to the cities caused sufficient concern for the government to attempt a new campaign of female recruitment.

New legislation has provided for the development of vocational training for women to become machine operators. Once at work, women in these jobs receive additional holidays and retirement at 50 after 15 years' service. Farm managements are obliged by law to provide women with the newest machines and full technical support, and to set work quotas for women 10 per cent lower than for men. At the same time the press has tried to attract women into this work by focusing attention on those few who have become highly successful machine operators. Yet after 13 years the results of the campaign have been meagre: less than 1 per cent of agricultural machine operators are women.[5]

The reasons for this lack of success are debated regularly in the national press. It has become clear that many aspects of the work which women dislike are unattractive to men also; design faults in tractors and combines lead to excessive amounts of time spent on repairs, whilst the vibration, fumes and dust experienced by drivers are all much higher than approved safety levels.[6] Yet the extremely long hours worked by most machine operators in distant fields during peak periods are especially difficult for women who bear prime responsibility for childcare and domestic tasks. These factors are, in themselves, enough to dissuade most women from seeking training, yet they are reinforced by the common practice in rural schools of providing technical education for boys only and by the reactions of parents, husbands and teachers who regard the work as unsuitable for women.

Yet for many women who are undeterred by traditional notions of 'women's work', and who receive training as machine operators, the battles are only just beginning. The principal difficulties encountered by women who attempt to take up the work are created by the attitudes of male managers and workmates. 'It's extremely important', remarked one leading woman tractor driver, 'how women are received by men who see the machine operator's profession as practically their monopoly. It has to be said that the reception can be none too friendly.'[7] Farm managers who are

unwilling to employ women in this work but are reluctant to be seen as openly obstructive often resort to the ploy of providing women with an ancient wreck in the hope that they will give up the work in despair. As complaints to the press make plain, this stratagem is often successful. 'It's misery, not work! All I did were endless repairs', is a typical grievance.[8] Managements regularly flout the law by assigning new machines to men, the usual excuse being, 'It's a heavy tractor; you won't be able to work on it. You'll just spoil it.'[9] Likewise, the technical back-up for women stipulated in the new laws often fails to materialise, sometimes deliberately: 'You go to the mechanic and he curses you. He hasn't got time to mess about with your tractor: in working hours he either reads a book or mends his own motorbike.'[10] In the worst examples of discrimination, farm managers simply refuse to employ women in the job for which they have trained. A not untypical story which found its way into the press involved a girl who came top of her class in the final qualifying exams for tractor drivers. She was promised a new tractor but later told there were none available, though all the boys who studied with her were assigned machines at once. She was finally employed washing out milk churns and became the object of ridicule of her former classmates who would greet her with, 'It's your own fault. You should have been born a boy and you'd have been driving a tractor long ago.'[11]

The intervention of the press and Communist Party occasionally rights the wrongs suffered by aspiring women tractor drivers. Yet it is clear that in far more cases women simply give up the unequal struggle and find other work in the village or seek skilled work in the towns. The only areas of the country in which the campaign has been a success are those in which local party secretaries have taken government measures seriously and have adhered to the letter of the law. In a tiny minority of cases local officials have looked beyond the legislation and considered the needs of women in agricultural employment. In the most outstanding example, Millerovo district in the Rostov Region, over a quarter of tractor brigades are staffed solely by women. All the women in these brigades enjoy full technical support, priority access to childcare facilities and mobile shops with goods in high demand, the use of field stations with showers and rest rooms and the provision of transport to and from work. Most important of all, the large numbers involved make possible the establishment of a two-shift system for women which cuts working hours and permits regular days off.[12]

Without efforts of this type, which attempt a genuine response to

the needs of women in the countryside, there is little likelihood that sufficient numbers of women will ever be found to solve staff shortages in this field. Women are clearly no longer prepared to be self-sacrificing in response to patriotic appeals. In the absence of a national emergency they expect more sensitivity to their needs and attention to their demands if they are to fulfil the role the government has in mind.

Dairying
Unlike tractor driving, dairying has always been regarded as an appropriate occupation for women. In peasant households before collectivisation, the care of dairy cows was considered to be women's work and, since 1930, women have dominated dairy farming on both collective and state farms so totally that in most regions of the USSR over 96 per cent of staff involved in milking are women.[13] Yet dairying is far from being an easy option in the conditions of the Soviet countryside. Cows in the USSR have traditionally been milked three times a day, making unsocial hours a permanent feature of the dairy woman's working week. A typical day in dairying stretches from four or five in the morning until six or seven in the evening, whilst on a significant proportion of farms women are on call from the first milking session at 3 a.m. to the end of the third milking session at ten or eleven at night. Under this single-shift system women are free to return home between milking times in both morning and afternoon, yet the effect of such a work schedule, as one writer has put it, is that 'women do not in fact feel free from their work at any time of the day or night'.[14]

Not only are the hours worked in dairying extremely awkward but, for many women, holidays are rare. On collective farms dairy women receive an average of no more than one day off per week throughout the year, giving them less free time than any other group of workers in industry or agriculture. Add to this the fact that on a high proportion of farms feeding and mucking out are still done by hand and that machinery in dairy units often breaks down and is left unrepaired, and a picture emerges of a job which makes extremely high demands of women's time and energy.[15] The rewards for all this effort are high by the standards of agricultural wages, with women often receiving higher basic pay than agricultural machine operators. As the work not only pays well but, unlike work in arable farming, provides a constant income throughout the year, dairying attracts women who are single parents or married with large families.[16] Women with heavy family

responsibilities are clearly prepared to endure the rigours of the job for the sake of the financial security that it brings.

In recent years investment in dairy farming has greatly improved levels of mechanisation. Over 40 per cent of dairy farms are now fully mechanised which has greatly reduced the physical strain of the work and has diminished the risk of premature arthritis in the hands, the major occupational health hazard of milking staff.[17] Yet mechanisation alone has proved insufficient to attract young women into dairying and many farms have suffered from labour shortages over the past decade. The problem of staffing has prompted farm managements to take a fresh look at traditional work schedules and the resulting innovations have now been adopted as recommended practice by the USSR Ministry of Agriculture. The favoured system of the ministry, already in use on the more progressive farms in the USSR, involves milking twice a day rather than three times and splitting the long working period into two shifts. Each woman works either the morning or evening shift, alternating each week, and, as extra staff can be attracted by the shorter hours, deputising dairy women ensure that everyone works a five-day week. A survey of farms using the two-shift system found that, since its introduction, the number of women under 30 employed on their dairy units had doubled.[18] The publicity which this system has received in the national press has provoked increasing complaints from women who feel that they have put up with arduous working conditions for too long, and has led many to voice demands for regular days off. For many, however, the most common response to poor conditions is to look for work elsewhere. Farm managers are increasingly coming to realise that without reasonable hours of work and adequate levels of mechanisation they are faced with the constant problem of high staff turnover and low productivity.

In some regions, however, staff shortages have become so severe that the problem cannot easily be solved by a rearrangement of work schedules. In Pskov Province, for example, in the north-west of the European USSR, dairy units are so short of labour that it is literally impossible to introduce a two-shift system, and without such a system young women refuse to work on the farms.[19] Thus a vicious circle is created in which the old-style dairy farms become dominated by elderly women and the problem becomes ever more acute. In recent years the Komsomol has attempted to alleviate situations of this type by directing nearly 400,000 of its members into dairying and by urging whole classes of school-leavers to remain on the farms for at least a year before going on to further

education or work elsewhere.[20] It remains to be seen, however, whether campaigns of this type will have any long-term effect on staff turnover or working conditions.

In recent years it has become evident that the mechanisation of dairying does not always provide better jobs for women but may provide increased opportunities for men. There is a clear tendency amongst farm managers to employ men in the most highly-mechanised units both in dairying and in other areas of animal husbandry. In many cases, women are employed exclusively in machine-milking, whilst back-up staff serving dairy units are men with technical skills. Very few women are trained in technical colleges as machine operators for livestock farms and cases have been reported where farms have been fully mechanised but no attempt has been made to retrain experienced women livestock workers as technicians or operators. It is significant that, as young women are refusing to work on old-fashioned dairy farms, young men from the new, highly-mechanised units are increasingly to be found amongst the prizewinners in national competitions for milking machine operators. With the advent of machinery, men clearly feel that this work is no longer beneath their dignity; as two recent prizewinners remarked, 'It's a machine operator's profession now.'[21]

Agricultural Labourers
For women who are not prepared to tolerate prevailing working conditions in livestock units and are unwilling to make the attempt to become machine operators, opportunities for congenial skilled work in the villages are very few indeed. The largest group of women employed in the countryside are agricultural labourers whose work in arable farming is seasonal, low-skilled and often backbreaking. More than two-thirds of all female agricultural workers are employed in this manner, the content of their work changing with the demands of the farming year.[22] As most of the work involved in tillage and harvesting has now been mechanised, women labourers are involved principally in work which is seen as subordinate to the main agricultural campaigns: sorting seed in winter, weeding root crops in spring, stacking hay in summer, lifting potatoes and beet in the autumn. Female manual labour is also extensively employed in the cultivation of cotton, rice and fruits of all kinds. In practice, the sharply seasonal pattern of arable farming over much of the USSR means that, whilst machine operators can be transferred to a wide variety of driving jobs during the winter, manual workers are often temporarily unemployed, or

are recruited on a casual basis for work during the winter months.

As manual agricultural labour is therefore both seasonal and unskilled, the income which these women receive is considerably less than they could earn in dairying. The work is typically the province of middle-aged and elderly married women who are poorly educated and lack any sort of professional training. Women with young children are also often attracted to the work precisely because of the seasonal idleness and less stringent work schedule. Though these women frequently express dissatisfaction with the nature of the work itself, it often appears to be the only way of earning money where childcare facilities are inadequate or non-existent.[23] Manual fieldwork is by nature arduous and repetitive, demanding constant exertion. A women sugarbeet grower gives an example of what is involved in thinning out the beet seedlings after sowing:

> The main thing is not to make a mistake when, straining your eyes and summoning all your patience, you try to leave the strongest seedlings in the rows, not to litter them with sickly shoots. Up to thirty sprout in every metre but you only keep six or seven. You have to leave enough room for the root to grow between each seedling that you keep. Altogether up to 400,000 seedlings are pulled up from each hectare. And you have to bend over every one of them, have a long look at some of them; you don't choose immediately as if one were as good as another. And from the very first the weeds have to be pulled up. Your back aches and your feet get heavy. That's what it's like, farming the crop.[24]

Despite high levels of mechanisation in certain processes, sugarbeet still demands a great deal of manual labour. The manner in which the production of this crop has changed as mechanisation has increased provides probably the most graphic illustration of the rigid division of labour between the sexes in agriculture. As the operation of agricultural machinery is so thoroughly dominated by men, the leading teams of workers in sugarbeet production are now male or led by men. There have been few attempts to train women, who have been long involved in beet production, to drive the new machinery. Instead, an extraordinary split has developed in which, as one journalist put it, 'the men have the machines, the women have years of experience, natural patience and the knack of dealing with this capricious crop'.[25]

There is evidence that women feel upset at this turn of events,

and particularly at the way in which their work has been devalued with the coming of machines. There have been complaints that, whilst the men get honours and rewards, the women are still toiling unnoticed as their grandmothers did. Certainly, it is a state of affairs which holds little appeal for young women, as one team leader in the Ukraine remarked,

> Those of us who are used to manual work are getting older. When we finish work who will grow the beet? Young girls today have secondary education so of course it's hard on them to become labourers. Unskilled work scares them off. There's no way out of this. We need 100 per cent mechanisation in beet production. There's no question about it. But until the technology is developed it's essential to raise the status of manual work in operations which decide the fate of the harvest.[26]

To ease the problem several areas have experimented with various types of bonus system for manual workers which have proved popular with the women involved. Some farm managements have tried to introduce two-shift working at peak periods to cut working hours, or to use greater quantities of herbicides to avoid much of the heavy work involved in weeding fields sown with vegetables.[27] Alongside these initiatives there have been occasional attempts in the press to paint glowing portraits of leading women farm labourers. Yet the job performed by the largest single group of women in the Soviet countryside remains in the eyes of the world at large, and of the women themselves, an extremely unglamorous profession.

Between 1959 and 1970 the number of women employed in rural areas fell by a sixth to just under 22 million. In the same period, patterns of rural employment altered considerably as the industrial and service sectors of the rural economy expanded. In 1959 more than three-quarters of working women in the countryside were employed directly in agriculture. By 1970 one woman in three was working in the service sector, rural industry or education and welfare.[28]

Industry and the Service Sector

The expansion of the service sector and rural industry has begun to provide an alternative for women to manual labour in agriculture. Though rural industry in particular still employs very few women in Central Asia and the Caucasus, in the more developed European areas of the country this aspect of the rural economy is becoming

increasingly important. In the most highly developed regions of the Baltic republics, one in five rural women is now employed in industry and construction, transport or communications.[29] The industries in which women are employed are, in the main, connected with local agricultural production, for example, food processing, the production of animal feed or textiles. Additionally, women are employed in factory farming units which may be independent of state or collective farms and produce primarily eggs, chicken and pork. A survey of rural industry in Belorussia in the early 1970s found that the majority of its employees were men. The women employed in factories were generally less well-educated than the men and concentrated in the least skilled work. Young people did, however, make up a far higher proportion of the workforce in industry than on the farms; one in five as against one in ten; in the youngest age-groups the women had higher levels of education than their male peers.[30] For young women who have no wish to leave the countryside, the development of industry offers some the chance of skilled work, though conditions in rural factories have been found to fall short of approved standards of health and safety. The rigid division of labour characteristic of agriculture is, however, perpetuated in factory farming, where women look after the animals and men operate the machines. Although little information is available about this aspect of women's employment, limited evidence suggests both that the hours are reasonable and that the work is particularly well paid by comparison with equivalent work on the farms.[31]

The service sector, though expanding, cannot as yet provide sufficient job opportunites for girls leaving school who would like to take up skilled work in their native village. The provision of services is, however, seen as a fundamentally female sphere of work with employees from health workers to cooks seeing themselves as members of the 'caring professions'. Unskilled women workers in the service sector appear to have on average higher levels of education than unskilled workers in agriculture. It would appear that women are content to undertake jobs which make few demands of their abilities in exchange for better working conditions than can be found in farming.[32]

Specialists and Managers

At specialist level in health and education, women predominate in both town and country. In the countryside, teaching is slighly less feminised than in the towns but, even so, more than three-quarters of rural teachers are women. Despite their numerical predomi-

nance, women are disproportionately concentrated in class teaching, whilst the majority of head teachers are men. Though rural teachers are overall less highly trained than their urban counterparts, they nevertheless represent the largest group of workers in the countryside with higher or specialised secondary education.[33] Though Soviet law provides for a range of benefits to rural teachers in order to attract a stable workforce into education in the countryside, it is clear that many women experience problems in obtaining housing and find the usually unavoidable necessity of keeping an allotment difficult to combine with the demands of their work in the schools and in the cultural life of the village. As a result, teachers who remain in the countryside are usually of rural origin. Both teaching and medicine are extremely popular choices of profession with rural girls, yet the lower standards of rural education have meant that school-leavers aften experience great difficulty in gaining a place in a medical or pedagogical institute. As a result, rural schools suffer from a high turnover of young staff from urban backgrounds who work their compulsory three-year period in the countryside and then return to the town at the first opportunity.[34]

Whilst specialists in health and education are predominantly female, men form the majority of aricultural specialists in the USSR. Women make up approximately two-fifths of agronomists and veterinary surgeons or technicians, their proportion having risen slowly over the last ten years. Amongst other specialists employed by the farms, women form a majority of accountants and economists. It is significant that the rural bias against women working with machines extends to specialist level; just over 5 per cent of engineers and technicians on the farms are women, despite the fact that women make up almost half the engineers employed across the country as a whole.[35]

Farm managers are increasingly recruited from the ranks of agricultural specialists, yet very few of them, less than 1 in 50, are women. Women remain a minority at the lower level of brigade leader or head of a livestock unit. Although women form the overwhelming majority of livestock workers, no more than 40 per cent of management posts in this area are held by women.[36] Surveys have indicated that the dearth of women in management persists despite the fact that women are often more highly trained than men. This has been found to stem on the one hand from a reluctance to promote women to posts of responsibility due to an underestimation of their abilities and, on the other hand, from a tendency amongst women themselves to refuse these jobs due to

family responsibilities. Women are often unwilling to take on work which is very demanding and time-consuming when they are at the same time expected to cope almost single-handed with the demands of their families. Commenting on this situation recently, a district party secretary in the Ukraine remarked:

> It is evident that a woman on whose shoulders lies the main burden of concern for the running of the home and the children's upbringing at times finds herself faced with an unhappy dilemma: work or home? And so we lose high-class specialists and good, competent managers.[37]

Nikita Krushchev, at a farm conference in Kiev in 1961, commented on the workforce in agriculture that, 'It turns out that it is the men who do the administrating and the women who do the work.'[38] Twenty years on, Khrushchev's crude but telling observation is echoed in the interview with the Ukrainian district party secretary, 'The strong and healthy man is to be found sitting behind an office desk, whilst out in the fields where there is mud, dust and heavy physical work, there is the woman.'[39]

Although the participation of women in the rural workforce is slowly changing, the overwhelming majority remain firmly at the bottom of the chain of command, their chances of promotion strictly limited by the burdens of the 'double shift' and discriminatory attitudes in the workplace. The findings of rural sociologists and complaints to the press make it clear that many women feel their powerlessness acutely. Complaints by women to party officials are principally about rudeness, indifference and high-handed attitudes towards them on the part of their male superiors. The press provides numerous examples of women who are upset at finding themselves not only expected to work in deplorable conditions but also the target of obscenities and condescension.[40] Employment in the countryside remains firmly divided by sex both in areas of work and on the ladder of promotion, and women are clearly resentful of those who add insult to injury by taking advantage of this state of affairs.

The Changing Rural Family
In recent years, concern over labour shortages in both urban and rural areas has increased as the birthrate has fallen. In the past, increased industrial output in the Soviet Union has been largely dependent on an expanding labour force; labour productivity has remained considerably lower than in other developed countries. In

recent years government attention has turned to the family to secure the workforce of the future. The birthrate in rural areas of the Soviet Union has always been higher than in the towns, yet the sharp decline in births which took place in the towns during the 1960s was experienced in the villages also. Outside the predominantly Moslem areas of Central Asia and the Caucasus, the small family characterised town and country alike: more than three-quarters of rural families in the Russian Republic now have no more than two children. Nevertheless, the birthrate amongst rural women is today higher in all age-groups than it is in the towns, and this is especially marked amongst older women; births to women over 30 in the countryside are more than double the number in the towns.[41] The higher rural birthrate is not merely a continuation of traditional practices but reflects living and working conditions in the countryside. The seasonal nature of much argicultural work has in effect always served as a form of part-time employment for women with young children, housing is considerably less cramped than in the cities whilst relatives and neighbours are more readily available to assist with child-minding. In addition, the countryside provides a less hazardous environment for children and one in which they are encouraged to participate in their parents' concerns from an early age by helping on the family's allotment. Yet the development of the small family in the last 20 years provides an indicator of changing attitudes towards marriage and family life in the countryside. For centuries peasant tradition placed an enormous burden on women in the home and on the family's land, at the` same time as it continually reinforced their subordination to men at every level of society. The poverty of the Russian peasantry made marriage a matter of economic calculation: romantic attachments were a luxury few could afford. 'Let a wife be like a cow so long as she is strong', ran the proverb which succinctly summarised this state of affairs.[42] Rural attitudes towards marriage slowly began to change between the wars under the impact of social upheaval caused by the revolution, changing legislation and the propaganda of the Community Party's Women's Department. Yet the calamitous losses of the Second World War left a generation of rural women with little hope of marriage and a tendency to accept gratefully any husband who came their way. The following account from a woman who married in the early 1950s provides a graphic example of the prevailing attitudes of the post-war years:

> He came from a neighbouring village for another girl but she refused to marry him. His friend suggested me. They called me

out of the club into the street. It was a dark night. They made
the proposal and I, just imagine, knowing about his character
and good qualities only from what I'd heard, accepted at once. [43]

Over the past two decades, the spread of secondary education
and increasing geographical mobility have led to a considerable
modification in rural attitudes towards the family. A more favour-
able demographic balance, together with the impact of the mass
media, have had a profound effect on women's views of marriage.
Young women especially have come to see emotional fulfilment as
a primary function of family life. Although the choice of a marriage
partner remains more restricted in the countryside than in the
towns, women appear to have abandoned the prosaic attitudes of
the past in favour of a search for personal happiness.

Romance

Letters to the press indicate that rural women are increasingly
preoccupied with romance, 'Love with a capital L', as one writer
recently put it: 'What if it's my destiny to marry him and because of
my parents I've let it pass me by?' 'I know that love comes once in a
lifetime and I have fallen in love for good. But the one I love has
married someone else. What am I to do now?'[44] These anguished
questions in letters from teenage girls are not unusual in portraying
the act of falling in love as a dramatic and unrepeatable event. Older
married women recounting their experiences and expressing their
opinions on personal relationships characteristically place a high
value on romantic love as an uplifting and enriching experience:
'Not everyone experiences a great love, it's a gift.' 'I can't forget
that time when I felt as if I had wings', are typical of the sentiments
expressed by rural women in letters to the magazine *Krest'yanka*
('The Peasant Woman').[45] The content of many of these letters
makes it clear that this yearning for love is often likened to a
fleeting romance in later life or associated with an unhappy
personal experience. Many women letter-writers explain that they
did not marry for love in the strict sense but for a whole range of
reasons, from the need for companionship or to numb disappoint-
ment to a sense of pity or, in some cases, revenge. Other
correspondents starkly express the feeling that love is something
which they have missed in life and which they would dearly like to
experience:

I envy those letter writers; they have all loved someone. It
doesn't matter if it was unrequited or if they were married, it

doesn't matter what their relationship was with the one they loved. The main thing is that they know what it is to love. But I feel hurt; am I any worse than other people, or am I just unfeeling? [46]

Love is seen by many older correspondents as unobtainable and beyond one's normal expectations of married life. As such it is to be treasured and worth suffering for: 'My dear', wrote the elderly aunt of a woman involved in an extra-marital affair, 'if you feel a love like that and he returns it, cherish it, don't insult it, don't break down. Hold your head high and go on through everything, only don't renounce love.'[47] This unexpected reaction is indicative of how far women have travelled from the pragmatic and utilitarian attitudes they were constrained to adopt in the past.

Domestic Labour and Childcare
The appearance of romance as an element in rural life has undoubtedly led women in the countryside to entertain far higher expectations of marriage than did their mothers or grandmothers. Yet although the old-established male despotism in the family has all but disappeared from the countryside, marital relationships remain far from egalitarian. As in the towns it is usual in the countryside for men to abnegate all responsibility in domestic labour and childcare, leaving their wives to face the double shift of full-time employment plus almost sole responsibility for the home. In rural conditions, domestic labour is particularly arduous and time-consuming. Though electricity is supplied to nine out of every ten rural homes, and the majority now receive gas, around two-thirds of the housing stock of collective and state farms and almost all housing privately built by rural inhabitants was, in the mid-1970s, without running water, mains sanitation or central heating. In regions where villages are scattered over vast areas or where capital investment has traditionally been very low, these amenities become rarer still.[48] The heavy work involved in carrying fuel and water is unavoidable in many Soviet villages today. A survey of the Novgorod Region in north-west Russia found that the average family spent between 12 and 14 hours each week fetching water and that almost all the family's free time for two months was absorbed by preparing firewood in time for the winter.[49]

Where homes are equipped with modern amenities, rural dwellers are still handicapped by comparison with their urban counterparts through the lack of shops and consumer services. Complaints

to the press by women on the subject paint a picture of sparsely-filled shops with erratic opening hours, interminable delays over repairs, and shoddy workmanship on finished goods. As a result, women are obliged to make regular trips to town to obtain essential items for the home. Both men and women in the countryside work far longer hours in the domestic economy than do city-dwellers and this is due chiefly to the tending of private allotments and the keeping of livestock. In rural conditions this small-scale private agriculture remains essential for the provision of basic vegetables, meat and dairy products; estimates suggest that around half the average rural family's food is produced on these allotments.[50] The nature of domestic labour in the villages is therefore far broader than in the cities and involves men in a good deal of work on the allotments in particular. It must be said, however, that jobs which form the major components of housework in the cities — washing, shopping, cooking, childcare, cleaning — are regarded as women's work in the villages. Time-budget surveys provide a rough guide to the amount and type of domestic labour performed by men and women in rural areas. On an average working day, men spend around half an hour on domestic tasks whilst women spend between three and five hours, mostly on cooking and clearing up. The greatest amounts of time are spent by older women and by those who have least access to shopping facilities, especially where all bread has to be home-baked.[51] In addition to these traditionally 'female' tasks within the home, women supply most of the labour on the private allotments. Men's contribution is often restricted to the repair or construction of shelters for livestock and preparing the soil for the vegetables. Women generally have the major responsibility for the care of livestock and for the day-to-day upkeep of the vegetable garden. A recent survey in Western Siberia found that in areas where well-stocked shops were rare, women put in nearly 23 hours a week on their allotments, compared with a maximum of 12 hours a week worked by the men.[52] A large-scale survey in the Russian Republic found that rural women had only eleven hours free time each week, less than half that of women in the towns.[53]

In village and town alike, the overwhelming responsibility for childcare falls to women. Though places in rural creches and nursery schools have more than doubled since the mid-1960s they in no way meet the very high demand of rural women. Over the country as a whole, one in four rural children of nursery age has a place in some form of pre-school institution, though many of these are seasonal facilities intended to free women for work in the peak agricultural season.[54] Letters to the press indicate the growing

demand for nursery facilities by women who cannot find relatives to take care of their children whilst they are at work, and are no longer content to sit at home or to leave their children unattended during the day. Whether children have nursery places or not, their care in the evenings and on days off rests primarily with women. Sociologists have in recent years noted with concern that a large proportion of rural women experience difficulty in bringing up their children, and that this is often a direct result of the lack of help or understanding received from their husbands. Many women complain that their husbands show no interest in childcare; a recent survey found that in 40 per cent of families the wife had sole responsibility for the children's upbringing.[55] Though sociologists are beginning to stress the need for greater participation by fathers, there is little evidence of action being taken to redress the balance in and particularly at the way in which their work has been devalued of someone who not only recognises the problem but attempts to do something about it. The head teacher of a nursery school in the north of the European USSR described her approach to the subject:

> Not long ago we held a fathers' evening . . . I suggested that before beginning the discussion we should listen to the children; what do they think of you, how do they see you? And I switched on the tape recorder . . . Everyone grew quiet and pricked up their ears. 'My daddy never plays with me or takes me for walks' came a voice from the tape. 'When daddy's drunk I'm frightened of him.' 'On his day off daddy takes me for walks; he tells me all sorts about the trees, about the street, about birds.' 'My daddy gets tired after dinner, lies on the couch and watches television, but mummy washes up and does the washing. Mummy says, "clear the table", but he replies, "clear it yourself." ' That night quite a few left the nursery school shamefaced. We're not in the town here, everyone knows everyone else and could easily recognise the children by their voices. Some of them were indignant — what a thing to do, playing a tape! It's outrageous! — But I thought, if it's hit home then it's been some use.[56]

Sadly, initiatives such as this remain no more than isolated incidents, and it is still a rare household in which the parents share childcare and domestic chores. As one rural sociologist has observed, 'There still remains a considerable gulf between the proclamation of political equality and legal regulation of equal

rights and actual equality in practice between men and women in family and personal relationships.'[57]

The Soviet Media and the Rural Family
The gross inequalities within the family which are characterised by the present distribution of domestic labour cannot, however, simply be dismissed as 'survivals' of the old peasant mentality which will disappear in time. Although rural conservatism certainly has a role to play in dissuading young couples from attempting an egalitarian approach to housework,[58] this cannot explain the universality of female oppression within the home. Leonid Brezhnev, for example, was himself on record as noting that 'We are still far from having done everything possible to ease the double burden which [women] bear at home and at work.'[59] Yet the response to the problem by politicians and sociologists alike is to speak in terms of improved consumer services, communal facilities and childcare institutions. Despite the existence of a whole body of information on male inactivity in the home and the knowledge that improved services cost money and are most unlikely to materialise in the near future, the press remains extremely unwilling to attack sexist attitudes in anything other than the most perfunctory manner. It is significant that the most trenchant comments on the subject by sociologists who are concerned either with the family or with women's role in the workforce appear in dissertations which are unavailable to the general public. In the popular press the advocacy of male participation in domestic labour is, with rare exceptions, confined to a cursory, 'my husband helps me with everything', in interviews with leading women workers.[60]

If the media are reticent on the subject of the husband's role in the home they are, however, far from reserved on the question of the ideal wife and mother. In line with government priorities the press emphasises motherhood as a woman's most important function and devotes a good deal of attention to the encouragement of large families. Throughout the 1970s articles with titles such as 'The Village of Heroines' and 'The Greatest Happiness' have portrayed women who have received the title of 'Heroine Mother' - for giving birth to more than ten children - as models for emulation by their rural readership.[61] Yet no doubt conscious that the lifestyles of Heroine Mothers are so far removed from those of most women as to be almost meaningless, and in line with official promotion of the three-child family, the press has recently adopted a more subtle approach. The image of motherhood as the highest expression of feminity is conveyed to rural women through interviews with

leading film and stage actresses. In a typical example, Ada Rogovt-seva, People's Artist of the USSR, in response to the question, 'what does being modern mean to you?', replies:

> Being first and foremost an ordinary mum! Being a good wife, a loving daughter . . . Our emancipation never liberated us from this great female duty and never took away these great joys. In my opinion, the fear of having children and the neglect of family responsibilities are signs of social laziness.[62]

The growing emphasis on femininity, as it is defined by the state's propagandists, whilst cushioning the government's pro-natalist stance, makes extraordinarily complex demands of women who are at the same time expected to be exemplary members of the workforce.

In interview after interview with women who have highly successful careers it is made plain to the reader that, for a woman, achievements at work are not enough. 'A woman remains a woman', as one female journalist put it, 'and her great strength is probably that, whilst on par with men at work, she reserves for herself that area of women's affairs which make her the custodian of the family hearth.' The subjects of these interviews themselves echo the theme: 'Happiness in a home depends on the woman', declares a woman machine operator and we are told that her husband and sons are better workers than those who do not have such a loving and caring woman to look after them.[63] This emphasis on the woman as homemaker is at its most explicit in occasional articles offering advice to young couples on avoiding marital discord. One such piece in a magazine aimed at rural readership warns wives not to be jealous or possessive and, above all, not to nag: 'Men really value women's indulgence . . . their talent for forgiveness'. The writer urges the young wife to take an interest in her husband's work – 'Ask him about the new tractors or how the meeting of the collective farm management committee went' – and never to neglect her appearance or forget a man's love for his stomach; 'There is of course no need to make a cult of cooking, but to say you hate it is unnatural.' Husbands meanwhile are informed that, although they are the head of the family, they should take care to include their wives in decision-making. They are advised of the importance of paying their wives compliments, buying them presents and expressing gratitude for their help: 'When she gives you a clean shirt say "Thankyou, Lenochka". When she notices an article in a magazine to do with your work say

"Clever girl, Tamara, thankyou!" [64] Such a prescription for
marital bliss – pretending that women have no concerns outside the
home and relying so heavily on male condescension and female
deference – cannot but reinforce the traditional village view of 'a
woman's place'. In the absence of an autonomous women's move-
ment, there is no one to point out how demeaning and patronising
to women such articles can be. Nor is there anyone to warn how
the new emphasis on femininity is likely to increase the already
prodigious levels of male egocentricity.

Surveys of rural attitudes make it clear that women, especially
those who are young and fairly well educated, are increasingly
unwilling to tolerate their husbands' lack of consideration, rude-
ness, heavy drinking and indifference towards the care of their
children. Only a tiny minority of rural women now believe that
housework and childcare is the woman's sole responsibility, yet
surveys indicate that the overwhelming majority of men help their
wives either irregularly or not at all. [65] Women's resentment at what
they clearly see as parasitic behaviour by many men occasionally
appears in letters to the press. A typical outburst runs:

> Nowadays all the work and all the worry about the family lie in
> the main on women. Men have no sense of responsibility either
> towards their family, or towards their children or towards their
> work. And so they start to 'play around', first they like one
> woman, then another . . . [66]

The logical outcome of an ideology which makes women the
source of harmony in the home is to place the burden of guilt on
women's shoulders should discord arise. Women are warned to
take care when voicing their grievances:

> The demands of modern young women are as a rule justified,
> but the manner in which they are expressed is not always
> appropriate. Many wives do not understand that they should
> spare their husbands' self-esteem, that they should not be too
> categorical or express their demands abruptly. Otherwise a
> husband may develop an inferiority or guilt complex towards
> his family and the whole thing may boil over from time to time
> in drunkenness and rows. [67]

In a similar vein, women are deemed to hold the key to men's
attitudes towards their children. A letter from a young woman,
Nadya, written to Krest'yanka magazine to express her feelings after

she and her young baby have been deserted by her husband, receives the following commentary:

> A man who has a child is still not a father. To become one he must take upon himself a father's functions. And in this a great deal depends upon the woman . . . Nadya didn't succeed in teaching her husband to be a father.[68]

Thus women are at fault for being too insistent or not insistent enough; they have, it seems, no one but themselves to blame if they fail to walk the tightrope between their own self-respect and the demands of the male ego. In this mass of exhortations to women men are, by implication, portrayed as extraordinarily passive recipients of female care. The suggestion is clearly made that the woman, as 'the custodian of the family hearth', is responsible for her husband's sobriety, for his becoming a good father, even for his being an industrious worker. She is urged to show diplomacy in the face of provocation and indulgence to what are portrayed as the inevitable masculine failings; in short, she is to be a mother to her husband as well as to her children.

Conflict and Divorce

The pressure on women to combine their many roles smoothly and efficiently inevitably produces unwanted physical and psychological effects. A survey of women agricultural workers in the Ukraine found that the overwhelming majority complained of fatigue at the end of their working day before beginning the second half of their 'double shift'. Nearly 80 per cent of these women said that they found it difficult, and at times very difficult, to cope with their workload at home and in their jobs; a finding supported by surveys of women in other sectors of the economy. In an unpublished dissertation one prominent writer on the role of women in the economy has blamed overwork as a cause of increasing psychological strain on women which has contributed to the falling birthrate, marital breakdown and child neglect. A writer on divorce has noted that, 'discord between spouses often results from placing on a woman full responsibilities at work and at the same time expecting her to be a good housewife', an opinion supported by letters to the press on the subject.[69] The rising divorce rate has become a source of concern to those in government who see a stable family as essential if the birthrate is to rise.

The divorce rate in rural areas is far lower than in the towns; although well over a third of the Soviet population lives in the

countryside, only one divorce in six is granted to a rural couple. During the 1970s, however, the rate of increase in divorce has been significantly higher in the countryside than in the cities.[70] Social pressure in small rural communities does much to militate against divorce and, for women especially, chances of remarriage are considerably lower than in the towns. It is significant, therefore, that the majority of divorce petitions are brought by women and, of these, over 40 per cent state the husband's alcoholism as the reason for requesting dissolution of the marriage. One survey of rural divorce has indicated that in the majority of cases marital breakdown was in some way connected with heavy drinking by men.[71]

Though bouts of drunkenness are by no means a new phenomenon in the countryside, the pattern of drinking appears to have changed a great deal. Orgies of universal drunkenness were a feature of traditional Russian peasant festivals, especially those which marked the end of periods of heavy agricultural work. Today heavy drinking is no longer confined to occasions of mass celebration but takes place steadily throughout the year and forms for many men a principal leisure activity. It is not difficult to imagine the effect on relationships within the family of such an attitude to alcohol. Though domestic violence receives very little publicity in the Soviet press, it is clear from the occasional report and from the importance attached by women activists to combatting drunkenness that it is by no means unknown in Soviet villages.[72]

The sale of alcohol is strictly controlled by law in the USSR yet it is evident that supply is rarely a problem in rural areas. Not only is home-distilling a frequent practice, but wines and spirits are often sold in state shops in a manner which contravenes the law. Over the last decade complaints by rural women to the press about illegal alcohol sales have become a regular feature. Women complain that, whilst local shops are empty of essential household items, they often carry plentiful supplies of alcohol which can be bought on credit at any hour of the day or night. This seemingly puzzling state of affairs stems from the fact that targets in the five-year plans for shop trading are set by monetary value and it is thus considerably easier to fulfil the plan by selling expensive items such as alcohol rather than the more mundane products required in the running of a home. The immediate results of this practice are the accumulation of large debts by many men and the consequent family rows on pay day.[73] Women's complaints to local officials often fall on deaf ears and are only answered following the intervention of the press. It

seems clear that women are becoming increasingly aggrieved at what they see as official insensitivity to the misery which the drink problem causes. A recent letter to *Krest'yanka* about the effects of the opening of a new public bar in a rural community in Belorussia is typical:

> Until this drinking establishment appeared it was a bit quieter in our village. What did they build it for? Was it to make drunkards of our husbands? If that was it, then it has successfully achieved its mission . . . The bar is flourishing but the money can't be found to build a nursery school, and many women who would like to go to work are obliged to sit at home with the children.[74]

When the failure to take the problem seriously is coupled with indifference to women's own needs, a complaint to a national magazine is often seen as the only way to combat local inertia.

The traditional conservatism of country-dwellers on the question of divorce makes itself felt in cases involving marital infidelity. It is a commonly held belief in the countryside that a marriage should not be broken up because one of the partners has fallen in love with someone else. In letters to the press many women express the view that responsibility toward's one's children should take precedence over a search for personal happiness. The writers often make it clear that their opinion results from personal experience and is adhered to despite their evident distress:

> We met in the fields. A middle-aged man got down from a tractor and asked me for a drink of water. That was all. But he fell in love with me and started to follow me around. We both have families. The whole village began to talk about it. I won't pretend that I love my husband. It probably wasn't love at all but just pity when we decided to unite our lives. But now there's no escape for me. I have to live for the children. My friends tell me, 'you'll live, you'll get used to it, you'll love.' No! My heart aches and loves someone else. How can this have happened? Who's to blame? Can it really be that hot July day and that glass of water?[75]

Surveys of rural opinion have shown that, in circumstances such as these, rural inhabitants are far less likely to condone the break-up of a marriage than are city-dwellers, with women more frequently opposed to divorce than men. It is clear, however, that younger people in the villages are less inclined to adopt hard and fast moral

rules than their parents' generation and display sympathy for those who face difficult personal decisions.[76] Yet for people who live in small villages fear of public censure remains a major deterrent to anyone contemplating an extramarital affair, as this account by a woman school teacher who left her husband for another man demonstrates:

> He and I have had to put up with a lot of unpleasantness. People look askance at us, there's no way to avoid it in our village — this is where you really envy townspeople! His wife is ready to pounce on me like a tigress, after all, we work together. My husband calls me obscene names and of course my children and pupils are all around . . . How do you endure this sort of thing! . . . I know that there are sure to be readers who will write about family duty, moral rules and so on. I too am all for a strong, healthy family where mutual understanding, respect and love reign, where joy and hardships come equally, where there are no lies or betrayals. But if for years on end there has been none of this and there is only an outward show of real relationships — then, there is no family![77]

In marked contrast to the peasant family of the past, research has shown that young women in the countryside today are often better educated than their husbands. As a result they are no longer prepared to accept the standards of family life experienced by their mothers and grandmothers.[78] As women's expectations of marriage increase, there is every indication that the rate of divorce in rural areas will continue to rise.

In its anxiety to raise the birthrate, the state is putting pressure on women with heavy commitments at work and in the home to have more children. At the same time, little effort is being made to challenge the apathy and inertia of men within the family. Inevitably, many women clearly resent the burdens placed upon them and see the restriction of their family size as the only way to obtain a manageable workload. For rural women, the growing readiness to air their grievances marks a decisive break with the past. It seems improbable that women who are demanding nursery schools and consumer services and expressing their concern at the quality of

Not long ago we held a fathers' evening . . . I suggested that tional role.

Without a radical change in men's attitudes towards their wives and children, the aims of the state and the behaviour of women in family life seem likely to remain at loggerheads.

Migration to the Cities

In many areas of the USSR the characteristic response of the young to rural conditions is a move to the town. Men and women alike are seeking a higher standard of living and a different lifestyle from that of their parents. Until relatively recently, migrants from the villages to the towns across the Soviet Union have been predominantly men. Now, however, in the most developed areas of the country migration is higher amongst young women.[79] A major reason for this change lies in the pattern of employment which has developed in agriculture.

As educational standards in the countryside have risen, opportunities for women to find skilled work have remained small. Indeed, as mechanisation has increased in agriculture, the demand for female labour has actually declined. The traditional rural view that machines are not for women has led to a paradoxical situation in which the most prosperous and highly-automated farms are often those which offer women the worst conditions of work. Where nothing but manual labour is open to them, women's rate of migration from the countryside is at its highest. As one rural sociologist has concluded, 'The prevailing division of labour between men and women in agriculture limits the productive activity of women collective farmers, fosters dissatisfaction with their work, lowers their productivity and opposes the interests of society.'[80]

Surveys of the plans of school-leavers have shown that girls consider work with agricultural machinery to be closed to them and regard work outside agriculture as highly attractive. Girls are encouraged in their wish to study for such occupations by their mothers. Far from wishing to see their daughters settle nearby them in the village, it is clear that many mothers have high aspirations for their children which reflect their own dissatisfaction with agricultural work:

> Her father and I have spent our whole lives in muck and filth, let Zina do some other work. There's nothing for her to do in the country . . . But if she wants to, then we're not against it. She can sit in an office, she can learn book-keeping by all means.

Such a comment is said to be characteristic of many older unskilled women in the countryside.[81]

The rigid division of labour in agriculture has, in many regions, led to a severe demographic imbalance in the working population under the age of 30. Where unmarried young men far outnumber

eligible women, it is proving difficult to retain a stable workforce of trained machine operators on the farms. The 'bride problem', as it has become known, is obliging farm managers and local party officials to listen seriously to women's demands for better conditions and the provision of skilled work. As one state farm director put it, 'This is now the number one problem . . . and we won't get it off the agenda until we create good working and living conditions for women.'[82] The effect of high rates of female migration has been to bring issues affecting rural women to the forefront of debates on the future of agriculture. Where there is a lack of childcare facilities, adequate consumer services and, above all, skilled work in acceptable conditions. women in ever larger numbers are refusing to remain on the land.

In recent years planners have attempted to keep young women in the countryside by opening subsidiary industrial units on the farms and expanding services as a means of providing attractive employment. Some farms have diversified, for example by introducing fur-farming or bee-keeping, in an effort to provide women with productive work. Others have revived traditional peasant crafts on a commercial basis to supply souvenirs for the tourist trade. Yet, as at least one economist has pointed out, subsidiary industries would become considerably less profitable if every farm were to see them as the answer to the problem of female employment. Other warning voices have observed that, to see the development of the service sector as the answer, as many do, is to forget the Marxian tenet that only the active involvement of women in production can ensure economic and social equality between the sexes.[83]

The many local approaches to the provision of skilled work for rural women are at one in their assumption that men are the central figures in agriculture. Rural attitudes towards women and technology have proved to be so entrenched that farm managers rarely consider the recruitment of women into work on machines as a serious option. Government campaigns to tackle this pronounced bias against women machine operators had a marked lack of success during the 1970s. One reason for their failure lies no doubt in the ambivalence of official images of women presented in the popular press. As journalists have attempted to combat the prejudices which keep women off machines, they have simultaneously released a stream of pro-natalist propaganda which has reinforced traditional notions of femininity. It seems unlikely, therefore, that great strides will be made in promoting equal opportunities on the land as long as boosting the birthrate remains the government's top priority.

For most rural women, sexual inequality remains a fact of life both within the family and in employment. Until widespread efforts are made to tackle discrimination in the workplace and to lighten the workload in the rural home, thousands of young women will continue to see a move to the city as the only means of obtaining the lifestyle they desire.

Notes and References

1 B.S. Khorev and V.N. Chapek, *Problemy izucheniya migratsii naseleniya* (Moscow, 1978), p. 173.

2 *Narodnoe khozyaistvo SSSR v 1980 g* (Moscow, 1981), p. 7; The rural population stood at 23 per cent in the United Kingdom in 1971, 25 per cent in Canada in 1976, 27 per cent in the United States in 1970 and 30 per cent in France in 1968. See United Nations Department of International Economic and Social Affairs, *Demographic Yearbook, Historical Supplement* (New York 1979), pp. 193–202.

3 *Sovetskaya Rossiya* (24 August 1982), p. 2.

4 Yu. V. Arutyunyan, *Mekhanizatory sel'skogo khozyaistva SSSR v 1929-1957 gg.* (Moscow, 1960), p. 59.

5 *Sel'skaya Nov'*, no. 8. (1981), p.7.

6 M. Fedorova, 'Ispol'zovanie zhenskogo truda v sel'skom khozyaistve', *Voprosy ekonomiki*, no. 12 (1975), p. 58.

7 *Sel'skaya Nov'*, no. 8 (1979), p. 7.

8 *Krest'yanka*, no. 9 (1978), p. 5.

9 *Krest'yanka*, no. 4 (1977), p. 16.

10 Ibid.

11 *Krest'yanka*, no. 1 (1977), p. 28.

12 *Krest'yanka*, no. 5 (1981), p. 7.

13 *Itogi vsesoyuznoi perepisi naseleniya 1970 goda*, vol. 6. (Moscow, 1973), pp. 166–242,

14 V.I. Staroverov, *Sotsial'naya struktura sel'skogo naseleniya SSSR na etape razvitogo sotsializma* (Moscow, 1978), p. 235; L.P. Lyashenko, 'Otnoshenie molodezhi k sel'skokhozyaistvennomu trudu' in T.I. Zaslavskaya and V.A. Kalmyk, *Sotsial'no-ekonomicheskoe razvitie sela i migratsiya naseleniya* (Novosibirsk, 1972), p. 146.

15 Fedorova, 'Ispol'zovanie zhenskogo truda', p. 62; *Narodnoe khozyaistvo 1980*, p. 112.

16 L.A. Erem'yan and V.N.Martynova, 'Analiz sostava zhenshchin, zanyatykh v zhivotnovodstve sovkozov', in I.N. Lushchitskii (ed), *Proizvodstvennaya deyatel'nost' zhenshchin i sem'ya* (Minsk, 1972), p. 192.

17 *Narodnoe khozyaistve 1980,* p. 112.
18 *Krest'yanka,* no. 1 (1981), p. 11; Fedorova, 'Ispol'zovanie zhenskogo truda', p. 15.
19 *Sovetskaya Rossiya* (24 Aug 1982), p. 2.
20 *Krest'yanka,* no. 10 (1981), p. 7.
21 *Kest'yanka,* no. 9 (1978), p. 5; *Krest'yanka,* no. 12 (1978), p. 4.
22 *Itogi . . .1970,* vol. 6, p. 166
23 V.P. Zagrebel'nyi, *Formirovanie otnoshenii sotsial'nogo ravenstva zhenshchin i muzhchin-kolkhoznikov v usloviyakh razvitogo sotsializma* (Candidate Degree dissertation, Kiev, 1977), p. 61, Lyashenko, 'Otnoshenie molodezhi', pp. 149–151,
24 *Krest'yanka,* no. 3 (1980), p. 11.
25 *Krest'yanka,* no. 4 (1980), p. 15; *Krest'yanka,* no. 4 (1981), p. 14.
26 *Krest'yanka,* no. 8 (1978), p. 11.
27 *Krest'yanka,* no. 10 (1980), pp. 13–14; *Sel'skaya Zhizn'* (15 Jan 1980), p. 3.
28 *Itogi . . .1970,* vol. 5, p. 202; *Itogi sesoyuznoi perepisi naseleniya 1959 goda. SSSR (svodnyi tom)* (Moscow, 1962), p. 108.
29 *Itogi . . 1970,* vol. 5, pp. 202–94.
30 Z.I. Monich, V.G. Izokh and I.V. Prudnik, *Rabochii klass v strukture sel'skogo naseleniya* (Minsk, 1975), pp. 44–53.
31 L.M. Volynkina, *Ispol'zovanie zhenskogo truda v kolkhozakh Kostromskoi oblasti* (Candidate Degree dissertation, Moscow, 1976), pp. 126–33.
32 *Nauchno-tekhnicheskii progress i sotsial'nye izmeneniya na sele* (Minsk, 1972), p. 60; *Krest'yanka,* no. 8 (1979), p. 3.
33. P.A. Zhil'tsov, *Vospitatel'naya rabota v sel'skoi shkole* (Moscow, 1980), pp. 52–6; R.K. Ivanova, *Sblizhenie sotsial'no-ekonomicheskikh uslovii zhizni trudyashchikhsya goroda i sela* (Moscow, 1980), p. 76.
34 ` *Krest'yanka,* no. 6 (1980), p. 26; L.G. Borisova, 'Ustoichivost' huchitel-skikh kadrov sela' in Zaslavskaya and Kalmyk, *Sotsial'no-ekonomicheskoe,* pp. 183-5; N.A. Shlapak, *Zhiznennye plany sel'skoi molodezhi i ikh realizatsiya* (Candidate Degree dissertation abstract, Sverdlovsk, 1967), p. 15.
35 *Narodnoe khozyaistvo 1980,* pp. 285–7; Staroverov, *Sotsial'naya struktura,* pp. 265–6.
36 *Narodnoe khozyaistvo 1980,* pp. 285–7.
37 *Krest'yanka,* no. ii (1981), p. 25; Monich et al., *Rabochii klass,* p. 86.
38 *Izvestiya* (26 Dec 1961), p. 4.
39 *Krest'yanka,* no. 11 (1981), p. 25.
40 Zagrebel'nyi, *Formirovanie otnoshenii,* p. 100. See also, for example, *Krest'yanka,* no. 8 (1979), pp. 20–1; *Sel'skaya Zhizn'* (15 Feb 1980), p.1.
41 *Narodnoe khozyaistvo 1980,* p. 31; *Zhenshchiny v SSSR* (Moscow, 1975), p. 92; V. Perevedentsev, *270 millionov* (Moscow, 1982), p. 15.
42 Elaine Elnett, *Historic Origin and Social Development of Family Life in Russia* (New York, 1926), p. 105.

43 *Krest'yanka,* no. 10 (1981), p. 26.
44 *Krest'yanka,* no. 8 (1981), p. 32 and no. 2 (1980), p. 11
45 *Krest'yanka,* no. 9 (1981), p. 29 and no. 1 (1982), p. 28.
46 *Krest'yanka,* no. 10 (1982), p. 27.
47 *Krest'yanka,* no. 1 (1981), p. 29.
48 Ivanova, *Sblizhenie,* p. 70; N.A. Medvedev, *Razvitie obshchestvennykh otnoshenii v sovetskoi derevne na sovremennom etape* (Moscow, 1976), p.129.
49 R.V. Ryvkina, *Obraz zhizni sel'skogo naseleniya* (Novosibirsk, 1979), p. 198.
50 *Literaturnaya Gazeta* (24 Aug 1977), p. 11
51 V.D.Patrushev (ed), *Byudzhet vremeni sel'skogo naseleniya* (Moscow, 1979), pp. 125 and 134; G.G. Markova, *Svobodnoe vremya i razvitie lichnosti zhenshchin-kolkhoznits na sovremennom etape stroitel'stva kommunizma* Candidate Degree dissertation, Rostov on Don, 1977), pp.52–62.
52 *Problemy derevni i goroda,* vol.2 (Tallin, 1979), p. 105.
53 *Literaturnaya Gazeta* (17 Jan 1979), p. 12.
54 *Sel'skaya Zhizn'* (28 May 1980), p. 3.
55 Z.A. Yankova and V.D. Shapiro (eds), *Vzaimootnoshenie pokolenii v sem'e* (Moscow, 1977), p. 59.
56 *Krest'yanka,* no. 3 (1980), p. 23.
57 Yu. G. Serebryakov, *Kul'tura i byt sovremennoi derevni* (Cheboksary, 1977), p. 68.
58 *Literaturnoe Obozrenie,* no. 5 (May 1977), p. 51.
59 *Krest'yanka,* no. 10 (1980), p. 6.
60 See, for example, *Sel'skaya Zhizn'* (18 Aug 1979), p. 4.
61 *Sel'skaya Zhizn'* (14 Sept 1979), p. 4 and (19 Aug 1979), p. 4.
62 *Krest'yanka,* no. 6 (1982), p. 26.
63 *Zhenshchiny-mekhanizatory* (Moscow, 1979), p. 60; *Sel'skaya Zhizn'* (21 Oct 1979), p. 4.
64 *Sel'skaya Nov',* no. 10 (1979), p. 33
65 M.G. Pankratova, *Sel'skaya sem'ya v SSR i nekotorye problemy planirovaniya* (Moscow 1970), p. 4; Zagrebel'nyi, *Formirovanie otnoshenii,* pp. 135 and 167; T.D. Ermolenkova, 'Izmenenie sotsial'nogo polozheniya zhenshchiny-krest'yanki v protsesse stroitel'stva sotsializma', *Vestnik Belorusskogo Gosudarstvennogo universiteta imeni V.I. Lenina,* series 3, no. 1 (1973), p. 56.
66 *Krest'yanka,* no. 1 (1982), p. 28.
67 *Krest'yanka,* no. 6 (1982), p. 25.
68 *Krest'yanka,* no. 3 (1982), p. 27.
69 N.P. Rusanov (ed), *Okhrana truda zhenshchin v sel'skom khozyaistve* (Orel, 1979), p. 73; N.M.Shishkan, *Sotsial'no-ekonomicheskie problemy zhenskogo truda v usloviyakh razvitogo sotsializma* (Doctoral Degree dissertation abstract, Moscow, 1978), p. 19; Yu.A. Korolev, *Brak i razvod; sovremennye tendentsii* (Moscow, 1978), p. 121; Perevedentsev, *270 millionov,* p. 32.

70 A.G. Volkov, 'Sem'ya kak faktor izmeneniya demograficheskoi situatsii', *Sotsiologicheski Issledovaniya*, no. 1 (1981), p. 38.

71 *Sotsiologicheski Issledovaniya*, no. 3 (1976), p. 78; Zagrebel'nyi, *Formirovanie otnoshenii*, p. 171; V.N. Kolbanovskii (ed), *Kollektiv kolkhoznikov* (Moscow, 1970), pp. 215–16.

72 See, for example, *Krest'yanka*, no. 11 (1981), p. 11 and no. 12 (1979), p. 20; Yu. Arutyunyan and Yu. Kakhk, *Sotsiologicheskie ocherki o Sovetskoi Estonii* (Tallin, 1979), p. 56.

73 *Krest'yanka*, no. 10 (1979), p. 27 and no. 7 (1975), p. 28.

74 *Krest'yanka*, no. 5 (1980), p. 29.

75 *Krest'yanka*, no. 1 (1982), pp. 28–9

76 Arutyunyan and Kakhk, *Sotsiologicheskie ocherki*, p. 51.

77 *Krest'yanka*, no. 1 (1982), p. 29.

78 M.G. Pankratova, *Sel'skaya sem'ya v SSSR — problemy i perspektivy* (Moscow, 1974), p. 10.

79 T.I. Zaslavskaya and I.B. Muchnik, *Sotsial' no-demograficheskoe razvitie sela. Regional'nyi analiz* (Moscow, 1980), p. 109.

80 Zagrebel'nyi, *Formirovanie otnoshenii*, p. 81.

81 *Molodoi Kommunist*, no. 9 (1977), p. 86.

82 *Krest'yanka*, no. 12 (1978), p. 5.

83 *Sovetskaya Rossiya* (24 Aug 1982), p. 2; Volynkina, *Ispol'zovanie zhenskogo truda*, p. 34.

7 SOVIET POLITICS – WHERE ARE THE WOMEN?
Genia Browning

IT IS now well established that there are no women in power positions amongst the Soviet political leadership. We are all familiar with the rows of elderly male look-alikes. There are no women on the Politburo, the most powerful of the political committees, nor on the secretariat of the Communist Party (CPSU). Indeed, there has only ever been one full female member of the Politburo, Ekaterina Furtseva. She lasted just four years, and that was over 20 years ago.

The percentage of women on the large Central Committee of the party is not only small — 3.81 per cent in 1981 — it has not increased during the period of the USSR's existence.[1] (The Politburo (political bureau) is elected to the Central Committee at each party congress. It operates similarly to the British cabinet. The Central Committee usually meets only twice yearly. The work of the various departments of the Central Committee is supervised by the secretariat, which consists of top party Secretaries.) Clearly, there is an absence of women at these all important levels. Yet the Soviet Constitution guarantees women equal rights with men, which includes political rights. Soviet authorities claim time and again that their women are far more politically active than their Western counterparts.

To some extent the claims are justified. Where are these women, then? They appear at the lower levels of the Soviet political structure. In the local Soviets (councils), women participate in almost equal numbers to men. Even at the level of the Supreme Soviet (the government), women constitute one third of the members (see Table 1). This compares favourably with all other national legislatures. Soviet women are similarly well represented in the trade unions. This marks a real advance, and should not be ignored by anyone seriously interested in the Soviet political system. However, in a one-party state, positions of authority in that party are paramount. The pervasiveness of the party extends into all areas of Soviet life. Leadership positions in the Soviets and public institutions, such as voluntary social organisations, are dependent on the party.

TABLE 1: % of Women as Soviet Deputies (elections 4 March 1979)

Local	49%
Union republics	35%
Supreme Soviet	32%
Praesidium	11%

Source: Vestnik Statistiki 1980, p.70.

So what about women in the CPSU? In the party's youth organisation, the Komsomol, membership is over 50 per cent female and women are well represented on the low level committees: just over 57 per cent of the primary (local) Komsomol groups.[2] The extent of this participation in the Soviets and Komsomol suggests that women neither exclude themselves from such political activity, nor are they excluded. In the Communist Party itself though, women's participation is not so impressive. Women make up just a quarter of the membership. At primary level, their committee representation is commensurate with this and remains so up to obkom (district committe) level (see Table 2). More significantly, women's share on all these committees is on the increase, hence the legitimacy of the Soviet claim that progress is being made. Does this not make the absence of women in high positions of the CPSU all the more startling?

It has been suggested that given the nature of political power, women do not seek high office.[3] However, this does not explain why once women do make a commitment to political activity, they do not eventually occupy leading positions in the way men do.

This chapter considers why this apparent demarcation line, between what have been called the 'high' and 'low' levels of politics, exists.[4] By examining why the extensive involvement of women in the 'low' and informal political arena has not led to their participation in the political hierarchies, this section outlines Soviet attitudes to women's politicisation. It then aims to show how these underpin the activities of Soviet women's organisations, whose task, in part, is to raise woman's social and political consciousness. The section concludes by indicating why much of this activity not only fails to politicise women, but appears counterproductive.

Surveys have indicated that Soviet women are less interested in politics than men.[5] The lack of women in high office does not appear to worry women themselves. The response of one Soviet acquaintance to any enquiry about the omission of women on the

politburo was, 'Oh, aren't there any? Well, that's not a matter of concern.' There is a common-sense notion that women themselves do not need to be in positions of political power. Paternalism is commonly regarded as adequate for achieving goals of sexual equality. This attitude was clearly expressed by a Soviet physicist during a visit to London in 1981. When questioned about women's political position, she answered that the main acts of equality in 1917 were introduced by men. Men support equality, therefore it is not necessary to have similar numbers of women in power positions.

TABLE 2: % of Women Elected to Party Committees 1980–1, compared to 1975–6

	%
Secretaries, members of workplace groups	22.9 (20.6)
Secretaries of primary organisations	35.1 (31.5)
Members & candidate members of raion & gorod committees	31.3 (28.9)
Members & candidate members of krai & union republics central committees & inspection committees	24.2 (22.9)

Partiinaya Zhizn, no. 14 (1981), pp. 13–26.

Women as % of CPSU members (as from 1 Jan 1981; 1982)

Full membership	1981: 26.5%	1982: 27%
Candidate members	1976/80: 32.2%	1982: 33.8%

Partiinaya Zhizn, no. 14 (1981), pp. 3–26; *Partiinaya Zhizn*, no.10 (1982), p.36.

The impression that such attitudes are common was born out in an interview with a 'specialist in women's affairs'. She agreed that little is said about the lack of women, and that, 'No one is bothered by it, not even women.' Her explanations were twofold, the first echoing those of the physicist. The party Central Committee has people specialising in 'women's problems', and attention is given to the question in party policy adopted at each congress. Hence there is no acute necessity for a woman in the Politburo. All that is

objectively possible is already being done. Secondly, whilst she accepted that an equal representation of women at all levels of party organisation would be indicative of their general status in society, she argued that the 'bite' was taken out of this point by the participation of women, on a mass scale, at other levels. She emphasised that, with women so politically and socially active at the lower levels, there was little to worry about.

The sexual division in political power, however, is a crucial factor in women's given status in society. Without meaningful participation by women, political systems can only be 'democratic' in a limited sense. This is as true for the USSR as for elsewhere. Although authoritative claims that equal rights have been implemented in full continue to appear from time to time, it is now widely accepted in the USSR that equal rights between the sexes are not fully exercised. As we have noted, common-sense notions appear not to associate this with the lack of women in political power. Yet official calls are made for the more active promotion of women, such as that contained in Brezhnev's speech at his last congress: 'It has to be acknowledged that so far not all possibilities are being used to promote women to executive posts. This must be corrected.'[6] This concern, echoed in recent party and academic writings, usually fails to be specific about political posts. Where it does, it is limited to district level.

Official Soviet explanations for the inequality are threefold. First, the sexual division of labour gives women the major responsibilities for family and home. This allows them less time than men to devote to sociopolitical activities. Secondly, traditional attitudes towards women persist and lead to some sexual discrimination. Thirdly, in some cases, female political consciousness still falls behind that of men.

The corresponding policies put forward by the party and state all emphasise the importance of time. The double burden of home and work responsibilites is to be alleviated by improved facilities at some time in the future. This is seen as the main panacea. General policy to change male attitudes remains muted, despite official condemnation of sexual discrimination, appeals for men to assist women more in the home and share parental responsibilities, and the occasional campaign. The implicit assumption, that women have the main responsibility for children and the home, remains virtually unchallenged. The response to the third explanation, that female political consciousness is in some way underdeveloped, is to raise women's consciousness. It is understood that this will take place in two main ways: by women taking a full part in the public

world of work, and by participating in public (social) organisa-
tions. As mentioned above, it is the third approach which is the
concern of this chapter.

Consciousness-raising has come to be seen by feminists as vital
for women's attainment of equality. It enables women to appreciate
that 'their personal problems are not individual or inevitable but are
generalised, systemic, socially caused and common, and need to be
solved via political action'.[7] Although Soviet ideology recognises
the common and social causes of sexual inequality in general terms,
Soviet understanding of political consciousness, and of the way it is
generated, differs in crucial respects from that of many feminists, as
Sheila Rowbotham explains: 'The experience of feminism has been
that the specific gender oppression of women requires an indepen-
dent movement in order for us to develop and assert a new
collective consciousness of being female.'[8] This autonomy, what-
ever form it might take, is considered necessary because sexual
inequality is, in part, due to oppression by men. Yet because of the
intimate relations between women and men, much of the oppres-
sion is unrecognised and internalised, and perceived through male
definitions of reality. For political consciousness to take place,
feminists argue that women's sense of self must have space to
emerge.

Marxist thought also considers that political consciousness initi-
ally develops from individual awareness of problems being socially
caused. However, the all-important distinction is that, for Soviet
Marxists, this takes place at the 'point of production'. Thus, trade
union consciousness can develop to class consciousness, and even-
tually political consciousness, with membership of a political party.
Although Soviet political practice acknowledges the need to differ-
entiate between the sexes, this differentiation is recognised only in
limited terms. Consciousness is not perceived as lived experience
according to sex, but primarily to class. Thus women's conscious-
ness will ultimately be raised by entering the public world. The
orientation of consciousness-raising thus differs. Yet notwithstand-
ing such differences, there are some apparent similarities between
feminist and Soviet Marxist approaches. These are to be found in
the attitude to the sociopolitical activity of 'low' politics.

Soviet political theorists, and many Western Feminists, consider
women's public activity, such as organising facilities for preschool
children, is a valid from of political activity. For feminists, this
notion is extended to all areas of women's lives – 'the personal is
political'. Such a concept of the political can enable women to
perceive themselves as political, whilst changing the definition of

what politics is about. In the USSR, women's rights, such as childcare provision, are part of community politics, both formal and informal. This has been institutionalised in the formal political structure. Since 1976 the local Soviets have had statutory standing 'Commissions for the Problems of Labour and Everyday Life of Women and Mother and Child Protection'. Women's activity in the social organisations around such issues as maintaining 'order in the environment' and 'setting up kindergartens', is likewise defined as political. It is this informal and 'low'-level formal political activity which is understood by Soviet political theorists to be an avenue for raising political consciousness. 'Social work raises women's interests in collective regional and state affairs.' [9]

In the early years of the revolution, it was recognised that women's political and social consciousness would be facilitated with the support of other women. A women's department of the party, the Zhenotdel, was set up for this purpose. It achieved much, but was disbanded by 1930 on the official grounds that it was no longer needed, that women were now equal to men. It was not until the 1960s that it could be officially admitted that this was not so. Under Khrushchev, the idea of women's-only organisations was revived as one of the means for raising women's political consciousness. There were a number of reasons for this volte-face.

To distinguish the new regime from the Stalin era, the policy of developing 'participatory democracy' by management of social activities was emphasised. This was a feature which led to the growth of social organisations, of which the women's organisation was one. At the same time, the role of the CPSU was to be strengthened. This required the party to make more effective use of 'agitprop' (agitation and propaganda), to reach all those who remained outside its sphere of influence. This was pertinent to women, especially housewives. In addition, Krushchev's plans for 'Communism by the 1980s' demanded the mobilisation of far more women in production. To meet these needs, women's organisations – the Zhenskie Sovety (women's councils), commonly known as the *zhensovety* – were encouraged throughout the USSR.

In *Women Under Communism*, Barbara Wolfe Jancar proposes that the low participation of Soviet women in formal politics is due, in part, to their lack of facilities to come together as women: 'they have no way to discover the mutuality or universality of their problems, to discover female bonding, to find support and reinforce one another, in short, to mobilise politically'.[10] The existence of the zhensovety appears to contradict this. The following ex-

amination of them, and of their relationship to the party, however, may well validate her point.

The zhensovety appear to meet a number of criteria which make this examination worthwhile for feminists. Their purpose, at least in part, is to raise women's political consciousness. 'Raising the political level and consciousness of the sailors' wives is an important part of zhensovety activity.'[11] They are women–only organisations, described as 'an organ of collective thought'.[12] Part of their intent is to support women. In the words of one activist, 'The zhensovety must speak up in defence of women and girls by exposing the survial of "feudal attitudes" to women.'[13] The zhensovety are described as 'independent organisations', 'whose activists use their own initiative' (from correspondence with the Soviet Women's Committee). By this is meant that the zhensovety do not have a formal structural relationship with other organisations. This distinguishes the zhensovety from both the 'Commissions for Work Amongst Women', which are attached to the trade unions, and the standing commissions of the Soviets. The Committee of Soviet Women is an appointed body which exists only at national level.

The zhensovety are also described as *ad hoc*, 'spontaneous' organisations.[14] In the context of women's needs, and the highly centralised and male-dominated structure of the USSR, this is a further interesting feature.

The activities of the zhensovety are diverse, tackling many issues of real concern to Soviet women. We will look at these women's organisations in two respects: their potential for raising women's political consciousness in Soviet terms, and also in the feminist sense. From this we hope to learn something about the failure to translate women's wide political activity in the 'low' and informal areas, to the power positions of the formal political structure.

The Zhensovety

The zhensovety are widespread through the USSR, although they predominate in particular areas such as rural communities, ethnic minorities and areas of strong religious influence, such as the Caucasas, Central Asia and Lithuania. These are the regions where traditional culture is thought to have prevented the level of development for women that is found in the major Russian cities. Hence there are no zhensovety in Moscow and Leningrad. The Central Asian Republic of Tadzhikistan claimed to have 1,310 zhensovety in 1980.[15] The Chuvash Autonomous Republic has

1,700[16] and 2,000 zhensovety exist in Moldavia, most being attached to collective farms.[17]

The zhensovety are organised at varying levels; local (residential or place of work), raion (borough), gorod (town), oblast (district) or republic, although there is no republic zhensovety for the RSFSR. They are committee based and the most important position is the chair. The higher the level, the larger the committee: at district level there can be 30 to 50 members, with as few as 5 at local level.

It is common for the zhensovety at all levels to have sectors responsible for specific areas of work. Members ars ostensibly elected by open ballot at public meetings or congresses of women. In most areas, these appear to be held sporadically. Women do not have to be elected to take part in the zhensovety organisation. In some areas, the sectors are staffed by other women, usually under the direction of an elected member. Some zhensovety activists (i.e. the committee) see this as an important way of giving a wider group of women experience, and in the words of one report, 'contributing to the further growth of women's political activity'. In this case, the zhensovety in Veshkaimai village (Ul'yanovsk), had three sectors. Each had non-elected women in leading positions; a dairy woman, a teacher and a doctor. 'We did this consciously, in order to involve in the work of the zhensovety fresh strength.'[18] The average age of the activists has fallen. In the early years of the zhensovety, many of the activists were women who had been active in the old zhenotdel. The most substantial information about the zhensovety comes from the 'Reports of Work' written by the activists, but most of these date to the 1960s. More recent accounts are to be found in the women's journals of *Rabotnitsa* and *Krest'yanka*.

It is clear that there is no centralised plan for the zhensovety. However, a general pattern is discernible, which indicates that local 'initiative' is governed by a framework of general expectations. The scope of their activities is considerable:

> [they] . . . involve women workers in social activities, direct the moral education of the growing generation, struggle to overcome past traditions, help organise public services and facilities in populated areas, help the protection of nature, public control, ensure that the labour protection rules are observed, organise women's domestic life, and control public catering.[19]

These activities can be grouped into four main areas: economic,

social, political/educational and childcare. Most zhensovety have sectors responsible for each, but this is not institutionalised. One group in Tashkent, for example, has nine sectors: production, agitprop, cultural and enlightenment, care of mother and child, nationalities, education, atheism, cultural life and legal.[20]

The projected plan of work of one raion zhensovety shows how the general aims are interpreted, through a more detailed break-down of proposed activities.

> Acquaint women systematically with the important decisions of the party and government, carry out talks, lectures and papers more frequently.
>
> Raise the activity of women in the struggle for the fulfilment of the commitments taken and the annual plans.
>
> Publicise the best women workers in print, on the radio and at meetings.
>
> Discuss, at zhensovety meetings, poor workers and those who relate to their commitments half-heartedly.
>
> Strive for the speedier building of nurseries and kindergartens in the villages and towns, carry out spot checks on children's establishments, and be directly responsible for them.
>
> Check on the work of medical institutions, canteens and shops.
>
> Organise talks for parents on rearing well-behaved children.
>
> Hold evenings for young people and arrange talks in the afternoon for children.[21]

Although this formidable list is presented as the tasks of individual groups, there are two main concerns of the zhensovety. These are summed up by Olya Tallya on the basis of her experiences as assistant chair of the Chuvash Republic Zhensovet. 'The zhensovety aim for the wide involvement of women in productive and social political life.'[22] These are the two facets which are to combine for women to become 'Active Builders of Communism' – in other words, for women's political consciousness to be raised.

There are two main approaches involved in Soviet political consciousness-raising; agitation and propaganda. Agitation is particularly connected with the mobilisation around the aims and policies of the party and government. Propaganda concerns political enlightenment, that is, political education. These are the two aspects of zhensovety activity to be considered, if we are to see what consequences participation in 'low' informal politics has for Soviet women.

The first of these, mobilisation, is undoubtedly the one to which

the zhensovety give most attention. It will be seen, from the details of zhensovety activity, that much emphasis is made of women's economic role. In Soviet Marxist theory, this presents no contradiction to the aim of politicising women. The 'New Communist Woman, Active Builder of Communism' will be brought about by the integration of women's participation in production and sociopolitical activity. Women's participation in paid employment, fulfilment of the economic plan − better still, overfulfilment − is thought to provide the evidence of commitment to the social system. One of the few new female members to the Central Committee elected at the Twenty-sixth Party Congress (1981), was the weaver V.N. Golubeva. Her speech, which began by eulogising Brezhnev, then focused on her achievement in production. It seems that she had 'worked on more than a million metres of cloth and fulfilled in five years the tasks of twenty years. It is my worker's present to the 26th congress of our Communist Party.'[23] Here is an example of woman as 'active builder of communism'. In Soviet terms, Golubeva had proved her political maturity and, as an example to others, had been rewarded with a seat on the Central Committee. Thus, when Soviet sources claim that the 'work of the zhensovety has led to the growth of consciousness of many hundreds of women',[24] in essence what is meant is that women are actively participating in building the economic base for communism by being 'Shock Workers', 'Heroines of Labour' and generally overfulfilling the set plan. This can be illustrated by the activities of the zhensovety.

Zhensovety and Mobilisation.
In their early years, the zhensovety concentrated on bringing women into the labour force. (During the 1950s and early 1960s, 15 million people, mainly women, entered the labour force.) Now, with 90 per cent of women in paid employment, in full-time study or retired, the zhensovety concentrate on the quality and volume of productive output. In this respect, the zhensovety claim considerable success.

 In a factory in Chuvash for example, the zhensovety, in conjunction with the trade union committee, organised a course to raise women's qualifications, and encouraged their participation in 'socialist competition'. 'The result was 80 per cent of the women workers participating for the title "shock worker of communist work".'[25] In Lithuania, International Women's Year was celebrated by the republic zhensovet with a call to fulfil the current five-year state plan.

Zhensovety and Political Education

What is entailed in political enlightenment, the second facet in developing the 'New Communist Woman', can be seen from the declaration addressed to all women which marked the end of the second Uzbek Women's Congress, 17 May 1961.

Our duty, comrade activists, is to involve women in production and socially useful activity. It is also important to carry out political education amongst women daily, especially where they live. We need to vary the forms and methods of our work. We need to involve more women in political enlightenment . . . and to strengthen anti-religious propaganda. Our duty, comrade activists, is constantly to help the party organisations educate all women in the spirit of high ideals. The main task of political work is the education of people by positive example. Education in the individual is a communist mark of character. We will struggle against backward attitudes to women.

Political education is mainly organised along formal lines. Despite the appeal above for new methods of work, the main way of helping to 'develop the social activity of women and politically educate them', is through congresses, meetings, conferences and rallies. Such events consist of a 'political expert' handing out information to the audience. According to the 'Reports of Work', in many regions, formal political meetings for women are extensive. During 1965, for example, 100 talks took place in one raion of Dushanbe.[26] Themes vary from those associated directly with mobilisation, 'The Role of Women in Fulfilling the Tasks Proposed at the 22nd Congress CPSU', to more general political information such as talks on Soviet foreign policy. Sometimes political roles for women specifically are considered. 'The Role of Women in Strengthening Peace on Earth'.

Judging by zhensovety reports, it is now common to have such formal lectures dressed up with a social event such as a quiz or concert. Indeed, it has frequently been suggested, as in the Uzbek Declaration above, that the form of political enlightenment needs to be varied. In a few regions, this has led to the zhensovety organising small group discussions in women's homes. Eighteen women, for example, took part in a discussion on current politics at House No. 10 in Chelyabinsk, and at House No. 1, women attended readings from Lenin.[27]

Whilst references to this more intimate form of discussion come from the early period of the zhensovety, another form of political

education, the 'Oral Journals', remain popular at the present time. In these, leading members of the zhensovety, reinforced by other specialists, 'act out' political events to their audience. One source, claiming that this is a helpful form of enlightenment work, describes what takes place.

> Large numbers always gather together in the auditorium. The speakers are women: veteran communists, party and social workers, scientists and artists. They have a wide range of material. The audience become better informed on questions of national and international politics, on contemporary literature and the arts, as well as receiving advice on childcare and housework.[28]

It is difficult to distinguish this approach from the formal lecture, given that the audience of women are still being presented with a diet of political information for their consumption.

Rooms known as 'Agit Points' and 'Red Corners', set aside for political education either at the place of work or residence, are often run by the zhensovety committee. In Tuvinskoi, for example, the zhensovety in 1980 set up 'agit departments' in ten blocks of flats. Women were invited to talks on a variety of topics given by specialists. Agit areas are often decorated with wall newspapers dealing with topical events. Newspapers and books are available so that women who 'pop in' for a chat or for help, do so in a 'political atmosphere'. Most zhensovety arrange 'get togethers' with war veterans as part of their political education programme. The zhensovety also take an active part in the Soviet Peace Fund, with activists collecting for the fund and holding meetings of 'solidarity' with women abroad.

These are the activities associated with the two main areas of political consciousness-raising for Soviet women. In the main, political activity is synonymous with what the zhensovety define as 'social' activity. The dilemma here, for the purpose of analysis, is whether such activity has the status of politics, or whether it remains ghettoised as part of women's concerns. To give an actual example, which comes from an interview I had in 1981 with Olya, the chair of a women's commission of her trade union (although not a zhensovety, she referred to it as such, and for the purpose of this point it will suffice). The example she gave of political activity was the provision of a beauty consultant for the women, the idea being that 'women at work will always be very beautiful and pleasant and always jolly. That's our task.' We will return to this

concern with traditional images of femininity.

There is little connection to be found between zhensovety activity and the advancement of women in the CPSU. Although Olya Tallya does cite the increase in female membership and posts in the Chuvash party as a consequence of zhensovety activity, it is impossible to ascertain to what extent the zhensovety were the effective factor in this development. Furthermore, the membership figures of Chuvash follow the general pattern of female party membership at the time. Beyond the bland assertion that the groups 'will help women to get to such posts', nothing further could be elicited in the interview with Olya on how Brezhnev's call for more women in executive posts would be implemented.

Due to differing cultural concepts of what constitutes political awareness, it is debatable to what extent we from the West can assess the effect of zhensovety activity on women's political consciousness. Assessment is further hampered by the problems of empirical investigation. With this constraint in mind, only a tentative assessment can be attempted.

The zhensovety appear to have had most success in mobilising women around the political and socioeconomic decisions of the party and state. In Soviet terms, this suggests that the level of women's political consciousness has indeed been raised. The extent to which this is so, however, even on this basis, is open to conjecture. There are as many references to the ineffectiveness of the zhensovety as there are claims for their achievements. Furthermore, the Soviet and the trade union commissions which work with women were formed after the zhensovety and largely reproduce their work. This suggests the ineffectiveness of the zhensovety, a deduction reinforced by the persistence of the problems facing women.

In feminist terms of consciousness, such mobilisation can be seen as the antithesis to women's political awareness. The zhensovety mobilise women around the economic necessities that have primarily been decided upon by men. Despite pronouncements on the need to alleviate the double burden of women's lives, reiterated regularly since the early days of the zhensovety, there has been no major mobilisation on such issues as the provision of childcare in rural areas. Where pressure has been exerted for improved facilities, this has been in particular regions, by individual groups, rather than as a nationwide campaign.

References to a different understanding of how political consciousness can develop are minimal, dating mainly from the early period, the years of de-Stalinisation. One activist's report, for

example, suggests that it is important for women themselves to complain directly to the management about bureaucracy, rather than have the committee do so on their behalf. She sees such self action as likely to facilitate political awareness more readily.

The political enlightenment activities of the zhensovety have no doubt enabled many Soviet women to be more informed both on specific issues and on general party policy. Whether the form that such political education takes can be considered as developing political consciousness, is debatable. Certainly, as women, they are presented not only with an *a priori* definition of political priorities, but also with one that is male orientated. In many crucial respects, such political concepts are likely to be far removed from women's own experiences.

The activity of the zhensovety has made no real difference to the position of women in the political hierarchies. Yet the zhensovety have provided women with the experience in social work often cited as a criterion necessary for party membership, which has indeed risen over this period.

The Zhensovety and Social Activity

The reasons for the apparent limitations in the work of the zhensovety can be explored further by looking at the social side of their political activity. Existing research on women and political roles suggests the incompatibility of traditional female responsibilities and political activity. Yet much of zhensovety social activity involves improving those very skills associated with the traditional sexual division of labour. A common feature of their work has been the organisation of classes and circles, of skills considered necessary for good housekeeping. Crafts appear to be popular — knitting, crochet and sewing — as are domestic tasks such as cooking and home management.

These activities in themselves are not necessarily contradictory to women becoming more aware. Indeed, it seems was some attempt in the early years by zhensovety activists to use such circles for the purpose of 'enlightenment' by reading books and papers aloud to women whilst they sewed. Other activists saw such circles as providing a place for women to meet and talk together. One report about sailors' wives on the Black Sea Coast suggests the women favoured such classes, not least because their husbands considered such leisure pursuits legitimate. 'More than once, I heard a woman say: "When I am sewing at home, my husband helps me, prepares the dinner himself, looks after the children." '[29] Although such classes remain popular, their purpose is now less ambiguous. The

response by Olya, when asked if the sewing classes provided an opportunity for discussion, was adamant, there is no time for anything except to 'sew, sew, sew'. In this case, the classes were organised at the request of the women themselves. Whilst it did mean that on that evening at least, husbands had responsibility for the children, this was a secondary consideration. The notion that such activity is a legitimate pastime for women appears to have changed little over the years. Of particular interest was Olya's information that, 'at present our government is propagandising for such classes'. This was verified and also justified by the research specialist on women's affairs mentioned earlier. She thought time spent on these traditional skills should be viewed as a positive development:

> Knitting, for example, is extremely relaxing and good for one's nervous system. Isn't it good, that there should be a transition from strenuous work to this relaxing leisure activity? And there is a useful product at the end too. Therefore today women see this as a kind of opportunity to distinguish themselves, to show their gifts and talent by doing embroidery, which is an art in its own right actually. So these are all hobbies. Before, women had to do these things to provide for their families, while now there is not such a direct need for that – there is a developed light industry, one can buy all one needs. Now it is done to adorn everyday life.

Such a response should be seen in the context of general zhensovety activity. A major area of their work deals with differing aspects of childcare and with women as mothers. Again, this in itself does not necessarily reinforce gender roles. It is the context within which this work is approached. The zhensovety are responsible for women's work, and thereby reinforce the sexual division of labour. Zhensovety activists, for example, act as 'watchdogs', supervising school meals and the sanitation in children's institutions – in one area, this entailed taking the laundry home to do it themselves. They help to provide leisure activities after school for children and have responsibility for individual children's behaviour, in conjunction with the teachers and parents' committees.

Despite these responsibilities, though, zhensovety activists do not have control or decision-making powers even for those areas which are considered to be their legitimate concern. In many instances the activists, as women, are officially taking direct

responsibility for doing the very jobs with which women have always been associated. The purpose can be seen as relieving other women for greater productivity. This is clearly understood by the activists themselves.

> The zhensovety does not forget the other side of their activities. In order that women can work fully, in a good mood, they must be free from worry about their children, and the family. Therefore the zhensovety members visit the nurery time and time again.[30]

Support is given by the activists to individual families, especially to single and heroine mothers (those with large families). In one Moldavian village, for instance, the zhensovety arranges daily transport for one such mother and her children, and ensures they receive benefits to which they are entitled.

The attention given by the zhensovety activists to childcare can be all-embracing. In the far northern Autonomous Republic of Komi, for example, the activists are responsible for the children at their boarding school, acting as 'substitute mothers'. They ensure that the children receive a varied diet, that they are adequately clothed, and that 'even the smallest feels confident despite being far from their parents'. At the end of term, they arrange the children's travel home, 'even going with them part way'.[31]

Whilst such help could be construed as sisterly support, the zhensovety can alternatively be seen as a voluntary welfare service, making a necessary contribution within a system which lacks institutionalised social services. In this respect, the activists are not only working within official expectations, they are also continuing a traditional women's role. Such activity is thereby reinforced as the legitimate and exclusive responsibility of women. The zhensovety not only fail to challenge the sexual division of labour, they serve to strengthen it.

A further area of zhensovety activity underlines this point. In many areas, the zhensovety are responsible for 'public order'. This ranges from dealing with the 'public nuisance' of drunkenness, to keeping the local environment orderly and attractive. As letters to the women's journals, Krest'yanka and Rabotnitsa show, help is given to families where either parent has a 'drink problem'. Zhensovety members plant trees, decorate local party offices with flowers, and help women organise their homes. In the Uzgensk region of Kirghizia, for example, the zhensovety, together with the local soviet, spent two years educating the local women in home

care, using what they termed 'a delicate and subtle approach'. This entailed talking to women individually, inviting those requiring help to visit the homes of other women, and organising seminars on the theme: 'Every flat, every house, comfortable, beautiful and convenient.'[32]

Underlying all these activities is the Soviet concern to strengthen the nuclear family. The family is seen as the 'cell' of society, and considered vital for its orderly functioning. The zhensovety are undoubtedly the transmitters of this familial ideology. Indeed, seminars, such as those in the Edinets region of Moldavias, are held for activists specifically on the role of the zhensovety in strengthening the family. The zhensovety also take part in the old and new traditions associated with family life, like the 'Festivals of Young Families'. In some regions, for example the Kokchelavskaya district of Kazhakstan, zhensovety activists perform the registration of marriages and births.

The politicisation of women is linked to this importance given to the family, particularly to the maternal role. This has been quite explicit since the early years of the zhensovety. Here it is spelt out by an activist from a zhensovet on the Black Sea:

> Raising the political level and consciousness is an important part of zhensovety work . . . It is necessary that Soviet women should know all about events abroad and in our country to raise their consciousness, after all, they have the responsibility to educate their children, the future builders of the new society. That is why the zhensovety constantly pay attention to this part of their work.[33]

In other words, it is not the intrinsic value of politicisation to 'he woman herself that is all important, but its importance to her role as mother, as the 'upbringer' of the future generation. The zhensovety are thus performing a cultural and ideological role which serves to perpetuate women's traditional position.

From the material looked at so far, it seems indisputable that the zhensovety are incapable of providing the space for the emergence of a feminist consciousness. There are, however, other facets of their activities which should be considered in this respect.

Some attention, for example, is given to the role of fathers: talks are organised on the importance of the father's role; zhensovety activists intervene in individual cases where husbands prevent their wives from working, or furthering their qualifications. This, of course, is in keeping with official policy: men should help women

in their roles as workers, wives and mothers. In one recent article on the zhensovety, an activist claims that in Tadzhikistan they have helped to ensure that Lenin's words are put into practice: 'much of the emancipation of women was in fact concerned with the education of men'. Prospective male members to the CPSU are therefore required to answer the following questions: 'Who is your wife; what is her profession; is she a Komsomol member; does she work? Do you help in the house, with your children's unbringing and education?'[34] Whilst having such questions on a form does little to ensure that they are put into effect, it does suggest that the question has been raised and is of concern at least to some zhensovety activists. However, it should be noted that such examples are to be found in those areas generally considered less developed in terms of women's emancipation. Thus zhensovety activity is concerned with trying to bring the position of women here in line with the standards of European, industrialised Russia. Whatever attention is given to male roles is far outweighted by the primacy of the role of mother.

Zhensovety as Pressure Group

It seems there is space for the zhensovety to act as a form of pressure group. In one sanatorium where the workforce was 90 per cent female, the zhensovety had criticised the management, without effect, for ignoring women's special needs. The zhensovety chair, herself a doctor, then took their criticism of the management to the local party branch, which resulted in the women's demands being met. In other areas, the zhensovety have successfully taken up cases of inadequate child provision, rearranged holiday times to suit the women rather than their place of work, insisted on working regulations being adhered to despite management practice, and helped in the provision of facilities aimed to ease the lives of women, such as rest rooms, shoe repairers and, in one case, the building of a bakery at a kolkhoz, 'saving the women ten hours' baking time'.[35]

Whilst it is clear that many of these achievements have the effect of improving women's productivity — the time saved in baking was to be spent on the kolkhoz — it does have the additional effect of improving women's daily lives. This, of course, makes it easier for women to carry out their designated roles of wife and mother. It should also be remembered that the activities are kept within the bounds of legitimate concerns, and decided as such elsewhere, not by the zhensovety or the women themselves. However, some ambiguity does exist about whom the zhensovety is acting for.

This can be explored in the attitude of the activists themselves, and the effect on the women they involve.

There is a sense of 'sisterhood', a solidarity with other women, to be found in the writings of some activists. Some are quite explicit: their main priority is to act on behalf of women. A zhensovety recently set up on a kolkhoz in the autonomous republic of Checheno Ingushskaya, decided their main responsibility, after 'a long argument', was to 'stir up all women, even the most reticent, and to establish women's rights in the home and at work'.[36] Similarly, the report of an early zhensovety declares that the initial meeting resolved that 'they would open men's eyes', 'to show them, that everyone, including women, can be agitators'. The report goes on to claim that the main achievement in the first year was to help 'women believe in their own strength', and that the women's 'relationships became warmer amongst themselves'.[37]

Although such attitudes, at least in the written reports and articles, are few and far between, they do exist. They should be seen in the context of the common-sense acknowledgement that the position of Soviet women is problematic. The main areas of emphasis in zhensovety activity – mobilisation for economic production, and social activity around women's traditional roles – present a real contradiction to the aim of raising women's political consciousness. On the one hand, there is the practical contradiction between extending women's productive activity in the workplace and at the same time expecting greater political participation. In the reality of Soviet daily life, greater involvement at work means less time and energy for political activity. Party membership itself requires a commitment beyond holding a party card. Members are expected to do 'social work' which is often both time-consuming and demanding. Whilst zhensovety activity would undoubtedly be of relevance, women in particular have limited time and resources. Olya, for example, was hoping to be relieved of her post, as the demands of social work were proving too exhausting.

Social activity presents the other serious contradiction to women's politicisation. The emphasis on family roles for women encourages an image incompatible with woman as a political being. As pointed out earlier, zhensovety activists serve to reinforce the traditional sexual division of labour by carrying out many of the traditional tasks themselves. Giving women and their organisations responsibility for childcare, for example, reinforces the deeply-held belief that this should remain the concern of women.

Thus, by the combination of this increased economic role and the reinforcement of traditional values, the zhensovety serve in part to

perpetuate those very features of women's lives which prevent their participation in formal politics. Whatever the zhensovety try to do about women's political consciousness will be seriously modified by the ambiguous position from which they operate. Why should this contradiction be inherent in the aims and activities of the zhensovety?

The Zhensovety and the Communist Party

Part of the answer is to be found in the relationship of the zhensovety, as a 'social organisation', to the political organisation of the Communist Party. It was noted earlier that one of the special features of the zhensovety is their 'independence' of the CPSU. In this respect, the zhensovety provide an interesting example of how party political culture is legitimised. The zhensovety are described as 'autonomous', there is no evidence of formal central direction by the CPSU or the soviets (with the exception of the Buryat ASR), yet it is evident that the aims and targets of the zhensovety are firmly entrenched in the politics of the CPSU, even where these diverge from the interests of Soviet women.

There is no ambiguity on the intent of party influence. As the 'vanguard' of the working class, leadership is considered to be the duty of the CPSU: 'Leadership of the social organisations is one of the most important roles of the primary party organisations.'[38] Even so, as the zhensovety do differ from other Soviet organisations for women, in that there is no formal structural relationship, the concept of 'leadership' in this context is worth investigating.

A number of sources define this relationship as one of 'guidance' or 'systematic help' by the party to the zhensovety. What this means can be illustrated by the 'Plans of Works', the detailed records of the zhensovety. (Although most examples date from the 1960s, the relationship appears unchanged.) We should bear in mind that the closer the relationship, the less likely it is that the zhensovety are able to raise women's consciousness in the feminist sense: first, because of the feminist stress on autonomy; secondly, the male dominance of the CPSU; and thirdly, the different understanding of feminists and the CPSU on how consciousness is generated.

There does appear to be some regional variation in the relationship with the party. In Odessa, the zhensovety were presented with their tasks by the party, which then helped them organise their 'Plan of Work'. In Chelyabinsk during the same period, the zhensovet drew up thier own plan of work, which they afterwards presented to the local party for approval. The former method is the

normal pattern for most organisations. The 'Plan of Work' for the trade union Commissions for Work Amongst Women, for instance, is agreed on first by the trade union committee, and then the women make suggestions within the framework of the agreed plan. Whereas all trade union groups operate in this way, the zhensovety do present some variation and flexibility.

This variation is also to be found in the day-to-day activity of the zhensovety. In some regions, seminars are organised by the activists themselves, to which they then invite party officials, especially the education secretary. In other regions party involvement is more direct. In the Ukraine, quarterly meetings for zhensovety activists are organised by the party and likely to be on topics such as 'The Central Committee January plenum, both the overall plan and the specific tasks as they relate to the zhensovety.' Even where the zhensovety do organise their own meetings and seminars, party officials have an active role. In Sverdlovsk, for example, such a meeting organised on the zhensovety's 'own intiative' had, as its main speakers, the first secretary of the raikom on 'The Role of Women in Fulfilling the Seven Year Plan'; and the second secretary on 'International Women's Day and the Tasks of Women in Building Communism'.[39]

Thus, whatever diversity exists in the relationship of these women's organisations to the CPSU, it is clearly within the accepted framework that the role of the zhensovety is to 'help' the party in its work with women. In the words of one authority, the zhensovety are 'Effective helpers to the party organisations and communist education of women, in mobilising them in the successful realisation of the tasks decided by the party.'[40]

This help has taken different forms. In the earlier period, activists increased newspaper circulation by encouraging individual women to subscribe. More usually, help means mobilisation around the economic plan. The party organises seminars for zhensovety activists, as in the Edinets region of Moldavia, to 'teach them how to help the party and Soviet organisations'.[41]

This relationship is consolidated still further by the zhensovety personnel. Whilst there is no obvious system of nomenklatura, the system by which appointments to political and administrative posts are controlled either directly or indirectly by the party, it can be presumed that the vetting of committee members does take place. Party policy has been quite unequivocal about this since the earliest days of the zhensovety.

The party in every way supports and develops in these organisa-

tions a spirit of intiative . . . and independent activity. The party puts its influence into these organisations through communists who are members of them.[42]

Whilst this is an underlying principle, there is no apparent central directive regarding the number and position of party women in the zhensovety. Although concrete data are not readily available, sufficient exist to show that in this respect, too, zhensovety vary from region to region. Sources which suggest that the majority of activists are communists are not always supported by actual figures. In Moldavia, for example, where 'thousands of communist women working in agriculture are zhensovety activists', it turns out that half the members of the republic zhensovety are non-party.[43] Of the Miass zhensovety committee, only 12 of the 55 members were party members.[44]

It is more probable that the posts of responsibility are held by party women. In Chuvash, the raion and gorod zhensovety 'are headed by secretaries and other responsible workers of the raikoms (district party committee, or borough) and gorkoms (town party committee)'.[45] Yet here again, there appears to be no formal directive. Indeed, the suggestion that important posts are usually given to party members was strongly rejected in an interview with the zhensovety 'specialist' on the staff of *Rabotnitsa*. However, those who are not actually party members are very likely to be 'responsible' people. The non-party chair of the Miass zhensovety was 'jokingly called the political commissar, and is the right hand of the secretary of the party committee'.[46] By this combination of party and non-party women, all responsible people, the party doubly ensures that the zhensovety work within the context of party policy, albeit with special reference to women.

In some regions, this is further reinforced by a formalised relation between the party and the zhensovety personnel. In the Altai, the elections to the zhensovety are led by the party and the soviets. In Ashkhabad, candidates are first discussed by the party and then by the zhensovety committee. In Turkmenia, in 1973, the party looked at the staffing of the zhensovety as part of strengthening the group's work. One region, the Buryat ASR (Autonomous Socialist Republic), actually has a set of rules for the zhensovety, one of which stipulates that members are elected with the agreement and participation of the soviet.

It is clear that the characteristics ascribed to the zhensovety will at first acquaintance seem of interest to feminists, from what the latter understand as autonomy, independence and initiative in a sex-

specific way. The description of 'independence' refers to the lack of an institutionalised and formal relationship with the CPSU, to the 'lack of common structure and instructions'.[47] The party does not envisage that the zhensovety should work independently from it in an autonomous sense.

Nor is this likely to change in the near future. Recent discussion on the role of the zhensovety has centred on the need to strengthen further the relationship with the party. It has been argued that the zhensovety would be more effective if their work were more systematised, centralised, and if the party gave them more direction and had greater control. There is a general acceptance that the quality of party leadership is an essential factor in the effectiveness of the zhensovety. 'The success of the zhensovety, as is well known, depends on the level of the Party and Soviet leadership.'[48]

Such ideas are not new, and echo much of the debate around the Zhenotdel. Criticisms and proposals come from different groups for a variety of reasons. One such group is the activists themselves. It is they who experience directly the lack of priority given by the party to women. In the context of Soviet society, the effectiveness of organisations, in terms of resources, depends on the extent of party support — in other words, official recognition. Activists have accused the party of not attaching sufficient importance to their work.[49] Female academics, concerned with the as yet unrealised potential of the zhensovety, are another source of criticism. One recent suggestion, for instance, was that the zhensovety should become 'social commissions answerable to the party organisations'.[50] Presumably, the zhensovety would then parallel the women's commissions attached to the soviets and trade unions.

Such strengthening of party control has not, however, been accepted entirely without question. There have been calls for less party involvement, especially during the Khrushchev period, when the concept of 'democratic participation' was being aired. One party theorist, for example, rejected the idea of the zhensovety being seen as an 'appendage' of the party, calling for 'flexibility and diversity' towards women and their zhensovety.[51] Likewise, some zhensovety activists themselves found that their work benefited from less association with the party. In Suzemke, educational work amongst women improved when organised by the zhensovety rather than the local party. The activists claimed that their own approach was more 'delicate'.[52]

The main reponse, though, has undoubtedly been to extend party involvement. This suggests two things. First, that the zhensovety are not formally controlled by the party, and thus retain

some semblance of 'independence'. Secondly, that the zhensovety, and by extension the woman question, has remained a low priority in the work of most party organisations. This is despite the 20 years of zhensovety existence, and official recognition that women's lives are problematic.

The zhensovety thus appear to have little room, in theory or practice, to exert great autonomy from the party. It is evident that, despite the variation and the lack of a statutory relationship, the zhensovety are expected to, and indeed do, identify with the policies and aims of the CPSU, both in general terms and with specific respect to women.

Let us now summarise Soviet assessments of their zhensovety. The written reports of the zhensovety activists during the 1960s usually presented their work in glowing terms. In the words of the former Uzbek president, 'the zhensovety are a wonderful school for millions of women'.[53] The occasional feature article in women's journals continues to present them as successful, useful organisations. It is not uncommon to find quoted such claims as that of a local party secretary: 'In charging the zhensovety with any task, the buro of the raikom does not doubt its success. The zhensovety has substantial authority in the locality.'[54]

Whilst the current work of female academics considers that the zhensovety have a potential role in the social, political and economic lives of women, the general inference is that they lack status and efficiency. This low status is associated with the very characteristics of their being 'women-only' organisations. According to the women's research specialist, 'one cannot regard these as some sort of serious school, this is just women's initiative finding expression'. This dismissive attitude to women's organisations finds more concrete expression in the recommendations by individual party officials to disband the zhensovety. It is suggested that they double up on the party work amongst women, and further that 'women-only' organisations are no longer necessary. The zhensovety are said to have, 'outlived their time'.[55] Such attitudes contradict the frequent calls, made by both party and academic authorities, for the zhensovety to redouble their efforts amongst women. Yet they represent a continuous strand of opposition to such organisations which stretches back to the early days of the zhensovety, and finds an echo in the attitudes to the Zhenotdel.

We have seen that in the Soviet terms of raising women's political awareness, the zhensovety function as party 'schools for women'. Yet it is disputable to what extent they have been successful within these terms. It seems likely that activists will have

developed organising skills, and in some regions women will have had their attention brought to political information more readily, than without the zhensovety. It is probable that the zhensovety have encouraged and helped women, by providing practical support, to take a greater part in paid work. In this respect they have no doubt had some success in the Soviet concept of political consciousness-raising. Although it could be argued that they have been a contributory factor in the gradual increase in the number of women which is taking place in the 'low' and informal political bodies, the zhensovety have failed to raise women's consciousness, in terms of their necessary preparation for entering the formal party structures of 'high' politics.

In terms of consciousness-raising in a feminist sense, the zhensovety have far less to offer. Whilst it appears that in some areas the zhensovety do act as a form of pressure group, the potential this activity might have for feminist consciousness is restrained by the parameters of what the party considers as legitimate. Pressure does not mean altering the plans, it only means putting into effect what has been already agreed upon, but which, without the zhensovety, might have been ignored. The role of the zhensovety as a form of pressure group is thus debatable. On the one hand, it could mean that more attention is paid to women. On the other, the relegation of 'women's concerns' to the zhensovety and the commission allows the party to give even less attention to women. They are provided with the excuse that special women's groups already exist for just that purpose.

The low status of such groups further ensures that women's issues remain a low priority. This notion is encapsulated by Gail Lapidus in her assessment of the zhensovety. They 'enshrine "women's concerns" in Soviet political life, as in effect, a counterpart of "women's work" in the economy'.[56] Yet as we have seen, this still needs to be augmented. The support given by activists to women as women, cannot be reduced to party mobilisation. Hence the existence of the zhensovety is ambiguous, despite the fact that they accept as their main role the dissemination of party decisions, and that their activities take place within the framework of the political culture of the Communist Party.

In conclusion, we will examine some of the reasons for what can be seen as the virtually inevitable failure of both the aim of the zhensovety in raising women's consciousness, and in contributing to women's advance in the formal political structure.

The traditional bifurcation of the sexual division of labour associated men with the public sphere where politics was located.

Women were associated with the private sphere. As we have seen, the Soviet Marxist schema attempts to overcome this by a two-pronged approach. First, women are to enter public life, particularly in the productive process. Secondly, the concerns of the private sphere, at least some of them, are redefined as political. Policies on motherhood enter the political agenda.

The activities of the zhensovety serve to show the inadequacy of this theoretical approach. Private issues have entered 'low' politics and, though now public, have been retained primarily as the province of women. Thus the traditional division between public and private has been transferred, virutally intact, to a division between 'high' and 'low' public politics. Women's issues meet this barrier, just as women themselves do. Defining women as political beings by instancing their entry into production, and their participation in local soviets and social organisations such as the zhensovety, avoids the question of their absence from positions of political power. In turn, the inferior status of low politics, despite claims to redefine the political, is illustrated by the low status of the zhensovety. Thus the male—female dichotomy continues. It is only the position of the demarcation line which has shifted.

These limitations in the theory have meant that official Soviet commitment to equality has failed to provide an adequate alternative to the underlying 'biologism' found in Soviet society, by which I refer to the ideology which suggests that gender roles are mainly determined by biologically assigned characteristics. Once Soviet authorities had admitted that equality was yet to be achieved, reasons had to be sought. Biologism emerged, unstated, as an explanation.

It is a recurrent approach, found not only in common-sense notions, but also in the party controlled media, and in officially sanctioned attitudes to women. Biology is the basis of the so-called 'psychological reasons' given as explanation for women's lack of political participation. It is spelt out, for example, in an article celebrating International Women's Year which says that women's political involvement will take place to the extent that

> . . . it will not prevent them from fulfilling their prime social function, that of being mothers. Therefore the proportion of women in the party, the soviets and the trade unions, and especially those holding high elective posts, is smaller than that of men.[57]

Although no official statements are so explicit, biologism is

reinforced officially – the role of motherhood, as distinct from parenthood, is constitutionalised in Article 35 of the Constitution of the USSR.

To politicise women, the notion of how this politicisation can happen has to be redefined. At present, it depends on the wisdom of the opposite sex. It is men who have defined the ultimate goal of sexual equality. As Hilda Scott has said:

> It is only recently that we have begun to draw conclusions from the fact that throughout recorded history, societies' needs have been defined by men, Marx and Engels included. One of the needs which is now being dimly perceived is for a stereoscopic vision of the future which will take this into account.[58]

In other words, women have to be in a position to contribute to the concept of sexual equality. The zhensovety show that no official female dimension exists to challenge the present concept. With no alternative to its theoretical basis, there is unlikely to be a fundamental change in the position of women in political power.

Soviet socialism does not appear, in essence, to have lessened the patriarchal hold. Currently there is little to suggest that the male leadership of the CPSU intend to surrender their political monopoly, either as elites or as males. It is predominantly men who decide whether women–only groups are desirable, and if they are, on what terms. It is men who determine the nature of the relationship between such groups and other bodies. The idea of an organisation existing as autonomous from the CPSU has become enshrined as an anachronism. I would suggest that it is this element that called forth the swift reaction of the authorities to the editors of the Leningrad feminist *Almanac*. The content did not differ dramatically from some of the public debates on women: however, the editorial call for women to come together autonomously as women – to discover and share their experiences on a common platform – did. In this respect, Jancar's contention that Soviet women have no space to develop an autonomous sex-specific consciousness remains valid – despite the existence of the zhensovety.

Without autonomy, the zhensovety cannot have that space for women to create a fundamental change in their role as women. Owing to the inbuilt relationship between the zhensovety and the politics of the CPSU, they are unable to challenge the neglect of women in power politics. The zhensovety are committed to creating women in the accepted image of the Communist Party.

The USSR has done much to show that women can be politically

as active as men, by broadening the concept of what constitutes politics, and then involving women in such areas. However, the Soviet experience can also indicate to women elsewhere that such an extension of the political, even when accompanied by political activity by women in equal numbers to men in such low and informal politics, can be contained within the existing traditional model of power, a power which is male, and which continues both to limit and to omit women. It is not sufficient for women to be 'in politics'. They have to be in the politics of power, both to participate as women, and to change the very nature of that power which serves to preclude women.

Notes and References

1 Gail Warshofsky Lapidus, *Women in Soviet Society: Equality, Development and Social Change* (Berkeley: University of Californa Press 1978), p. 219. The number of women has increased from 3 on the Central Committee in 1917, to 14 in 1976. However, as Gail Lapidus shows, due to the increase in size from 31 to 426 respectively, the percentage of women has actually decreased.

2 Jerry F. Hough, 'Women and Women's Issues in Soviet Policy Debates' in Atkinson, Dallin and Lapidus (eds), *Women in Russia* (Sussex: Harvester, 1978), p. 362.

3 Barbara Wolfe Jancar, *Women Under Communism* (London: John Hopkins, 1978), pp. 121–90.

4 Seweryn Bialer, *Stalin's Successors: Leadership, Stability and Change* (Cambridge University Press, 1980), p. 166.

5 Stephen White, *Political Culture and Soviet Politics* London: Macmillan 1979), p. 155.

6 Leonid Illyich Brezhnev, 26th Congress CPSU 23.2.81, translation *Soviet Weekly* (London), p. 42.

7 Nancy McWilliam, 'Feminism, Consciousness Raising and Changing Views', in J.S. Jaquette (ed), *Women and Politics* (New York, 1974), p.160.

8 Sheila Rowbotham, 'The Women's Movement and Organising for Socialism' in S. Rowbotham, L. Segal and H. Wainwright, *Beyond the Fragments* (London: Islington Community Press, 1979), p. 26.

9 Olya Tallya, *Politicheskaya rabota sredi zhenshchin* (Chusbash, 1975), p.19.

10 B. Jancar, *Women Under Communism*, p. 110.

11 N.A. Koval', *Podrugy Moyakov* (Moscow, 1961).

12 Y.S. Nasriddinova, *Zhenshchiny Uzbekistana* (Uzbekistan, 1964), p.170.
13 Delegate at Askhabad Conference for Soocial Workers, 1972.
14 Richard Stites, *The Women's Liberation Movement in Russia: Feminism, Nihilism and Bolshevism 1860-1930* (Princeton University Press, 1978), pp. 414–15.
15 G.B. Bobosadikova, *Rabotnitsa*, no. 11 (1980), p. 7.
16 *Krest'yanka* no. 11 (1978), p. 23.
17 A.V. Mel'nik, *Krest'yanka,* no. 10 (1978), p. 23.
18 A.P. Polegeshko, *Nashi Aktivistiki* (Ul'yanovsk, 1961), p. 5.
19 V.I. Cheidene, *Deyatel'nost po povysheniyu role zhenshchin v upravlenie obshchenarodnym gosudarstvom* (dissertation, Moscow, History Faculty KPSS, 1980), pp. 113–14.
20 R.N. Babadzhanova, *Tvorzhestvo i initsiativa* (Tashkent, 1970), p. 110.
21 Report of Work for Barisskai raion, quoted A.S. Stoyankina, *Zhenskie Sovety* (Moscow, 1962), pp. 5–6.
22 Olya Tallya, *Politicheskaya rabota sredi zhenshchin* (1975), p. 54.
23 V.N. Golubeva, speech at 26th Congress CPSU, *Pravda* (25 Feb 1981) pp. 4–5.
24 V. Kuriedov, secretary Sverdlovsk obkom, *Partiinaya Zhizn,* no. 9. (1959), pp. 7–8.
25 Olya Tallya, *Deyatel'nost' KPSS po povysheniyu ideinopoliticheskogo urovnya sovetskikh zhenshchin v usloviyakh stroitel'stva kommunizma* (dissertation, Moscow, History Faculty, 1971), p. 223.
26 Zaripova, secretary Tadzhikistan Central Committee, 'Zhenshchiny Aktivnie Stroiteli Kommunisma', *Kommunist,* no. 12 (1965), p. 32.
27 K. Mavlova and I. Chernyadeva, 'Khozyaikii bol'shovo goroda', in K.P. Kuzbetsova (ed), *Zabotlivyi ruki – iz opyta raboty zhenskikh sovetov* (Chelyabinski, 1961), p. 14.
28 M. Mollaeva, 'Rastet' sotsial'naya aktivnost' sovetskikh zhenshchin', *Partiinaya Zhizn,* no. 5 (1978), p. 60.
29 N.A. Koval', *Podrugi moyakov,* pp. 20–1.
30 N.A. Egorova, *Krest'yanka,* no. 4 (1977), p. 4.
31 L. Chuprova, 'Zhivem v prinolyar'e', *Krest'yanka,* no. 6 (1981), p. 21.
32 *Krest'yanka,* no. 8 (1976), p. 1.
33 N.A. Koval', *Podrugi moyakov,* p. 14.
34 G.B. Bobadikova, *Rabotnitsa,* no. 11 (1980), p. 8.
35 *Krest'yanka,* no. 1 (1978), p. 11.
36 *Krest'yanka* no. 9 (1980), p. 27.
37 Mariya Semoneva Kuznetsova, *Est' v Suzemka Zhensovet* (Bryansk, 1962), p. 9.
38 *Spravochnik Sekretarya pervichnoi partiinoi organisatssi* (Moscow, 1980), p. 312.
39 A.S. Stroyankina, *Zhenskie Sovety,* p. 14.
40 O. Prosvetova, *Zhenshchini Marinskoi ASR* (Isoshkar Ola, 1975), p.194.
41 A.A. Rotar', 'Opora na Aktiv', *Krest'yanka,* no. 7 (1976), p. 22.

42 G.I. Shitarev, 'Vozrastanie roli KPSS v period razvernitogo stroitel-'stva kommunizma', *Vsesoyuznoe Obshchestvo*, no. 20 (1959), p. 34.
43 *Krest'yanka*, no. 10 (1978), p. 23.
44 K. Zel'dich, in K.P. Kuznetsova (ed), *Zabotlivyi ruki*, p. 27.
45 Olya Tallya, *Politicheskaya rabota sredi zhenschin*, p. 62.
46 K. Zel'dich, in K.P. Kuznetsova (ed), *Zabotlivyi ruki*, p. 28.
47 Olya Tallya, *Politicheskaya rabota sredi zhenshchin*, p. 62.
48 V.I. Cheidene, *Deyatel'nost' KPSS po povysheniyu role zhenshchin*, p.117.
49 A.S. Belyaeva, *Zhenskie sovety* (Saratov, 1962), p. 24.
50 S.Ya. Zhvirble, *Zhenshchiny v sostave KPSS i ikh uchastie vo vnutripar-tiinoi zhizni* (dissertation, History Faculty, Academy of Social Sciences, Moscow 1980), p. 164.
51 G.I. Shitareve, *Partiinaya Zhizn*, no. 11 (1961), p. 16.
52 M.S. Kuznetsova, *Est' v Suzemke zhensovet*, p. 14.
53 Y.S. Nasriddinova, *Zhenshchin Uzbekistana* (Uzbekistan, 1964), p.147.
54 A.A. Rotar', 'Opora na Aktiv', p. 22.
55 Olya Tallya, *Politicheskaya rabota sredi zhenshchin*, p. 64.
56 Gail W. Lapidus, *Women in Soviet Society*, p. 208.
57 Y.D. Yemalyanova, 'The Social and Political Activity of Soviet Women', in Y.Z. Danilova et al., *Soviet Women* (Moscow, 1975), p.68.
58 Hilda Scott, 'Eastern European Women in Theory and Practice', *Women's Studies International Quarterly*, vol.1, no. 2 (1978), p. 198.

8 THE FIRST SOVIET FEMINISTS
Alix Holt

IN THE autumn of 1979 a small group of women met together in Leningrad to work on a women's journal — a *samizdat*, unofficial publication. Ten copies of *An Almanac: Women and Russia* were prepared and in September launched into circulation. In the Appeal which appeared as an epilogue to the journal, the authors expressed their dissatisfaction with women's lot:

> Hardly have we started out on life before we experience the full weight of women's destiny. At first we believe that the circumstances that hem us in, hurt us and humiliate us are accidental. It is inconceivable that they should be otherwise; that life should punish innocent people just because they happen to be born female.[1]

A journal, they felt, could help women share their experiences, discover common problems; it could 'examine the position of women in the family, at work, in hospitals and maternity homes, the lives our children lead, and the question of women's moral rights'; it could 'publish articles and fiction written by women and also the personal histories of modern women'. The Appeal ended with a request for articles and stories on whatever subjects readers felt most strongly about.

> If needs be, the women from our journal will come and see you and give whatever help they can. We hope that by pooling our efforts we can rekindle support for the forgotten cause of women's liberation and give women a new courage. After all: 'Where there is light, there is hope.'[2]

Over the next two years this hope was dimmed as copies of the *Almanac* were seized, further issues banned, and the government did everything in its power to silence the feminists. The authors of *Women and Russia* were repeatedly called in by the KGB for interrogation, their families and friends subjected to threats and intimidation. Four members of the collective were forced into foreign exile; another was twice arrested and put on trial for 'slandering' the Soviet state and system.

Although the Russian Revolution promised a socialist reorga-

nisation of society, including freedom of the spoken and written word, economic and social power in the USSR has become consolidated in the hands of a party elite, the soviets absorbed into an authoritarian system of government so that the distance between the individual citizen and the state is now as wide as it was in Tsarist times. The economic and social transformations of the post-revolutionary period have been enormous: today the population is predominantly urban, literate and relatively well-educated, but on the negative side, the state security system now draws on modern technology and modern organisational methods with the consequence that, for those who oppose the government, scope for action is even more limited than it was under the old regime. Radicals in the nineteenth century had illegal printing presses at their disposal, escaped from places of exile and even from prison, travelled to and fro across the border, arranging the distribution of literature and avoiding arrest. Soviet dissidents now are lucky if they can get their hands on a typewriter and usually travel abroad only when being deported. And while from the mid-nineteenth century onwards, independent journals were allowed to exist and express oppositional ideas (albeit heavily censored), and after 1905 a limited number of oppositional political parties were legalised, these days all organisations, including cultural and sporting bodies, are rigidly controlled by the party.

There is no scope for groups within Soviet society to possess an independent political voice; there are no organisations of ethnic minorities, no gay movement, no societies to promote conservation or nuclear disarmament. By the same token there is no women's movement in the way we understand the term in the West. Soviet propaganda defends this state of affairs by arguing that the Soviet system functions smoothly, that the interests of all its citizens, of all social groups, are taken care of and that criticism is thus misplaced. If inadequacies and shortcomings are recognised, as they sometimes are, it is argued that they will be overcome by the march of progress and the further maturing of Soviet socialism or by the intervention of the various official organisations such as the trade unions, the young communist organisation, and, in the case of women's issues, by the Committee of Soviet Women and the local women's soviets. Those who seek to protest against social wrongs outside this tightly-controlled system are categorised as slanderers of the Soviet system, as hysterical and possibly unhinged individuals who are at best misguided, at worst participants in a malicious attempt to undermine the Soviet way of life.

The official channels for the expression and consumption of

discontent on specifically women's issues have expanded over the last 20 years and undoubtedly provide an important lifeline for many. A number of women journalists have made their mark in recent years, putting the woman's point of view forcibly in the press; women readers have also had letters published in popular newspapers and magazines. Trade unions and soviets provide a forum for occasional debates on questions of childcare facilities, part-time work for women and improvements in the quality of public catering. The women's soviets in some areas can offer women companionship and relay grievances to party circles. The women's magazines, *Rabotnitsa* and *Krest'yanka*, give advice and reflect in a fairly realistic way the daily lives of ordinary women. Nevertheless, as the chapters in this book make clear, the available means of redress cannot solve the problems women face, problems which are woven into the organisation of the economy and of society as a whole.

Although the *Almanac* did not explicitly refer to the official women's organisations or the official channels for social criticism, its authors clearly considered them of little worth.

> Nothing . . . changes by itself, and we are convinced that no one will help us unless we help ourselves. Only by meeting together to discuss our bitterness and pain, only by exchanging our experiences and understanding them, can we find solutions to our problems. Only then shall we be able to help ourselves and the thousands of women who like us are unhappy.[3]

Nor did they place their faith in the dissident movement. Since the mid-1960s, when the present political opposition to the Soviet government took root (the earlier Trotskyist and Bukharinite oppositions were crushed by the mid-1930s), dissidents have campaigned actively on behalf of national minorities, particularly the Crimean tartars, but not on the question of women's subordination in Soviet society. In spite of the fact that a large number of women have been involved in the movement, few have aspired to leadership and most have accepted that the dissident movement should pass over feminist issues, which they saw as far less important than basic democratic rights.

Several of the women who collaborated on the *Almanac* had previously been active in the dissident movement. Tat'yana Mamonova first worked for a time as a translator on an official journal, but left, disappointed with the uninteresting work she was given. She then made contact with the unofficial 'non-conformist'

culture. During the 1960s, the period of the Khrushchevian thaw when social problems were aired with greater frankness in the press, she became concerned about the place of women in society and tried unsuccessfully to publish her essays on the subject. In the 1970s she began raising the 'woman question' with her non-conformist friends. She felt, though, that the dissidents found her feminist ideas amusing and that they tended to undervalue women's artistic achievement; this sharpened her awareness of women's subordination at all levels of society, in the 'second' as well as the official culture. A *samizdat* journal for women would, she thought, be a good way to start some discussions on these issues.

Yuliaya Vosnesenskaya was initially attracted to the 'alternative culture' because her poetry, which the state publishing houses refused to handle, found a ready audience amongst the readers of *samizdat*; later, after 1968, she became involved in its political activities. Unhappy with the elitist and hierarchical structure of the dissident community, she welcomed the idea of a new journal, though she had reservations and wondered whether the 'woman question' deserved this special attention. Nevertheless, she agreed to participate in the project and found it far more interesting than she had expected.

Tat'yana Goricheva, a dissident philosopher, had, like most Soviet intellectuals, always viewed feminism as frivolous and trivial until she came to study the ethical aspects of motherhood and family relations. She too agreed to join the *Almanac* collective. Her friend, Natalya Malakhovskaya, was tired of working with the 'second culture' which she found 'very snobbish' and responded enthusiastically to the proposal for a women's journal. 'It was like an intuition. I felt as if I were standing on a mountain and could see it all in perspective, because suddenly I saw that in the women's movement you can say exactly what I wanted to say — everything.'[4]

In the *Almanac*, she and the other authors had their opportunity to speak out on whatever they wanted and did so in poetry, fiction and in essay form. The main subjects of discussion and criticism were the quality of Soviet social services — the standard of care in maternity homes, in abortion wards, in creches and nursery schools, in pioneer camps — and the failure of men to pull their weight in the family. 'March 8 (once a year!) they dust the sideboard', wrote one contributor.[5] Another had this to say:

There exist today, to put it bluntly, two ways of life for men:

1 After work the man goes drinking and then tumbles into bed or kicks up a row;

2 After work the man sprawls on the sofa with the paper or sits in front of the television.[6]

The Soviet media ignored the publication of the *Almanac*. Neither at the time nor subsequently has the journal or the feminists who wrote for it been mentioned by the Soviet press or television. The government has not publically engaged with the ideas expressed in the journal, nor brought its existence to the notice of the Soviet people.

It might be thought that the government has refrained from engaging in debate because the cause espoused by the *Almanac* − the liberation of women − is already an official tenet of Soviet ideology. However, the main political demands of the dissident movement − freedom of speech and assembly − are enshrined in the Constitution, so the coincidence of dissident demands and Soviet ideology is nothing new. The Soviet state claims a monopoly on the right to criticise and will deal harshly with those who challenge it on this point, preferring though to do so whenever possible in private. Over the last few years, the success of repressive measures has thinned the ranks of the dissident movement and hence the government has not felt it so necessary to stage-manage the newspaper articles and television programmes denouncing anti-Soviet activities, which appeared from time to time in the early 1970s.

In private, however, out of sight of the Soviet public, the government acted swiftly against the feminists. In November 1979 Tat'yana Mamonova was interviewed by the KGB. On 8 December, she was summoned for a second interrogation and forced to sign a declaration accusing herself of publishing an 'ideologically tendentious review'. She was warned that should a second issue of the *Almanac* appear, criminal charges and a prison sentence would follow. In a letter to the Procurator-General of Leningrad, written a few days later, she protested against this treatment, indicating that all her actions had been within the law: the *Almanac* was published in conformity with Articles 50 and 52 of the legal code and distributed at home and abroad as authorised by Article 19 of the Helsinki Accords. 'I intend', she continued, 'to pursue my feminist activities because I consider that feminism is progressive and that a women's movement is an essential part of the world democratic movement.'[7]

Other members of the *Almanac* collective, Tat'yana Goricheva,

Yuliya Voznesenskaya and Sofiya Sokolova, were also taken in for
questioning. Other forms of intimidation were employed: mail was
intercepted, the women harassed in the streets. Tat'yana Mamono-
va and her husband Genadii Shikarev were threatened with charges
of parasitism, i.e. of not being in regular employment, and with the
loss of custody of their child. Yuliya Voznesenskaya's elder son lost
his place at an institute and was sent conscription papers for
military service in Afghanistan.

The Soviet government, in its own particular way, took a very
serious attitude to the first feminist *samizdat*; the circulation of ten
typed copies of *Woman and Russia* drew down upon its authors the
full force of the state's organs of repression.

Disagreements over Religion and Politics

This policy of intimidation was in the short term unsuccessful,
however, and within a matter of months not one but two new
feminist journals were published: *Rossiyanka* 'Russian Woman' and
Maria. Despite the intentions of the *Almanac* to provide a forum for
a range of opinions, the differing views and personalities of the
members of the editorial collective proved incompatible. Conflicts
arose and deepened leading to the formation of two distinct
feminist groupings.

Three members of the original *Almanac* collective, Tat'yana
Goricheva, Natalya Malakhovskaya and Yuliya Voznesenskaya,
wanted to adopt a religious identity and found other women eager
to follow their lead. As the title of the journal *Maria* (named in
honour of the Virgin Mary) indicated, its organisers were Chris-
tians and moreover saw Christianity the chief source and support of
their feminism. This group was soon by far the larger of the two.
By March 1980 they had set up a club and were widening the range
of their oppositional activity. The journal *Maria* presented the same
mixture of poetry, short stories and essays as the *Almanac*. It also
covered some of the same ground. A section of 'Women and the
Gulag' provided biographical material on recent victims of repres-
sion, another, 'Our Happy, Happy Life' contrasted the reality of
Soviet existence with the official rhetoric. The religious orientation
was far more evident, with the Bible quoted frequently, a contribu-
tion from Tat'yana Goricheva on prayers to the Mother of God,
and an article by Kseniya R. on how she came to be a Christian. In
its 'Appeal to Women of the New Russia', in the first issue the
editors explained:

We have named our club and journal after She who will save the

world, after She who intercedes for Russia in heaven and on earth.

She hears every sigh that issues from our land, She descends to the hell of women's existence and lifts up the souls of women who have already despaired and are without hope. She walks over this our land over which so much blood has been spilt and through Her the Golgotha of Russian life is resurrected.

This was no sudden conversion to Christianity. Tat'yana Goricheva as a philosophy student at Leningrad University in the early 1970s had shown a preference for existentialism over dialectial materialism and had specialised in Kierkegaard and Heidiger. The journal 37 of which she was one of the founders, was religious in orientation. Her contribution to *Woman and Russia* 'Rejoice, redemption from the tears of Eve', described how some years earlier she had turned from the emptiness of a hedonistic lifestyle to piety and the ascetic life, to veneration of the Mother of God, chaste and loving, the model of goodness to which womankind should aspire. Natalya Malakovskaya, a fellow philosophy student and university friend of Tat'yana's had been attracted to the same religious milieu and participated in the unofficial seminars organised in Leningrad to discuss theological questions.

Disagreement over the connection between religious beliefs and feminism was the main reason for the split in the original *Almanac* collective. Tat'yana Mamonova's outlook, for example, was from the outset determinedly secular. She told a reporter from the French magazine *Des Femmes en Mouvements Hebdo* that the Church was the enemy of women: it was hard for her to welcome the renaissance of the Orthodox Church. It was possible, she later remarked, that some women might come to feminism via the Church, but over 90 per cent of Soviet women were not religious and never would be. The christianisation of the feminist movement would, she feared, disorientate and alienate Soviet women. While she was willing to accept religion as one strand within the women's movement, she opposed its total christianisation. In her view it was the rejection of the principle of pluralism by the Christian women that led to the split and to the appearance of two journals, *Rossiyanka,* under her editorship, continuing the traditions of the *Almanac* and *Maria,* establishing an exclusively religious identity for Soviet feminism.

This rapid identification of the larger of the two feminist groups with Russian Orthodoxy is in marked contrast to the development of modern feminism in the West, where only a minority has linked

women's rights and religion – the major orientation of the Western women's movement has been secular and political. The Soviet dissident milieu from which the feminist group emerged, however, has a strong religious current. Orthodox views are widely held or deeply respected by almost all who participate in the 'second culture'. This reverence for the Church, which exists not only amongst the dissidents but among broad layers of the intelligentsia, is at first glance surprising: in the nineteenth century, the Russian intelligentsia was enthusiastically secular, devoted to Western science and the pursuit of rational knowledge. The Orthodox Church, conservative and closely linked with autocracy, was seen by many as a part of the old order that had to be swept away. The Western radical religious sects which made connections between Christianity and social protest did not have counterparts in Russia at this period. However, in the years following the defeated 1905 revolution, the intelligentsia threw itself with an enthusiasm born of despair at the failure of political protest into the search for a faith and found comfort in a religion of mysticism, irrationality and the worship of absolute ideals. A number of prominent Marxists advocated the merger of scientific socialism and idealist religion, arguing that in this way both the material and spiritual prerequisites for the new life could be won.

After the Bolsheviks had seized power in October 1917, they declared their intention of preserving all that was best in the pre-revolutionary culture – this 'best' in their view did not include religion, either of the Orthodox variety or the mystical philosophies of the intelligentsia. The Church was formally separated from the state and atheist propaganda undertaken on a wide scale. Though the militancy of those early godless years has long been spent, religion in official Soviet ideology is still branded as the opium of the people, atheism is taught in schools and higher educational establishments, and religious belief is held to be incompatible with party membership or government office.

Religious faith is thus an act of defiance, an expression of non-allegiance to the official ideology; as such, it has a strong appeal to those who oppose the established order. Although the Orthodox Church cannot boast a history of resistance to the communist state as stubborn as that of the Catholic Church in Poland, and is unlikely to become a symbol of popular revolt and regeneration on the same scale, it does provide a moral code for those people who no longer believe in the values proclaimed by the Soviet government. The Orthodox Church as an official body has to keep on the right side of the authorities and thus holds itself aloof

from all politics, yet individual priests have supported the dissident movement and encouraged the resurgence of interest in theology and related philosophical and ethical questions. The Church also represents the continuity of Russian culture; religious faith is a link with the non-Soviet past, with those cultural currents of the early twentieth century which have a special fascination for modern Soviet intellectuals. Though few of these men and women can claim direct descent from the pre-revolutionary intelligentsia, they see themselves as its spiritual heirs. The dissident intellectuals in particular seek to pick up the threads of the cultural life of their country at the point when it was interrupted by the Bolshevik Revolution; in passing over the 60 years of Soviet power and returning to their pre-revolutionary roots, they hope to find inspiration for new developments.

The attitude of the Orthodox Church to women has always been anything but enlightened. Along with other forms of Christianity it taught obedience and chastity, and its extremely hierarchical and autocratic structure granted little scope for women to find friendship or social status through religious observance. Women, the Church ordered, were to be banned from all places of worship during menstruation and after childbirth. It was humiliation at this ban that prompted Inessa Arnand, later a prominent member of the Bolshevik Party, to question her religious beliefs. The pre-revolutionary women's movement had no significant religious current.

For the feminist authors of *Maria,* religion stands for protest and change, not for the oppression of women. According to Yuliya Voznesenskaya:

> Christianity attracts us primarily because of its moral principles. We are tired of hearing that the only good is what serves the Party. We long for eternal, absolute values — of justice, love, goodness — not a new set of values every time a bolshevik bandit comes to power.[8]

For the women of the modern intelligentsia, as well as for the men, Christianity affords a sense of cultural continuity and the moral satisfaction of defying the authorities.

This alliance between feminism and religion has become possible because, on the one hand, those priests who have contacts with the dissident movement are prepared to update the Church's teaching on women, to respect demands for dignity and intellectual equality, and on the other, the feminist ideal of many members of the

Maria collective is curiously close in a number of ways to the traditional model of womanhood upheld by the Orthodox Church. In reacting against the tractor-driver image of the emancipated Soviet woman, several of the Christian feminists have emphasised woman's right to family life and stressed the responsibilities she has as wife and mother.

This religious basis of their feminism, which distances them from the Western women's movement, brings them the support and understanding of fellow dissidents. There is some evidence, it is true, that the initial attitude to the *Almanac* of dissidents both at home and in exile was far from friendly. It was reported in the Western press that they found the journal ridiculous and unimportant, 'too petty to be taken seriously':[9] that the Russian émigrés did not know what to say about these 'amazons, lesbians'.[10] Though Andrei Sakharov was said to approve of the journal from the start, it evidently took some time for the majority of dissidents to accept the idea of feminist *samizdat*. Nevertheless the publication in France of a translation of the *Almanac* and the coverage the women received in the foreign press helped win some of them round and the definite Christian identity adopted by the majority of the women made feminism acceptable to the dissident community as a whole. Articles by members of the Maria group appeared in émigré publications such as *Russkaya Mysl'* and *Posev*. Alexander Solzhenitsyn wrote to them expressing his sympathy for their movement; its religious orientation differentiated them fundamentally, in his view, from 'superficial Western feminism'.[11]

Tat'yana Mamonova, whose secular outlook was closer to that of 'superficial Western feminism', has had greater problems fitting into the 'second culture'. She clashed with the dissident movement not only over the question of Christianity, but also over politics. In an interview with the French journal, *Des Femmes en Mouvements Hebdo*, she said that it was the fashion in the USSR to speak slightingly of the revolution and she had had enough of it, too, if Soviet society was to be equated with revolution. However, in her view this equation should not be made. She had some respect for Lenin, she said, and sympathised with the socialist ideas of 1917 and the liberational politics of the 1920s. The editorial to the *Almanac* which she drafted stated:

> Lenin never overlooked women when appealing to the masses. A demand for equality for all people could not exclude half the human race. The revolution brought about not only bloodshed, but also a change for the better for the nation (and for indi-

viduals). The enthusiasm in Russia during the 1920s is well known and can be understood. There was full-blooded hope in the new times, new personal relationships and a new family. The Russian revolution resounded throughout the world, and the world was transformed by it. The liberalisation of society as a whole has gradually liberalised the position of women. In Russia this process ground to a halt with the cult of the personality under Stalin.[12]

In the eyes of the majority of Soviet dissidents, the radical and socialist political ideals which motivated the educated elite of the nineteenth century have been discredited by the experience of 60 years of Soviet power. Though the moral fervour and self-sacrifice of rebels such as Sofiya Pekrovskaya, hanged for her part in the assassination of Alexander II in 1881 are admired, the faith of these radicals in the people, their belief in the positive benefits of communal property, are seen as naive. The dissidents rarely spell out the institutions with which they would like to replace the present regime, but for the Soviet system they have no good word to say and hold the Bolsheviks responsible for all present political evils. Those few oppositionists who still cling to socialist ideals or believe, like Roy Medvedev, that the present regime is not past redemption, that judicious reform could usher in socialist democracy, are held in suspicion. Thus Tat'yana Mamonova with her sympathy for the social experiments of the 1920s, her praise for Lunacharsky and Alexandra Kollontai, was labelled a *komsomolka* (young communist woman) — a clearly derogatory term in this context.

The religious women share the political views of the dissident majority. In a 'Debate on Feminism and Marxism' published in the first issue of their journal, they all expressed a deep dislike of Bolshevism. Marxism they condemned out of hand as a satanic force, a loveless doctrine that ignored art and beauty and eternal truths, a doctrine preached only by rascals and careerists, that reduced people to abstractions and in doing so denied real people their human rights.

Disagreements over Feminism
The focus of attention of most articles in the *Almanac* was the crisis in the family. Authors, however, offered different solutions to the problems they raised: some wanted radical change, particularly in the role of husbands and fathers; others seemed to advocate a return to the traditional family and appeared to accept the traditional conception of the feminine personality.

The split in the *Almanac* collective at the beginning of 1980 was interpreted by the women themselves as a reflection of disagreements on feminist issues as well as of different attitudes to religion and politics. The Maria club believed that Christianity influenced the views of its members on woman's social role and led them to reject the 'radical' type of Western feminism they ascribe to Tat'yana Mamonova and her group. The Christian women have subsequently taken a different stand to the secular feminists on a number of questions. While Tat'yana Mamonova and Natalya Mal'tseva have publically proclaimed abortion to be a woman's inalienable right, the Maria group has found the issue 'very difficult'[13] and most of the religious feminists have followed the teaching of their Church in condemning abortion as infanticide, though they do not seek to impose their views on others. The attitude of Tat'yana Belyaeva is probably typical. A recent convert to Orthodox Christianity, she now believes abortion to be against the law of God and regrets her own sins. Nevertheless she appreciates the circumstances that lead women to terminate pregnancy and is still willing to put friends in touch with a doctor who performs abortions privately and whom she herself visited in the past. The religious feminists have been similarly cautious in their approach to questions of sexuality. They prefer to talk of love and chastity and to discuss relations between men and women in religious terms. Marriage, for Tat'yana Goricheva is 'a microcosm in which two meet in His name . . . [which] must be the threshold of heaven. Two free individuals love each other, and each through the beloved sees and speaks with Christ.' 'Real marriage', she continues, 'is the secret, the Mystery, the eschatological precursor of the future marriage of the Lamb and the Church.'[14] Tat'yana Mamonova, on the other hand, has expressed herself in a very different language, seeking to understand how society moulds our views on personal relations, and has published articles on female sexuality and given her support to the struggle for gay and lesbian rights.

However, the disagreements over feminism have not been as clear-cut as those over religion and politics. The divisions in the original *Almanac* collective were not entirely between advocates of the new family and defenders of the old. Natalya Malakhovskaya, whose contribution to *Woman and Russia* was the most outspoken in its criticisms of family inequalities and the failings of men as husbands and fathers, joined the Maria group, whilst Vera Golubeva (pseudonym of Natalya Mal'tseva) who wrote in the *Almanac* that: 'To fulfil one's destiny as a mother is the greatest

blessing nature holds in store for a woman', sided with Tat'yana Mamonova.

Natalya Mal'tseva has subsequently identified herself closely with the views of Tat'yana Mamonova on the family and social change and the ideas presented by the secular feminists have been consistently close to those which are current in the Western women's movement. The Maria group, on the other hand, has continued to express a variety of views.

During the 'Debate on Marxism and Feminism', Tat'yana Mikhailova declared that woman was 'above all a mother'. Sofiya Sokolova, writing in the same issue, argued that women were in some sense better off than men in Soviet society for they could satisfy themselves through maternity, while men were denied access to the public and political world without which they could not be expected to realise their potential.[15] Natalya Malakhov-skaya, on the other hand, has championed women's right to contribute to all aspects of social life, to be creative in all spheres. In *Maria 2*, published in 1982, she returns to the question of sex roles in the modern family and the effect that the routine and drudgery of running a household has on the female personality. She seeks a way out of this 'insatiable womb':

> Given the present atomised, disjointed state of our society it is very hard to find a way out. Of course if men as well as women were to service the family the problem would be easier by half. But no exploiting class has ever given up its privileges voluntarily so such a solution to the problem is only possible in the future when we have brought up our sons to be decent people.[16]

In the meantime, she suggests, Soviet women should practise self-help: friends should get together and organise childcare and catering on communal lines. The contribution of Tat'yana Goricheva to this discussion on everyday life, *byt*, is particularly significant because it represents a change in her thinking. While in the *Almanac* she criticised Soviet society for teaching women to despise their domestic duties she now accepts that everyday life stifles women and advises escape. Woman is chained to the kitchen, she says, and is forever standing in queues; she is reified, her whole life taken up with shopping and housework; *byt* prevents being.[17] The Soviet family, she continues is an authoritarian unit, a gulag in miniature, encouraged by the state because it understands that in strengthening the family it consolidates its own positions. Thus the latest writings of the most influential members of the Maria group

take up the problems of the family in a far from traditional manner.

According to Yuliya Voznesenskaya, another major disagree-
ment between the two wings of Soviet feminism has been over
men: the religious women see men as partners, the secular feminists
seek to 'liberate themselves from the tortuous constraints of their
wretched existence through conflict with the opposite sex and see
in this conflict the only solution to the woman question'.[18] The
secular feminists would undoubtedly reject this description of their
views, and, in fact, they do not appear to think so very differently
on this subject from the Maria group. Though Tat'yana Mamono-
va has chosen to work in the West mainly with women's organisa-
tions, she has always put emphasis on the creation of new and equal
relations between men and women and sought in her personal life
to practise what she preaches. Though neither group would be
classified in Western terminology as subscribing to 'radical' let
alone 'revolutionary' feminism, they both have some harsh words
to say about male vices (alcoholism and swearing), about the
irresponsible behaviour of fathers and the insensitivity of husbands.
And both groups share the belief that women, because of their
particular life experiences, possess spiritual qualities of great value
to society and should work together and have a social and political
voice separate from men. Tat'yana Mamonova told *Ms* magazine:

> I think woman is altruistic. She gives life and appreciates life.
> That's one of my main concepts. I think the woman is organical-
> ly against war, for example, and nuclear and chemical destruc-
> tion, and she can really save the world if she is permitted to play
> an active role in government in different countries, the Soviet
> Union among them.[19]

The religious feminists say they have found great comfort in each
other's company and friendship. They feel that their group has
been able to realise a new and more democratic form of organisa-
tion without the jostling for leadership, without the rules and
statutes that plague most dissident groups. Yuliya Voznesenskaya
had this to say on the subject:

> Notwithstanding all my respect for dissidents and activists of the
> 'second culture' amongst whom I count many of my closest
> friends and with whom I have worked shoulder to shoulder for
> many years I have to admit . . . that they almost all strive for
> authority and leadership. It seems that democracy in the very

deepest sense of the word is a female characteristic. Never mind though, we will when the time comes share our secret with the men.[20]

In 1980 the religious feminists publically demonstrated their political opposition to the Soviet government by speaking out against the war in Afghanistan. On 1 March they appealed to 'Women of Russia!': 'Do not let your husbands and sons become the victims of this bloody slaughter! Explain to them how disgraceful and criminal it is to be the aggressor in a foreign country. . .'[21] Call-up papers, they argued, ought to be burned and women should persuade their men not to fight. In May, when news reached Leningrad of a peaceful demonstration of school children in Kabul fired on by government troops, the Maria club reacted by issuing a second statement; the participation of young girls in the demonstration, they said, was another illustration of the decisive and uncompromising struggle waged by modern women. On 19 July in a letter demanding an end to the bloodshed the feminists expressed the shame they felt as Russian women at the lies perpetrated by their government and at its interference in the affairs of Afghanistan.

Such audacious behaviour could not be left unpunished. However, this was Olympic year, the world was in the throes of the boycott debate, and arrests and trials would have been inconvenient at this point. The government continued with its policy of harassment and intimidation, hoping thereby to keep the women silent. Once the Games were safely underway, on the day after the opening ceremony, Tat'yana Goricheva and Natalya Malakhovskaya were arrested and given the choice of a place in prison or a ticket to the West. Tat'yana Mamonova was offered the same alternatives. They all opted to leave and on 20 July arrived in Vienna to join Yuliya Voznesenskaya who had been forced into exile a couple of months previously.

Western Reactions to Soviet Feminism

The West*(zapad)* looms large in the minds of Soviet citizens as the paradoxical land of unemployment and of those consumer goods — French eyeshadow, Finnish sausage, American blue-jeans — for which they queue for hours in the shops or procure by stealth on the black market. For the dissidents the West plays a rather different role, providing them with information about political events both domestic and foreign (via the foreign radio stations broadcasting in Russian) and with the opportunity to relay in-

formation to the world (via meetings with foreign journalists). The Soviet feminists, through their participation in the 'second culture' had been part of this East/West exchange. Poems of Yuliya Voznesenskaya had been published in the West, a film about her made for Boston television. Tat'yana Mamonova had sold her paintings to diplomats and through them, apparently, met foreigners interested in and knowledgeable about feminism. Hence, *Woman and Russia*, though it drew upon personal experience and the specific conditions of the USSR, used foreign terms such as Shallocracy and was aware of foreign discussions on bisexuality.

The publication of the *Almanac* and the harassment of the feminists by the KGB was widely reported in the Western press. *Le Monde* mentioned Tat'yana Mamonova's letter of protest to the Procurator-General: *The Times* noted the pressure exerted on the feminists to give up their activities. *Des Femmes en Mouvement Hebdo*, a French feminist magazine, published a translation of the *Almanac*. The Soviet women welcomed this foreign interest and hoped that it would serve to cushion them against the full force of KGB repression. (The attention of the foreign media is valued by the dissidents not only because it compensates for their lack of means of communication within their own political system, but also because if they are known abroad and win the support of international public opinion, the Soviet government, they believe, is less likely to make arrests and sentence them to long terms of imprisonment.) Following usual dissident practice, the feminists wrote a series of open letters to 'world opinion' asking all 'people of good will' to show solidarity with their cause and to protest against the government attempts to silence them. Tat'yana Mamonova stated her intention of applying to the United Nations to have her journal recognised and to obtain help with the translation and distribution in the USSR of feminist books. The coverage they received in the West did serve, it seems, to protect them. When Yuliya Voznesenskaya was taken in for interrogation at the beginning of 1980 she told the KGB what good publicity her arrest would be for the American film about her life — five hours later she was released. 'The KGB began several times to organise a trial of the feminists', wrote Peter Reddaway in the *Observer*, on 4 January 1981, 'but each time they retreated in the face of world opinion.' This retreat, though, was partial and did not prevent the government sending the four most vocal feminists into foreign exile.

Once in the West, however, the women became more accessible to the media, and for a time at least, interest in their cause increased. In the autumn of 1981 a speaking tour of the United

States was arranged for Tat'yana Mamonova and during this visit she addressed a press conference organised for her in Capitol Building sponsored by two Republican congresswomen and the assistant secretary in charge of human rights for the State Department. She was interviewed by the Voice of America and her public engagements were extensively reported in the press. In Britain the following year she spoke on local and national radio. The major daily newspapers, though, felt that as they had already carried articles on the Soviet feminists the visit was not newsworthy.

The *Guardian* had already published two feature articles. The first, 'Can Perfume and Flowers conceal a Whiff of Discrimination?' by Jill Nicholls and Karen Margolis, which was published in February 1980 soon after the *Almanac* first came to the attention of the foreign press, commented on the articles included in the *Almanac,* gave a brief historical background on Russian feminism and Soviet dissidence and some information on the position of women in the USSR today. The second article, by Shusha Guppy, published in the *Guardian* on 31 July 1980, reported the emergence of the Maria group and explained the religious feminism of its members. It provoked an angry response from Genadii Shikarev, secretary of the *Almanac*: he issued a statement alleging that the Maria group was spreading false information and distorting facts. It was not true, he said, that Tat'yana Mamonova had capitulated to threats from the KGB, as the *Guardian* had reported, nor that she had ceased her feminist activity. The following month one of the secular feminists, Vera Golubeva, sent an open letter from the USSR calling for an end to the 'false information about Tat'yana Mamonova'. Shusha Guppy, writing some months later in the *Observer*, on 13 December 1981, in an article entitled 'The Women's Camp', remarked that since arriving in the West the feminists had suffered from 'a slight touch of emigritis'. This was a tactful understatement. The November cover of the American feminist magazine *Ms* carried a group photo of the four women in Vienna; Tat'yana Goricheva, Yuliya Voznesenskaya, Natalya Malakhovskaya and Tat'yana Mamonova are smiling, their arms on one anothers shoulders. This happy family portrait was strictly for the camera, however: relations between the secular and religious groups, strained even before the women left Leningrad, were growing increasingly acrimonious.

The women were undoubtedly under a great deal of stress. Apart from the problems of coping with foreign languages, foreign customs, of finding gainful employment, they had to seek out ways and means of continuing their struggle, or rather their two separate

SOVIET SISTERHOOD

struggles, as by the winter of 1980 the secular and religious groups had ceased to cooperate or even keep in touch. Both groups talked bravely of keeping up contact with the women they had left behind. Both groups managed to maintain a presence in the USSR for some time; the Maria group was particularly successful in this respect and through 1981 its members grew. However, few new feminist manuscripts found their way to the West and in the face of fierce KGB repression the feminist groups were contained and then began to decline in strength.

On 24 September 1980 searches were carried out at the homes of Sofiya Sokolova and Ludmilla Dmitrieva and manuscripts, including feminist literature, were confiscated. Both women were interrogated but neither woman was charged. Natalya Lazareva, arrested that same day, was not so lucky and found herself charged under Articles 190–1 with 'defamation of the Soviet system', an offence which carries penalities of up to three years in a forced labour camp or five years in Siberian exile. A puppet theatre specialist unable to find a job in her field, Lazareva had worked as a central heating attendant; for a number of years she had been active in the 'second culture' and was a founder member of the Maria club. Her arrest was publicised in the foreign press and a defence campaign launched. On 26 September the International Society of Human Rights issued a leaflet calling on world public opinion to express its anger; on 28 September, 110 Russian émigrés protested to the Procurator-General of the USSR about the persecution of the women's movement; on 22 October, United States congresswomen sent a letter to the Soviet ambassador demanding an end to the persecution of the independent feminist movement and the liberation of Natalya Lazareva; on 6 November three members of the European parliament drafted a resolution condemning the repression and mentioned in particular the case of Natalya Lazareva. These measures were, the Maria club believed, not without effect. The arrested woman received a relatively mild sentence of eleven months in a camp. Her story, unfortunately, does not have a happy end, for in March 1982 she was rearrested and this time charged with the more serious crime of 'slandering the Soviet state and social system' (Article 70). She was sentenced to four years in prison and two years in internal exile. The term was much lighter than might have been expected, Tass reported, because she showed 'sincere repentance'.

Natalya Mal'tseva was also forced to show 'sincere repentance'. An old friend of Genadii Shikarev, she had sided with the secular feminists in opposing the christianisation of the movement and

when Tat'yana Mamonova was exiled became the chief spokes-woman within the USSR of the secular feminist group. Arrested on 6 December 1980, she was charged under Article 70. At the trial the following February the court released her on a two-year suspended sentence, not because of a change of heart towards the feminist movement on the part of the Soviet authorities nor because of the pressure of Western campaigning, but because Natalya Mal'tseva was ill with tuberculosis and in no condition to continue her dissident activity.

The feminists have received more notice from the Western media than many dissident groups. They are the first to speak out on the subordination of women in Soviet society and thus have novelty value. Nevertheless, press coverage, in Britain at any rate, has been in a relatively minor key. And few government or other official bodies have come forward to defend the movement or aid its exiled members.

Feminist Reactions

The Soviet feminists looked particularly to the Western women's movement for support and defence. In an appeal 'To World Public Opinion' issued in July 1980, Tat'yana Mamonova asked women everywhere to show their solidarity. After the arrest of Natalya Lazareva in the winter of 1980, Yuliya Voznesenskaya, Tat'yana Goicheva and Natalya Malakhovskaya addressed 'all' women's organisations and all democratic forces throughout the world' in a request for aid. Galina Grigoreva, a member of the Maria club who was still in the USSR at this time and still at liberty, called on the world feminist movement 'to do everything possible to protect us from the tyranny of the authorities'.[22]

The first contact the Leningrad women had with a Western feminist organisation was not an altogether happy experience. *Editions des femmes,* the publishing house attached to the French women's group 'des femmes', broke the unwritten rules of conduct established in France for dealing with dissident writings. Usually a mutual agreement is reached between those interested in a particular manuscript; in this case a collective decision was taken in favour of a small feminist concern, *Edition Tierce,* who hired a translator and set publication dates. *Editions des femmes,* already unpopular because of their high-handed and arrogant behaviour, ignored this agreement, obtained a copy of the *Almanac* and rushed their own translation into print in their monthly magazine. This understand-ably angered other French feminists. At the press conference called to launch the translation, Irene Baskina, a recent émigré from

Leningrad, raised another objection: the magazine had not placed the Russian writings in any context, had nowhere explained that the *Almanac* was a dissident publication nor indicated the specific features of the Soviet women's struggle. The publishers came under even greater fire for their subsequent action. *Edition des femmes* flew its representatives to Leningrad to arrange a contract with the feminists for the first three issues of their journal – the Soviet women, aware only of the valuable publicity the translation had given them, were pleased to give their consent – and shortly afterwards published the *Almanac* in book form announcing in the title-page their world copyright on the material, thereby exposing the Leningrad women to prosecution under Soviet law. (All publishing contracts between the USSR and the West have to be agreed through official channels and so publishers of unofficial manuscripts protect their authors by stating that the work is printed 'without the author's knowledge or authorisation'.[23] As *F Magazine* commented, in issue no. 26, 1980: 'In establishing a monoply of foreign rights over the *Almanac, Des femmes* has in fact jeopardised the freedom of other women.'

Other feminist groups and organisations both in France and elsewhere have given support and publicity of a less controversial kind. The women's press reported the publication of the *Almanac*, translations of this and subsequent writings appeared, speaking tours for the exiled feminists were organised and defence campaigns launched to protest the measures taken by the Soviet government against the women's movement.

In its reporting on the Soviet feminists, however, the Western women's press has been hampered by lack of information and by the language barrier. Translations of the *Almananc* and *Maria* journals appear months, even years after the original Russian edition and consequently it has been difficult for Western feminists to follow the development of their ideas.

Robin Morgan, who met the feminists shortly after they arrived in the West and spent some time with them, wrote that she had been prepared to find their ideas radically different from her own and was surprised to find that in fact they had so much in common: 'Our pain differs, more in detail than in kind, and our respective governments, while claiming major ideological distinction from one another, share a similar patriarchal indifference to and suppression of their female citizens.'[24] Several other feminists commenting on the *Almanac* have sought to establish the extent of overlap in ideas between West and East: shared grievances over the unequal household burdens shouldered by women have been noted, while

the religious 'spiritual' language of the Soviet feminists is the most frequently mentioned difference.

However, coverage has been, on the whole, descriptive and supportive rather than analytical and critical. Carol Anne Douglas, in an article entitled 'Russian Feminists Challenge Phallocracy' in *Off Our Backs* in December 1980, for instance, found her meeting with one of the feminists 'incredibly moving and exciting. Knowing that we are part of a truly international feminist movement cannot help but strengthen our commitment' (p. 20).

As part of a campaign to defend the Soviet feminists, a Comité féministe de solidarité avec les femmes de Léningrad was set up in January 1980, on the initiative of the feminist press in Paris and various French women's groups. French feminists also protested against the arrest and trial of Natalya Lazareva and Natalya Mal'tseva and petitions circulated in a number of countries. Western feminists, however, have not managed to sustain a long-term campaign on behalf of the Soviet women nor to exert much influence in high places. The fragmentation of organised feminism is one reason for this failure to respond in a more positive way.

In Britain where no national women's conference has been held since 1977, a focus for debate and for organising nationwide campaigns on international issues is lacking. The economic recession has hit feminist pockets hard and campaigning on international issues tends to be expensive. Finally, the climate of ignorance in the West and the East about the lives of women on the other side of the propaganda divide means that when feminists meet they often cannot fully comprehend each others' problems, each others' ideas. Tat'yana Goricheva, for instance, is under the impression that 'to become a witch is the ideal of Western feminists'.[25] East/West feminist informational interchange is clearly far from satisfactory!

Reactions of the Western Left

There are few socialists in the West today who would deny dissidents their right to raise their voice in protest against the Soviet regime. Nevertheless, some still refrain from giving active support to the dissident movement out of discomfort at taking the same side of an argument as arch-conservatives, for fear of appearing to join the right wing in red-baiting. Within the labour and trade union movements a sense of solidarity with the non-capitalist countries lingers on; the USSR in particular remains the embodiment, however tarnished, of the idea of popular power, of working-class men and women creating a new social and economic

order. Hence, though these movements are critical of the lack of democracy in the countries of the Eastern bloc, they are apt to phrase those criticisms cautiously and speak them softly. This is unfortunate since both the labour and trade union movements occupy a far more influential position in Western societies than socialist intellectuals and could, if they were willing to campaign energetically, achieve much both in raising awareness on East Euopean political issues amongst their fellow countrymen and women and in aiding the dissident cause on its home ground. In Britain neither the unions nor the labour movement has given any extensive coverage to the Soviet feminists.

The organised extra-parliamentary left wing both in Britain and abroad has shown more interest. For these groups the nature of the Soviet state has always been a central issue of debate; indeed it is differing analysis of this question that often lies at the origin of their separate identities. It is argued by some that the absence of private property in the countries of Eastern Europe has definite effects on their economic and social structure and that despite the distortions of the Stalinist era and despite the authoritarian political system which survives to this day, these societies are moving in a socialist direction. Others contend that the nationalised economy is only a façade for a system of production and distribution no different from that existing in the West, and they label these societies 'state capitalist'. On the whole, left-wing press coverage of the *Almanac* has given little space to an explanation of the dissident movement and its aims, and has tended to examine the feminists only in terms of the interpretation of Soviet society subscribed to by the paper in question. Hence, though there was support, there was also unease at the women's lack of theory: 'They have no analysis of Stalinism or why women's oppression exists in Soviet Russia, other than a vague anti-establishment feeling',[26] or it was felt necessary to apologise for or justify the women's failure to measure up to the Marxist model:

> Their radical feminism is an instinctive, emotional response to the extreme oppression of women in the Soviet Union.
> They shouldn't be condemned for it.[27]

> These women are so disillusioned with men and with the society they live in they have placed their faith in building an alternative based on 'female values' and even religion.
> They are wrong. But they are none the less brave for all that.[28]

The Spartacist League allows no extenuating circumstances. Its analysis of the Soviet Union leaves no room for such generosity. Taking literally Trotsky's dictum that the USSR has to be defended against imperialism it characterises Soviet dissidents as the lackeys of the Western bourgeoisie (ironically, using many of the labels employed by the Stalinists in their smear campaign against Trotsky in the 1930s). 'Mamonova on Tour for Counterrevolution' was the title of an article in *Canadian Spartacist* in the spring of 1981 and its author was of the opinion that the International Feminist Union for which the Soviet exile was campaigning would serve as 'an auxiliary to imperialist-sponsored counterrevolution in the USSR'. The Soviet feminists, thus, are accused of acting as allies of imperialism in its attempt to restore capitalism in the USSR: 'The sob stories about "our Russian sisters' " horrible plight are intended to whip up support for the American war drive against the USSR.'[29] The Spartacists do not recognise Soviet society as having any internal dynamic of its own. Its problems are not real problems; dissidents and human rights are merely the projection of an imperialist plot. Soviet citizens with criticisms of their society have no choice in this case but to knuckle under and wait for the world revolution to straighten out the deformities of their workers' state.

The ideas of this small, little-known Trotskyist group are worth giving space to because they do reflect — admittedly in a highly exaggerated form — the prejudices of many other socialists, and because an article in the Spartacist journal, *Women and Revolution,* 'Fake-left Hails Holy Russian Daughters', provoked a long reply from Natalya Malakhovskaya. Her letter conveys very nicely the distrust the Soviet feminists have of theory, which in their eyes is inextricably linked with the doubletalk of official propaganda, and their preference for the direct and undeceitful language of experience.

What on earth is one supposed to make of labels like 'petty bourgeois poetesses' she asks; this 'strange, fusty and moth-eaten terminology' serves to obscure rather than explain.

> How can you have the gall to make sweeping judgements about the spiritual life of a country which bears not the slightest resemblance to your own? You consider that because you find our tone incomprehensible (obviously none of you has ever had to howl with pain!) gives you the right to make such irresponsible generalisations.[30]

Again and again she returns to the personal experience from which

the Soviet women speak. It is not an exaggeration to say that many women bear children without anaesthetic, she insists. We know. We have suffered. 'You say that "the accusation that Soviet women are forced into doing body-destroying labour is a lie pure and simple." Have you ever worked in a Soviet factory? I have. And I was forced to do such work. When I refused to pick up heavy weights, the foreman would declare: "What's wrong with you? A healthy woman like you — and you say you can't shift this timber?" We talk not about what we have seen or heard', she says, 'but about that which we ourselves have experienced.'

The Christian women continue to identify themselves as anti-Marxist and anti-Bolshevik (socialism is not a word they use), but they are not interested in political analysis. Their chief enemy, the Soviet state, is usually only implicit in their writings. They assume that it is government at the source of the repressive social mechanisms which set the framework of private as well as public lives, poisoning human relationships and stunting spiritual life. It is consistent with this approach that they should have spoken out on Poland and Afghanistan, two recent casualties of the Soviet state, and that they should have limited themselves to reporting economic hardships in the first instance and the brutalities of war in the second, stopping short of political discussion.[31]

Tat'yana Mamonova shares their hatred of the Soviet state and its organs of repression. In *Rossiyanka* she published an account of her first interview with the KGB and in a number of articles has described the various methods of intimidation employed against her and her friends by the security forces. She has also criticised the privileges of the Communist Party bureaucrats in the USSR. She places her criticisms, though, in a strikingly different context from the religious feminists. She is anti-totalitarian but not anti-socialist. Those illusions about the position of women in Europe which led her to write in the introduction to the *Almanac* that the woman question there 'is close to being resolved' have long since been shed. While appreciating the democratic freedoms of Western society, she recognises its imperfections and sees socialism as potentially a better system. During her tour of Britain in 1981 she used the term "partocracy" to describe the Soviet system which she characterised as reactionary and conservative; she also talked of a 'new class'. She would not be drawn further than this into public discussions of the nature of the USSR.

For the Soviet feminists to put aside their distrust of theory they will have to be convinced that their experiences is being taken seriously, and that political analysis is not necessarily rhetoric

employed for anti-humanitarian ends. In the modern world, still divided by ideologies and living under the threat of nuclear war, dialogue between Eastern and Western political oppositions is needed more than ever. It is understandable that the labour and trade union movements should hesitate to make common cause with those dissidents who are loud in their denunciation of socialism. But the onus is on the West, where opposition movements have so much more scope for action and access to information, to create conditions for contact and discussion.

At the moment the exchange between Western radicals and the dissidents is minimal. A number of journals exist which provide information about East European oppositions and a socialist critique of the political systems against which the dissidents struggle, but they are not sufficiently influential to bridge the gap between the two political cultures, between socialist theories about the nature of East Euopean society and the dissident experience of living within it. Several Soviet dissidents who in the USSR considered themselves socialist have found the milieu of Western left politics inhospitable and alienating and, failing to make a place for themselves within it, have gravitated further and further to the right.

Neither does Western mainstream political culture — government and official bodies, political parties – sustain close ties with the exiled dissidents. Though a large émigré community lives in Germany, France and America it remains on the whole self-contained, participating little in the political life of the host countries. The exiled dissidents often feel that these countries do not support them as much as they could and ought. Alexander Solzhenitsyn, in his letter to the Maria group mentioned earlier, complained that the West, despite its loud trumpeting about human rights, was very selective in the causes it chose to champion. Western people did not understand, he said, how women lived in the USSR and did not want to try to understand. The Maria group appears to have come to similar conclusions about the West's political commitment, noting its 'timid protests on Afghanistan',[32] and its members increasingly have turned inwards to the émigré community.

Tat'yana Mamonova, on the other hand, has shown an interest in Western politics. While on a lecture tour in the USA she talked to reporters about the presidential elections — she was distressed by the 1980 Reagan victory — and wrote an article on the political attitudes of the young Americans she met on her travels: it was necessary, she said, to fight the apathy of the Soviet and the

American peoples, their pragmatism and commercialism, and to encourage individuals to think seriously about their personal responsibility for the fate of the world; neither Brezhnev nor Reagan will do the thinking for us, she concluded.[33] Since then she has toured the world tirelessly describing to audiences the conditions of women in the USSR. But she is isolated from the émigré community, estranged from the other exiled feminists, cut off from the USSR and is therefore in no position to liaise between Soviet feminism and the Western world.

The Future of Soviet Feminism

The publication of the *Almanac* and the feminist organisation and activity that followed raised for the first time in the dissident movement the question of women's social subordination and offered a critique of male (patriarchal) behaviour that challenged the complacency of the 'second culture'. Though feminism has not succeeded in gathering sufficient momentum within the Soviet Union to weather the storm of KGB repression in this period of decline of oppositional activity in general, it will, one suspects, have had a lasting effect on the dissident movement. From now on it will be more difficult for men to be condescending about the 'weaker sex', less difficult for women to take more active and visible roles in the opposition and to raise feminist issues.

However, the aim of the *Almanac* was to reach other women, not to reform the dissident movement — and on this score the immediate future is not bright. Many of the grievances voiced in *Woman and Russia* are widely shared in the Soviet Union: the problems of finding a creche place, anxiety over hospital and school standards, exhaustion after days of work and evenings of housework, are topics for complaint when women get together with neighbours and friends. It is a long way, however, from a private grumble to a public protest, especially in the USSR. The vigilance of the KGB is not necessitated in the short term by the appeal of the protest movements. Were the dissident movement to be legalised it would probably win far less support than many in the West believe. The Soviet Union is very different from Poland: the majority of Soviet people, despite the criticisms they make in private, are loyal to their government. Many even among the disaffected intelligentsia are of the opinion that too much liberty might be dangerous for the Russian people who, without a firm hand at the helm, would sink into anarchy and chaos. The mass of workers and peasants are proud of the industrial progress their country has made over the last few generations, of their nation's status as a superpow-

er and give the present political system credit for these achieve-
ments. If pride in the state is mixed with fear, this is only in the
Russian tradition. The authoritarian relationship between indi-
vidual and state is not seen and condemned as something specifical-
ly Soviet but accepted with fatalism as the normal state of affairs.
Collective action simply does not cross the minds of most citizens.
The methods of resistance they practise are low productivity and
absenteeism, the individual type of protest associated in Western
history with pre-capitalist societies. The decimation of the mass
movements which flourished briefly in the 1920s has only served to
confirm the population in its preference for primitive forms of
rebellion.

Thus, even if the millions of Soviet women had had access to the
Almanac, it is doubtful whether many would want to join the ranks
of a feminist movement. When the recent wave of Western
feminism developed at the end of the 1960s, the Soviet press
presented its advocates as hysterical middle-class women with
nothing better to do and no understanding of the 'real' problems of
the world. This campaign of denigration of feminist struggle in the
official media was in line with the patriarchal prejudices of popular
culture, prejudices shared by women as well as men. The urbanisa-
tion of the Soviet Union which might have been expected to push
women to demand change paradoxically has worked to reinforce
certain of the traditional notions of the female personality and the
female role in society.

Because of the shortcomings of the service sector of the Soviet
economy it is women who shoulder the main burden of distribu-
tion and in this cut-throat allocation of scarce resources are pitted
one against the other. Woman faces woman across the food store
and in the doctor's surgery and the disappointments and frustra-
tions that these encounters involve do nothing to raise women's
opinion of their own sex. They are often the first to say that
women are gossips, obsessed with trivia, less capable of rational
thought and efficient action. And as the much vaunted economic
equality bestowed upon them by Soviet power has in most
instances landed them in dead-end low-paid jobs, women are in the
main only too pleased to opt out of the scramble for promotion,
which they have little chance of winning anyway, and seek to
satisfy their growing aspirations for autonomy and emotional
fulfilment in the family. The modern Soviet women is intrigued by
the image of the feminine woman. This is her model. She strives
for elegance in dress and in self-presentation; she aspires to elegance
in lifestyle. A well-appointed apartment, an abundantly-stocked

larder, husband and children competing successfully in their respective spheres – these are her chief delights. The era of domesticity which flourished in England in the early nineteenth century is today dawning in the USSR. Now for the first time the country has a large and increasing number of educated city-dwellers who have the leisure, the money and the inclination to secure for themselves family comforts. It would be tempting to suppose that as in Western Europe, these developments will be followed by the emergence of a liberal political system and that, as in the West, hard on the heels of the domestic ideal will come the growth of a mass women's movement. History, though, is unlikely to repeat itself. But of something we can be certain – the first case of feminist dissidence will not be the last.

Notes and References

1 *An Almanac: Woman and Russia* was published in the West as *Woman and Russia. First Feminist Samizdat* (London, Sheba Feminist Publishers, 1980), p. 103.
2 Ibid., p. 103.
3 Ibid., p. 103.
4 Ibid., p. 83.
5 Ibid., p. 47 (R. Balatova ia a pseudonym of Tat'yana Mamonova).
6 Ibid., p. 38.
7 This letter was subsequently published in the West in the émigré newspaper, *Russkaya Mysl'* ('Russian Thought') 10 January 1980; *Des Femmes en Mouvements Hebdo*, January 1980.
8 Shusha Guppy, 'The Women's Camp' in the *Observer* (13 Dec 1981).
9 'Newsmakers' in *Newsweek* (3 Nov 1980).
10 Alice Braitberg, 'Les femmes en Union Sovietique', in *Questions feministes* (Feb 1980).
11 'Iz pochty kluba "Mariya" ' ('From the Maria club's post-bag') in *Mariya 2. Zhurnal rossiiskogo nezavisimogo zhenskogo religionznogo cluba 'Maria'* ('Maria. Journal of the Russian independent religious club "Maria" '), (Leningrad-Frankfurt, 1982), p. 101. This letter from A Solzhenitsyn to the Maria club is patronising in tone and discouraging in the extreme. The attempts of the Christian women to help their sisters in Soviet prisons is he says a worthy one but not likely to have results. The information the group provides on the position of Soviet women would be of use to people living in the USSR but they are not likely to ever see the Maria journal; it would be useful to people in the West, but they do not want to try to understand. To Russian émigrés,

he says, the journal is of 'no use whatever', as they know already.

12 The Editors, 'Those Good Old Patriarchal Principles' in *Woman and Russia First Feminist Samizdat*, p. 23.

13 Tat'yana Belyaeva, 'Plachet Rakhil' o detyakh svoikh' ('Rachel cries for her children'), in *Maria 2*, pp. 55–8.

14 Tat'yana Goricheva, 'Antivselennaya sovetskoi sem'i' ('The anti-universe of the Soviet family') in *Maria 2*, p. 36.

15 Sof'ya Sokolova, 'Slabyi pol? Da, muzhchiny' ('The weaker sex? Yes, men') in *Maria 1*.

16 Natalya Malakhovskaya, 'V nenasytnoi utrobe' ('In the insatiable womb') in *Maria 2*, p. 42.

17 Tat'yana Goricheva, 'Antivselennaya sovetskoi semi'i' in *Maria 2*, pp.35–7.

18 Yuliya Voznesenskaya, 'Zhenskoe dvizhenie v Rossii' in *Posev*, p. 42.

19 Robin Morgan, 'The First Feminist Exiles from the USSR' in *Ms* (November 1980), p. 108.

20 Natalya Malakhovskaya, 'Zazhivo pogrebbennye' ('Buried alive'), in *Maria 1*.

21 Quoted in 'Russian "Feminist Dissidents" vs *Women and Revolution*', *Women and Revolution*, no. 23 (1981–2), p. 13.

22 Peter Reddaway, 'Russia puts First Feminist on Trial' in *the Observer* (4 Jan 1981). Another appeal – 'Appeal to Women of the Whole World' – signed by the same three women, was published in Russia in *Posev*, no. 10 (1980), pp. 17–18.

23 For the story of these unfortunate events see: Sylvie Caster, 'Le triomphe de l'amalgame' in *Charlie-hebdo* (12 March 1980); 'Dissidentes: bilan globalement repressif' in *F Magazine*, no. 26 (1980); 'Own the movement?' in *Off our Backs* (July 1980); Shusha Guppy, 'The Women's Camp' in the *Observer* (13 Dec 1981).

24 Robin Morgan, 'The First Feminist Exiles from the USSR', p. 49.

25 Tat'yana Goricheva, 'Paradoksy zhenskoi emansipatsii' ('Paradoxes of emancipation') in *Posev*, no. 2 (1980).

26 Ann Evans, 'Woman and Russia', in *Socialist Press* (4 Feb 1980).

27 Anna Paczuska, 'No One but Ourselves' in *Women's Voice* (May 1980). In March 1981 this same SWP magazine commented that *Woman and Russia* 'was . . . disappointing in its anti-working class, anti-male and pro-religious stance'.

28 Vera Slutskaya, 'Woman and Russia' in *Socialist Worker* (5 July 1980).

29 'Holy Mother Russia's Daughters' in *Spartacist Britain* (March 1981).

30 'Russian "Feminist Dissidents" vs *Women and Revolution*', *Women and Revolution*, no. 23 (1981–2), p. 8.

31 See *Maria 2*: the section on Poland, 'Solidarnost's "Solidarnost'yu" ' ('Solidarity with "Solidarity"', pp. 3–9, and on Afghanistan, 'Zemlya v ogne' ('Land in flames'), pp. 11–34.

32 'Klub "Maria" protiv okkupatsii Afganistana', in *Maria 2*, p. 12.

33 Tat'yana Mamonova, ' "Jane Fonda for President" ', typed manuscript.

INDEX

abortion, 11, 20, 248
 clinic staff, 142
 law, 22, 34, 40, 133, 137, 152
 repeated, 158, 169
agriculture, 102, 105, **177–88**, 201
 agricultural labourers, 183–5
 collectivisation of, 39, 177
 mechanisation of, 182–4
 private, 187, 192
alcoholism, 19, 20, 72, 126, 132, 198, 222
Almanac : Women and Russia, 11, 19, 22, 81, 134, 142, 145, 233, **237–63**
antenatal care, 153–9, 162–4
Armand, I. 23, 33, 34, 88, 245

Belyaeva, T. 248
biological sex differences, 46, 55, 57–8, 60, 94–5, 232
birthrate, 20, 73, **126–31**, 197, 200
 and childcare facilities, 123
 and labour problems, 46, 178, 188
 Muslim, 26, 46, 139
 policies to raise, 116
 press handling of, 71
 rural, 189
Bolsheviks, 33, 37, 57, 88–9, 94, 145, 148, 177, 244–5, 247
Brezhnev, L. 26, 41, 103, 106, 116, 131, 134, 194, 210, 216

childbirth, 20, 145–61, **164–73**
children

allowances, *136*
and zhensovety, 215, 221
care of, 36, 46–7, 49–50, 72, 94, 249
development and upbringing of, 44, **56–62**
facilities for, 123, 184, 194
in the family, *141*
in rural life, 189, **191–5**, 219
men and, 149, 196, 200
nurseries for, 33, 123, 142, 192, 200
of single women, 34
sex characteristics of, 71
collectivisation, 22, 39, 177
collectives, 63, 181, 191
communism, 32, 41, 43–5, 216–7, 228
Communist Party of the Soviet Union
 and role of women, 105, 177, 180, 212
 and zhensovety, 219, **226–33**
 Central Committee of, 93, 207
 congresses, 25, 46, 88, 101, 116, 131, 134, 207, 216–7
 ideology, 27
 membership of, 219, 224–5
 privileges, 260
 relationship to press, 80–2, 90, 97, 99, 103
 women in, 23, 207–8, 219
consumer goods and services, 87, 99, 123, 134, 191, 194, 200
contraception, 134, 152, 170

atheist, 244
in the press, 78-9, 83-3, 93, 96-7, 99, 110
psychophysiological sex differences, 19, 44, 50, **54-77**
public
life, 211, 231
order, 222
services, 93, 111, 116, *120*, 142

Rabotnitsa (The Working Woman), 19, 84, **86-110**, 214, 222, 228, 239
Rabselkor, 83-4, 98, 100, 103
religion, 242-7
reproduction, 30, 32, 36, 43, 45-6, 60, 116, 126-8, 131, 139-42
revolution of 1917, 9, 22, 28, 33, 91, 99, 147-8, 177, 189, 212, 238, 245
rights
employment, 162
equal, 207, 210
gay, 248
lesbian, 248
maternity, 150, **161-2**
political, 207
welfare, 162
women's, 212, 244
rural
attitudes, 189, 196, 199, 202
birthrate, 189
employment, 20, 123, **177-206**
environment, 189
family, 100, **177-206**
health, 154, 182, 186
industry, 185-6, 202

migration, 20, 126, 131, 179, 201-3
pay, 181, 185
population, 129, 177
schools, 186-7, 190, 200-1
services, 185-6, 191, 202
women, 96, 100, **177-206**

samizdat, 11, 237-46
schools, 71-2, 95
nursery, 33, 123, 142, 192, 200
rural, 186-7, 190, 200-1
sex
biological sex differences, 46, 55, 57-8, 60, 94-5, 232
discrimination, 23, 72, 180, 188, 203, 210
division of labour between the sexes, 42, 50, 55, 60, 122, 135, 142, 184-6, 201, 210, 221-2, 231
education, 102, 152
equality, 18, 22, 30-4, 39-44, 49, 55, 73, 94-5, 122, 149, 207, 210-11, 233
inequality, 11, 20, 25-6, 39-43, 46, 49, 194, 203, 209-11, 232-3
psychophysiological sex differences, 19, 44, 50, **54-77**
relationships, 22, 36-7, 190-1, 200, 248
roles, 19, 25, 47, 50, **54-77**, 92, 94-5, 110, 116, 134, 138, 221-3, 232, 247
sexuality, 32, 36-8, 102, 248
stereotypes, 50, 54, 60, 62, 65, 95, 134, 138, 140
Shikarev, G. 242, 253-4
single mothers, 34, 137, 163, 222